FOTOGRAFIE IM FOKUS

FOCUS ON PHOTOGRAPHY

DIE SAMMLUNG
FOTOGRAFIS
BANK AUSTRIA

THE FOTOGRAFIS
BANK AUSTRIA
COLLECTION

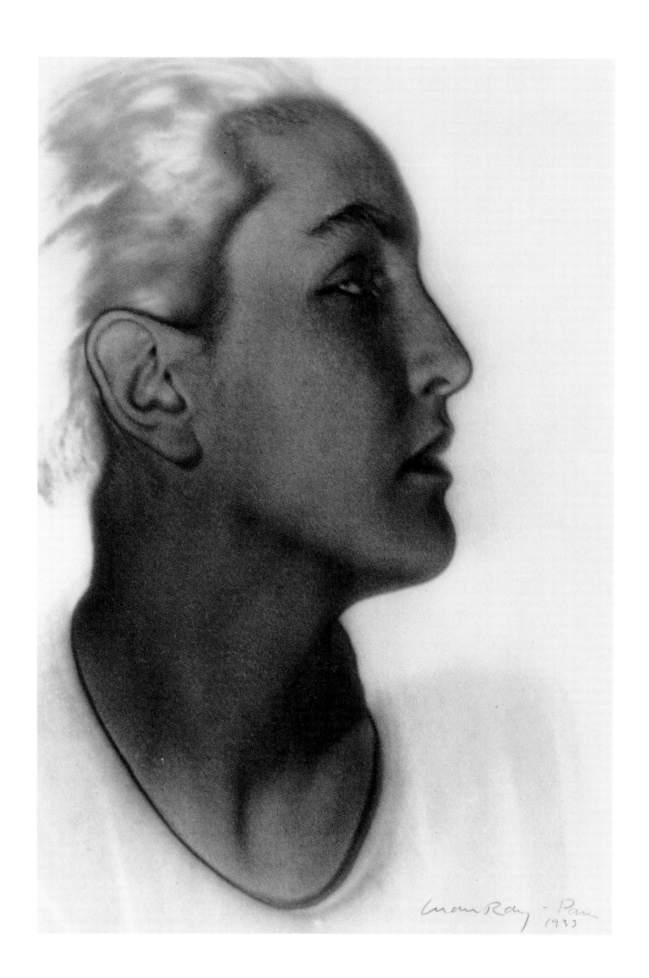

MdM SALZBURG
Museum der Moderne

FOTOGRAFIE IM FOKUS FOCUS ON PHOTOGRAPHY

DIE SAMMLUNG FOTOGRAFIS BANK AUSTRIA THE FOTOGRAFIS BANK AUSTRIA COLLECTION

Herausgegeben von / Edited by

Toni Stooss
Margit Zuckriegl

Mit Beiträgen von / With contributions by

Anna Auer
Vladimír Birgus
Simone Förster
Walter Guadagnini
Walter Moser
Ulrich Pohlmann
Uwe M. Schneede
Toni Stooss
Margit Zuckriegl

HIRMER

VON DER BANK INS MUSEUM.
EIN VORWORT

FROM THE BANK TO THE MUSEUM.
A FOREWORD

Toni Stooss

Der Dadaist, Surrealist, Maler und Fotokünstler Emmanuel Rudnitzky, dessen weltweit bekannter Künstlername Man Ray zu der speziellen Bezeichnung Rayogramme für seine Fotogramme führte, nahm 1933 in Paris eine Reihe von Porträts und Aktfotos der surrealistischen Künstlerin Meret Oppenheim auf, jener Schweizer Künstlerin, die zum Kreis der Pariser Surrealisten um André Breton gehörte und gleichzeitig zu deren Muse wurde. Diese Bilder, darunter auch die berühmten inszenierten Aktaufnahmen der Künstlerin mit der Druckerpresse, die 1934 innerhalb der Serie *L'érotique voilée de Meret Oppenheim et Man Ray* veröffentlich wurden, zählen heute zu den »Klassikern« künstlerischer Fotografie und gingen als kostbare Vintageprints, Neuabzüge sowie in unzähligen Reproduktionen in die internationale Fotogeschichte ein. Die Sammlung FOTOGRAFIS Bank Austria, die über drei Rayogramme von 1922/1926 im Reprint sowie über zwei Vintageprints von Man Ray aus den Jahren 1929 und 1933 verfügt, besitzt mit dem *Portrait of Meret Oppenheim* einen der seltenen signierten und mit »Paris 1933« bezeichneten Originalabzüge des teilsolarisierten Profilporträts Meret Oppenheims. Es isoliert das Gesicht der Künstlerin im Bildganzen – ähnlich wie die ebenfalls teilsolarisierten Porträts von Meret Oppenheim mit weißer Badehaube, nur mit dem Unterschied, dass die *Nudes with bathing cap* auch den nackten Oberkörper des Modells abbilden. Man Ray verleiht dem Porträt hier nicht durch die Inszenierung oder durch im Fotoatelier erzeugte Lichteffekte »die Aura einer ätherischen Persönlichkeit« (Uwe M. Schneede), sondern durch die Kombination von direkter Fotografie und teilweiser Solarisation. Das *Portrait of Meret Oppenheim* steht dabei zum einen für die Aneignung der Fotografie

The Dadaist, Surrealist, painter and photographic artist Emmanuel Rudnitzky, whose world-renowned pseudonym Man Ray led to the special designation "Rayogram" for his photograms, took a series of portrait and nude photographs in Paris in 1933 of the Surrealist artist Meret Oppenheim. She was a Swiss artist who belonged to the group of Parisian Surrealists surrounding André Breton, and she also came to be their muse. These images and the famously staged nude photographs of the artist with the printing press were published in 1934 in the series *L'érotique voilée de Meret Oppenheim et Man Ray*. They are today considered classics of fine art photography and have been accepted into international photographic history in the form of valuable vintage prints, new prints and countless reproductions. The FOTOGRAFIS Bank Austria Collection has three Rayograms from 1922/1926 in reprint and two vintage prints by Man Ray from the years 1929 and 1933, and with the *Portrait of Meret Oppenheim* it possesses one of the rare signed original prints labelled "Paris 1933" of the partially solarized profile portraits of Meret Oppenheim. The work isolates the artist's face in the overall picture – similar to the likewise partly solarized portrait of Meret Oppenheim with a white bathing cap, with the sole difference that the *Nudes with bathing cap* portrait also depicts the naked torso of the model. Man Ray does not give the portrait "the aura of an ethereal personality" (Uwe M. Schneede) here through staging or photo-studio lighting effects, but by combining direct photography and partial solarization. On the one hand the *Portrait of Meret Oppenheim* stands for the appropriation of photography by the visual artist, which made quite a stir in the 1920s. On the other hand, this photograph is a central work in

durch die bildenden Künstler, was vor allem in den 1920er-Jahren Furore machte. Zum anderen ist diese Aufnahme ein zentrales Werk in jenem Diskurs, der sich von den Anfängen der Fotografie bis in die jüngere Gegenwart mit dem möglichen Kunstwert dieses ursprünglich dokumentarisch eingesetzten Mediums beschäftigte.

Ein Wettstreit zwischen Malerei und Fotografie, wie ihn zahlreiche Maler provozierten – nicht zuletzt besorgt um ihre Aufträge für Porträts der bürgerlichen Klasse oder exotische Ansichten fremder Länder für dieselbe Kundschaft –, wurde vor allem in der zweiten Hälfte des 19. Jahrhunderts, in der Belle Époque, ausgetragen. War dieser kämpferische Vergleich bildgenerierender Medien seit den 1920er-Jahren in professionellen Kreisen obsolet geworden, so sollte er doch in der breiten Öffentlichkeit bis weit ins 20. Jahrhundert hinein nicht an Aktualität verlieren. Die Diskussion über den Kunstwert fotografischer Arbeiten wurde fortwährend weitergeführt, wobei sich schon seit der Erfindung der Fotografie wissenschaftliches und künstlerisches Interesse durchdrangen, wie etwa beim Natur- und Geisteswissenschaftler William Henry Fox Talbot, der heute vor allem als Fotopionier bekannt ist. Malerei und Fotografie hielten sich – als parallel angewandte Medien – die Waage, wie bei dem später als Fotograf zu Ruhm und Ehre gelangten Maler Edward Steichen. Die Fotografie konnte auch zum fast ausschließlichen künstlerischen Medium werden, wie im Spätwerk des als Dadaist und Surrealist in die Kunstgeschichte eingegangenen Raoul Hausmann.

Man Rays *Portrait of Meret Oppenheim* entspricht einer interpretierenden Wahrnehmung eines Künstlers, die auf bildhaften Vorstellungen der zeitgenössischen avantgardistischen Kunst basiert und diesen im Feld der inszenierten Fotografie einen spezifischen Ausdruck verleiht. Somit ist es weit entfernt von bloßer Dokumentation, es wurde mit eigenen Mitteln bearbeitet und spätestens durch die handschriftliche Signatur und Datierung zum autonomen Kunstwerk deklariert. Der Künstler lässt sein Modell, eine Künstlerin, im Bild selbst zum Kunstwerk »gerinnen« – so changiert die Rolle der Dargestellten zwischen der des künstlerischen Subjekts und der des Objekts. Bildästhetisch gesehen nimmt dieses Werk eine Mittelposition ein zwischen einem einfachen Porträt und einer eigentlichen Bildmontage. Näher haben bildende Kunst und Fotografie kaum je zueinandergefunden. Man Rays Erfindungen und Experimente in der Dunkelkammer, seine kalkulierten Spiele mit dem Zufall, die ihren Niederschlag vornehmlich in seinen Rayogrammen fanden, weisen der Fotografie einen Stellenwert zu, der sie der Frage nach dem künstlerischen Mehrwert

the discourse focusing on the early days of photography to the most recent past, with the feasible artistic value of this medium originally used in a documentary way.

Many painters provoked a rivalry between painting and photography – if for no other reason than concern about orders for portraits of the bourgeois class and exotic views of foreign countries from the same clientele – mainly in the second half of the nineteenth century, during the Belle Époque. While this combative comparison of image-generating media had been obsolete in professional circles since the 1920s, it would not lose its relevance for the general public until well into the twentieth century. The discussion about the artistic value of photographic work goes on continuously and has piqued scientific and artistic interest since the invention of photography, as in the case of the natural and social scientist William Henry Fox Talbot, who is best known today as a pioneer of photography. Painting and photography – as analogously applied media – remained in balance, as with the photographer and painter Edward Steichen, who later achieved fame and recognition. Photography also became an almost exclusively artistic medium for some, as in the late work of Raoul Hausmann, who entered art history as a Dadaist and Surrealist.

Man Ray's *Portrait of Meret Oppenheim* corresponds to an interpretive perception of an artist based on pictorial representations of contemporary avant-garde art, and this makes it a specific expression in the field of staged photography. Thus it is far from mere documentation; it was produced with his own equipment and later declared an autonomous work of art with the handwritten signature and date. The artist lets his model, an artist, "congeal" herself in the image – thus the role of the sitter alternates between artistic subject and object. Aesthetically this work takes the middle ground between a simple portrait and an actual photomontage. The visual arts and photography have rarely come together more closely. Man Ray's inventions and experiments in the darkroom and his calculated games of chance, which were mainly reflected in his Rayograms, assign photography a significance that a priori removes the question of artistic value in relation to seemingly simple "documents". The photographic works that the painter Man Ray initially saw as a source of income became genuine works of art on par with painting.

With *Portrait of Meret Oppenheim* in 1933, one of the most famous photographs, we get to the heart of the FOTOGRAFIS collection, a compilation of about 640 pictorial documents from the period

gegenüber den scheinbar einfachen »Dokumenten« a priori entzieht. Hier werden die fotografisch entstandenen Arbeiten, die der Maler Man Ray anfänglich vor allem als Verdienstquelle sah, zu genuinen Kunstwerken; sie stehen gleichsam auf Augenhöhe mit der Malerei.

Mit *Portrait of Meret Oppenheim* von 1933, einem der bekanntesten Fotos, gelangen wir gleichsam ins Zentrum der Sammlung FOTOGRAFIS, in der rund 640 Bilddokumente von der Pionierzeit der fotografischen Erfindungen in den 1840er-Jahren bis zur Mitte der 1980er-Jahre zusammengestellt wurden. Das Sammlungskonzept der FOTOGRAFIS wurde am 25. Mai 1976 vorgestellt und danach in zehnjähriger Sammeltätigkeit vorangetrieben. Mit der Gründung der Sammlung machte die damalige Österreichische Länderbank, die heutige Bank Austria – Member of UniCredit, einen für die damalige Zeit erstaunlichen Schritt. Bemerkenswert war der Aufbau einer eigenen Fotosammlung vor allem, weil Fotografie in Österreich in den 1970er-Jahren als Sammelobjekt kaum von Bedeutung war. Dem damaligen Weitblick der für die Sammlung Verantwortlichen ist es zu verdanken, dass das Museum der Moderne Salzburg, in dem sich die FOTOGRAFIS seit 2009 als Depositum befindet, eine Kollektion aus rund 140 Jahren Geschichte internationaler Fotografie präsentieren kann, die heute selbst mit großen finanziellen Mitteln nicht mehr zusammenzustellen wäre – und somit schon gar nicht für eine öffentliche Sammlung. Anders als bedeutende Privatsammlungen, etwa in den USA oder in Deutschland, wollte sich die Sammlung FOTOGRAFIS nicht auf einzelne, nach subjektiven Vorlieben ausgewählte Fotoarbeiten konzentrieren, sondern war bemüht, einen repräsentativen, historisch fundierten Querschnitt aus dem internationalen Fotoschaffen zusammenzutragen, der hierzulande in keiner Institution, in keinem Museum zu finden war, wessen sich die an der Wiege der Sammlung stehenden Persönlichkeiten mehr als bewusst waren. Heute bildet die Sammlung FOTOGRAFIS gleichsam das international ausgerichtete historische Fundament für die 1983 am Rupertinum ins Leben gerufene Österreichische Fotogalerie, die aus den museumseigenen Beständen sowie dem Depositum der Sammlung des Bundes besteht und auf die Initiative des ersten Direktors des Stammhauses des Museum der Moderne Salzburg, Dr. Otto Breicha, zurückgeht. Breicha, einer der ersten Museumsleiter, die sich für das Sammeln von Fotografie im musealen Kontext einsetzten, galt bei der Eröffnung des damals Moderne Galerie und Graphische Sammlung Rupertinum genannten Museums 1983 noch als Pionier – zu einem Zeitpunkt also, zu dem die Sammlung FOTOGRAFIS fast schon abgeschlossen war.

between the pioneer days of photographic inventions in the 1840s and the mid-1980s. The collection concept of FOTOGRAFIS was presented on 25 May 1976 and then promoted over ten years of collecting activity. With the establishment of the collection, what was then the Österreichische Länderbank (present-day Bank Austria) – a member of UniCredit – took an amazing step for that time. The development of its own collection of photographs was noteworthy mainly because photography had little significance as a collectible item in the 1970s in Austria. It is thanks to the foresight of those responsible for the collection at that time that the Museum der Moderne Salzburg, where the FOTOGRAFIS collection has been on permanent loan since 2009, can present a collection of about 140 years of the history of international photography, which would not be possible to compile today even with considerable financial resources – and certainly not possible for a public collection. Unlike major private collections like those in the USA or Germany, the FOTOGRAFIS collection did not focus on individual photographs selected according to subjective preferences, but attempted to collect a representative, historically sound cross-section of international photography not found in any institution or museum in this part of the world, and those present at the birthplace of the collection were more than aware of this. Today the FOTOGRAFIS collection forms an internationally oriented historical base for the Österreichische Fotogalerie founded in 1983 at the Rupertinum. This consists of the museum's own inventory and deposits from the collection of the Federation, and can be traced back to the initiative of the first director of the original home of the Museum der Moderne Salzburg, Dr Otto Breicha. Breicha was one of the first museum directors committed to collecting photography for the museum and considered a pioneer at the opening of what were then the contemporary gallery and graphic collection of the museum called the Rupertinum in 1983 – at a time when the FOTOGRAFIS collection was already almost complete.

This publication presents the highlights of FOTOGRAFIS with a selection of over seventy photographs, and also documents the history of the collection. The founding of the FOTOGRAFIS collection and its development are inseparably connected with three people: Anna Auer and the photographer Werner H. Mraz, who from 1970 directed the first photo gallery in Europe, Die Brücke in Vienna, as well as Ivo Stanek, director of the art collection of the former Österreichische Länderbank. The founding of the photo collection was decided in 1975 and soon afterwards the content structure had three main strands: early photography, Pictorialism and New Objectivity. At the

Die vorliegende Publikation präsentiert mit einer Auswahl von über siebzig Fotografien die Highlights der FOTOGRAFIS und dokumentiert zugleich die Geschichte der Sammlung. Die Gründung der Sammlung FOTOGRAFIS und ihr Aufbau ist dabei untrennbar mit drei Personen verbunden: mit Anna Auer und dem Fotografen Werner H. Mraz, die von 1970 an in Wien die Galerie Die Brücke als erste Fotogalerie Europas führten, sowie mit Ivo Stanek, dem Leiter der Kunstsammlung der damaligen Österreichischen Länderbank. Die Gründung der Fotosammlung wurde 1975 beschlossen und schon wenig später fand sich für sie eine inhaltliche Struktur mit drei Hauptsträngen: der Frühen Fotografie, dem Piktorialismus und der Neuen Sachlichkeit. Gleichzeitig sollten Einzelleistungen aus der Dokumentations-, der Reportage-, der Porträt- und Sozialfotografie sowie aus der zeitgenössischen österreichischen Fotokunst in die Sammlung integriert werden. Noch im Mai 1975 hatten Auer und Mraz in einem Brief an Stanek die »besondere Empfehlung« ausgesprochen, »… eine Auswahl der Bilder von Henri Cartier-Bresson zu erwerben« und die Kollektion »sukzessive durch Einbezug alter Meisterfotografen wie Alfred Stieglitz oder Julia Margaret Cameron« zu ergänzen.

Ein Bericht von Anna Auer informiert über die Entstehungsgeschichte der FOTOGRAFIS, während sieben Essays – je einer ist den sieben Gruppen vorangestellt, in denen die Werke hier präsentiert werden – deren Sammlungsschwerpunkte herausarbeiten: Simone Förster schreibt einleitend zu den frühen Versuchen sowie zur Fotografie im 19. Jahrhundert allgemein, mit besonderer Akzentuierung der Reisefotografie. Ulrich Pohlmann kommentiert die Geschichte des piktorialistischen Porträts. Vladmír Birgus trägt einen Essay zur tschechischen Fotografie vor dem Zweiten Weltkrieg und ihren Auswirkungen bei, ein Sammlungsfeld, auf das die FOTO-GRAFIS ein besonderes Augenmerk richtete. Uwe M. Schneede leitet die surrealistischen Bildfindungen ein, während Margit Zuckriegl die Beispiele der Neuen Sachlichkeit in den zeitgenössischen Kontext setzt. Walter Moser nimmt sich der »klassischen« Fotografie in den USA an, die einen weiteren Schwerpunkt der Sammlung ausmacht. Walter Guadagnini führt uns schließlich mit zeitgenössischer österreichischer Fotografie bis in die frühen 1980er-Jahre, in denen die FOTOGRAFIS ihren Abschluss fand. Er analysiert dabei die Entstehungsgeschichte der Sammlung, die von Anna Auer in ihrer Chronologie geschildert wird, auf drei eigentliche »Beweggründe« hin: den Willen zu sammeln, die Notwendigkeit, entsprechende Überzeugungsarbeit zu leisten, und die generell vorhandene

same time individual achievements from documentary, reportage, portrait, social photography and contemporary Austrian photo art were supposed to be integrated into the collection. Already in May 1975 Auer and Mraz expressed in a letter to Stanek a "special recommendation … to acquire a selection of photos by Henri Cartier-Bresson" and to "successively build the collection by including old master photographers such as Alfred Stieglitz and Julia Margaret Cameron".

A report by Anna Auer provides information about the history of FOTOGRAFIS, while seven essays – each one introducing one of the seven groups in which the works are presented here – elaborate on the focus of the collection. Simone Förster has written the introduction on the early attempts and on photography in the nineteenth century in general, with special emphasis on travel photography. Ulrich Pohlmann comments on the history of the Pictorialist portraits. Vladimír Birgus contributes an essay on Czech photography and its impact before the Second World War, to which the FOTOGRAFIS collection pays special attention. Uwe M. Schneede introduces the Surrealist imagery, while Margit Zuckriegl uses examples of New Objectivity in a contemporary context. Walter Moser covers "classic" photography in the United States, which accounts for a further focus of the collection. And finally, Walter Guadagnini takes us from the era of contemporary Austrian photography until the early 1980s, when FOTOGRAFIS was completed. He analyses the history of the collection, which Anna Auer portrays in her chronology, with three real "motivations": the will to collect, the need to provide corresponding convincing work and the generally existing opportunity for meaningful acquisition that the market still offered at the time of origin of the FOTOGRAFIS collection.

The earliest photographs in the FOTOGRAFIS collection originated in the 1840s and were made by William Henry Fox Talbot, one of the "inventors" of photography, as well as by Robert Adamson & David Octavius Hill. Based on such experiments from the early days of the medium, the focus in this publication is on individual photographers and photographic works of the nineteenth century and the turn of the century, such as Nadar's portrait of George Sand and one of the famous Parisian cityscapes by Eugène Atget. Today many of these are often seen as a true documentation of societal reality and real ambience photographs that seemingly regard the environment as an infinite series of possible shots and already indicate an aesthetic difference to "pure" documentation. The travel photographs from the second half of the nineteenth century popularized by Felice and

Möglichkeit zum sinnvollen Erwerb, die der Markt zur Entstehungszeit der Sammlung FOTOGRAFIS noch bot.

Von William Henry Fox Talbot, einem der »Erfinder« der Fotografie, sowie von Robert Adamson & David Octavius Hill stammen die frühesten in der Sammlung FOTOGRAFIS vertretenen Fotografien, entstanden schon in den 1840er-Jahren. Ausgehend von solchen Experimenten aus den Anfangszeiten des Mediums wird in dieser Publikation das Augenmerk auf einzelne Fotografen und fotografische Arbeiten des 19. Jahrhunderts und der Jahrhundertwende gelegt, wie etwa auf Nadars Porträt von George Sand oder auf eine der berühmten Pariser Stadtansichten von Eugène Atget. Viele dieser heute oft als wahrhaftige Dokumente von gesellschaftlicher Realität und realem Ambiente gesehenen Fotografien, die die Umwelt scheinbar als unendliche Reihe möglicher Aufnahmen betrachteten, weisen bereits eine ästhetische Differenz zum »reinen« Dokument auf. Die in der zweiten Hälfte des 19. Jahrhunderts populär gewordenen Reisefotografien von Felice und Antonio Beato und Maxime Du Camp oder von dem wohl berühmtesten unter den Reisefotografen, Francis Frith, lassen den im bürgerlichen Heim verweilenden Betrachter scheinbar authentisch am Alltag an exotischen Orten des Nahen oder Fernen Ostens oder an der Naturgewalt unwegsamer Bergwelten teilhaben.

Ein weiteres Kapitel ist dem Piktorialismus gewidmet – jenem Bestreben stilbildender Fotokünstler, ihre Werke ästhetisch und mittels symbolistischer Aussagekraft der zeitgenössischen Malerei anzunähern – und dabei insbesondere den Porträts der Zeit nach der Wende vom 19. zum 20. Jahrhundert. Von einem der Meister dieser kunstfotografischen Stilrichtung, Edward Steichen, befindet sich in der Sammlung FOTOGRAFIS nebst einem Selbstporträt aus dem Jahr 1903 – einer Fotogravüre, die ihn als Maler zeigt – sowie einem frühen, schemenhaften Porträt des Plastikers Auguste Rodin und einem späten Bildnis des deutschen Dramatikers Gerhart Hauptmann auch das von dekorativen Cyclamenblüten gerahmte Bildnis der den Betrachter fixierenden Mrs. Philip Lydig. Unter den piktorialistischen Bildnissen finden sich auch bedeutende Werke dreier österreichischer Fotografen: Von den Arbeiten Dora Kallmus', die sich Madame d'Ora nannte, ist das besinnliche Porträt einer Unbekannten mit malerischem »Elisabethkragen« von 1925 hervorzuheben. Von Heinrich Kühn, einem der international renommiertesten österreichischen Fotografen, der mit den beliebten Techniken des Gummidrucks und der Fotogravüre malerische Effekte erzielte, besitzt die Sammlung unter anderem das Gruppenbildnis dreier Kinder und das Porträt

Antonio Beato and Maxime Du Camp and by the most famous of travel photographers, Francis Frith, allowed the bourgeois home viewer to seemingly authentically participate in everyday life in exotic locations in the Middle and Far East, and to participate in the natural forces of impassable mountain environments.

Another chapter is devoted to Pictorialism – the endeavour of stylistic photographic artists to approach their work aesthetically and by means of the Symbolist expressiveness of contemporary painting – and in particular to the portraits of the time after the turn of the nineteenth to the twentieth century. A master of this style of photography, Edward Steichen, is also represented in the FOTOGRAFIS collection with a self-portrait from 1903 in a photogravure that shows him as a painter. Also by him is an early, shadowy portrait of the sculptor Auguste Rodin and a late portrait of the German playwright Gerhart Hauptmann, and a portrait of Mrs Philip Lydig, who is surrounded by decorative cyclamen flowers as she looks at the viewer. Among the Pictorialist portraits are also important works of three Austrian photographers. Noteworthy among the works of Dora Kallmus, also known as Madame d'Ora, is the contemplative portrait of a stranger with a picturesque "Elizabeth collar" from 1925. From Heinrich Kühn, one of the most internationally renowned Austrian photographers, who achieved picturesque effects with the popular techniques of gum print and photoengraving, the collection includes a group portrait of three children and a portrait of Alfred Stieglitz. And of the nine works of Viennese-born portrait photographer Trude Fleischmann, who eventually immigrated to the USA via Paris and London after the Anschluss of Austria to the German Reich, special attention should be given to the 1928 half-length portrait of Austrian writer Karl Kraus, which shows him with his right hand supporting his head and somewhat lost in his thoughts.

Czech photography of the twentieth century forms a large section of the FOTOGRAFIS collection, with one or two photographs each by František Drtikol, the first internationally famous Czech photographer, and by Karel Novák, Jaroslav Rössler, Drahomír Josef Růžička and Hugo Táborský, as well as four works by Jaromír Funke and nine photographs by Josef Sudek, who became known for his photographs of urban Prague. The works of Rössler, a student of Drtikol, come from the beginning of abstract photography in the Czech Republic, while Funke's still lifes mark the path from Pictorialist landscapes and genre scenes to compositions tending towards abstraction. Encouraged by the international exchange with German,

Alfred Stieglitz'. Und von den neun Werken der in Wien geborenen und nach dem »Anschluss« Österreichs an das Deutsche Reich über Paris und London schließlich in die USA immigrierten Porträtfotografin Trude Fleischmann ist besonders auf das Halbfigurenporträt des österreichischen Schriftstellers Karl Kraus von 1928 hinzuweisen, das ihn mit auf die rechte Hand gestütztem Kopf zeigt, gleichsam in sich selbst versunken.

Eine größere Gruppe innerhalb der Sammlung FOTOGRAFIS bildet die tschechische Fotografie des 20. Jahrhunderts mit jeweils ein bis zwei Fotos von František Drtikol, dem ersten auch international bedeutenden tschechischen Fotografen, von Karel Novák, Jaroslav Rössler, Drahomír Josef Růžička und Hugo Táborský sowie mit vier Werken von Jaromír Funke und neun Fotos von Josef Sudek, der vor allem durch seine Aufnahmen des urbanen Prag bekannt wurde. Die Werke von Rössler, einem Schüler Drtikols, stehen am Beginn der abstrakten Fotografie in Tschechien, während Funkes Stillleben den Weg von piktorialistischen Landschaften und Genreszenen zu Kompositionen mit Tendenz zur Abstraktion markieren. Begünstigt durch den internationalen Austausch mit deutschen, österreichischen und auch französischen Kollegen weisen viele Werke tschechischer Fotografen besondere Spielarten surrealistischer und neusachlicher Stilformen auf.

Die für die Malerei der 1920er-Jahre postulierte Neue Sachlichkeit und die surrealen Bildfindungen fanden auch in der Fotografie ihren kongenialen Ausdruck, was nicht zuletzt die bedeutenden Beispiele in der Sammlung FOTOGRAFIS belegen, so unter anderem – und über die genannten Porträts und Rayogramme von Man Ray hinaus – die Werke von Francis Bruguière, Raoul Hausmann, André Kertész oder Maurice Tabard und eine wunderbare, aus den 1930er-Jahren stammende Gruppe von Fotomontagen und sogenannten Fotoplastiken des gebürtigen Österreichers Herbert Bayer, die für den Surrealismus stehen. Aufnahmen von Karl Blossfeldt, Heinz Loew, August Sander, Carl Strüwe, Xanti Schawinsky und eine Reihe von neusachlichen Architekturaufnahmen von Fritz Henle sowie Pflanzenstudien von Albert Renger-Patzsch dokumentieren das »Neue Sehen«, die Neue Sachlichkeit und die Fotografie am Bauhaus. Gleichsam die Stilrichtungen verbindende Arbeiten von Alexander Rodtschenko und László Moholy-Nagy sind weitere Glanzpunkte der Sammlung.

Ein eigenes Kapitel ist der Fotografie in den USA gewidmet: Neben den schon sehr früh für die FOTOGRAFIS erworbenen Serien von

Austrian and French colleagues, many works of Czech photographers indicate special versions of Surrealism and New Objectivity styles.

The New Objectivity movement of the painting of the 1920s and the surreal imagery found congenial expression in photography, as evidenced by the important examples in the FOTOGRAFIS collection. These include – along with the aforementioned portraits and Rayograms by Man Ray – the works of Francis Bruguière, Raoul Hausmann, André Kertész and Maurice Tabard and a wonderful group of photomontages and photo-sculptures originating from the 1930s by the native Austrian Herbert Bayer, which are representative of Surrealism. Photographs by Karl Blossfeldt, Heinz Loew, August Sander, Carl Strüwe, Xanti Schawinsky and a number of New Objectivity architectural photographs by Fritz Henle and plant studies by Albert Renger-Patzsch document the "New Vision", New Objectivity and photography from the Bauhaus. Similarly, the works connecting the styles of Alexander Rodchenko and László Moholy-Nagy are other collection highlights.

A separate chapter is dedicated to photography in the USA. In addition to the series acquired very early on by FOTOGRAFIS of Diane Arbus, the most famous student of Lisette Model, and Duane Michals, the collection includes incunabula from individual major photographers as well as entire groups of works by Weegee and Paul Strand, who was probably the most well-known representative of straight photography. There may be gaps where important pieces by the Austrian-American photographer Lisette Model (who became known as a portraitist), or even works by Ansel Adams and Berenice Abbott, would be. And yet the group comprising more than eighty works provides a valid overview of American photography and represents a high point of the FOTOGRAFIS collection. This is further enhanced by photographs by Margaret Bourke-White, Walker Evans, Lewis Hine, Les Krims, Paul Outerbridge, Edward Steichen, Alfred Stieglitz, and, last but not least, Edward Weston, seven of whose photographs the collection contains.

Individual works by various internationally working artists such as Henri Cartier-Bresson, Horst P. Horst and Mario Giacomelli lead towards contemporary photography. When acquiring contemporary works, a focus was placed on the work of Austrian photographers for both substance and economic reasons. The oeuvre of Sepp Dreissinger, Johannes Faber, Leo Kandl, Karin Mack, Anna Auer's companion Werner H. Mraz, Thomas Reinhold, Christian Wachter

Diane Arbus, der berühmtesten Schülerin Lisette Models, und Duane Michals umfasst die Sammlung auch Inkunabeln einzelner bedeutender Fotografen sowie ganze Werkgruppen von Weegee und Paul Strand, dem wohl bekanntesten Vertreter der *straight photography*. Wenngleich wichtige Positionen, wie etwa die der als Porträtistin bekannt gewordenen österreichisch-amerikanischen Fotografin Lisette Model, oder auch Werke von Ansel Adams oder Berenice Abbott »fehlen«, stellt die über achtzig Arbeiten umfassende Gruppe einen gültigen Überblick über die US-amerikanische Fotografie und einen Höhepunkt der Sammlung FOTOGRAFIS dar. Dazu tragen ebenso Aufnahmen von Margaret Bourke-White, Walker Evans, Lewis Hine, Les Krims, Paul Outerbridge, Edward Steichen, Alfred Stieglitz und nicht zuletzt von Edward Weston bei, von dem die Kollektion allein sieben Fotos ihr Eigen nennt.

Einzelne Werke so verschiedener international arbeitender Künstlerpersönlichkeiten wie Henri Cartier-Bresson, Horst P. Horst oder Mario Giacomelli führen hin zur zeitgenössischen Fotografie. Beim Erwerb zeitgenössischer Arbeiten wurde sowohl aus inhaltlichen wie ökonomischen Gründen ein Schwerpunkt auf das Schaffen österreichischer Fotografen gelegt. Die Œuvres von Sepp Dreissinger, Johannes Faber, Leo Kandl, Karin Mack, von Anna Auers Weggefährten Werner H. Mraz, von Thomas Reinhold, Christian Wachter oder Manfred Willmann bilden einen fundamentalen Bestandteil der österreichischen Fotogeschichte seit Ende der 1960er-Jahre und sind in der Sammlung FOTOGRAFIS mit werktypischen Beispielen dokumentiert. VALIE EXPORT und Arnulf Rainer, zwei der international bekanntesten Künstlerpersönlichkeiten Österreichs, vertreten mit ihren Werken Positionen des Aktionismus und der feministisch geprägten Performance.

Darüber hinaus runden bislang nicht erwähnte Fotografinnen und Fotografen, die mit größeren Werkgruppen Einlass in die Sammlung fanden, das Profil der FOTOGRAFIS ab. So ist Arthur Benda, der zusammen mit Madame d'Ora von 1907 bis 1926 das Atelier d'Ora in Wien führte, mit Porträts, Reisefotografien und anderem mehr aus den Jahren 1911 bis 1947 vertreten, Jan Lukas mit den Vorkriegsaufnahmen der Wiener Trabrennbahn, Olga Wlassics mit Fotomontagen aus den 1940er-Jahren, Renata Breth mit farbigen Tierfotos oder Judy Dater mit intimen Frauenporträts aus den frühen 1970er-Jahren.

Die Sammlung FOTOGRAFIS stellt damit ein erstaunliches Spektrum von Anwendungen und Ausdrucksformen jenes Mediums vor,

and Manfred Willmann have formed a fundamental part of Austrian photographic history since the late 1960s and typical examples of their work are documented in the FOTOGRAFIS collection. With their works, VALIE EXPORT and Arnulf Rainer, two of the most famous artists of Austria, represent the positions of Actionism and feminist-influenced performance.

Furthermore, the FOTOGRAFIS profile is complemented by male and female photographers not mentioned thus far who found their way into the collection with larger groups of works. Thus Arthur Benda, who ran the Atelier d'Ora in Vienna from 1907 to 1926 together with Madame d'Ora, is represented by portraits, travel photography and other items from 1911 to 1947; Jan Lukas by the pre-war photographs of the Viennese trotting course; Olga Wlassics by photomontages from the 1940s; Renata Breth by colourful animal photographs; and Judy Dater by intimate portraits of women from the early 1970s.

The FOTOGRAFIS collection thus presents an astonishing range of applications and forms of expression from the medium that is still sometimes subsumed by "new media" in museums and collections – although it was invented about thirty years before Impressionism conquered painting, nearly seventy years before Cubism began to shape international art, and eighty years before the Bauhaus teachers and their students photographically captured their architecture, stage productions and festivals. Almost a century passed before photography gradually took its place as an artistic medium and could be asserted as glamorous. Photo art, which is now collected quite naturally in corporate collections or by institutions and art museums specializing in photography, was hardly considered worthy of being displayed in a museum until the 1970s. Although photography attracted the interest of museum professionals in some places already in the late 1960s, "fine art photography" was initially distinguished from "documentary photography" in order to legitimize its raison d'être in the context of a collection and to contrast it with a medium equivalent to graphics and painting.

When selecting works for the photographic collection from the former Länderbank in Vienna, the two photography experts Anna Auer and Werner H. Mraz mainly followed the goal of clearly illustrating the international history of fine art photography in its infancy and its international development until the contemporary era with their research, exploration and procurement of original documents.

das im Museums- und Sammlungskontext zuweilen noch immer den »Neuen Medien« subsumiert wird – obwohl erfunden rund dreißig Jahre bevor der Impressionismus die Malerei eroberte, fast siebzig Jahre bevor der Kubismus die internationale Kunst zu prägen begann und achtzig Jahre bevor die Bauhaus-Lehrer und deren Schüler ihre Architekturen, ihre Bühneninszenierungen und ihre Feste auch fotografisch festhielten. Seither ist nahezu ein Jahrhundert vergangen, in dem die Fotografie ihren Platz als künstlerisches Medium schritt-weise erobern und glamourös behaupten konnte. Die Fotokunst, die heute ganz selbstverständlich in Firmensammlungen, in den soge-nannten *corporate collections,* oder von auf Fotografie spezialisierten Institutionen und in Kunstmuseen gesammelt wird, galt jedoch noch bis in die 1970er-Jahre hinein kaum als »museumswürdig«. Wenn die Fotografie dennoch mancherorts schon Ende der 1960er-Jahre auf das Interesse der Museumsfachleute stieß, wurde eine »künstlerische Fotografie« vorerst von der »Dokumentarfotografie« abgegrenzt, um ihre *raison d'être* im Sammlungskontext zu legitimie-ren und sie als gleichwertiges Medium der Grafik und der Malerei gegenüberzustellen.

Mit der Auswahl der Arbeiten für eine Fotosammlung der damaligen Länderbank in Wien folgten die beiden Fotoexperten Anna Auer und Werner H. Mraz vor allem dem Ziel, die internationale Geschichte der künstlerischen Fotografie in ihren Anfängen sowie ihrer inter-nationalen Entwicklung bis in die Zeitgenossenschaft hinein an-schaulich zu machen und ihrer Erforschung wie ihrer Vermittlung originale Dokumente an die Hand zu geben. Internationalität war die – Mitte der 1970er-Jahre nicht selbstverständliche – leitende Idee für das Sammlungskonzept. Die Sammlung FOTOGRAFIS »ist nicht inkorporierter Teil eines Kunstmuseums«, schrieb Anna Auer 1986 im Ausstellungskatalog zur Präsentation der Sammlung FOTO-GRAFIS im heutigen Bank Austria Kunstforum, »hat aber dessen Funktion – was die Fotografie betrifft – voll übernommen«. Mit der Übergabe der wertvollen Kollektion als Dauerleihgabe an das Museum der Moderne in Salzburg erhielt die Sammlung nach über zwanzig Jahren ihren musealen Rahmen. Die hier ansässige Öster-reichische Fotogalerie machte durch die Sammlung FOTOGRAFIS Bank Austria im Museum der Moderne Salzburg, wie sie heute ge-nannt wird, gleichsam einen qualitativen Quantensprung. Die Öster-reichische Fotogalerie trug in den rund dreißig Jahren ihres Bestehens einen Fundus von etwa 18 800 fotografischen Werken zusammen. In gemeinsamen Bemühungen stellten das Museum der Moderne mit dem Land Salzburg und dem Bund jährlich Mittel für umfangreiche

Although internationalism was not a matter of course in the mid-1970s, it was the guiding principle for the collection concept. The FOTOGRAFIS collection "is not the incorporated part of an art museum", wrote Anna Auer in 1986 in the exhibition catalogue for the presentation of the FOTOGRAFIS collection in today's Bank Austria Art Forum, "but FOTOGRAFIS took over its function in terms of photography." With the transfer of the valuable collection as a permanent loan to the Museum der Moderne in Salzburg, the collection obtained its museum environment for over twenty years. The Österreichische Fotogalerie based here made a quantum leap with the FOTOGRAFIS Bank Austria Collection in the Museum der Moderne Salzburg, as it is called today. In the thirty years of its existence, the Österreichische Fotogalerie has collected an inventory of about 18,800 photographic works. In joint efforts the Museum der Moderne Salzburg, Land Salzburg and the Federation annually provided funds for extensive purchases, primarily of the work of Austrian artists of today and even sometimes of very young photo-graphers. In addition to the 8,800 photo purchases of the Federation, the Österreichische Fotogalerie has 10,000 works from museum holdings, donations and permanent loans from private collections. The FOTOGRAFIS Bank Austria Collection, which is largely "classic" and internationally oriented, complements this collection of contem-porary and especially Austrian photographic art. In comparison to the 640 individual works in the holdings of the Österreichische Foto-galerie, the rather small number of photographs in the FOTOGRAFIS collection reinforce the importance of their historical orientation and internationalism, which support the role of the Museum der Moderne as a centre of excellence for fine art photography in Austria. Although the name of the Österreichische Fotogalerie until 2009 referred mainly to the fact that the artists and the works were of Aus-trian origin, the Österreichische Fotogalerie can now also rightfully claim to be an Austrian centre of photography in general.

The completed FOTOGRAFIS collection and the ever-expanding Österreichische Fotogalerie firmly share the objectives that already characterised FOTOGRAFIS from its early stages, seven years before the genesis of the Salzburg photo collection by the founding director of the Rupertinum, Otto Breicha: photographic works were supposed to find their way into the collection that first and foremost deal with artistic expression, and that are distinguished by their relevance to art history, general history and the socio-political situation. Because the FOTOGRAFIS collection was also associated with the endeavour to embed the photographic works of art into a scientific and com-

Ankäufe, vornehmlich aus dem Schaffen österreichischer Künstler der Gegenwart und bisweilen auch von ganz jungen Fotografen, bereit. Neben den rund 8 800 Fotoankäufen des Bundes finden sich in der Österreichischen Fotogalerie 10 000 Werke aus Museumsbesitz, Schenkungen und Dauerleihgaben aus Privatbesitz. Zu dieser Sammlung zeitgenössischer und vor allem österreichischer Fotokunst verhält sich die großenteils »klassisch« sowie international ausgerichtete Sammlung FOTOGRAFIS Bank Austria komplementär. Es ist demnach nicht die mit rund 640 einzelnen Werken in Relation zu den Beständen der Österreichischen Fotogalerie eher geringe Anzahl von Fotografien der Sammlung FOTOGRAFIS, sondern es sind deren historische Ausrichtung und Internationalität, die den Stellenwert des Museum der Moderne als Kompetenzzentrum der künstlerischen Fotografie in Österreich untermauern. Hatte die Landesnennung im Begriff Österreichische Fotogalerie bis 2009 vor allem die künstlerische Autorschaft sowie die Herkunft der Werke bezeichnet, darf die Österreichische Fotogalerie nun mit Fug und Recht auch für ein österreichisches Zentrum der Fotografie überhaupt stehen.

Die abgeschlossene Sammlung FOTOGRAFIS und die sich stets erweiternde Österreichische Fotogalerie teilen dabei Ziele, die für die FOTOGRAFIS schon in ihrer Anfangsphase – sieben Jahre vor der Genese der Salzburger Fotosammlung durch den Gründungsdirektor des Rupertinums, Otto Breicha – feststanden: In die Sammlung sollten fotografische Werke Eingang finden, in denen es in erster Linie um die künstlerische Ausdruckskraft geht und die sich durch ihre Relevanz für die Kunstgeschichte, für die allgemeine Historie und für die jeweilige gesellschaftspolitische Situation auszeichnen. Da mit der Sammlung FOTOGRAFIS auch das Bestreben verbunden war, die fotografischen Kunstwerke in einen wissenschaftlichen und kommunikativen Kontext einzubetten, boten die *Internationalen Symposien der Sammlung Fotografis* von Beginn an eine Plattform für den professionellen Diskurs rund um bestimmte fotografische Schwerpunkte. Auch das heutige Museum der Moderne mit seinen Programmen zur Bearbeitung und Pflege, zur Vermittlung und Publikation der fotografischen Bestände und mit seiner internationalen Ausstellungstätigkeit widmet sich diesen Anliegen und ist damit zum gesuchten Partner für Kooperationen und Leihgaben im In- und Ausland geworden.

An dieser Stelle darf ich im Namen der Mitarbeiterinnen und Mitarbeiter des Museum der Moderne Salzburg all jenen herzlich danken, die am Projekt der Sammlung FOTOGRAFIS Bank Austria für das Museum der Moderne Salzburg mitgewirkt haben. Dass diese

municative context, the *International Symposia of the Fotografis Collection* provided a platform for professional discourse around certain photographic priorities right from the start. Today's Museum der Moderne, too, with its programmes for processing, maintaining, disseminating and publishing the photographic holdings and with its international exhibition activity, is dedicated to this cause and has become a sought-after partner for cooperation and loans nationally and internationally.

At this point, on behalf of the staff of Museum der Moderne Salzburg, I would like to warmly thank all those who have contributed to the project FOTOGRAFIS Bank Austria Collection for the Museum der Moderne Salzburg. That this valuable collection came into the possession of the museum on permanent loan after prolonged negotiations is also due to several persons who have offered us help and advice since 2005. In particular our thanks go to Tine Salis-Samaden, who was at the time the president of the Association of Friends and Supporters of the Museum der Moderne Salzburg, and Dr Wolf Maritsch, both of whom were dedicated to obtaining this collection for our museum before my official work started at the museum. Together with the director of the Österreichische Fotogalerie, Dr Margit Zuckriegl, we pursued the project to acquire a collection unique to Austria for our museum not only in a "goal-oriented" way – to use the language of management – against tough competition from colleagues whose museums would also have benefited from the collection, but also "persistently", as the former director-general of Bank Austria, Dr Erich Hampel, conceded at that time. We are very grateful to Dr Hampel for his decision to give the collection to Salzburg. We discussed our plans with Anton Kolarik, who as director of public and community relations also presided over the art collection of Bank Austria, and with Dr Katja Erlach, responsible for event management and cultural sponsorship. This led to the negotiations that ultimately resulted in the handover of the FOTOGRAFIS Bank Austria Collection to the Museum der Moderne, and was crowned with its first presentation. We would like to express our sincere thanks to them for their dedication. We also owe thanks to Anna Auer, who, as the spiritus rector of the FOTOGRAFIS collection, initially created it in its present form with Werner H. Mraz, and we want to thank her for the extensive information and suggestions she gave us with the transfer of the collection to Salzburg. After the highlights of the FOTOGRAFIS Bank Austria Collection were displayed one last time in the autumn of 2008 at the Bank Austria Kunstforum – after an exhibition pause of more than 20 years – the collection was presented to the

wertvolle Sammlung nach längeren Verhandlungen als Dauerleihgabe in den Besitz des Museums gelangte, verdanken wir auch einigen Persönlichkeiten, die sich seit 2005 mit Rat und Tat für uns einsetzen. Namentlich geht unser Dank an die damalige Präsidentin des Vereins der Freunde und Förderer des Museum der Moderne Salzburg, Tine Salis-Samaden, sowie an Dr. Wolf Maritsch: Beide engagierten sich schon vor Beginn meiner offiziellen Tätigkeit am Museum dafür, diese Sammlung für unser Haus zu gewinnen. Gemeinsam mit der Leiterin der Österreichischen Fotogalerie, Dr. Margit Zuckriegl, verfolgten wir das Projekt, die nicht nur für Österreich einmalige Sammlung an unser Haus zu binden – »zielorientiert«, wie das in der Sprache des Managements heißt, gegen harte Konkurrenz von Museumskollegen, deren Häusern die Sammlung auch gut angestanden hätte, und auch »beharrlich«, wie uns der ehemalige Generaldirektor der Bank Austria, Dr. Erich Hampel, seinerzeit zubilligte. Dr. Hampel sind wir für sein Plazet, die Sammlung nach Salzburg zu geben, zu sehr herzlichem Dank verpflichtet. Mit Anton Kolarik, der als Leiter der Public and Community Relations auch der Kunstsammlung der Bank Austria vorstand, und mit Dr. Katja Erlach, verantwortlich für Eventmanagement und Kultursponsoring, diskutierten wir unsere Pläne und führten die Verhandlungen, was letztlich von der Übergabe der Sammlung FOTOGRAFIS Bank Austria als Depositum ans Museum der Moderne und von deren erster Präsentation gekrönt war. Ihnen sei herzlich gedankt für ihren Einsatz. Anna Auer, die als *spiritus rector* die Sammlung FOTOGRAFIS, anfänglich zusammen mit Werner H. Mraz, in ihrer heutigen Form schuf, danken wir auch für zahlreiche Hinweise, die sie uns bei der Übertragung der Sammlung nach Salzburg geben konnte. Nachdem die Highlights der Sammlung FOTOGRAFIS Bank Austria – nach mehr als zwanzigjähriger Ausstellungspause – im Herbst 2008 ein letztes Mal im Bank Austria Kunstforum gezeigt worden waren, wurde die Sammlung nahezu in ihrer Gesamtheit im zweiten Halbjahr 2009 erstmals dem Salzburger Publikum im Museum der Moderne Mönchsberg präsentiert. Dr. Ingried Brugger, der Direktorin des Bank Austria Kunstforums, und ihren Mitarbeitern danken wir herzlich für die Zusammenarbeit.

Es ist uns eine Ehre und eine Verpflichtung, diese kostbare Kollektion zu bewahren und zu pflegen, sie aufzuarbeiten und für Fachleute wie für eine breite Besucherschaft zugänglich zu machen und einer interessierten Öffentlichkeit zu vermitteln. Dazu soll nicht zuletzt die vorliegende Publikation dienen, die im Herbst und Winter 2013 eine neuerliche Präsentation der Sammlung mit rund 160 Fotografien im Museum der Moderne Rupertinum begleitet.

Salzburg public almost in its entirety for the first time in the second half of 2009 at the Museum der Moderne Mönchsberg. We warmly thank Dr Ingried Brugger, director of the Bank Austria Kunstforum, and her staff for the cooperation.

It is an honour and a responsibility to preserve and maintain this valuable collection, to process it and make it accessible to experts and a broad audience, and to present it to an enthusiastic public. And last but not least, this publication will serve the new presentation of the collection in the autumn and winter of 2013 with about 160 photographs at the Museum der Moderne Rupertinum.

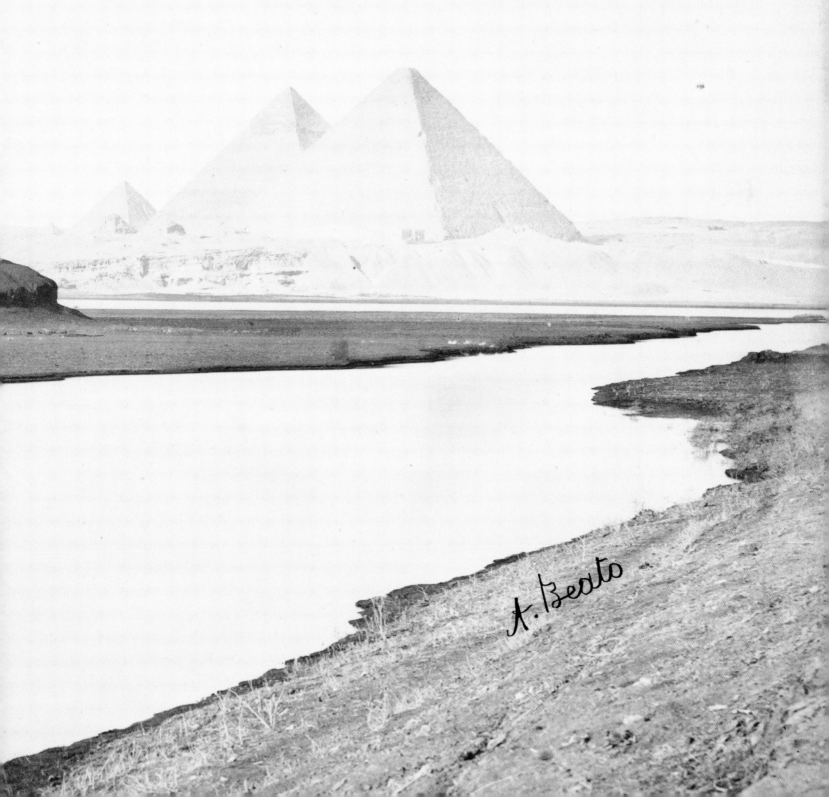

Fotografie im Fokus
Focus on photography

A. Beato

DIE SAMMLUNG FOTOGRAFIS.
EINE REFLEXION

THE FOTOGRAFIS COLLECTION.
A REFLECTION

Anna Auer

Als die Österreichische Länderbank (ÖLB) 1975 beschloss, eine Fotosammlung aufzubauen, geschah dies mit Sicherheit nicht aus Spekulationsgründen, nicht wegen eines möglichen späteren Wertzuwachses. Dazu war dieses Sammelgebiet noch zu neu und unbedeutend. Vielmehr wollte sich die Länderbank mit der Fotografie kulturpolitisch neu positionieren, also Ausstellungen in ihren Filialen präsentieren sowie Vorträge über Fotografie und schließlich auch die ersten Fotosymposien im deutschen Sprachraum (1976–1981) durchführen lassen. Sie ist die einzige internationale Fotosammlung in Österreich, die aufgrund der Privatinitiative einer Bank und nach einem festgelegten Konzept Bilder erwarb. Die Sammlungsrichtlinien waren von der Bank auf die Fotografie und im Besonderen auf deren künstlerische Formensprache gerichtet, wobei sich der Sammlungskern auf drei Bereiche konzentriert: auf Frühe Fotografie, Piktorialismus und Neue Sachlichkeit. Die Idee, eine Fotosammlung innerhalb einer Bank einzurichten, stammte von Direktor Ivo Stanek (1936–2006) und wurde am 25. Mai 1976 im Festsaal der Bankzentrale der Presse vorgestellt. Um die zukünftige internationale Ausrichtung der Sammlungsaktivitäten zu untermauern, wurde als prominenter Gast Jean-Claude Lemagny von der Bibliothèque nationale in Paris nach Wien eingeladen, um über die Richtlinien des Sammelns von Fotografien an diesem renommierten französischen Institut zu berichten. Die Länderbank beauftragte Werner H. Mraz und mich im Jahr 1975, eine möglichst umfassende Konzeption für die Sammlung FOTOGRAFIS zu erstellen, die nicht nur den Ankauf von Fotografien, sondern auch ein Vermittlungsprogramm in Form der Organisation von Ausstellungszyklen, Vorträgen, Seminaren und Symposien sowie eine Dokumentation darüber umfassen sollte. Ab 1976 bot sich mir dann

When the Österreichische Länderbank (ÖLB) decided in 1975 to build up a photograph collection, it certainly did not do so for reasons related to speculation, nor due to a potential increase in value later on. This collecting area was too new and unimportant. Rather, the bank wanted to reposition itself in its cultural policy, to present exhibitions in its branches and hold presentations on photography and ultimately the first photography symposiums in the German-speaking world (1976–1981). It is the only international photograph collection in Austria to have acquired images through a bank's private initiative and according to an established concept. The bank geared the collection guidelines towards photography and towards a photographic rhetoric in particular, with the core of the collection focusing on three areas: early photography, Pictorialism and New Objectivity. The idea of setting up a photograph collection within a bank came from director Ivo Stanek (1936–2006) and was presented to the press on 25 May 1976 in the ceremonial hall of the bank headquarters. In order to underpin the future international orientation of the collection's activities, Jean-Claude Lemagny from the Bibliothèque nationale in Paris was invited to Vienna as a distinguished guest to report on the guidelines for collecting photographs at the renowned French institute. The bank commissioned Werner H. Mraz and me in 1975 to prepare the most comprehensive concept possible for the FOTOGRAFIS collection, which was to include not only the purchase of photographs but also a mediation programme in the form of organizing exhibition cycles, talks, seminars, symposiums and documentation on them. From 1976, I had the pleasant opportunity for ten years to implement this concept in terms of its content and organization as the managing consultant.

für zehn Jahre die erfreuliche Möglichkeit, dieses Konzept inhaltlich wie organisatorisch als leitende Konsulentin umsetzen zu dürfen.

Wie alles begann: Die Österreichische Länderbank besucht die Galerie Die Brücke

Der Fotograf Werner H. Mraz und ich leiteten in Wien seit März 1970 die erste kommerzielle Fotogalerie auf dem europäischen Festland, die Galerie Die Brücke[1]. Wir waren nicht wenig überrascht, als am 9. April 1974 Ivo Stanek, der damals noch Prokurist der ÖLB war, in die Galerie kam und uns mit dem Auftrag verblüffte, ihm ein Konzept für einen Ausstellungszyklus in den Bankfilialen zu entwerfen, denn, so Stanek: »Ein derart angelegtes Konzept unter der Schirmherrschaft einer Bank würde sicherlich die Aufmerksamkeit sowohl des Bundesministeriums für Unterricht und Kunst als auch die der Museen auf sich ziehen und der Fotografie als Kunstform ein entsprechendes Gewicht geben.«[2] Von der Errichtung einer Sammlung war dabei noch nicht die Rede.

Tatsächlich zogen unsere Ausstellungen in der Galerie Die Brücke immer größte mediale Aufmerksamkeit auf sich. Als Newcomer hatte uns die kleine, aber nicht minder rege Wiener Galerienszene interessiert zur Kenntnis genommen. Viele unserer Ausstellungen waren überhaupt zum ersten Mal in Wien zu sehen, beispielsweise die

How it all began: The Österreichische Länderbank visits the gallery Die Brücke

The photographer Werner H. Mraz and I managed the first commercial photo gallery on the European continent, called Die Brücke.[1] We were very surprised when on 9 April 1974 Ivo Stanek, who was the general manager of the ÖLB at the time, came into the gallery and amazed us with the job offer of drafting a concept for him for an exhibition cycle at the bank branches, because, as Stanek said: "A concept designed this way under the auspices of a bank would surely draw the attention of both the Federal Ministry for Education and Art and that of the museums and would give photography a corresponding weight as an art form."[2] At this point there was no talk of setting up a collection.

Indeed, our exhibitions at the Die Brücke gallery drew increasing levels of attention. The small but no less active Viennese gallery scene had noticed us, as newcomers, with interest. Many of our exhibitions were unique for Vienna. The abstracts of Jean-Pierre Sudre in 1972, the jubilee exhibition *Sequenz* on the occasion of the 50th anniversary of the Swiss magazine *camera*[3] in December of the same year, works by Brett and Edward Weston in 1973 and a retrospective dedicated to Walker Evans in 1975, for example, were shown for the first time in Vienna. However, the public and press gave particular attention to our exhibition of the work of Herbert Bayer with his *Fotoplastiken* and *Fotomontagen* in April 1971. In August 1971, a first letter arrived

Ausstellungskoje der Sammlung FOTOGRAFIS bei der Kunstmesse *Kunst nach '45* im Wiener Künstlerhaus, 16. bis 20. Februar 1978 / Exhibition booth of the FOTOGRAFIS collection at the art fair *Kunst nach '45* in Vienna's Künstlerhaus, 16 to 20 February 1978

Abstraktionen von Jean-Pierre Sudre im Jahr 1972, die Jubiläums-ausstellung *Sequenz* anlässlich des 50-jährigen Bestehens der Schweizer Zeitschrift *camera*[3] im Dezember desselben Jahres, Arbeiten von Brett und Edward Weston 1973 oder eine Walker Evans gewidmete Retrospektive 1975, um nur einige zu nennen. Besondere Aufmerksamkeit von Publikum und Presse wurde jedoch unserer Ausstellung von Herbert Bayer mit seinen *Fotoplastiken* und *Fotomontagen* im April 1971 zuteil. Auch traf, für uns völlig überraschend, im August 1971 ein erstes Schreiben von Beaumont Newhall (1908–1993) ein, kurz nachdem er sich von der Leitung der Fotoabteilung am George Eastman House (1958–1971) zurückgezogen und eine Professur für Fotogeschichte an der University of New Mexico in Albuquerque angenommen hatte. Er schrieb: »I have read with interest that you have recently held an exhibition of photographs by herbert bayer. I am glad you showed bayer's work, which is largely unknown, even though he lives here.«[4] Zweifelsohne war es unsere Wiederentdeckung des fotografischen Werkes von Herbert Bayer gewesen, die unseren Ruf als eine ernst zu nehmende Plattform für Fotografie international rasch festigte. So beschlossen wir, 1973 mit Bayers *Fotoplastiken* und *Fotomontagen* an der Kunstmesse Art Basel teilzunehmen. Noch nie zuvor hatte sich eine ausschließlich auf Fotografien spezialisierte Galerie auf das internationale Parkett der Kunst gewagt.

Zur Gründung der Sammlung FOTOGRAFIS

Das Konzept der Galerie Die Brücke, welches von Anbeginn international ausgerichtet war, hatte maßgeblichen Einfluss auf die spätere Sammlungskonzeption der FOTOGRAFIS. In unserem ersten Konzept vom 22. April 1974 an die ÖLB ging es vorerst um die Organisation von Ausstellungen, um die Zusammenarbeit mit Schulen, Lehrern und Kunstpädagogen und um die Abhaltung von Fotoworkshops und Seminaren sowie diversen Sonderprogrammen. Angedacht waren auch die Produktion von Katalogen und Kalendern sowie die Herausgabe einer Zeitschrift für Fotografie. Die Errichtung einer Fotosammlung war noch nicht vorgesehen.

Als die Gründung einer Fotosammlung schon in den Bereich des Möglichen gerückt war, holen wir uns Rat bei Beaumont Newhall. Prompt erhielten wir von ihm Unterlagen, die darauf zurückschließen ließen, dass er und seine Frau Nancy bereits 1966 eine ähnliche Initiative vorangetrieben hatten. Damals hatten die beiden Kunsthistoriker die Verantwortlichen der Exchange National Bank in Chicago, der späteren LaSalle Bank, angeregt, eine Fotosammlung zu gründen – mit einem so einfachen wie überzeugenden Argument: »um den Einfluss der Fotografie auf alle Aspekte des Lebens auszudehnen und zum Wohle der Stadt und der Bevölkerung beizutragen«[5]. Für die ÖLB kam das nahezu einer Empfehlung »von Haus zu Haus« gleich

from Beaumont Newhall (1908–1993), much to our surprise, shortly after he had stepped down from managing the photography department at George Eastman House (1958–1971) and had accepted a professorship for the history of photography at the University of New Mexico in Albuquerque. He wrote: "I have read with interest that you have recently held an exhibition of photographs by Herbert Bayer. I am glad you showed Bayer's work, which is largely unknown, even though he lives here."[4] Without doubt, it had been our rediscovery of the photographic works by Herbert Bayer that quickly established our reputation internationally as a platform for photography to be taken seriously. We therefore decided to participate in the art fair Art Basel in 1973 with Bayer's *Fotoplastiken* and *Fotomontagen*. Never before had a gallery specializing exclusively in photography ventured onto the international stage.

Towards the establishment of the FOTOGRAFIS collection

The gallery concept of Die Brücke, which had been internationally oriented from the start, had a considerable influence on the later design for the FOTOGRAFIS collection. Our first concept submitted on 22 April 1974 to the ÖLB concerned mainly the organization of exhibitions, cooperation with schools, teachers and art teachers and the holding of photography workshops and seminars and various special programmes. The production of catalogues and calendars and the publication of a magazine for photography were also considered. Setting up a photograph collection had not yet been envisaged.

When establishing a photography collection had moved into the realm of the possible, we consulted Beaumont Newhall for advice. We promptly received documents from him that indicated that he and his wife Nancy had already advanced a similar initiative in 1966. At the time, both art historians had prompted the manager of the Exchange National Bank in Chicago, later the LaSalle Bank, to establish a photography collection – with a simple but persuasive argument: "to extend the influence of photography on all aspects of life and to contribute to the wellbeing of the city and the population".[5] For the ÖLB, this almost amounted to a recommendation "from one company to another" and clearly contributed a lot to the fact that the proposal to establish a company photograph collection was received positively by the bank's board of directors. Ivo Stanek then managed – thanks to his great diplomatic skills – to convince both of the directors of the board, Dr Leopold Schaubb and Dr Josef Koliander, and the General Director, Dr Franz Ockermüller, and to achieve a consensus for establishing the FOTOGRAFIS collection.

On 18 May 1975 we presented a second concept, which already had detailed proposals for setting up an international photography

Wilfried Wiegand, Duane Michals und dahinter Hans Frank
beim zweiten Symposium der Sammlung FOTOGRAFIS, 8. Oktober 1976 /
Wilfried Wiegand, Duane Michals and, behind them, Hans Frank
at the second symposium of the FOTOGRAFIS collection, 8 October 1976

und trug offensichtlich viel dazu bei, dass der Vorschlag, eine haus-eigene Fotosammlung zu gründen, vom Vorstand der Bank positiv aufgenommen wurde. Ivo Stanek gelang es damals – dank seines großen diplomatischen Geschicks –, die beiden Vorstandsdirektoren Dr. Leopold Schaubb und Dr. Josef Koliander sowie den General-direktor Dr. Franz Ockermüller zu überzeugen und sie zu einem Konsens für die Gründung der Sammlung FOTOGRAFIS zu bewegen.

Am 18. Mai 1975 präsentierten wir ein zweites Konzept mit bereits detaillierten Vorschlägen für den Aufbau einer internationalen Foto-sammlung. In diesem Exposé waren zudem die Organisation von Ausstellungszyklen, Vorträgen, Seminaren und Symposien sowie die Edition eigener Publikationen enthalten. Uns war bewusst, dass es für eine Gesamtdarstellung der Fotografie von ihren Anfängen bis zur Gegenwart längst zu spät war. Zu umfangreich war das Gebiet in-zwischen geworden, zu lange war der Kulturauftrag von Österreichs Museen, die Fotografie als ein der Kunst gleichgestelltes Medium ein-zubeziehen, vernachlässigt worden. So einigten wir uns darauf, für die Sammlung FOTOGRAFIS die drei bereits erwähnten Schwer-punkte Frühzeit der Fotografie, Piktorialismus und Neue Sachlich-keit zu wählen. In die Sammlung sollten einerseits Beispiele aus der Frühzeit der Fotografie mit der bahnbrechenden Entwicklung der ersten Papier-Positiv-Negativ-Verfahren aufgenommen werden, an-derseits sollten in ihr auch jene wichtigen Impulse des ausgehenden 19. Jahrhunderts dokumentiert werden, die der Piktorialismus in sei-ner Anlehnung an die impressionistische Malerei kreiert hatte. Die Weiterentwicklung der Kameratechnik, wie zum Beispiel durch die serienmäßige Produktion der Leica-Kamera ab 1925, ermöglichte durch eine neue Bildschärfe eine größere Klarheit der Motive, was unter anderem für die Entwicklung der Stilrichtung der Neuen Sach-lichkeit grundlegend war. Neben den experimentellen Tendenzen aus dieser Zeit sind auch die Subjektive Fotografie sowie herausragende Einzelleistungen aus der Sozial-, Porträt-, Reportage- und der Doku-mentationsfotografie in der Sammlung vertreten.

Als freie Mitarbeiterin der ÖLB

Bereits ab Mai 1975 betreuten Werner H. Mraz, der bis September 1977 an diesem Projekt mitarbeitete, und ich als freie Mitarbeiter der ÖLB die Sammlung. Die Aufgaben waren fest umrissen: Uns oblag das Konzipieren und Organisieren von Ausstellungen, Vorträgen und Symposien, wir konnten Vorschläge für den Erwerb von Fotografien machen und deren Ankauf durchführen. Einen Konsulentenvertrag

collection. The organization of exhibition series, talks, seminars and symposiums and the edition of publications were also included in this synopsis. We were aware that it was far too late for a complete representation of photography from its beginnings through to the present day. The area had become too extensive in the meantime; the cultural order from Austria's museums had neglected to include photography as an equivalent medium for art for too long. We there-fore agreed to choose the three focuses already mentioned for the FOTOGRAFIS collection: early photography, Pictorialism and New Objectivity. On the one hand, examples from the early days of pho-tography with the pioneering development of the first paper positive-negative process should be included in the collection. On the other hand, it should also document those important impetuses of the late nineteenth century, which had created Pictorialism in its reliance on Impressionist painting. The enhancing of camera technology, such as through the serial production of the Leica camera after 1925, made possible a greater clarity of the subject due to new image definition, which was fundamental for the development of New Objectivity, among other things. In addition to the experimental trends from this period, subjective photography and excellent individual work in social, portrait, reporting and documentation photography are also included in the collection.

As a freelancer for the ÖLB

From May 1975, Werner H. Mraz and I, working together on this project until September 1977, looked after the collection as freelanc-ers for the ÖLB. The tasks were clearly defined: the assignment to design and organize exhibitions, talks and symposiums lay with us, and we could make suggestions for purchasing photographs, and

erhielt ich erst 1981; er wurde jährlich verlängert und 1983[6] noch beträchtlich erweitert. Das Jahr 1985 brachte eine entscheidende Änderung für die FOTOGRAFIS, da sich die Geschäftsführung entschied, die Sammlung in das neu gegründete Kunstforum Wien zu integrieren und Dr. Klaus Albrecht Schröder als dessen neuen Leiter zu bestellen. Ab diesem Zeitpunkt wurden meine Agenden stark reduziert und mein Vertrag für 1987 nicht mehr verlängert.

Erwerbspolitik

Die ersten Ankäufe 1975 und 1976 waren von starken innerbetrieblichen Turbulenzen der ÖLB geprägt, verbunden mit einem häufigen Vorstandswechsel. Diese Umstände ließen die Belange der Sammlung FOTOGRAFIS immer wieder in gefährliches Stocken geraten. Ich konnte jedoch mit hohem eigenem Engagement und dank meiner Vorfinanzierung bei anstehenden Erwerbungen dieser sehr unbefriedigenden Startsituation gegensteuern. So hatte ich seit Anfang 1975 die Option auf ein Bilderkonvolut, das ich für die Sammlung reserviert hielt und für das mir der Händler eine letzte Frist setzte, welche jedoch vonseiten der Bank nicht einzuhalten war. Ich befand mich in einer äußerst prekären Lage. Also setzte ich alles auf eine Karte und folgte dem Rat Staneks, der mir vorschlug, die Bilder selbst zu erwerben, indem er mir einen zinslosen Kredit von öS 300 000 – rund € 22 000 – bei der Merkur-Bank, einem Schwesterinstitut der ÖLB, ermöglichte. Diesen Betrag sollte ich zurückerhalten, sobald der neue Vorstand mit der Errichtung der Sammlung FOTOGRAFIS einverstanden wäre. Die Sache ist letztendlich gut ausgegangen, sodass wichtige Arbeiten von Robert Adamson & David Octavius Hill, Julia Margaret Cameron, Lewis Hine, Emil Otto Hoppé und Edward Weston sowie Portfolios von Judy Dater und Diane Arbus, ein Foto von Margaret Bourke-White und die Serie *Things are Queer* von Duane Michals heute Teil der Sammlung sind.

Ein Glücksfall waren die jährlichen Symposien, bei denen die besten Fotohistoriker und Kuratoren ihrer Zeit nach Wien kamen und oft wichtige Impulsgeber für die Sammlung waren. Deshalb hielt ich meist ein für den Ankauf bestimmtes Konvolut bis dahin zurück, um die Bilder bei dieser Gelegenheit begutachten zu lassen. Manchmal riet ein Mitglied aus dieser Expertenrunde von einem bestimmten Ankauf auch ab, woraus sich oft spannende Gespräche und Diskussionen über das Für und Wider eines Werks ergaben, unter anderem mit Beaumont Newhall, Helmut Gernsheim, Van Deren Coke und Weston J. Naef. Letzterer war Kurator am Metropolitan Museum in New York gewesen und hatte dort 1978 die erste große Retrospektive von Alfred Stieglitz[7] präsentiert, ehe er 1984 zum Chefkurator der Fotoabteilung am J. Paul Getty Museum ernannt wurde. Auch Heinz K. Henisch (1922–2006) von der Pennsylvania State University,

carry out the purchases. I only received a consultant contract in 1981. It was renewed annually and expanded considerably in 1983[6]. The year 1985 brought a decisive change for FOTOGRAFIS because the management team decided to integrate the collection into Vienna's newly established Kunstforum and to appoint Dr Klaus Albrecht Schröder as its new manager. From this point onwards, my brief was reduced considerably and my contract was not renewed for 1987.

Purchase policy

The first purchases in 1975 and 1976 were shaped by considerable internal turmoil at the ÖLB, combined with frequent changes to the board of directors. These conditions caused the interests of the collection to falter again and again. However, with my own high level of commitment and thanks to my preliminary financing of pending purchases, I was able to counteract this very unsatisfactory starting situation. Therefore, from the beginning of 1975, I had an option on a set of photographs that I had reserved for the collection, and for which the seller had set a final deadline that could not be kept by the bank. I found myself in a very precarious situation. So I went for broke and followed Stanek's advice, who suggested that I purchase the images myself and granted me an interest-free loan of öS 300,000 (around € 22,000) at the Merkur-Bank, a sister institute of the ÖLB. I was to regain this amount as soon as the new board of directors had agreed on setting up the FOTOGRAFIS collection. The affair ultimately resolved itself, so that important works by Robert Adamson & David Octavius Hill, Julia Margaret Cameron, Lewis Hine, Emil Otto Hoppé and Edward Weston, and portfolios by Judy Dater and Diane Arbus, a photograph by Margaret Bourke-White and the series *Things are Queer* by Duane Michals are part of the collection today.

The annual symposiums were a stroke of luck. The best historians of photography and curators of their time came to Vienna and were often important sources of inspiration for the collection. I therefore generally deferred purchases of specific sets of photographs until then, so that they could be appraised on these occasions. Sometimes a member from this group of experts also advised against a specific purchase, which often resulted in lively conversations and discussions on the pros and cons of a work, for example with Beaumont Newhall, Helmut Gernsheim, Van Deren Coke and Weston J. Naef. The latter had been curator at the Metropolitan Museum in New York and had presented the first great retrospective show of Alfred Stieglitz[7] there in 1978, before he was nominated head curator for the photography department at the J. Paul Getty Museum in 1984. Heinz K. Henisch (1922–2006) from Pennsylvania State University, founder and publisher of the photography magazine *History of Photography*, in print since 1977, was also always an excellent advisor to me.

Begründer und Herausgeber der seit 1977 erscheinenden fotowissenschaftlichen Zeitschrift *History of Photography*, war mir immer ein hervorragender Ratgeber.

Das jährliche Ankaufsbudget lag dabei zwischen öS 300 000 und öS 450 000 – zwischen rund € 22 000 und € 32 000 – und nahm sich, vom heutigen Standpunkt aus betrachtet, eher bescheiden aus. Bedenkt man jedoch, dass es vor vierzig Jahren noch möglich war, relativ preiswert wichtige Bilder zu erwerben, so war das doch eine respektable Summe. Allerdings waren darin auch die jährlichen Auslagen für die Symposien, etwa für die Honorar- und Reisekosten der Referenten, enthalten. Es galt also, sehr umsichtig und gut zu wirtschaften. Der Weg von einem Ankaufsvorschlag bis zur Genehmigung des Ankaufs war oft lang, denn die Bank erwartete von mir immer präzise Angaben zum Werk und zum Fotografen und war selbstverständlich auch an Preisvergleichen interessiert. Fallweise erfolgten Schenkungen; manche Bilder fanden auch nach Wohltätigkeitsversteigerungen der ÖLB den Weg in die Sammlung, wie etwa zwei Bilder von Pedro Kramreiter, was aber letztlich dem Grundkonzept der Sammlung keinen Abbruch tat. Die Ankaufslage besserte sich, als Dr. Franz Vranitzky, der spätere österreichische Bundeskanzler, die Generaldirektion der ÖLB von 1981 bis 1984 übernahm. Er stand der Sammlung FOTOGRAFIS sehr positiv gegenüber und wusste gut einzuschätzen, welche Verantwortung es mit sich brachte, dass in seinem Institut eine bislang in Österreich fehlende internationale Fotosammlung im Aufbau begriffen war. Er förderte das Vorhaben dementsprechend, was die zahlreich getätigten Ankäufe in seiner Ära bestätigen.

Um den Auftrag der ÖLB zu erfüllen, Wechselausstellungen in einem möglichst raschen Turnus in den Bankfilialen zu zeigen, hatte ich für die Sammlung eine Anzahl Portfolios erworben, unter anderem von Eugène Atget, Diane Arbus, Karl Blossfeldt, Florence Henri, Kenneth Josephson und Otmar Thormann, um nur einige zu nennen. Einzelbilder hingegen, wie zum Beispiel von Herbert Bayer, Robert Adamson & David Octavius Hill, Julia Margaret Cameron, Guillaume Benjamin Amand Duchenne, Heinrich Kühn, László Moholy-Nagy, Lotte Jacobi, Edward Steichen und Alfred Stieglitz, wurden selten ausgestellt, da sie zu fragil waren.

Vorträge und Symposien

Um den Mangel an Vorlesungen über Fotografie an Österreichs Universitäten auszugleichen, waren von 1976 bis 1981 im Konzept der Sammlung auch Vorträge und Fotosymposien eingebunden, die wiederum im engen Zusammenhang mit dem Sammlungsprogramm standen. Sie waren europaweit die ersten Veranstaltungen zur Fototheorie, sollten aber nur so lange von der Sammlung fortgeführt

The annual purchase budget fluctuated between öS 300,000 and öS 450,000 (approximately € 22,000 and € 32,000 respectively): rather modest from today's perspective. However, if one considers that 40 years ago it was still possible to purchase important photographs relatively cheaply, it was a respectable amount. This also included the annual expenses for the symposiums, though, such as the speakers' fees and travel costs. It was necessary, therefore, to economize carefully and well. The route from a purchase offer to approval of the purchase was often long because the bank always expected precise information on the work and on the photographer from me, and naturally it was also interested in comparing prices. Occasionally there were donations; some photographs also found their way into the collection after charity auctions by the ÖLB, such as two images by Pedro Kramreiter, which ultimately did not spoil the basic concept of the collection. The purchasing situation improved when Dr Franz Vranitzky, the subsequent Austrian chancellor, took over the general management of the ÖLB from 1981 to 1984. He was very positive about the FOTOGRAFIS collection and appreciated the responsibility entailed by the fact that an international photography collection that had hitherto been lacking in Austria was being built up in his institute. He promoted the project accordingly, a fact confirmed by the numerous purchases transacted in his era.

To meet the task of the ÖLB to display changing exhibitions in bank branches at the fastest possible rate, I had purchased a number of portfolios for the collection, including portfolios by Eugène Atget, Diane Arbus, Karl Blossfeldt, Florence Henri, Kenneth Josephson and Otmar Thormann, to name just a few. On the other hand, individual photographs such as those by Herbert Bayer, Robert Adamson & David Octavius Hill, Julia Margaret Cameron, Guillaume Benjamin Amand Duchenne, Heinrich Kühn, László Moholy-Nagy, Lotte Jacobi, Edward Steichen and Alfred Stieglitz were rarely exhibited because they were too fragile.

Talks and symposiums

To counterbalance the lack of lectures on photography at Austria's universities, talks and symposiums were also integrated into the concept of the collection from 1976 to 1981, which once again were closely related to the collection programme. They were the first events on photographic theory in Europe but they were to be continued by the collection only until another Austrian institution had taken up the idea, which the Forum Stadtpark in Graz did in 1979 under Christine Frisinghelli and Manfred Willmann.

At the beginning, the ÖLB invited Van Deren Coke to Graz for a talk in a bank branch on 11 April 1975. The event was linked to the

werden, bis eine andere österreichische Institution diese Idee aufgenommen haben würde, was 1979 das Forum Stadtpark in Graz unter Christine Frisinghelli und Manfred Willmann auch tat.

Zum Auftakt hatte die ÖLB Van Deren Coke am 11. April 1975 zu einem Vortrag in eine Bankfiliale nach Graz eingeladen. Die Veranstaltung war mit der Ausstellung *Der Maler und der Fotograf: Alfons Maria Mucha und Dick Arentz* verknüpft, die sich auf Cokes bahnbrechendes Werk *The Painter and the Photograph. From Delacroix to Warhol* von 1974 bezog. Das mit Coke vereinbarte Thema war die fotografische Ausbildung an amerikanischen Universitäten. Wir hofften damals noch – recht naiv –, auch in Österreich eine Initialzündung für das akademische Fach Fotografie zu bewirken, was natürlich absurd war. 1980, im Rahmen des fünften Symposiums der Sammlung FOTOGRAFIS, *Kritik und Fotografie, 1. Teil,* stellte Dr. Otto Breicha (1932–2003) die Frage in den Raum, inwieweit es zweckdienlich wäre, eine Fotosammlung, bestehend nur aus Werken österreichischer Fotografen, einzurichten. Breicha sprach zudem von seiner Idee, anlässlich der Eröffnung des Rupertinums in Salzburg eine Sammlung für österreichische Fotografie einzurichten, die 1983 auch umgesetzt wurde.[8] Aus Kostengründen wurden die Symposien[9] jeweils nur in einer unbebilderten Kurzfassung in Skriptform dokumentiert. Das letzte und umfangreichste Symposium, *Kritik und Fotografie, 2. Teil,* fand 1981 im Rahmen der 5. Wiener Biennale *Erweiterte Fotografie*[10] statt. Dessen Akten erschienen als Sonderausgabe in der Fotozeitschrift *Camera Austria* Nr. 10/1982.

exhibition *Der Maler und der Fotograf: Alfons Maria Mucha und Dick Arentz* , which was related to Coke's pioneering work *The Painter and the Photograph. From Delacroix to Warhol* of 1974. The topic agreed with Coke was photography training at American universities. At the time we hoped – rather naively – to bring about the initial impetus for the establishment of the academic subject of photography in Austria as well, which was of course absurd. In 1980, as part of the fifth symposium of the FOTOGRAFIS collection, *Kritik und Fotografie, 1. Teil,* Dr Otto Breicha (1932–2003) raised the question of the extent to which it would be expedient to set up a photography collection consisting only of works by Austrian photographers. Breicha also spoke of his idea to set up a collection for Austrian photography at the opening of the Rupertinum in Salzburg, which was also implemented in 1983.[8] For reasons of cost, the symposiums[9] were documented only as an image-free summary in script form. The last and most extensive symposium, *Kritik und Fotografie, 2. Teil,* took place in 1981 as part of the fifth Viennese biennial *Erweiterte Fotografie*.[10] Its documents were published as a special issue in the photography magazine *Camera Austria* no. 10/1982.

The vision of a "House of Photography": Collecting, conveying, documenting

At the beginning of my work for the ÖLB, setting up a study and documentation centre for photography in the large hall of the bank

Die Vision von einem »Haus der Fotografie«: Sammeln, Vermitteln, Dokumentieren

Bereits zu Beginn meiner Tätigkeit für die ÖLB war auch angedacht gewesen, ein Studien- und Dokumentationszentrum für Fotografie im großen Kassensaal des Bankhauses auf der Wiener Freyung einzurichten und es der Öffentlichkeit zugänglich zu machen. Diese Zielsetzung forcierte ich sehr stark, da ich sie bereits in der Galerie Die Brücke in ähnlicher Form umgesetzt hatte und sie in der Situation der Fotorezeption dieser Zeit für die beste didaktische Strategie hielt. Die Großausstellung *Österreichs Aufbruch in die Moderne 1880–1980*[11] anlässlich des 100-jährigen Bestehens der ÖLB, bei der die Sammlung FOTOGRAFIS zum ersten Mal mit *Entwicklungen in der Fotografie: Frühe Fotografie, Piktorialismus und Neue Sachlichkeit* der Öffentlichkeit vorgestellt wurde (September 1980 bis Januar 1981), hatte das eindrucksvoll bewiesen. Damit hätte der österreichischen Länderbank ein »Haus der Fotografie« gelingen können, das es übrigens trotz der in regelmäßigen Abständen laut werdenden Forderung danach in dieser Form in Österreich bis heute nicht gibt.

In Hinblick auf ein mögliches »Haus der Fotografie« erwarb ich neben Bildern auch über tausend Publikationen für die Sammlung, darunter Monografien, seltene Bildbände, Lexika und eine kleine, aber feine antiquarische Abteilung, die auch eine komplette Reprint-Ausgabe der legendären Zeitschrift *Camera Work* von Alfred Stieglitz aus dem Jahr 1969[12] beinhaltete. Außerdem legte ich ein umfangreiches Tonband- und Kassettenarchiv an, das auch Interviews mit Tim Nachum Gidal, Trude Fleischmann und Fritz Henle enthielt. Des Weiteren existieren Magnetaufzeichnungen von nahezu allen Symposien der Sammlung sowie diverse Mitschnitte von Rundfunk- und Fernsehsendungen zur Fotografie.

Die Zäsur im Jahr 1985: Die Sammlung FOTOGRAFIS wird Teil des Kunstforums Wien

Ein neuerlicher Vorstandswechsel im Jahre 1984 brachte auch für die Sammlung FOTOGRAFIS massive Veränderungen: Direktor Ivo Stanek wechselte in die Auslandsabteilung, während Dr. Klaus Albrecht Schröder als Direktor des Kunstforums auch die Leitung der Sammlung FOTOGRAFIS übernahm, die dem Kunstforum inkorporiert wurde. Mit der Bestellung von Schröder, dem heutigen Direktor der Wiener Albertina, zum Kulturbeauftragten der ÖLB hatte sich ein großer Strukturwandel vollzogen. Von diesem Zeitpunkt an wurde ein vorwiegend an Marketing-Richtlinien orientiertes Kulturprogramm verfolgt. Die erste Ausstellung Schröders galt dem Zeichner Alfred Kubin und fand im Herbst 1985 im großen Kassensaal des Hauses auf der Freyung statt, der nach dem Umbau den Namen

on Vienna's Freyung and making it accessible to the public was also considered. I pushed strongly for this objective because I had already implemented it in a similar manner at Die Brücke and I considered it the best didactic strategy given the state of photography reception at the time. The major exhibition *Österreichs Aufbruch in die Moderne 1880–1980*[11] on the occasion of the 100th anniversary of the ÖLB, at which the FOTOGRAFIS collection was presented to the public for the first time with *Developments in Photography: Early Photography, Pictorialism and New Objectivity* (September 1980 to January 1981), proved this impressively. As a result, the ÖLB could have managed a "House of Photography", which still does not exist despite the recurrent demand for it in this form in Austria.

For a possible "House of Photography", I purchased over a thousand publications for the collection in addition to images, including monographs, rare illustrated books, lexicons and a small but fine antiquarian department that also included a complete reprint edition of the legendary magazine *Camera Work* by Alfred Stieglitz from 1969.[12] I also compiled an extensive tape and cassette archive containing interviews with Tim Nachum Gidal, Trude Fleischmann and Fritz Henle. Furthermore, there are recordings of almost all of the symposiums of the collection and various recordings of radio and television programmes on photography.

The turning point in 1985: The FOTOGRAFIS collection becomes part of the Kunstforum Wien

A new change in management in 1984 brought massive changes for the FOTOGRAFIS collection, too: director Ivo Stanek switched to the international department, while Dr Klaus Albrecht Schröder took over the management of the FOTOGRAFIS collection, which was incorporated into the Kunstforum, as the director of the Kunstforum. With the appointment of Schröder, the current director of Vienna's Albertina, as a culture commissioner of the ÖLB, a significant structural change had been carried out. A cultural programme largely geared towards marketing guidelines was followed from this point on. Schröder's first exhibition was for the illustrator Alfred Kubin and took place in the autumn of 1985 in the large hall of the bank on the Freyung, which was called Kunstforum Wien after the renovation. Though the FOTOGRAFIS collection remained an integral part of the new programme – after all, its ten-year anniversary was approaching in 1986 – in the autumn of 1985 Schröder explained to me in an open discussion that he had to set priorities and the acquisitions for FOTOGRAFIS could not continue as before. However, at my request he was prepared to grant some of my purchasing proposals due to the impending anniversary of FOTOGRAFIS. These included the photomontage *L'Enigme* by Raoul Hausmann from 1946, William Henry

Kunstforum Wien erhielt. Zwar blieb die Sammlung FOTOGRAFIS noch integrativer Teil des neuen Programms – schließlich stand 1986 ihr zehnjähriges Jubiläum bevor –, doch schon im Herbst 1985 hatte mir Schröder in einem offenen Gespräch dargelegt, dass er Prioritäten setzen müsse und die Sammeltätigkeit der FOTOGRAFIS nicht mehr wie bisher weitergeführt werden könne. Dennoch war er auf mein Drängen hin bereit, einige meiner Ankaufsvorschläge des kommenden Jubiläums der FOTOGRAFIS wegen zu bewilligen. Dazu zählten unter anderem die Fotomontage *L'Enigme* von Raoul Hausmann aus dem Jahr 1946, William Henry Fox Talbots *View of Loch Katrine* von 1945, Alexander Rodtschenkos Fotografie *Pro Eto* von 1923, Otto Steinerts Fotogramm-Montage *Strenges Ballett* von 1949, Karel Nováks Stillleben von 1926 und Maurice Tabards Fotostudie von 1929. Das zehnjährige Jubiläum der Sammlung wurde mit der Ausstellung *Meisterwerke internationaler Fotografie. 10 Jahre Sammlung Fotografis Länderbank* und dem von der Österreichische Länderbank Aktiengesellschaft edierten Katalog im Kunstforum Bank Austria begangen.

Im Jahr 1986 war mein Vertrag mit der ÖLB ausgelaufen, ich blieb aber noch einige Monate, um das Inventar der Bilder vor meinem Weggang zu überprüfen. Im Mai 1987 übergab ich der Generaldirektion der Österreichischen Länderbank und ihren Vorständen einen siebzig Seiten umfassenden Abschlussbericht[13]. Das Kapitel der Entstehung der Sammlung FOTOGRAFIS war damit abgeschlossen. Ankäufe unterblieben von nun an und die Sammlung und die mit ihr verknüpften Aktivitäten ruhten. 2008 wurde schließlich von Ingried Brugger eine Sammlungsausstellung für das Kunstforum Bank Austria mit dem begleitenden Katalog *FOTOGRAFIS collection reloaded* organisiert, die auch in Prag gezeigt wurde. 2009 wurde die Sammlung ausführlich im Museum der Moderne Salzburg in dessen Ausstellungsräumen auf dem Mönchsberg gezeigt, als die Sammlung als Dauerleihgabe in den Bestand des Museums überging, wo sie seither von Margit Zuckriegl, der Leiterin der dortigen Fotosammlung, betreut wird.

Fox Talbot's *View of Loch Katrine* from 1945, Alexander Rodchenko's photograph *Pro Eto* from 1923, Otto Steinert's photogram montage *Strenges Ballett* from 1949, Karel Novák's still life from 1926 and Maurice Tabard's photo study from 1929. The ten-year anniversary of the collection was commemorated with the exhibition *Meisterwerke internationaler Fotografie. 10 Jahre Sammlung Fotografis Länderbank* and the catalogue edited by the Österreichische Länderbank Aktiengesellschaft at the Kunstforum Bank Austria.

My contract with the ÖLB expired in 1986 but I stayed for a few more months to check the inventory of images before my departure. In May 1987, I handed over a seventy-page completion report to the general management of the ÖLB and its directors.[13] The chapter on the development of the FOTOGRAFIS collection was thus concluded. No more purchases were made from then on, and the activities associated with it ceased. In 2008 an exhibition of the collection was finally organized by Ingried Brugger for the Kunstforum Bank Austria, accompanied by the catalogue *FOTOGRAFIS collection reloaded*. It was also shown in Prague. In 2009 the collection was exhibited in detail at the Mönchsberg exhibition space of the Museum der Moderne Salzburg when the collection entered the museum's holdings as a long-term loan. Since then it has been overseen by Margit Zuckriegl, the head of the photography collection of the Museum der Moderne Salzburg.

1 Anna Auer, *Die Wiener Galerie Die Brücke – Ihr internationaler Weg zur Sammlung Fotografis,* Passau 1999.

2 »The Collection Fotografis and its Roots. Interview between the Collection's founding Director Anna Auer and Lisa Kreil«, in: Anna Auer und Uwe Schögl (Hrsg.), *Jubilee. 30 Years ESHPh. Congress of Photography in Vienna,* Salzburg 2008, S. 347.

3 »Allan Porter in Interview with Anna Auer. Voyager between the Art Worlds«, in: *PhotoResearcher,* Nr. 17/2012, S. 78–94, online unter: www.donau-uni.ac.at/eshph (aufgerufen am 17.7.2013).

4 Auer 1999 (wie Anm. 1), S. 36.

5 Jubilee 2008 (wie Anm. 2), S. 349.

6 Der Konsulentenvertrag vom 11.4.1983 nennt die folgenden Aufgaben: Erstellung der Gesamtkonzeption, deren laufende Aktualisierung und Realisierung, wofür wir Ihnen Einsicht in die gesamte die Fotografis Länderbank betreffende Korrespondenz gewähren; Erstellung der Jahrespläne; Erstellung der Ausstellungskonzepte, Veranstaltungskonzepte (z.B. Symposien) und Publikationskonzepte; Vorschläge und Beratung bei Bildankäufen, Ankäufe für die Bibliothek sowie die Einschulung von Fachkräften; Beratung bzgl. Beteiligungen an externen nationalen und internationalen Veranstaltungen; Organisationsverantwortung der oben genannten Veranstaltungen; Betreuung und Kontaktnahme mit der Presse im Rahmen des Aufgabenbereichs; Gestaltung von Katalogen, Plakaten und Texten bzgl. der Fotografis Länderbank, jedoch nur im Rahmen des Länderbank Corporate Identity Konzepts; nach vorheriger Absprache und Genehmigung die Zuziehung von Fachleuten zur Beurteilung von Konzepten oder Ankäufen sowie Abschluss von entsprechenden Verträgen mit anderen Institutionen.

7 Die Ausstellung *Alfred Stieglitz. The New York Secession zu Gast in der Wiener Secession* (5. bis 20.12.1978) wurde von der FOTOGRAFIS mitgesponsert.

8 Margit Zuckriegl, *Österreichische Fotografie seit 1945. Aus den Beständen der Österreichischen Fotogalerie im Rahmen der Salzburger Landessammlungen Rupertinum,* Salzburg 1989.

9 Ivo Stanek (Hrsg.), *Zusammenfassung von Vorträgen der Sammlung Fotografis von 1976–1978,* Wien 1979, und ders. (Hrsg.), *Zusammenfassung von Vorträgen der Sammlung Fotografis von 1979–1980,* Wien 1981.

10 Peter Weibel und Anna Auer, *Erweiterte Fotografie/Extended Photography* (5. Internationale Biennale 1981), Wien 1981, S. 6/7; Ausstellung vom 22.10. bis 22.11.1981.

11 Rupert Feuchtmüller und Christian Brandstätter (Hrsg.), *Österreichs Aufbruch in die Moderne 1880–1980* (Ausst.-Kat. Österreichische Länderbank, Wien), Wien 1980. Die Bilder der Sammlung FOTOGRAFIS finden sich auf S. 48, 50/51 und 53.

12 Alfred Stieglitz, *Camera Work 1903–1917,* Reprint, Nendeln 1969. Erworben von der Sammlung FOTOGRAFIS mit Rechnung Nr. 320 vom 10.4.1978.

13 Anna Auer, *Sammlung Fotografis Länderbank, Abschlußbericht, Mai 1987,* Wien.

1 Anna Auer, *Die Wiener Galerie Die Brücke – Ihr internationaler Weg zur Sammlung Fotografis,* Passau 1999.

2 "The Collection Fotografis and its Roots. Interview between the Collection's founding Director Anna Auer and Lisa Kreil", in: Anna Auer and Uwe Schögl (eds.), *Jubilee. 30 Years ESHPh. Congress of Photography in Vienna,* Salzburg 2008, p. 347.

3 "Allan Porter in Interview with Anna Auer. Voyager between the Art Worlds", in: *PhotoResearcher,* no. 17/2012, pp. 78–94, online at: www.donau-uni.ac.at/eshph (accessed on 17 July 2013).

4 Auer 1999 (cf. note 1), p. 36.

5 *Jubilee* 2008 (cf. note 2), p. 349.

6 The consultant contract dated 11 April 1983 names the following tasks: creating the overall concept, its continual updating and implementation, for which access to all of the correspondence concerning Fotografis Länderbank would be granted; preparing annual plans; preparing the exhibition concepts, event concepts (e.g. symposiums) and publication concepts; suggestions and advice for image purchases, purchases for the library and training of staff; advice regarding involvement in external national and international events; organisational responsibility for the aforementioned events; supporting and contacting the press within the remit; designing of catalogues, posters and tests for Fotografis Länderbank, but only as part of the Länderbank Corporate Identity concept; calling in experts to assess concepts or purchases and to conclude corresponding contracts with other institutions after prior discussion and approval.

7 The exhibition *Alfred Stieglitz. The New York Secession zu Gast in der Wiener Secession* (5 to 20.12.1978) was co-sponsored by FOTOGRAFIS.

8 Margit Zuckriegl, *Österreichische Fotografie seit 1945. Aus den Beständen der Österreichischen Fotogalerie im Rahmen der Salzburger Landessammlungen Rupertinum,* Salzburg 1989.

9 Ivo Stanek (ed.), *Zusammenfassung von Vorträgen der Sammlung Fotografis von 1976–1978,* Vienna 1979, and Ivo Stanek (ed.), *Zusammenfassung von Vorträgen der Sammlung Fotografis von 1979–1980,* Vienna 1981.

10 Peter Weibel and Anna Auer, *Erweiterte Fotografie/Extended Photography* (5. Internationale Biennale 1981), Vienna 1981, pp. 6/7; exhibition from 22 October to 22 November 1981.

11 Rupert Feuchtmüller and Christian Brandstätter (eds.), *Österreichs Aufbruch in die Moderne 1880–1980* (exh. cat. Österreichische Länderbank, Vienna), Vienna 1980. The images of the FOTOGRAFIS collection can be found on pp. 48, 50/51 and 53.

12 Alfred Stieglitz, *Camera Work 1903–1917,* reprint, Nendeln 1969. Purchased from the FOTOGRAFIS collection, invoice no. 320, on 10 April 1978.

13 Anna Auer, *Sammlung Fotografis Länderbank, Abschlußbericht, May 1987,* Vienna.

William Henry Fox Talbot

Geboren 1800 in Melbury/Großbritannien, verstorben 1877 in Lacock/Großbritannien. Nach einer vielfältigen Ausbildung in Literatur- und Naturwissenschaften schlug William Henry Fox Talbot eine politische Karriere ein, bevor er sich mit den physikalischen Phänomenen der fotografischen Bildproduktion auseinandersetzte. Ab 1834 mündeten seine Experimente mit diversen Chemikalien und Papierbeschichtungen in die Entwicklung eines Negativ-Positiv-Verfahrens, das die Haltbarkeit und Reproduzierbarkeit von Fotografien garantierte. Seine 1854 erfolgte »Erfindung der Fotografie« konnte er aber nicht patentieren lassen. Er lebte, abgesehen von seinen Reisen, zeitlebens in der Abtei von Lacock, einem zum Wohnsitz umgebauten Nonnenkloster, welches durch Talbots frühe Fotografien in die Fotogeschichte einging.

The Pencil of Nature hieß das erste von Talbot herausgebrachte Mappenwerk mit Fotografien auf Papier. Das hierfür von Talbot verwendete Verfahren ist ein Markstein in der Entwicklung der Fotografie, erlaubte es doch die für Editionen erforderliche Herstellung mehrerer Abzüge von einem Negativ. Durch Umkopieren in ein Positivbild konnte selbst ein Fotogramm wie das des hier gezeigten zart gefiederten Pflanzenblattes für eine Auflage vorgesehen werden – durch eine fotografische Technik, die den Namen ihres Urhebers trägt: Talbotypie.

Literatur/Further reading: William Henry Fox Talbot. *The Pencil of Nature,* mit einer Einleitung von/with an introduction by Colin Harding, Chicago und/and London 2011

Born in 1800 in Melbury/Great Britain, died in 1877 in Lacock/Great Britain. After a diverse education in literature and natural science, William Henry Fox Talbot embarked on a political career before exploring the physical phenomena of photographic image production. From 1834 onwards, his experiments with various chemicals and paper coatings led to the development of a negative-positive method, which ensured the stability and reproducibility of photographs. But he could not get his "invention of photography" patented in 1854. Apart from his travels, he lived in Lacock Abbey, a nunnery converted into a residence that became part of photographic history through Talbot's early photographs.

The *Pencil of Nature* was the name of the first portfolio published by Talbot with photographs on paper. The method Talbot used for this is a milestone in the development of photography, allowing the production of multiple prints from one negative as required to publish editions. By making it into a positive image, even a photogram of a delicate, feathery plant leaf as shown here allowed for an edition to be made by using a photographic technique that bears the name of its creator: Talbotype.

William Henry Fox Talbot
Blatt einer Pflanze/Leaf of a Plant, 1844
Talbotypie/Talbotype

DAS FESTHALTEN DES BLICKES UND DIE BESCHLEUNIGUNG DER BILDER. DIE ANFÄNGE DER FOTOGRAFIE IM 19. JAHRHUNDERT

CAPTURING THE VIEW AND THE ACCELERATION OF IMAGES. THE BEGINNINGS OF PHOTOGRAPHY IN THE NINETEENTH CENTURY

Simone Förster

»Wie ich gestern neben am Thal hinaufging, sah ich auf einem Steine zwei Mädchen sitzen, die eine band ihre Haare auf, die andere half ihr; und das goldene Haar hing herab, und ein ernstes bleiches Gesicht, und doch so jung, und die schwarze Tracht und die andere so sorgsam bemüht. Die schönsten, innigsten Bilder der altdeutschen Schule geben kaum eine Ahnung davon. Man möchte manchmal ein Medusenhaupt seyn, um so eine Gruppe in Stein verwandeln zu können, und den Leuten zurufen. Sie standen auf, die schöne Gruppe war zerstört; aber wie sie so hinabstiegen, zwischen den Felsen war es wieder ein anderes Bild. Die schönsten Bilder, die schwellendsten Töne, gruppiren, lösen sich auf.«[1] Mit diesen Worten lässt im Jahr 1835 der Schriftsteller, Naturwissenschaftler und Revolutionär Georg Büchner in seiner Erzählung *Lenz* den gleichnamigen Protagonisten über die Unmöglichkeit, Gesehenes im Moment des Erlebens festzuhalten, nachsinnen. Lenz wünscht sich, das als flüchtig Wahrgenommene durch seinen Blick zu einem beständigen Bildwerk werden lassen zu können. Als Medusenhaupt gelänge es ihm, Gesehenes in Stein zu arretieren und vorzeigbar zu machen. Denn selbst die feinsten Schöpfungen der Malerei könnten den Zauber der Wirklichkeit nicht wiedergeben, so Lenz. Er formuliert die Sehnsucht nach einem Mittel, den Augenblick zu fixieren, aus dem Kontinuum der Zeit herauszulösen und in ein Bild zu bannen. Vermutlich ohne sich dessen bewusst zu sein, trug Georg Büchner hier die grundlegenden Paradigmen der Fotografie vor: das Festhalten des Augenblicks, das präzise Abbilden der Wirklichkeit und die Vervielfältigung. Er benannte damit Fragestellungen, mit denen sich zur gleichen Zeit Künstler, Erfinder und Wissenschaftler wie Joseph Nicéphore Niépce, Louis-Jacques-Mandé Daguerre, William Henry Fox Talbot und Hippolyte Bayard beschäftigten. In England beispielsweise arbeitete der Univer-

"As I went up alongside the valley yesterday, I saw two girls sitting on a rock. One was doing her hair up and the other helped her; and the golden hair drooped, and a serious, pale face, and yet so young, and the black garb, and the other so diligently attended to her. The most beautiful, intimate paintings by the old German masters hardly give an inkling of this. Sometimes one would like to be a Medusa's head in order to be able to transform such a group into stone and to shout to the people. They stood up and the beautiful group was destroyed; but as they descended between the rocks it was a different image again. The most beautiful images, the most pulsating tones, form a group, dissolve."[1] In his novella *Lenz* from 1835 the writer, scientist and revolutionary Georg Büchner contemplates through his eponymous protagonist the impossibility of capturing what is seen in the moment of the experience. Lenz wishes to transform the fleetingly perceived into an enduring image through his gaze. As a Medusa's head he would be able to lock what he sees in stone and make it presentable. Or, to use Lenz's words: even the finest creations of painting cannot reproduce the magic of reality. He formulates the longing for a means to capture the moment, to separate it from the continuum of time and to capture it in an image. With this, and presumably without being aware of it, Georg Büchner presented the fundamental paradigms of photography: capturing the moment, the precise imaging of reality, and reproduction. He thereby addressed questions that artists, inventors and scientists such as Joseph Nicéphore Niépce, Louis-Jacques-Mandé Daguerre, William Henry Fox Talbot and Hippolyte Bayard dealt with at the same time. In England, for instance, the polymath William Henry Fox Talbot was working on the development of a process with which the images generated through exposure to light in the camera obscura could be chemically fixed on paper. In 1835, the

salgelehrte William Henry Fox Talbot an der Entwicklung eines Verfahrens, mit dem die durch Lichteinfall in der Camera obscura erzeugten Bilder chemisch auf Papier fixiert werden konnten. Im Jahr 1835, dem Jahr der Fertigstellung von Büchners *Lenz,* gelang es Talbot tatsächlich, eine kleinformatige negative Ansicht eines Sprossenfensters seines Anwesens auf Papier zu fixieren.[2]

Als Büchners Text posthum im Jahr 1839 veröffentlicht wurde,[3] waren die darin enthaltenen Wünsche und Gedanken zum Festhalten von Gesehenem erfüllt: Die Fotografie war erfunden, wie noch im selben Jahr bekannt gegeben wurde. Der französische Physiker, Astronom und Politiker Dominique François Arago hatte den Mitgliedern der französischen Akademie der Wissenschaften und der Deputiertenkammer ein Verfahren vorgestellt, das es möglich machte, Augenblicke der Gegenwart detailgetreu als Bild zu fixieren: Louis-Jacques-Mandé Daguerres sogenannte Daguerreotypie. Innerhalb weniger Monate wurde die Patentschrift in mehrere Sprachen übersetzt und erschien in zahlreichen Auflagen in ganz Europa und Amerika. Der französische Kunstkritiker und Schriftsteller Jules Janin, der als einer der Ersten über die neue Erfindung berichtete, schrieb: »Es gibt in der Bibel die schöne Stelle: ›Gott sprach: Es werde Licht, und es ward Licht.‹ Jetzt kann man den Türmen von Notre-Dame befehlen: ›Werdet Bild!‹ und die Türme gehorchen.«[4] Das Verfahren war aufwendig und kostspielig. Dennoch eröffneten in kürzester Zeit auch außerhalb der großen Ballungszentren Paris, London, Frankfurt und Wien Ateliers für Daguerreotypien, in denen sich das gehobene Bürgertum, der Adel und andere Prominenz porträtieren ließ. Die Zeitgenossen des sich schnell und weit verbreitenden Verfahrens lobten die enorme Detailgenauigkeit und Präzision des Abbildes,[5] die dem Betrachter den Eindruck vermittelten, mit der Daguerreotypie geradezu

year Büchner's *Lenz* was completed, Talbot actually succeeded in fixing a small-format negative image of a lattice window of his estate onto paper.[2]

When Büchner's text was posthumously published in 1839,[3] the wishes and thoughts expressed with regard to capturing what is seen were fulfilled: photography was invented, which was also announced in the same year. French physicist, astronomer and politician Dominique François Arago had presented to the French Academy of Sciences and the Chamber of Deputies a process that made it possible to fix moments of the present as a detailed image: Louis-Jacques-Mandé Daguerre's so-called "Daguerreotype". Within a few months, the patent specification was translated into several languages and was published in several editions throughout Europe and America. The French art critic and writer Jules Janin, who was one of the first to give an account of the new invention, wrote: "There is a beautiful passage in the Bible: 'God said: let there be light, and there was light.' Now one can command the towers of Notre Dame: 'become an image' and the towers obey."[4] The process was time-consuming and expensive. Nevertheless, studios for Daguerreotypes in which portraits of the upper middle classes, aristocracy and other notables were made also opened outside the major cities of Paris, London, Frankfurt and Vienna shortly thereafter. Contemporaries of the process that was spreading fast and far praised the image's enormous attention to detail and precision,[5] which to the viewer conveyed the impression of obtaining with the Daguerreotype a reflexion of nature and clearly seeing reality fixed in the image. However, this was misleading with regard to the disadvantage of the difficult handling of Daguerreotypes – the metal plates had to be viewed at a specific angle in order to reveal the image – and did not alter the fact that each item remained a unique specimen, either. And so it was Talbot's negative-positive process on paper that prevailed as a process in the long term, despite the initial criticism of the slight blurring of the prints. Talbot introduced a decisive development of his process in the early 1840s, under the concept of the calotype. With the separation of the technical process of photography from the chemical process of development, he laid the foundation on which modern photography developed, and which in the practice of analogue photography remains valid to this day. He managed to considerably shorten the exposure time in the camera and to establish a process of simple and fast reproduction. In order to publicize his process and to corroborate his authorship, in a sequence of six volumes between 1844 and 1846, Talbot published *The Pencil of Nature,* the first book illustrated with photographs.[6] Each of the 24 calotype prints pasted into the book – townscapes and

William Henry Fox Talbot, *Loch Katrine*, 1845
Talbotypie / Talbotype, 19 × 23 cm
Sammlung FOTOGRAFIS Bank Austria/
FOTOGRAFIS Bank Austria Collection

einen Spiegel der Natur zu erhalten und im Bild eindeutig die Wirklichkeit fixiert zu sehen. Dies täuschte allerdings weder über den Nachteil der schweren Handhabbarkeit der Daguerreotypien – die Metallplatten mussten unter einem bestimmten Winkel betrachtet werden, um ihr Bild preiszugeben – noch und über die Tatsache hinweg, dass jedes Stück ein Unikat war. Und so war es Talbots Positiv-Negativ-Verfahren auf Papier, das sich trotz der anfänglichen Kritik an der leichten Unschärfe der Abzüge langfristig als Verfahren durchsetzte. Unter dem Begriff Kalotypie entwickelte Talbot sein Verfahren schon in den frühen 1840er-Jahren entscheidend weiter. Mit der Trennung des technischen Vorgangs der Aufnahme vom chemischen Prozess der Entwicklung legte er die Grundlage, auf der sich die moderne Fotografie entfaltete und die bis heute gültige Praxis der analogen Fotografie ist. Es gelang ihm, die Belichtungszeit in der Kamera enorm zu verkürzen und ein Verfahren der einfachen und schnellen Vervielfältigung zu etablieren. Um sein Verfahren bekannt zu machen und seine Autorschaft zu bekräftigen, veröffentlichte Talbot zwischen 1844 und 1846 in einer Folge von sechs Bänden *The Pencil of Nature*, das erste mit fotografischen Aufnahmen illustrierte Buch.[6] Jede der 24 darin eingeklebten Kalotypien – Stadt- und Architekturansichten, Sach- und Objektfotografien, der Abdruck eines Pflanzenteils und einer Spitzenstickerei, Kunstreproduktionen, Genreansichten und eine Mehrpersonenansicht – ist von einem von Talbot selbst verfassten Kommentar begleitet, der die Charaktereigenschaften des fotografischen Bildes beschreibt und zugleich dessen Verwendungsvorzüge für Wissenschaft, Kunst und Lebensalltag aufzeigt. *The Pencil of Nature* ist kein Handbuch für die Erstellung von Kalotypien, sondern ein Buch über die Entstehung der Fotografie und eine Analyse des Mediums in seiner Zeit.[7] Dass Talbot in *The Pencil of Nature* eines der wichtigsten Genres der Fotografie, das Porträt, nicht mit einem Bildbeispiel berücksichtigt, mag seinem eher wissenschaftlich-analytischen Interesse geschuldet sein. Denn auch die Kalotypie wurde schnell als Verfahren für die Porträtdarstellung eingesetzt. Schon 1845 beispielsweise eröffnete Robert Adamson in Edinburgh ein Porträtatelier und tat sich mit dem Maler David Octavius Hill zusammen. In wenigen Jahren nahmen sie in mehreren tausend Kalotypien vor allem bedeutende Persönlichkeiten, aber auch Stadtansichten, Landschaften und Straßenszenen auf. Ihr umfassendstes gemeinsames Projekt war jedoch die Aufnahme von mehreren hundert fotografischen Einzelporträts als Vorlage für ein monumentales Gemälde des Gründungstreffens der schottischen Freikirche, das Hill plante.[8] Aufgrund der schieren Menge der zu erstellenden Porträts trat hier die Fotografie an die Stelle des Zeichenstifts. Durch die relative Einfachheit und Schnelligkeit des Verfahrens war das Pensum überhaupt erst

Robert Adamson & David Octavius Hill, *Sir Culling Eardly Smith*, 1847
Kalotypie/calotype, 20,4 × 15,4 cm
Sammlung FOTOGRAFIS Bank Austria /
FOTOGRAFIS Bank Austria Collection

architectural views, still-life and object photographs, the print of the leaf of a plant and lace embroidery, art reproductions, genre views and a multi-person view – is accompanied by a commentary written by Talbot himself, which describes the characteristics of the photographic image and at the same time the advantages of its usage for science, art and everyday life. *The Pencil of Nature* is not a manual for creating calotype prints, but a book about the emergence of photography and an analysis of the medium in his time.[7] The fact that there is no visual example of one of the most important genres of photography – the portrait – in *The Pencil of Nature* may be due to Talbot's primarily scientific, analytical interest. Nevertheless, the calotype process was soon used for portrait images. For instance, as early as 1845, Robert Adamson opened a portrait studio in Edinburgh and teamed up with the painter David Octavius Hill. In a few years they photographed primarily important personalities, but also townscapes, landscapes and street scenes in several thousand calotypes. However, their most comprehensive joint project was the creation of several hundred individual photographic portraits as a template for a monumental painting of the "Disruption Assembly of the Free Church of Scotland" that Hill planned.[8] Due to the sheer number of portraits

zu bewältigen und zugleich garantierten die fotografischen Ergebnisse mit ihrer enormen Detailgenauigkeit eine verlässliche, naturgetreue Vorlage für den Maler.

Diese spezifisch fotografischen Qualitäten waren es allerdings auch, die im Diskurs der zeitgenössischen Kritik als Argumente dienten, dem Medium den Status als Kunst zu verwehren.[9] Stand am Anfang der Geschichte der Fotografie die Bemühung um das Verstehen der Technik und des Verfahrens, folgte in den 1840er- und 1850er-Jahren die Erforschung und Verbesserung der Prozesse. Damit einher ging die weite Verbreitung, eine Demokratisierung und Kommerzialisierung des Mediums. Die ästhetischen Möglichkeiten der Fotografie waren erstaunlich früh erkannt und sowohl von Daguerre wie von Talbot schon in den Anfängen ausgelotet. Der »Makel« allerdings, dass ein Bild durch einen Apparat erzeugt wurde, dass durch die Detailgenauigkeit geradezu eine Kopie der Natur entstand, die reproduzierbar war und theoretisch unendlich oft vervielfältigt werden konnte, verstellte in der Rezeption des 19. Jahrhunderts lange den Blick auf die Eigenständigkeit der ästhetischen Kategorien der Fotografie. In wissenschaftlichen Feldern, wie beispielsweise in der Astronomie, Medizin, Ethnologie, Botanik und in den Altertumswissenschaften, war die Fotografie hingegen schnell akzeptiert. Sie diente als Mittel der genauen Beobachtung, der Vermessung, Analyse und Klassifizierung; sie bot die Möglichkeit, Unsichtbares sichtbar zu machen und Entferntes in die Nähe zu holen. Im ganz wörtlichen Sinne hatte sie die Kraft, Bilder zu »versetzen« und diese in einem neuen Kontext zu präsentieren. Die frühesten Fotografien waren zumeist Aufnahmen von Gebäuden, denn die Vorteile lagen nahe: Zum einen war aufgrund der langen Belichtungszeiten völlige Bewegungslosigkeit unabdingbar. Zum anderen wurde Architektur über fotografische Ansichten samt ihren vielteiligen Details vermittelbar. Für Forschungsbereiche wie Geografie, Archäologie und Geschichtswissenschaften hatte die Fotografie seit der Frühzeit immense Bedeutung. Schon Arago wies in seinem Plädoyer vor der Akademie der Wissenschaften 1839 auf den außerordentlichen Nutzen hin, den »die ägyptische Expedition aus einem so genauen und so schnellen Reproduktionsmittel hätte ziehen können«[10]. Die aufkommende Denkmalpflege, topografischer Forscherdrang und die Entdeckerlust am Exotischen, koloniale Expansion und der beginnende Tourismus führten um die Mitte des 19. Jahrhunderts zur systematischen Erkundung der Welt mit der Kamera. Im Zuge der französischen *Mission héliographique* wurden 1851 beispielsweise Fotografen ausgesendet, um historische Baudenkmäler in Frankreich zu erfassen und deren Erhaltungszustand und einen möglichen Restaurierungsbedarf zu dokumentieren.[11] Der Schriftsteller Maxime Du Camp erhielt 1849 von der französischen Regierung den Auftrag, eine groß angelegte Expedition entlang des Nils zu unternehmen.[12] Bevor er zusammen mit seinem Begleiter Gustave Flaubert aufbrach, ließ Du Camp sich durch den

Antonio Beato, *Les trois pyramides avec le village à Gizeh*, 1873
Albuminprint / albumen print, 25,5 × 36,5 cm
Sammlung FOTOGRAFIS Bank Austria /
FOTOGRAFIS Bank Austria Collection

to be created, photography took the place of drawing. The workload could be handled only due to the relative simplicity and speed of the process, and at the same time the photographic results with their enormous attention to detail guaranteed reliable, realistic models for the painter.

However, it was also these specific photographic qualities that served as an argument to deny the medium the status of art in the discourse of contemporary criticism.[9] The effort to understand the technique and the process was made at the beginning of the history of photography, followed in the 1840s and 1850s by research into and improvement of the process. This was accompanied by the prevalence as well as a democratization and commercialization of the medium. The aesthetic possibilities of photography were recognized amazingly early and explored in the initial stages by Daguerre as well as Talbot. However, the "blemish" that an image was created by an apparatus – that a virtual copy of nature emerged through the attention to detail which was reproducible and theoretically could often be endlessly reproduced – distorted the view of the autonomy of the aesthetic categories of photography for a long time in the reception of the nineteenth century. On the other hand, photography was quickly accepted in scientific fields such as astronomy, medicine, ethnology, botany and classical studies. It served as a means of accurate observation, measurement, analysis and classification; it offered the possibility to make the invisible visible and to bring distant objects closer. In every sense of the word it had the power to "transpose" images and to present these in a new context. The earliest photographs were mostly pictures of buildings, because the advantages were obvious. For one thing, complete motionlessness was indispensable due to the long

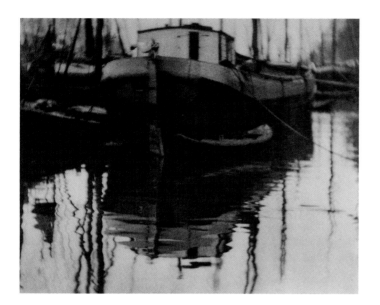

Alvin Langdon Coburn, *A Canal in Rotterdam*, 1908
Platinprint / platinum print, 32,4 × 40,8 cm
Sammlung FOTOGRAFIS Bank Austria /
FOTOGRAFIS Bank Austria Collection

professionellen Fotografen Gustave Le Gray in die Fotografie ein-weisen. In etwa auf der Route des Napoleonischen Feldzuges von 1798 reisend, brachte er mehr als zweihundert Papiernegative mit zurück und veröffentlichte viele davon 1852 in einem mehrteiligen Mappenwerk, das die Tradition der Reisebeschreibungen des 17. und 18. Jahrhunderts aufnahm und in einen Bildband überführte.[13]

Für die zahlreichen Bildungsreisenden in der Tradition der *Grand Tour* durch die Mittelmeerländer hatten die mitgebrachten Fotografi-en Mitte des 19. Jahrhunderts noch gewichtigen Dokumentations-charakter. Sie belegten visuell die Route des Reisenden, dienten dem Abgleich des durch Studium angeeigneten Wissens mit der Realität und vermittelten Informationen an die Daheimgebliebenen. Mit der Vereinfachung des Reisens und der zunehmenden Erreichbarkeit auch entfernter, exotischer Ziele entwickelte sich die Fotografie zu einem tragenden Wirtschaftszweig, zumal sich auch ihre technisch-chemischen Anforderungen in der zweiten Hälfte des 19. Jahrhun-derts vereinfachten. Zahlreiche Fotoateliers und Reproduktionswerk-stätten, die Reisefotografien vermarkteten, entstanden auch in entfernten Orten und Ländern und trugen zur großen Verbreitung der Bilder bei. Es wurde möglich, Bilder – und damit Wissen und Kenntnis von entlegenen Winkeln der Erde – auch ohne eine aufwen-dige Reiseaktivität zu erwerben. Vermittelt über die Fotografie geriet so die Welt in vielerlei Hinsicht in Bewegung; für das 19. Jahrhundert eröffnete sich ein neuer, visueller Zugang zu ihr. Durch die Möglich-keit, zu jeder Zeit an jedem Ort augenscheinlich unverfälschte Bilder aufzunehmen und diese Bilder ebenfalls zu jeder Zeit an jedem Ort betrachten zu können, entstand ein neues Verständnis von Realität und Authentizität.[14] Die Vereinfachung der anfänglich komplizierten technischen Verfahren der Fotografie – besonders in der zweiten Hälfte des 19. Jahrhunderts – trug auch dazu bei, dass die subjektive

exposure times. For another, architecture became communicable via photographic views together with their multipartite details. Since the early days, photography had immense importance for fields of research such as geography, archaeology and history. In his speech before the Academy of Sciences in 1839, Arago had already referred to the extraordinary benefit which "the Egyptian expedition could have derived from such an accurate and rapid means of reproduc-tion".[10] Around the middle of the nineteenth century, the emerging activities of preserving cultural heritage, the topographical explor-atory urge and the desire for discovering the exotic, colonial expan-sion and incipient tourism led to a systematic exploration of the world with the camera. For instance, in the course of the French *Mission héliographique* in 1851, photographers were sent out to record architectural monuments and to document a possible need for resto-ration in France.[11] In 1849, the writer Maxime Du Camp was com-missioned by the French government to undertake a large-scale expe-dition along the Nile.[12] Before he set out with his companion Gustave Flaubert, Du Camp was instructed in photography by the profes-sional photographer Gustave Le Gray. Roughly travelling along the route of the Napoleonic campaign of 1798, he brought back more than two hundred paper negatives, and in 1852 he published many of them in a multi-part portfolio adopting the tradition of travel accounts of the seventeenth and eighteenth century, and conveyed them in an illustrated book.[13]

In the tradition of the Grand Tour through the Mediterranean coun-tries, photographs brought back by travellers in the middle of the nineteenth century still had a distinct documentary character. They visually substantiated the route of the travellers and served as a com-parison of the knowledge acquired through studies with reality, and provided information to those who stayed at home. With the simpli-fication of travel and the increasing ability to also reach distant, exotic destinations, photography evolved into a fundamental trade, especially since its technical and chemical requirements were simpli-fied in the second half of the nineteenth century. Numerous photo-graphic studios and reproduction studios which marketed the travel photographs also emerged in distant locations and countries, and thereby contributed to the great dissemination of images. It was now possible to acquire images – and therefore knowledge and informa-tion with regard to remote corners of the world – without extensive travel activity. In many respects, the world was set in motion, conveyed by photography; a new, visual access to the world was opened up for the nineteenth century. As it was possible to take unadulterated pic-tures at any time and in any location, and to view these pictures at

künstlerische Gestaltung einer Aufnahme verstärkt wahrgenommen wurde und die Fotografie in der zeitgenössischen Kritik einen neuen Stellenwert einnahm. Dass die Fotografie als Kunstform anerkannt wurde, verdankt sie allerdings nicht der Anpassung an ästhetische Kategorien der Malerei, sondern ihren eigenen Bildfindungen, durch die sie einen originären Blick auf die Wirklichkeit warf, der uns die Vielschichtigkeit der Welt und deren Wandlungen erst wahrnehmen ließ. Der subjektive und aufmerksame Blick – wie der von Büchners Lenz im Gebirge – und die Fähigkeit, die Schönheiten, die sich vor dem Auge abspielen, zu erkennen, sind die Voraussetzungen für das Festhalten eines besonderen Moments durch die Fotografie. Francis Frith, selbst ein bedeutender Landschafts- und Reisefotograf des 19. Jahrhunderts, rief den Fotografen dazu auf, mit jeder Fotografie ein Bild zu erzeugen, »das allen Anforderungen seiner Urteilskraft und seines Geschmackes standhält. Dieses eine Bild wird zweifelsohne von unendlich höherem Wert für seine Gefühle und seine Reputation sein als eine Menge nur ›guter‹ Bilder«.[15]

any time and in any location, a new understanding of reality and authenticity emerged.[14] The simplification of the initially complicated technical process of photography – particularly in the second half of the nineteenth century – also contributed to the fact that the subjective artistic configuration of a photograph was increasingly perceived, and photography took on a new significance in terms of contemporary critique. However, the fact that photography was recognized as an art form is due not to the adaptation to aesthetic categories of painting, but to its own pictorial inventions. As a result, it cast an original view on reality that first allowed us to perceive the complexity of the world and its changes. The subjective and attentive gaze – like that of Büchner's Lenz in the mountains – and the ability to recognize the beauties that take place before one's eyes are the prerequisites for capturing a special moment through photography. Francis Frith, himself a distinguished landscape and travel photographer of the nineteenth century, called on photographers to generate with every photograph an image "that bears up against all requirements of their powers of judgment and their tastes. This one image will indubitably be of infinitely greater value for their feelings and their reputations than a multitude of merely 'good' images".[15]

1 Georg Büchner, *Lenz* (1835), neu hergestellt und kommentiert von Burghard Dedner, Frankfurt am Main 2013, S. 17.
2 Vgl. Hubertus von Amelunxen, *Die aufgehobene Zeit. Die Erfindung der Photographie durch William Henry Fox Talbot*, Berlin 1988, S. 27.
3 Büchner 1835 (wie Anm. 1), S. 40.
4 Jules Janin, »Der Daguerrotyp« (1839), in: Wolfgang Kemp (Hrsg.), *Theorie der Fotografie*, Bd. 1, München 1999, S. 46–51, hier S. 47.
5 Vgl. u.a. die Texte von Jules Janin, Dominique François Arago, aber auch von Ludwig Schorn und Eduard Kolloff in Kemp 1/1999 (wie Anm. 4).
6 William Henry Fox Talbot, *The Pencil of Nature*, London 1844–1846.
7 Vgl. Bernd Stiegler, *Theoriegeschichte der Photographie*, München 2006, S. 33–45, hier S. 37.
8 Vgl. Bodo von Dewitz und Karin Schuller-Procopovici (Hrsg.), *David Octavius Hill & Robert Adamson. Von den Anfängen der künstlerischen Photographie im 19. Jahrhundert* (Ausst.-Kat. Museum Ludwig, Köln), Göttingen 2000.
9 Zum Verhältnis von Malerei und Fotografie vgl. u.a. Ulrich Pohlmann und Johann Georg Prinz von Hohenzollern (Hrsg.), *Eine neue Kunst? Eine andere Natur!* (Ausst.-Kat. Kunsthalle der Hypo-Kulturstiftung, München), München 2003.
10 François Dominique Arago, »Bericht über den Daguerreotyp« (1839), in: Kemp 1/1999 (wie Anm. 4), S. 51–55, hier S. 51. Mit »ägyptische Expedition« ist Napoleons Feldzug zur wissenschaftlichen und militärischen Eroberung Ägyptens 1798 bezeichnet.
11 Vgl. Anne de Mondenard, *La Mission héliographique. Cinq photographes parcourent la France en 1851*, Paris 2002.
12 Vgl. Bodo von Dewitz und Karin Schuller-Procopovici (Hrsg.), *Die Reise zum Nil 1849–1850. Maxime Du Camp und Gustave Flaubert in Ägypten, Palästina und Syrien* (Ausst.-Kat. Museum Ludwig, Köln), Göttingen 1997.
13 Maxime Du Camp, *Égypte, Nubie, Palestine et Syrie*, Paris 1852.
14 Vgl. Jürgen Osterhammel, *Die Verwandlung der Welt. Eine Geschichte des 19. Jahrhunderts*, München 2011, besonders S. 76–80.
15 Francis Frith, »Die Kunst der Fotografie« (1859), in: Kemp 1/1999 (wie Anm. 4), S. 100–103, hier S. 103.

1 Georg Büchner, *Lenz* (1835), compiled and annotated by Burghard Dedner, Frankfurt am Main 2013, p. 17.
2 Cf. Hubertus von Amelunxen, *Die aufgehobene Zeit. Die Erfindung der Photographie durch William Henry Fox Talbot*, Berlin 1988, p. 27.
3 Büchner 1835 (cf. note 1), p. 40.
4 Jules Janin, "Der Daguerrotyp" (1839), in: Wolfgang Kemp (ed.), *Theorie der Fotografie*, Vol. 1, Munich 1999, pp. 46–51, p. 47.
5 Among other things, compare texts by Jules Janin and Dominique François Arago, but also by Ludwig Schorn and Eduard Kolloff in Kemp 1/1999 (cf. note 4).
6 William Henry Fox Talbot, *The Pencil of Nature*, London 1844–1846.
7 Cf. Bernd Stiegler, *Theoriegeschichte der Photographie*, Munich 2006, pp. 33–45, particularly p. 37.
8 Cf. Bodo von Dewitz and Karin Schuller-Procopovici (eds.), *David Octavius Hill & Robert Adamson. Von den Anfängen der künstlerischen Photographie im 19. Jahrhundert* (exh. cat. Museum Ludwig, Cologne), Göttingen 2000.
9 With regard to the relationship of painting and photography, compare Ulrich Pohlmann and Johann Georg Prinz von Hohenzollern (eds.), *Eine neue Kunst? Eine andere Natur!* (exh. cat. Kunsthalle der Hypo-Kulturstiftung, Munich), Munich 2003.
10 François Dominique Arago, "Bericht über den Daguerreotyp" (1839), in: Kemp 1/1999 (cf. note 4), pp. 51–55, p. 51. "Egyptian expedition" refers to Napoleon's campaign for the scientific and military conquest of Egypt in 1798.
11 Cf. Anne de Mondenard, *La Mission héliographique. Cinq photographes parcourent la France en 1851*, Paris 2002.
12 Cf. Bodo von Dewitz and Karin Schuller-Procopovici (eds.), *Die Reise zum Nil 1849–1850. Maxime Du Camp und Gustave Flaubert in Ägypten, Palästina und Syrien* (exh. cat. Museum Ludwig, Cologne), Göttingen 1997.
13 Maxime Du Camp, *Égypte, Nubie, Palestine et Syrie*, Paris 1852.
14 Cf. Jürgen Osterhammel, *Die Verwandlung der Welt. Eine Geschichte des 19. Jahrhunderts*, Munich 2011, particularly pp. 76–80.
15 Francis Frith, "Die Kunst der Fotografie" (1859), in: Kemp 1/1999 (cf. note 4), pp. 100–103, p. 103.

Robert Adamson & David Octavius Hill

Robert Adamson: geboren 1821 in Burnside, Schottland/Großbritannien, verstorben 1848 in St. Andrew, Schottland/Großbritannien. David Octavius Hill: geboren 1802 in Perth, Schottland/Großbritannien, verstorben 1870 in Edinburgh, Schottland/Großbritannien. Robert Adamson war ausgebildeter Techniker und Ingenieur und fertigte zusammen mit dem Maler David Octavius Hill zahlreiche Porträtfotografien an. Ihre Zusammenarbeit begann 1843, Grundlage war der Auftrag für das Gemälde der Free Church in Edinburgh. Die Fotos aus den Jahren 1843 bis 1848, auch die des Greyfriars-Friedhofs, sind sämtlich als Gemeinschaftsarbeiten zu sehen. Ab 1843 wohnten Adamson und Hill im selben Haus, schufen über 3000 gemeinsame Fotowerke und brachten gemeinsame Fotokonvolute heraus. Bis zu Adamsons Tod im Jahr 1848 stellten sie gemeinsam aus. Danach setzte Hill die fotografische Tätigkeit allein fort. In der Literatur wurden die beiden Künstler unterschiedlich gewichtet. Es setzte sich jedoch durch, für alle Werke der Zeit des gemeinsamen Arbeitens eine gemeinsame Autorenschaft anzugeben.

Robert Adamson: born in 1821 in Burnside, Scotland/Great Britain, died in 1848 in St Andrews, Scotland/Great Britain. David Octavius Hill: born in 1802 in Perth, Scotland/Great Britain, died in 1870 in Edinburgh, Scotland/Great Britain. Robert Adamson trained as a technician and engineer, and produced numerous portrait photographs together with the painter David Octavius Hill. Their collaboration began in 1843 and was based on the commission to make a painting of the Free Church movement in Edinburgh. The photographs from the years 1843 to 1848, and that of the Greyfriars Cemetery, are all considered works by both artists. From 1843 Adamson and Hill lived in the same house and created over 3,000 joint photographic works and published a joint photography portfolio. They exhibited together until Adamson's death in 1848. After this, Hill continued his photographic work alone. Although the two artists are rated differently in the literature, common authorship is listed for all works executed during the time they worked together.

Die Aufnahme *Greyfriars Churchyard* ist in mehreren Varianten bekannt, darunter die als *Der Künstler und der Totengräber. David Octavius Hill und seine Nichten Misses Watson und ein unbekannter Mann vor dem Dennistoun-Grabmal auf dem Friedhof Greyfriars, Edinburgh* bekannte Version. Auf der vorliegenden Fotografie ist also der Maler Hill mit seinen beiden Nichten abgebildet. Komposition und Situation sind dennoch als Gemeinschaftsarbeit Hills und Adamsons anzuerkennen. Die symbolhaft-romantische Situierung der Szene am Grabmal des königlichen schottischen Gesandten in den Niederlanden des beginnenden 17. Jahrhunderts steht für die Gegenwärtigkeit des Todes in einer Phase der Unsicherheiten und der Umbrüche, wie sie zur Entstehungszeit der Fotografie, im viktorianischen Zeitalter, allenthalben zu spüren waren.

The photograph of Greyfriars Churchyard is known in several variants, including the one kown as *The Artist and The Gravedigger. David Octavius Hill, his nieces, the Misses Watson, and an unknown man in front of the Dennistoun monument in the Greyfriars Cemetery, Edinburgh.* The painter Hill is pictured in this photograph with his two nieces. Composition and situation are nevertheless recognized as a joint work of Hill and Adamson. The symbolic and romantic situating of the scene at the tomb of the royal Scottish ambassador to the Netherlands in the early seventeenth century stands for the reality of death in a period of uncertainty and upheaval, as was felt everywhere in this formative time of photography in the Victorian era.

Literatur/Further reading: Bodo von Dewitz und/and Karin Schuller-Procopovici, *David Octavius Hill & Robert Adamson. Von den Anfängen der künstlerischen Photographie im 19. Jahrhundert* (Ausst.-Kat./exh. cat. Museum Ludwig, Köln/Cologne), Göttingen 2000

Robert Adamson & David Octavius Hill
Sir Robert Dennistoun's Tomb
Greyfriars Churchyard, Edinburgh, 1843
Kalotypie/Salzpapier/calotype/salt print

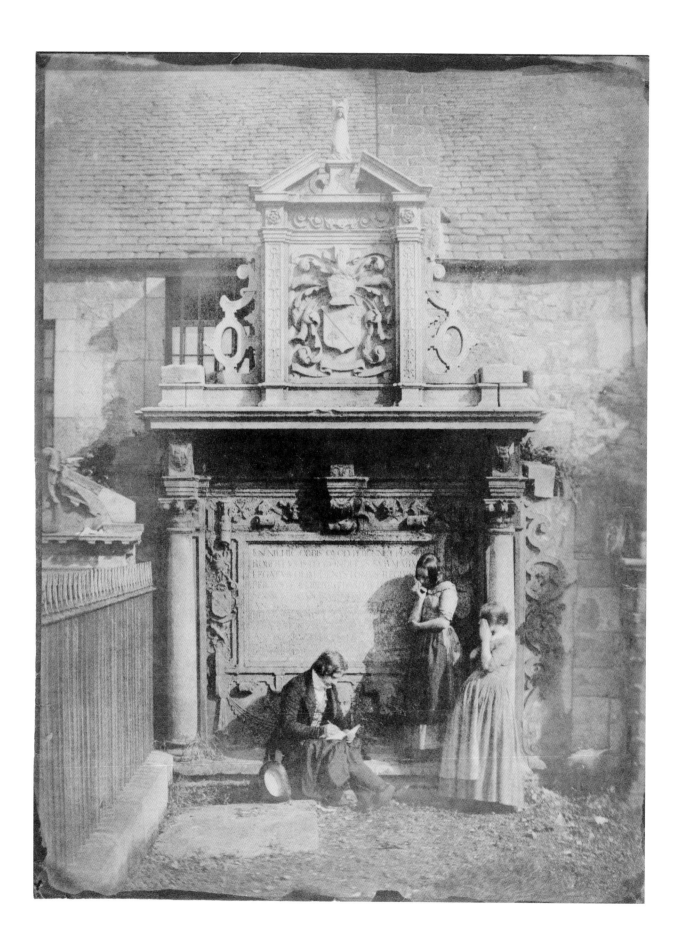

Frank Meadow Sutcliffe

Geboren 1853 in Headingley/Großbritannien, verstorben 1941 in Whitby/Großbritannien. Frank Meadow Sutcliffe erhielt seine allgemeine Schulbildung an einer Dame School und beschäftigte sich dann mit der damals neuen Technologie der Fotografie. 1875 eröffnete er ein Studio in Whitby in der Grafschaft North Yorkshire. Seinen Lebensunterhalt verdiente er als Porträtfotograf, seine Liebe galt allerdings dem Fotografieren der einfachen Menschen in seiner unmittelbaren Umgebung, der Kinder, Fischer und Arbeiter. Mit diesen Fotografien schuf er ein aufschlussreiches Bild des spätviktorianischen Zeitalters. 1922 gab er die Fotografie auf, arbeitete als Bibliothekar und Autor und schrieb eine regelmäßige Kolumne in der *Yorkshire Weekly Post*. 1935 wurde er Ehrenmitglied der Royal Photographic Society.

Das berühmteste Foto Frank Meadow Sutcliffes trägt den Titel *Water Rats* und zeigt Kinder, die im flachen Wasser rund um Fischerboote spielen. Den Fotografen interessierten immer wieder die Hafengegend von Whitby, das Leben der Fischer und ihrer Kinder und deren Alltag. Sutcliffe hielt diese Einblicke mit seiner umständlichen Holz-Messing-Kamera auf Glasplatten fest und arbeitete für jedes einzelne Foto an einer ausgeklügelten Komposition. Seine Prints sind trotz der Banalität der Motive sorgsam hergestellt und zeichnen sich durch abgestufte, weiche Schattierungen aus. Aus dem motivischen Umfeld der spielenden »Wasserratten« stammt auch der Blick auf die über die Hafenmauer spähenden Kinder.

Literatur/Further reading: *Frank Meadow Sutcliffe* (The History of Photography, Bd./vol. 13), mit einer Einleitung von/with an introduction by Michael Hiley, New York 1979

Born in 1853 in Headingley/Great Britain, died in 1941 in Whitby/Great Britain. Frank Meadow Sutcliffe received his elementary education at a Dame school and then became involved with the new technology of photography. In 1875 he opened a studio in Whitby in the county of North Yorkshire. He earned his living as a portrait photographer, but his heart was in photographing ordinary people in his immediate surroundings – children, fishermen and labourers. He created a revealing picture of the late Victorian era with these photographs. In 1922 he gave up photography and worked as a librarian and author and wrote a regular column in the *Yorkshire Weekly Post*. In 1935 he became an honorary member of the Royal Photographic Society.

Frank Meadow Sutcliffe's most famous photograph is entitled *Water Rats* and shows children playing around fishing boats in shallow water. The photographer was always interested in the harbour area of Whitby, the fishermen and their children and their everyday lives. Sutcliffe recorded these insights with his cumbersome wood camera on glass plates and worked out sophisticated compositions for each and every photograph. Despite the banality of the subject matter, his prints are carefully made and are characterized by layered, soft hues. The view of children peeking over the harbour wall also comes from the thematic environment of the playing "water rats".

Frank Meadow Sutcliffe
Expectation, 1888/89
Albuminprint/albumen print

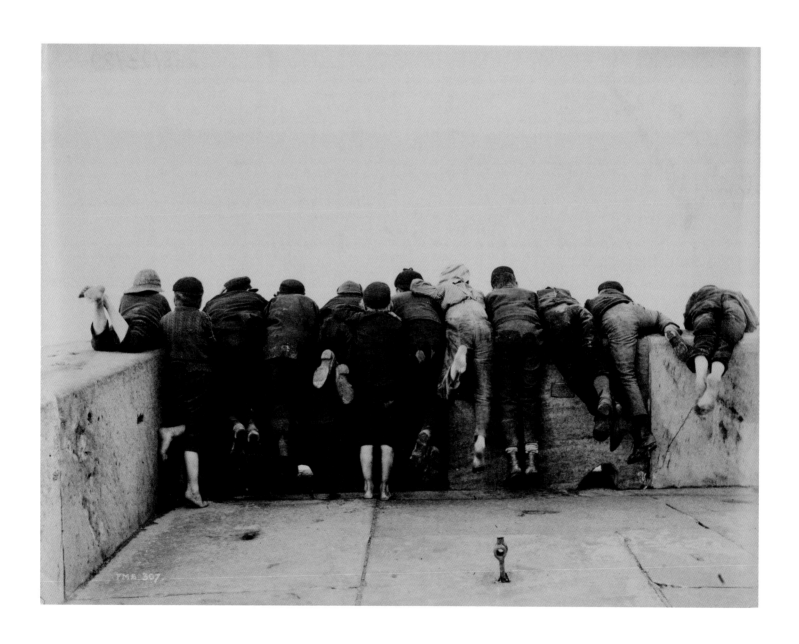

Lewis Carroll

Geboren 1832 als Charles Lutwidge Dodgson in Daresbury, Cheshire/Großbritannien, verstorben 1898 in Guildford, Surrey/Großbritannien. Ab 1850 studierte Charles Lutwidge Dodgson Mathematik und Logik in Oxford. Er war fantasiebegabt und hatte ein Talent für Wortspiel und Logik, was ihn zu einem berühmten Kinderbuchautor machte. 1856 nahm er den Künstlernamen Lewis Carroll an. Sein Roman *Alice in Wonderland* erschien 1865. Seine erste Kamera erwarb Carroll 1856 und richtete sich 1872 ein Atelier auf dem Dach seines Hauses ein, wo er sich mit dem Medium Fotografie als Kunst beschäftigte und mehr als 3000 Bilder schuf, meist fantasievolle und erotisch angehauchte Kinderporträts. Er war aktiv im Oxford University Photographic Club sowie im Oxford Literary Photographic Club.

Lewis Carrolls Modelle waren meist Mädchen aus seinem Bekanntenkreis, mit denen ihn Freundschaften verbanden, wie etwa mit Alice Liddell und ihren Schwestern, die Töchter des Vizekanzlers der Universität Oxford waren, oder mit den Töchtern von Reverend Kitchin, Alexandra – »Xie« – und ihrer jüngeren Schwester Dorothy, welche jedoch nur sehr selten in den Porträtserien auftaucht. Carroll äußerte sich in seinen Briefsammlungen und Tagebüchern zu seinen Neigungen, auch wenn er sie nie lebte. Die meisten seiner Kinderporträts entstanden von 1856 bis 1880, dem Jahr, in dem seine fotografische Tätigkeit abrupt endete.

Literatur/Further reading: Douglas R. Nickel, *Dreaming in Pictures. The Photography of Lewis Carroll* (Ausst.-Kat./exh. cat. San Francisco Museum of Modern Art, Houston Museum of Fine Arts u.a./and others), New Haven und/and London 2002

Born in 1832 as Charles Lutwidge Dodgson in Daresbury, Cheshire/Great Britain, died in 1898 in Guildford, Surrey/Great Britain. In 1850 Charles Lutwidge Dodgson studied mathematics and logic at Oxford. He was imaginative and had a talent for wordplay and logic, which made him into a famous author of children's books. In 1856 he took the pseudonym Lewis Carroll. His novel *Alice in Wonderland* was published in 1865. Carroll bought his first camera in 1856 and in 1872 he set up a studio on the roof of his house, where he worked with the medium of photography as art and created more than 3,000 images, mostly imaginative and erotically themed children's portraits. He was active in the Oxford University Photographic Club and the Oxford Literary Photographic Club.

Lewis Carroll's models were mostly girls from a circle of acquaintances with whom he was close friends, such as Alice Liddell and her sisters, the daughters of the Vice Chancellor of Oxford University and the daughters of Reverend Kitchin, Alexandra – "Xie" – and her younger sister Dorothy, who rarely appeared in the portrait series. Carroll commented on his inclinations in his collections of letters and diaries, even if he never acted on them. Most of his portraits of children originated in the years 1856 to 1880, the year in which his photographic activity abruptly broke off.

Lewis Carroll
Dorothy Kitchin Lying on a Sofa, 1869
Albuminprint/albumen print

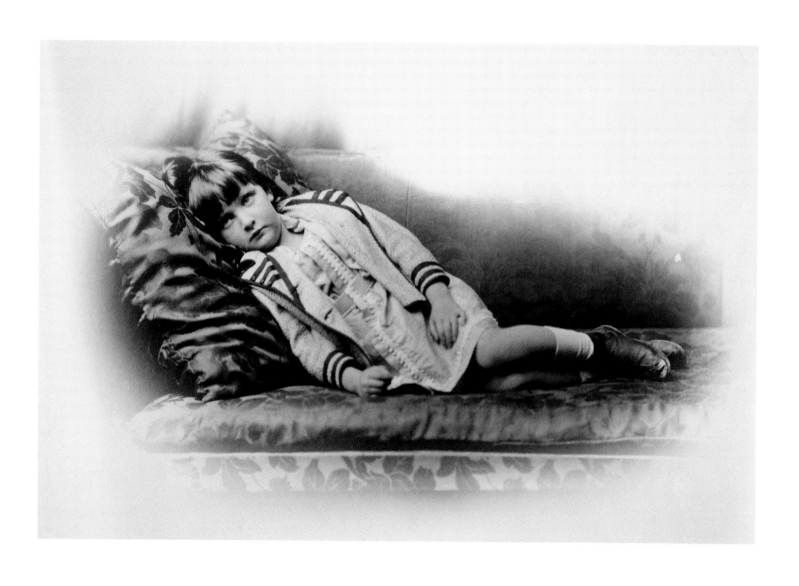

Nadar

Geboren 1820 in Paris/Frankreich, mit bürgerlichem Namen Gaspard-Félix Tournachon, verstorben 1910 in Paris. Nach einem abgebrochenen Medizinstudium in Lyon kehrte Nadar 1839 nach Paris zurück, wo er als Zeichner und Journalist tätig war und 1849 die *Revue comique* gründete. 1854 eröffnete er ein Studio für Porträtfotografie. Er pflegte Freundschaften mit bedeutenden Schriftstellern und Künstlern, deren Porträts 1854 im *Panthéon Nadar*, einer umfassenden lithografierten Mappenedition, erstmals publiziert wurden. In den folgenden Jahren entstanden Hunderte von Porträts von Persönlichkeiten aus Kultur, Wissenschaft, Politik und Gesellschaft, vielfach herausgegeben und publiziert von Verlagen wie der Galerie contemporaine, die zwischen 1876 und 1884 die Edition eines Konvoluts von 241 seiner bedeutendsten Porträts besorgte. Ab 1859 fertigte Nadar auch Luftaufnahmen an, wofür er aus einem Fesselballon heraus fotografierte. Von 1895 bis 1904 unterhielt er ein Studio in Marseille. 1899 erschienen seine Memoiren mit Rückblicken auf seine fotografische Tätigkeit.

Born in 1820 as Gaspard-Félix Tournachon in Paris/France, died in Paris in 1910. After discontinuing his medical studies in Lyon, Nadar returned to Paris in 1839, where he worked as an illustrator and journalist and founded the *Revue comique* in 1849. In 1854 he opened a studio for portrait photography. He formed friendships with important writers and artists, whose portraits he first published in 1854 in *Panthéon Nadar*, a comprehensive lithographic portfolio edition. In the following years, he created hundreds of portraits of celebrities from the worlds of culture, science, politics and society that were often issued and edited by publishers such as Galerie contemporaine, which was responsible for the edition of a collection of 241 of his most important portraits between 1876 and 1884. From 1859 Nadar also produced aerial photographs, which he took from a moored balloon. From 1895 to 1904 he maintained a studio in Marseille. In 1899 he published his memoirs, which looked back on his photographic work.

Nadar war der erste Fotograf, der eine eigens auf das Fotografische zugeschnittene Ästhetik einführte: Seine Porträts kommen ohne Attribute und Draperien aus, sie weisen einen planen, einfachen Hintergrund auf und modellieren die porträtierte Person mittels Licht und Körperpose. Das von ihm angewandte Kollodiumverfahren für seine Glasplattennegative garantierte eine satte Tonigkeit bei gleichzeitiger Schärfe in der Zeichnung. Die Schriftstellerin George Sand (1804–1876), ehemals Revolutionärin und erklärte Kämpferin für die Gleichstellung der Frau, wird hier auf einem Blatt des Kompendiums der Galerie contemporaine im Alter von sechzig Jahren gezeigt. Sie präsentiert sich abgeklärt und mit milder Kopfneigung und ist dennoch monumental ins Bild gesetzt.

Nadar was the first photographer to introduce an aesthetic especially tailored to photography. His portraits do without characteristic attributes and draperies; they have a designed, simple background and model the person portrayed by means of light and body pose. The collodion process he used for his glass-plate negatives guaranteed a lush tonality with simultaneous sharpness in the outlines. The writer George Sand (1804-1876), a former revolutionary and professed campaigner for the equality of women is shown here at the age of sixty on a sheet from the edition of the Galerie contemporaine. She looks serene, with a slight tilt of the head, but still presents herself in a monumental way.

Literatur/Further reading: Nigel Gosling, *Nadar. Photograph berühmter Zeitgenossen. 330 Bildnisse aus der Hauptstadt des 19. Jahrhunderts*, München/Munich 1977

Nadar
George Sand, 1864
Karbonprint/Woodburytype

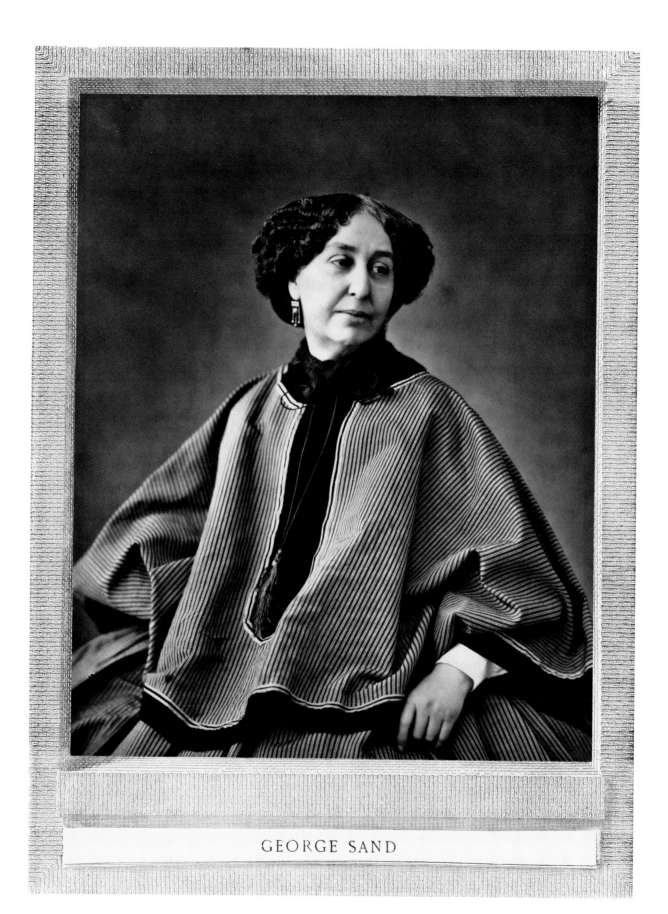

GEORGE SAND

Julia Margaret Cameron

Geboren 1815 als Julia Margaret Pattle in Kalkutta/Indien, verstorben 1879 in Kalutara/heutiges Sri Lanka. Nach den Jugendjahren, in denen sie eine Erziehung in Frankreich genoss, kehrte sie 1834 wieder in die britische Kolonie Indien zurück und heiratete dort vier Jahre später Charles Hay Cameron. 1848 übersiedelte die Familie nach London und unterhielt einen Landsitz auf der Isle of White. Julia Margaret Cameron begann – nach vielen Jahren eines großbürgerlichen Lebens als Hausfrau und Mutter – im Alter von 48 Jahren zu fotografieren, nachdem sie über ihre Freunde aus Wissenschaft und Kunst von dem neuen Verfahren gehört hatte. 1864 wurde sie in die Royal Photographic Society aufgenommen. 1875 zogen die Camerons nach Ceylon, dem heutigen Sri Lanka, wo die inzwischen sehr anerkannte Fotografin bis zu ihrem Tod lebte.

Bezeichnend für das fotografische Werk von Julia Margaret Cameron ist der auf den technischen Möglichkeiten des ausgehenden 19. Jahrhunderts basierende malerisch-weiche Stil. Er erforderte lange Belichtungszeiten und somit von den Modellen völlige Bewegungslosigkeit, von der Fotografin hohe Konzentration und überlegtes Vorgehen. Cameron gab der Bildnisfotografie den Vorzug: Sie legte den Fokus auf das Gesicht und die Mimik des Porträtierten und verzichtete auf Staffage oder attributives Beiwerk. Ihrer persönlichen religiösen Einstellung entsprechend ging es ihr um ein seelenvolles, emotional geprägtes Bild, oft in einem spirituell angelegten Kontext. Ihre Nichte Julia (1846–1895), verheiratet mit Herbert Duckworth, zeigt sie in piktorialistischer Manier als mildes, zart gezeichnetes weibliches Porträt, sinnend und sehend gleichermaßen. Eine Tochter Julias aus ihrer zweiten Ehe war die spätere Schriftstellerin Virginia Woolf.

Born in 1815 as Julia Margaret Pattle in Calcutta/India, died in 1879 in Kalutara/present-day Sri Lanka. After her teenage years, in which she enjoyed an education in France, she returned to the British colony of India in 1834 and married Charles Hay Cameron there four years later. In 1848 the family moved to London and maintained a country estate on the Isle of Wight. After many years of an upper-class life as a housewife and mother, Julia Margaret Cameron began to photograph at the age of 48 after hearing from her friends in science and art about the new procedures. She was admitted to the Royal Photographic Society in 1864. In 1875 the Camerons moved to Ceylon, present-day Sri Lanka, where the now highly acclaimed photographer lived until her death.

The soft Pictorialist style based on the technical possibilities of the late nineteenth century is characteristic of the photographic work of Julia Margaret Cameron. The process required long exposure times and thus the complete immobility of the models, along with the complete concentration of the photographer and a well-thought-out approach. Cameron preferred portrait photography: she put the focus on the face and facial expressions of the people portrayed and did away with accessories and other features. In accordance with her personal religious beliefs, she created soulful, emotionally shaped pictures, often set in a spiritual context. She shows her niece Julia (1846–1895), married to Herbert Duckworth, in a Pictorialist style with a mild and tenderly designed female portrait, meditating and beholding at the same time. The writer Virginia Woolf was one of Julia's daughters from her second marriage.

Literatur / Further reading: Helmut Gernsheim, *Julia Margaret Cameron. Her Life and Photographic Work*, New York 1975

Julia Margaret Cameron
Mrs. Herbert Duckworth, 1872
Albuminabzug / albumen print

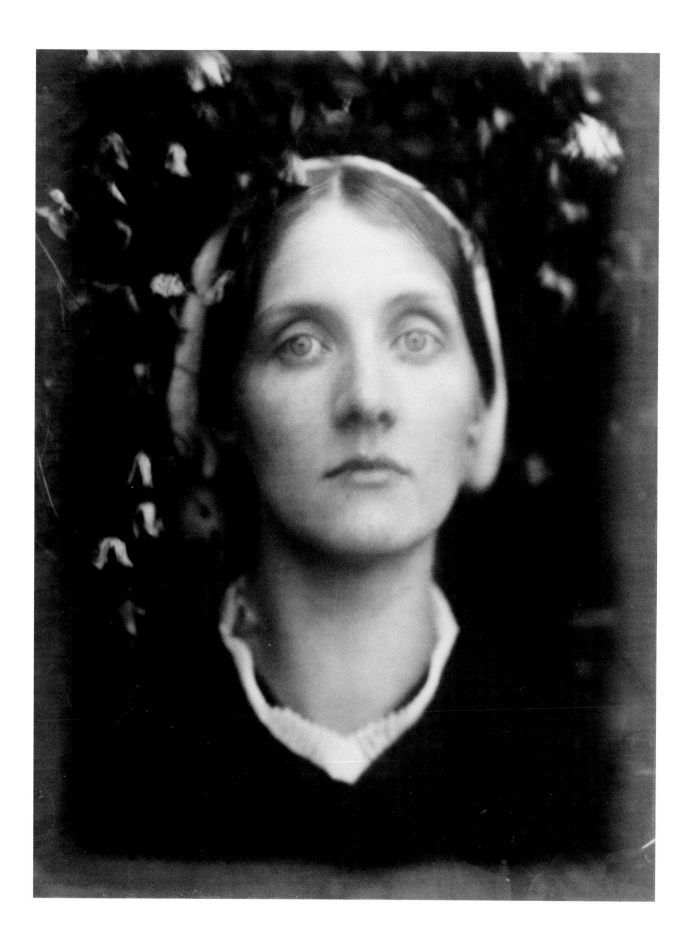

Maxime Du Camp

Geboren 1822 in Paris/Frankreich, verstorben 1894 in Baden-Baden/Deutschland. Der 1848 in der Pariser Februarrevolution politisch aktive Journalist und Amateur-Fotograf Maxime Du Camp bereiste die Länder des Orients. Von 1849 bis 1851 unternahm er im Auftrag der Regierung eine Expedition nach Ägypten und Nubien, auf der er von Gustave Flaubert begleitet wurde. Später war er hauptsächlich als Schriftsteller und Herausgeber tätig und wurde 1880 in die Académie française aufgenommen. Seine Reiseschilderungen – darunter das Kompendium *Égypte, Nubie, Palestine et Syrie* von 1852 – gehören zu den frühesten Büchern, die mit Fotografien illustriert waren.

Born in 1822 in Paris/France, died in 1894 in Baden-Baden/Germany. Politically active in the 1848 Parisian February Revolution, the journalist and amateur photographer Maxime Du Camp travelled to countries in the Orient. From 1849 to 1851 he undertook an expedition on behalf of the government to Egypt and Nubia, accompanied by Gustave Flaubert. He later worked mainly as a writer and editor and was admitted to the Académie française in 1880. His travel descriptions – including the compendium *Égypte, Nubie, Palestine et Syrie* from 1852 – were among the earliest books illustrated with photographs.

Auf der Expedition nach Ägypten und Nubien entstanden zahlreiche Aufnahmen von Tempelbauten, darunter die als *Vue générale* betitelte Aufnahme der Tempelanlage des antiken Pselchis, des heutigen ad-Dakka, die dem Kompositgott Thoth von Pnubs geweiht war, eine ursprünglich ägyptische Mond-Gottheit mit Anklängen an den römischen Götterboten Hermes. Dem ptolemäischen Tempel wurde in römischer Zeit im Westen ein Pylonenbau angefügt, der Du Camps Aufnahme dominiert. Flaubert beschreibt den Bau in seinem Reisetagebuch ganz genau und weist auch auf die rätselhafte senkrechte Öffnung zwischen den Pylonenteilen hin. Der Tempel wurde 1961 im Zuge der Errichtung des Assuan-Staudamms nach Wadi as-Subu versetzt. Die als Blatt 94 bezeichnete Fotografie wurde einem Exemplar von *Égypte, Nubie, Palestine et Syrie*, veröffentlicht bei Gide et Baudry Editeurs, entnommen.

On the expedition to Egypt and Nubia he took numerous photographs of temples, including the photograph entitled *Vue générale* of the temple complex of ancient Pselchis, now Dakka, dedicated to the composite god Thoth of Pnubs, originally an Egyptian moon deity reminiscent of the Roman messenger-god Hermes. A pylon construction was added to the western part of the Ptolemaic temple in Roman times, dominating Du Camp's photographs. Flaubert very carefully describes the construction in his travel diary and also alludes to the mysterious vertical opening between the pylon sections. The temple was moved to Wadi al-Subu in 1961 during the construction of the Aswan Dam. The photograph called Sheet 94 was taken from a copy of *Égypte, Nubie, Palestine et Syrie*, published by Gide et Baudry Editeurs.

Literatur/Further reading: Gustave Flaubert, *Reisetagebuch aus Ägypten*, Zürich 2003/Gustave Flaubert, *Flaubert in Egypt*, London 1972

Maxime Du Camp
Vue générale du Temple de Dakkeh, 1850
Salzpapierabzug nach Papiernegativ/
salted paper print from paper negative

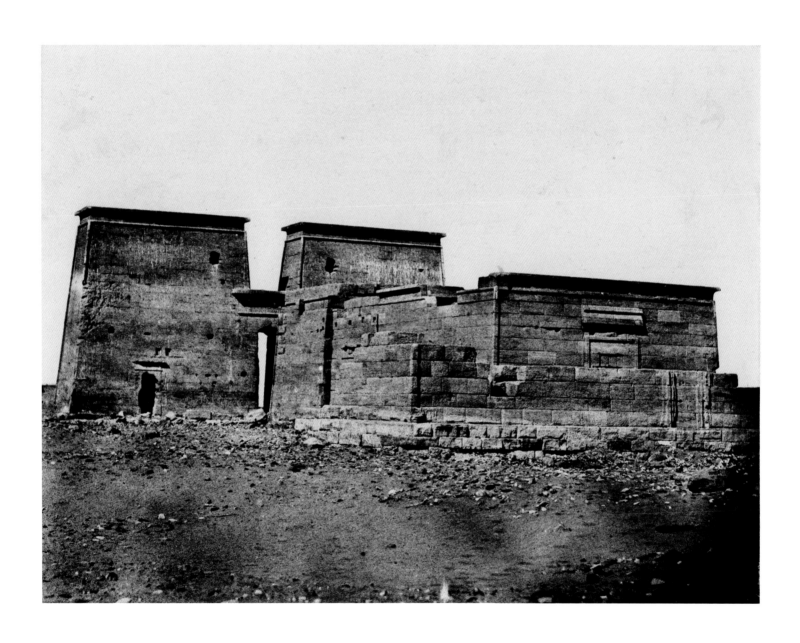

Francis Frith

Geboren 1822 in Chesterfield/Großbritannien, verstorben 1898 in Cannes/Frankreich. Francis Frith eröffnete in Liverpool ein Fotostudio, das er aber nach kurzer Zeit verkaufte, um sich Dokumentationsreisen widmen zu können. Diese führten ihn 1856 und 1857 nach Ägypten und 1858 sowie 1859 nach Palästina und Syrien. Zur Publikation seiner fotografischen Arbeiten gründete er in England seinen eigenen Verlag, der bald – unter anderem durch den Vertrieb von Ansichtskarten – zu einem der größten der Welt wurde. 1872 wurde er Reformpriester der Quäkergemeinde und zog sich in den 1880er-Jahren nach Südfrankreich zurück, um seine Memoiren zu schreiben.

Die Stadtansicht von Kairo hatte er auf seiner Ägyptenreise angefertigt und im Jahr darauf vom Glasnegativ geprintet. Diese Fotografie ist das Blatt 15 aus dem frühesten der Orient-Alben, Signatur und Datierung sind von 1858. Die Druckbogen bei diesen zwanzig Originalfotografien sind mit 75 x 50 cm sehr groß. Das Konvolut *Egypt, Sinai and Jerusalem* wurde um 1860, jedenfalls nach 1858, in London verlegt. Frith war von der Begeisterung für den Exotismus erfüllt, die besonders in England und Frankreich im ausgehenden 19. Jahrhundert verbreitet war. Dennoch dachte er stets auch an die Verwertbarkeit seiner Motive, die von F. Frith & Co. in unterschiedlichen Formaten, Zusammenstellungen und Bindungen weltweit vertrieben wurden.

Born in 1822 in Chesterfield/Great Britain, died in 1898 in Cannes/France. Francis Frith opened a photography studio in Liverpool, which he sold after a short time to devote himself to documenting travel. This took him to Egypt in 1856 and 1857 and to Palestine and Syria in 1858 and 1859. To publish his photographic work, he established his own publishing company in England, which soon – in part through the sale of postcards – became one of the largest in the world. In 1872 he became a minister in the Quaker community and then returned to southern France in the 1880s to write his memoirs.

He took this photograph of a street view of Cairo on his trip to Egypt and printed it from a glass negative in the following year. This photograph is Sheet 15 of the earliest of the Orient albums and is signed and dated 1858. The printed sheets for these twenty original photographs are very large at 75 x 50 cm. The selection *Egypt, Sinai and Jerusalem* was published in London in around 1860, in any case after 1858. The enthusiasm for exoticism so prevalent in England and France in the late nineteenth century sustained Frith. Nevertheless, he always also considered the usefulness of his motifs, which F. Frith & Co. distributed in different sizes, compilations and bindings throughout the world.

Literatur/Futher reading: Douglas Robert Nickel, *Francis Frith in Egypt and Palestine. A Victorian Photographer Abroad*, Princeton/New Jersey 2004

Francis Frith
Street View in Cairo, 1857
Albuminabzug/albumen print

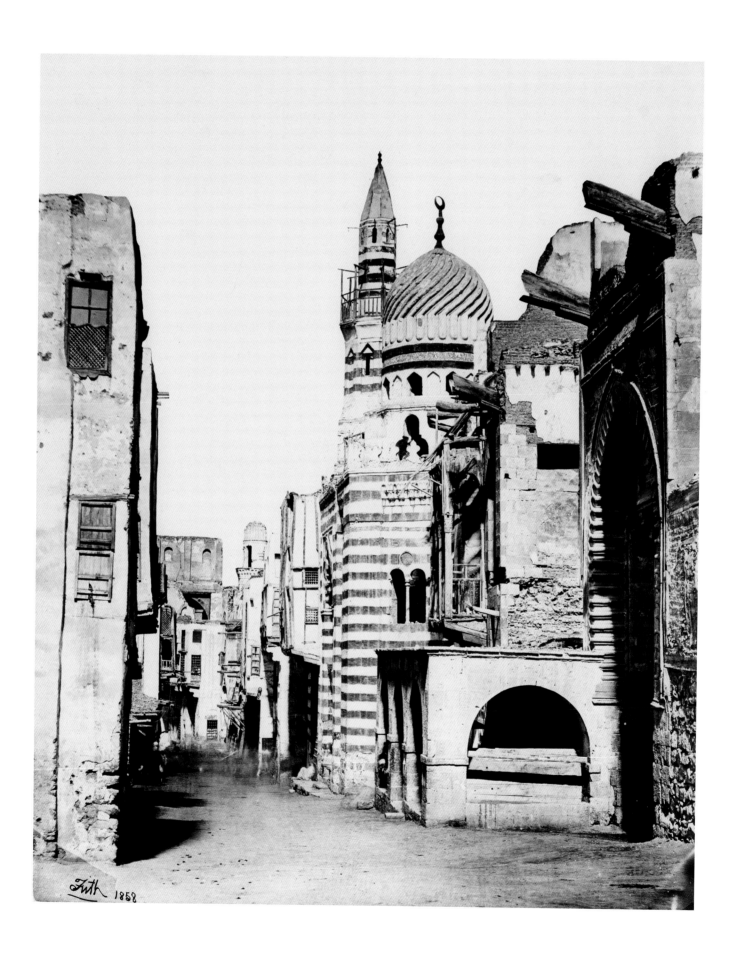

Felice und/and Antonio Beato

Felice Beato: geboren 1832 in Venedig/Italien, verstorben 1909 in Florenz/Italien. Antonio Beato: geboren 1824 in Venedig/Italien, verstorben 1906 in Luxor/Ägypten. Als Kinder kamen die Brüder Beato mit ihrer Familie ins britische Protektorat Korfu. Ab 1844 lebte Felice in Konstantinopel und startete ab 1853 die Zusammenarbeit mit dem britischen Fotografen James Robertson, an der auch sein Bruder Antonio beteiligt war. Ab 1860 waren die Brüder britische Staatsbürger. Bekannt wurde Felice durch seine Fotografien von diversen Kriegsschauplätzen, unter anderem vom Krimkrieg, sowie durch seine umfangreiche Reisefotografie, wie sie etwa 1857 in Griechenland, Jerusalem und Indien entstand. 1860 schloss er sich während des zweiten Opiumkriegs einer Militärexpedition nach China an. Die Jahre von 1863 bis 1884 verbrachte er in Japan, wo die berühmten Fotos der Vorläuferstadt von Tokio, Edo, entstanden. Seine Fotos sind rare Dokumente aus einem damals in Europa unbekannten Land, da Japan sich in der Edo-Zeit völlig abgeschottet hatte. 1884 verließ er Japan und reiste nach Ägypten und in den Sudan. Sein letzter Aufenthalt war Birma, wo er bis 1899 ein Fotostudio unterhielt. Danach beendete er seine fotografische Tätigkeit. Sein Bruder Antonio hatte in den 1860er-Jahren ein Fotostudio in Ägypten eröffnet, wo er bis zu seinem Tod tätig blieb.

Felice Beato: born in 1832 in Venice/Italy, died in 1909 in Florence/Italy. Antonio Beato: born in 1824 in Venice/Italy, died in 1906 in Luxor/Egypt. As children, the Beato brothers went with their family to the British protectorate of Corfu. From 1844, Felice lived in Constantinople and in 1853 started working with the British photographer James Robertson, who also worked with his brother Antonio. The brothers became British citizens in 1860. Felice was known for his photographs of various theatres of war, including the Crimean War, and for his extensive travel photography, for instance his trip in 1857 to Greece, Jerusalem and India. In 1860 he joined a military expedition to China during the Second Opium War. He spent the years 1863 to 1884 in Japan, where he took the famous photographs of Tokyo's precursor: the city of Edo. His photographs are rare documents from a country that was unknown in Europe at that time, as Japan was completely sealed off in the Edo period. In 1884 he left Japan and travelled to Egypt and Sudan. His last stay was in Burma, where he ran a photography studio until 1899. After this, he finished his photographic work. His brother Antonio opened a photo studio in the 1860s in Egypt, where he remained active until his death.

Die intensive Reisetätigkeit vor allem im Nahen und Fernen Osten und die geschäftsmäßige Kooperation mit seinem Bruder Antonio erschwerten die eindeutige Zuordnung des Werkes von Felice Beato. Antonio fotografierte durch sein Fotostudio in Ägypten große Konvolute von Ausgrabungen und historischen Stätten und bezeichnete, wie auch Felice, seine Arbeiten mit beiden Namen. Die Aufnahmen des großen Säulenhofes in der oberägyptischen Tempelanlage von Karnak dürfte damit ein Werk von Antonio sein, obwohl es die Signatur Felice A. Beato trägt. Bis in die 1980er-Jahre hatte man generell fälschlich angenommen, dass es sich dabei um nur eine Person handle.

The extensive travels, especially in the Middle and Far East, and the business-like cooperation with his brother Antonio, made it difficult to clearly identify the work of Felice Beato. Working in his photo studio in Egypt, Antonio took many photographs of large excavations and historical sites and, like Felice, designated his work with both names. The photographs of the great pillars of the court in the Upper Egyptian temple of Karnak are therefore likely to be the work of Antonio, although they bear the signature Felice A. Beato. Until the 1980s, it was generally and incorrectly assumed that this referred to only one person.

Literatur/Futher reading: Paolo Costantini und/and Italo Zannier, *Verso Oriente. Fotografie di Antonio e Felice Beato,* Florenz/Florence 2010

Felice und/and Antonio Beato
Karnak. Grandes Colonnes du Milieu, 1894/95
Albuminabzug/albumen print

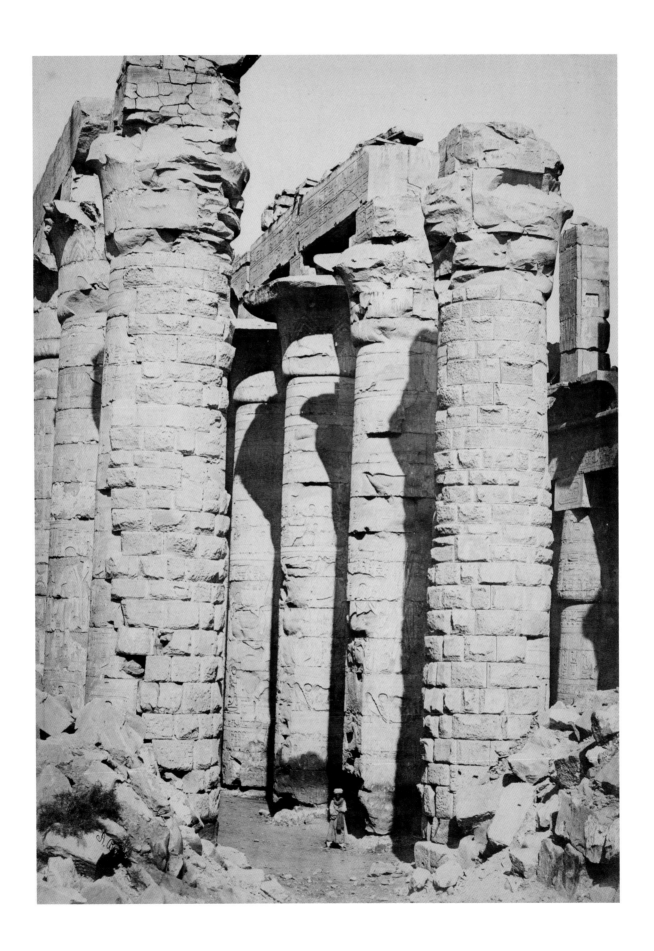

Alvin Langdon Coburn

Geboren 1882 in Boston/USA, verstorben 1966 in Rhos-on-Sea, Nordwales/Groß-britannien. Schon früh hatte Coburn zu fotografieren begonnen. Nach zweijähriger Mitgliedschaft in Alfred Stieglitz' Photo-Secession in New York konnte Coburn schon 1904 erste Arbeiten in *Camera Work* veröffentlichen. Auf vielen Reisen ent-stand sein renommiertes fotografisches Œuvre. 1912 übersiedelte er nach England und hatte dort Kontakt zu Ezra Pound und den Vortizisten, die ihm einen Weg in die Spiritualität öffneten. Abstrahierende und kubistisch wirkende Fotoexperi-mente begleiteten diesen Lebensabschnitt. Gleichsam als Fotograf in Vergessenheit geraten, zerstörte Coburn viele seiner Glasnegative am Ende seines Lebens.

Seine dem Piktorialismus zuzuordnenden Städtebilder und Porträts machten den erst Zwanzigjährigen berühmt. Die Fotografien der Jahre von 1903 bis 1915 sind fast ausschließlich in der für die Ver-vielfältigung probaten Technik der Fotogravüre gefertigt, wie auch seine London-Veduten, welche ein weiches, atmosphärisches Bild der Großstadt zeigen. Coburn wurde geschätzt für seine malerischen Valeurs und seine ungewöhnlichen Perspektiven. Eine Fülle von Publikationen transportierte diese Sicht und diese kunstsinnige Art von Fotografie.

Literatur/Further reading: Karl Steinorth, *Alvin Langdon Coburn. Fotografien 1900–1924*, Kilchberg 1998

Born in 1882 in Boston/USA, died in 1966 in Rhos-on-Sea, North Wales/Great Brit-ain. Coburn began to take photographs early on. After two years of membership in Alfred Stieglitz's Photo-Secession group in New York, Coburn was able to publish his first works in *Camera Work* in 1904. His renowned photographic oeuvre origi-nated on his many trips. In 1912 he moved to England and made contact with Ezra Pound and the Vorticists, who opened up a path to spirituality for him. Abstraction and Cubist photography experiments accompanied this stage of his life. Acting like a photographer who had faded into obscurity, Coburn destroyed many of his glass negatives at the end of his life.

His cityscapes and portraits attributable to Pictorialism made him famous in his early twenties. The photographs from the years 1903 to 1915 are almost exclusively produced in the tried and tested tech-nique of photogravure used for publication, as are his London vistas that show a soft, atmospheric image of the city. Coburn was valued for his pictorial *valeurs* and his unusual perspectives. A large number of publications conveyed this view and this art-minded approach to photography.

Alvin Langdon Coburn
London. Trafalgar Square, 1903
Fotogravüre/photogravure

Eugène Atget

Geboren 1857 in Libourne/Frankreich, verstorben 1927 in Paris/Frankreich. Atget arbeitete als Schauspieler, bevor er ab 1897 mit einer Großformatkamera die Straßen und Plätze von Paris fotografierte, wobei die Serien *Paris pittoresques* und *Le vieux Paris* entstanden. 1906 und 1907 fertigt er im Auftrag der Bibliothèque Historique de la Ville de Paris eine systematische Bestandsaufnahme der historischen Gebäude von Paris an. 1915 erwarben die Bibliothèque Nationale und das Musée Carnavalet große Konvolute seiner Fotografien. Die amerikanische Fotografin Berenice Abbott war in den 1920er-Jahren als Assistentin von Man Ray in Paris und besuchte Atget im Jahr 1925. Nach Atgets Tod erstellte sie fotografische Editionen seiner Werke, deren erste das Album *Photographe de Paris* von 1930 ist.

Born in 1857 in Libourne/France, died in 1927 in Paris/France. Atget worked as an actor before he started photographing the streets and squares of Paris using a large-format camera in 1897, which resulted in the series *Paris pittoresques* and *Le vieux Paris*. Between 1906 and 1907 he made a systematic inventory of the historic buildings of Paris for the Bibliothèque Historique de la Ville de Paris. In 1915 the Bibliothèque Nationale and the Musée Carnavalet acquired large numbers of his photographs. The American photographer Berenice Abbott was in Paris in the 1920s as an assistant to Man Ray and visited Atget in 1925. After Atget's death, she created photographic editions of his works, the first of which is the album *Photographe de Paris* from 1930.

Le Centaure Nessus enlevant Déjanire ist eine Skulpturengruppe des französischen Bildhauers Laurent Honoré Marqueste aus dem Jahr 1892. Sie wurde für die auf antikisierenden Themen basierende skulpturale Ausgestaltung des Tuilerien-Gartens geschaffen. Die kompliziert aufgebaute Gruppe aus zwei mythologischen Wesen stellt den Moment dar, in dem der Zentaur Nessos die Frau des Herakles, Deianeira, in die Höhe hebt und zu rauben versucht. Atget wählte die dramatische Perspektive von der Rückseite der Skulptur mit angeschnittenem Sockel, um gleichsam die ans Manieristische erinnernde *figura serpentinata* zu evozieren. Atget betätigte sich ab 1909 auch als Verleger seiner eigenen Fotoarbeiten und gab diverse Alben heraus, die thematisch organisiert waren. Davon waren etliche Parkmotiven gewidmet: Das früheste Album von 1901/02 galt Versailles; aus dem Jahr 1911 stammen zahlreiche Aufnahmen der Tuilerien, darunter Figurengruppen aus dem Grand Carré, in dem sich auch die Nessos-Gruppe befindet. Vermutlich ist diese Aufnahme daher ebenfalls in das Jahr 1911 zu datieren.

Le Centaure Nessus enlevant Déjanire is a group of sculptures by French sculptor Laurent Honoré Marqueste from 1892. It was created for the sculptural designs in the Tuileries Gardens based on classical themes. The grouping of the complicated structure of two mythological beings represents the moment in which the centaur Nessus lifts the wife of Hercules, Deianeira, in the air and tries to steal her away. Atget chose the dramatic perspective of the back of the sculpture with a truncated base to evoke the *figura serpentinata* reminiscent of Mannerism. Atget was also active as publisher of his own photographs starting in 1909, and published several thematically organized albums. Some of these were dedicated to park motifs. The earliest album of 1901/02 was dedicated to Versailles; dating back to 1911 are numerous photographs of the Tuileries, including groups of figures from the Grand Carré, where the Nessus group is also found. Presumably, this photograph therefore also dates to 1911.

Literatur/Further reading: Laure Beaumont-Maillet (Hrsg./ed.), *Atget. Paris*, Paris 1992

Eugène Atget
Le Centaure Nessus enlevant Déjanire, um/ca. 1911
Albuminabzug/albumen print

Arthur Benda

Geboren 1885 in Berlin/Deutschland, verstorben 1969 in Wien/Österreich. Seine Ausbildung zum Fotografen absolvierte Benda in Leipzig und Berlin. Von 1907 bis 1926 führte er gemeinsam mit Dora Kallmus, die sich Madame d'Ora nannte, das Fotoatelier d'Ora in Wien. Ab 1926 bestand das Atelier unter dem Namen d'Ora-Benda weiter und wurde ab 1927, nach Kallmus' Weggang aus Wien, von Benda allein unter der Bezeichnung Atelier d'Ora-Benda, Wien geführt.

Der damals europaweit renommierte Fotograf Arthur Benda folgte 1937 dem Auftrag des albanischen Königs Zogu I., ihn und seine Familie zu porträtieren. Benda verbrachte drei Wochen in dem Balkanland und brachte von dort über 900 Aufnahmen mit, die Einblick geben in eine Gesellschaft zwischen alter und neuer Zeit, zwischen Mittelalter und beginnender Neuzeit. Auch im vorliegenden Foto wird der Schwellencharakter dieser Zeit betont. Die Aufnahme wurde aus dem Inneren des Gebäudes des Landwirtschaftsministeriums heraus gemacht und zeigt einen Mann in traditioneller Landestracht sowie einen modern gekleideten Mann. Hinter den wie Silhouetten gesehenen Personen im Eingang öffnet sich der Blick auf die neue Moschee am Ende des Platzes und auf das Ministerium für Landesverteidigung.

Literatur/Further reading: Fritz Kempe (Hrsg./ed.), *Nicola Perscheid. Arthur Benda. Madame d'Ora* (Dokumente der Photographie 1, Museum für Kunst und Gewerbe), Hamburg 1980

Born in 1885 in Berlin/Germany, died in 1969 in Vienna/Austria. Benda completed his training as a photographer in Leipzig and Berlin. From 1907 to 1926 he ran the photo studio d'Ora in Vienna together with Dora Kallmus, who called herself Madame d'Ora. As of 1926 the studio continued under the name d'Ora-Benda and in 1927, after Kallmus's departure from Vienna, Benda ran it alone under the name Atelier d'Ora-Benda, Vienna.

Renowned throughout Europe at that time, the photographer Arthur Benda took on the assignment of taking portraits of Albanian King Zog I and his family in 1937. Benda spent three weeks in the Balkan country and brought back more than 900 photographs, which provide an insight into a society between ancient and modern times, between the Middle Ages and the onset of the modern era. The transitional character of this time is also emphasized on the present photograph. The picture was taken from inside the building of the Ministry of Agriculture, showing a man in traditional national costume and a man dressed in the modern style. Behind persons that can be seen like silhouettes at the entrance, the view opens up to the new mosque at the end of the square and to the Ministry of National Defence.

Arthur Benda
Tirana, 1937
Silbergelatineprint, getont/
silver gelatin print, toned

»DIE BILDER HABEN INNERLICHKEIT.«[1] KUNSTFOTOGRAFISCHE PORTRÄTS ZWISCHEN TRADITION UND ERNEUERUNG

"THE IMAGES HAVE INTERIORITY."[1] ART-PHOTOGRAPHY PORTRAITS BETWEEN TRADITION AND RENEWAL

Ulrich Pohlmann

Die Entwicklungsgeschichte der Kunstfotografie wird im Kontext der Reformbewegungen in Gesellschaft und Kultur im europäischen Fin de Siècle verständlich. Angeregt von der allgemeinen Aufbruchstimmung, die Architektur, Kunstgewerbe, Literatur und bildende Kunst erfasst hatte und sämtliche Bereiche des öffentlichen und privaten Lebens durchdringen sollte, setzte eine internationale Bewegung von »Liebhaberfotografen« um 1900 entscheidende Impulse für eine grundlegende Neuorientierung der künstlerischen Fotografie. In Vereinen oder anderen losen Vereinigungen organisiert, sahen sich die Amateure, allesamt Angehörige des wohlhabenden Bildungsbürgertums, Adels und Militärs, als Elite und Speerspitze einer Bewegung, die die Bildästhetik des Mediums von Grund auf erneuern wollte. Vor allem im Ausstellungswesen und in der Publizistik fanden die Ziele und Absichten der Amateure Ende des 19. Jahrhunderts wichtige Foren.

Das Porträt nahm dabei anfangs in der Motivwelt der Kunstfotografie keine besondere Stellung ein, vielmehr dominierten zunächst Landschaft, Architektur und Akt. »Anfänglich schienen alle Versuche zu scheitern. Die großen Amateurausstellungen zeigten nur wenige Porträts, und diese wenigen wieder näherten sich in ihrem Äußeren den Erzeugnissen der Berufsphotographen. Man wählte besonders schöne, weibliche oder irgendwie charakteristische Köpfe und begnügte sich meistens mit der einfachen Wiedergabe.«[2] Erst im Verlauf des letzten Jahrzehnts vor 1900 bildete sich zunehmend auch eine neue Gestaltungslehre in der Porträtdarstellung aus. Man distanzierte sich vom gründerzeitlichen Porträtbetrieb, der ästhetisch mit dem historistischen Stil der sogenannten Verfallszeit gleichgesetzt wurde.

The history of the development of art photography is comprehensible in the context of the reform movements in the society and culture of the European fin de siècle. Inspired by the general spirit of optimism, with architecture, arts and crafts, literature and fine arts permeating all areas of public and private life, an international movement of "amateur photographers" launched a decisive impetus for a fundamental reorientation of artistic photography around 1900. Organized in societies or other loose associations, amateurs, all of whom were members of the wealthy educated classes, the nobility and the military, saw themselves as the elite and innovators of a movement seeking to renew the visual aesthetics of the medium from the ground up. Especially journalism and exhibition management offered important forums for the goals and intentions of amateurs at the end of the nineteenth century.

Initially the portrait did not hold a special place in the range of artistic subjects, as landscapes, architecture and nudes predominated. "At first all the attempts seemed to fail. The large amateur exhibitions only displayed a few portraits and they looked like the work of professional photographers. They chose particularly beautiful, female or somehow characteristic heads and were mostly satisfied with simple reproduction."[2] It was only over the course of 1890s that a new school of design increasingly developed in portraiture. Photographers distanced themselves from the portraiture business of the Wilhelminian period, which was aesthetically equated with the historical style of the period of decline. Its venue had been the glass-roofed studio with all sorts of ornate decorations and equipped with props such as ideal landscapes painted as backgrounds, exotic animal skins,

Deren Schauplatz war das mit allerlei Zierrat überladene Glasdach-atelier gewesen, ausgestattet mit Requisiten wie gemalten Ideallandschaften als Hintergrund, exotischen Tierfellen, Pflanzen, Säulen und Balustraden aus Pappmaschee, die bühnenartig die Illusion einer anderen Welt vorgaukelten. Hier nahm das Bürgertum auf schweren Armsesseln Platz, um sich in steifer Pose ablichten zu lassen. Die Kamera, starr frontal auf den Porträtierten gerichtet, gab diesen als Ganzfigur, sitzend oder stehend, wieder. Nahsichtige Darstellungen des Kopfes blieben hingegen selten. Diese stereotype, uniform anmutende Inszenierung fand für die Porträts der höchsten Repräsentanten und Würdenträger und der gewöhnlichen Bürger im gleichen Maße Anwendung. Da das Glasnegativ die Physiognomie der Dargestellten und das Atelierambiente in »unnachahmlicher Treue« wiedergab, versuchten die Atelierfotografen, körperliche Auffälligkeiten, die von einem oberflächlichen Schönheitskanon abwichen, nachträglich durch Retusche zu korrigieren. Diesen Eingriff lehnten die Kunst-fotografen zwar kategorisch ab, um aber ihrerseits in der Dunkelkammer die Komposition nachhaltig zu manipulieren. Anstelle des traditionellen Albuminpapiers, das detailreich jedes einzelne Bildelement überdeutlich wiedergab, bevorzugten die Piktorialisten als Positivverfahren Edeldrucke wie den Platin- und Gummidruck, die äußerlich Druckgrafik und Zeichnungen ähnelten.

plants, pillars and balustrades made from papier-mâché, which conjured up the illusion of another world. Here the bourgeoisie sat in heavy armchairs to be photographed in rigid poses. Pointed straight at the sitter, the camera reproduced him as a full figure, either seated or standing. Close-up views of the head, on the other hand, remained rare. This stereotyped, uniform-looking production was used in the same way for portraits of the highest representatives and dignitaries, and for ordinary citizens. Since the glass negative reproduced the physiognomy of the sitter and the studio ambience in "inimitable faithfulness", studio photographers later tried to correct physical abnormalities that deviated from the conventional canon of beauty by retouching. Art photographers categorically rejected this intervention, but nevertheless drastically manipulated compositions in the darkroom. Instead of traditional albumen paper that reproduced each pictorial element in detail in a blatantly obvious way, the Pictorialists preferred the positive processes of pigment prints such as platinum or gum prints, which externally resembled graphic reproductions and drawings.

The art-photography portrait was no longer supposed to superficially and faithfully represent the status of the person, but instead aimed to make the character visible atmospherically and psychologically. Sophisticated lighting that focused on a few specific features of the portrait was used for this purpose, while the rest of the composition remained in the dark. The camera was supposed only to record specific gestures and looks, working as a kind of mirror of the soul in the view of the photographer. The general trend of veiling and concealment also included the method of representing the object of the image as out of focus and blurry using soft-focus lenses and monocle lenses: "It is the attempt to give a great impression of how the essence behind a thin veil is recorded without slavishly trying to force a resemblance. The whole is more like an atmospheric phenomenon than a likeness in portrait."[3] The old masters served as artistic models for the amateurs. Frans Hals, Rembrandt, Titian, but also the Pre-Raphaelites, such as Dante Gabriel Rossetti and George Frederic Watts, as well as contemporary portrait painters like Hubert von Herkomer, James McNeill Whistler, Léon Bonnat, Giovanni Boldini, John Singer Sargent and Franz von Lenbach were often cited as authorities on art photography.[4] The relevant handbooks of Sidney Allan (Sadakichi Hartmann), Charles Caffin and Willi Warstat drew on these artists in their instructions for the photographic process, the arrangement of the hands, head and body posture, as well as lighting.[5] No less important for the creative process was the post-processing of the negatives and the work in the darkroom.

Bertall (Charles Constant Albert Nicolas d'Arnoux de Limoges Saint-Saens), *Victor Hugo*, vor / before 1876
Woodburytypie / Woodburytype, 23,7 × 19,1 cm
Sammlung FOTOGRAFIS Bank Austria / FOTOGRAFIS Bank Austria Collection

Das kunstfotografische Bildnis sollte nicht mehr vordergründig wirklichkeitsgetreu den Status der Person repräsentieren, sondern vielmehr stimmungsvoll und psychologisch den Charakter sichtbar machen. Dafür sorgte unter anderem eine ausgeklügelte Lichtregie, die sich auf wenige spezifische Merkmale des Porträtierten konzentrierte, während der übrige Bildraum im Dunkeln blieb. Die Kamera sollte nur ausgewählte Gesten und Blicke – nach Auffassung der Fotografen eine Art Seelenspiegel des Dargestellten – registrieren. Zu der allgemeinen Tendenz des Verschleierns und Verbergens gehörte auch die Methode, den Bildgegenstand mithilfe von Weichzeichnerobjektiven oder Monokellinsen unscharf und verschwommen darzustellen: »Es ist das Streben vorhanden, einen großen Eindruck zu geben, der das Wesen wie hinter einem leichten Schleier festhält, ohne sklavisch eine Ähnlichkeit forcieren zu wollen. Das Ganze ist mehr eine atmosphärische Erscheinung, denn ein Konterfei.«[3] Als künstlerische Vorbilder dienten den Amateuren die Werke Alter Meister. Frans Hals, Rembrandt, Tizian, aber auch die Präraffaeliten Dante Gabriel Rossetti und George Frederic Watts sowie die zeitgenössischen Bildnismaler Hubert von Herkomer, James McNeill Whistler, Léon Bonnat, Giovanni Boldini, John Singer Sargent oder Franz von Lenbach wurden gerne als Kronzeugen der Kunstfotografie zitiert.[4] Die einschlägigen Lehrbücher von Sidney Allan (Sadakichi Hartmann), Charles Caffin oder Willi Warstat orientierten sich in ihren Anleitungen für den Aufnahmevorgang, das Arrangement von Händen, Kopf- und Körperhaltung sowie die Beleuchtung an diesen Künstlern.[5] Nicht minder wichtig für den schöpferischen Prozess waren die Nachbearbeitung des Negativs und die Arbeit in der Dunkelkammer.

»Diskret«, »einfühlsam«, »geschmackvoll« und »raumkünstlerisch« lauteten einige der Attribute, mit denen ein gelungenes Porträt damals gerne charakterisiert wurde. Voraussetzung dafür war ein Atelier, das eine bürgerliche Wohnzimmeratmosphäre verströmte und dessen Interieur sich am zeitgenössischen Kunstgewerbe orientierte. »Wie muß nun das moderne Atelier des Photographen eingerichtet sein? Diese Frage wird der moderne Raumkünstler zu beantworten haben. Das Wartezimmer, das den Eintretenden empfängt, muß unheimlich vornehm sein; es muß gewählten Geschmack bekunden. Wand, Boden, Decke müssen farbig, diskret gehalten sein. Die Möbel müssen Ruhe und Schönheit haben. Als Wandschmuck dient passend eine sparsame Auswahl der besten Lichtbildleistungen, womit zugleich die übliche Ansammlung der Photographien, die Anhäufung vermieden wird. Auch im Atelier sei die lieblose Nüchternheit vermieden. Gut beleuchtete Winkel können geschaffen werden. Der Charakter eines heiteren Empfangsraumes kann gewahrt sein. […] In diesen Räumen können moderne Kunstphotographien entstehen. Der Stil, den sie haben, entnimmt sein Wesen, seine Art den Dingen, mit denen der Photograph operiert. Großflächig, sachlich, zweckmäßig, und darum schön. […] Es ist eine Einheit vorhanden,

"Discrete", "sensitive", "tasteful" and "decorative" were some of the attributes with which a successful portrait was characterized at that time. This required a studio that exuded a bourgeois living-room atmosphere and whose interior was based on contemporary arts and crafts. "How should the modern studio of the photographer be set up? The modern decorative artist will have to answer this question. The waiting room that receives the entrant must be incredibly elegant and must express sophisticated taste. Walls, floors and ceilings must be colourful and discreet. The furniture must express calm and beauty. A frugal selection of the best photographic achievements should be used to decorate the walls, whereby the usual assortment of photographs and cluttering should be avoided. The studio should also avoid harsh austerity. Well-lit corners can be created. The character of a cheerful reception room can be maintained. [...] Modern art photographs can be created in these rooms. Their style should take its essence and nature from the tools with which the photographer works. They should be spacious, functional, purposeful and thus beautiful. [...] A harmony should prevail that is smooth and organic where formerly lack of discipline and confusion reigned."[6] The individual framing of the photographs, which were often presented on a passe-partout, mounted on several pieces of handmade paper or endpapers, was considered to be characterised by sophisticated taste. All of these factors, which Alfred Lichtwark called the "toilet" of photography, contributed to the overall impression of the medium as "interior decoration".

It took only a few years until the artistic maxims of the amateurs were incorporated into the practice of commercial studio photography and adopted by professional photographers. With the affluent clientele from the educated middle classes in mind, modern portraits were advertised in expensively designed brochures illustrated with select picture samples. In Germany, it was William Weimer, Rudolf Dührkoop, Hugo Erfurth, Erwin Raupp, Nicola Perscheid, Aura Hertwig, Franz Grainer and Jacob and Theodore Hilsdorf who successfully operated portrait studios along "modern lines." In Austria, Hans Watzek, Heinrich Kühn and Friedrich Spitzer excelled in this genre, and in the United States there were Edward Steichen, Fred Holland Day, Gertrude Käsebier, Frank Eugene, Clarence H. White and Alfred Stieglitz. In England and France, James Craig Annan and Robert Demachy were exemplary of the new portraiture. In 1903 an impressive overview was displayed at the First International Exhibition of Portrait Photography in museums in Wiesbaden, Hagen, Krefeld and Breslau, where more than three hundred portraits from Europe and North America could be viewed.

In Paris and Vienna Dora Kallmus, who had trained in the Berlin studio of Nicola Perscheid as his student, took portrait photographs of actresses, dancers and aristocrats in the Pictorialist style under the

lückenlos, organisch, wo früher Disziplinlosigkeit, Wirrwarr herrsch-
te.«[6] Zur gehobenen Geschmackskultur gehörte auch die indivi-
duelle Rahmung der Bilder, die häufig im Passepartout und montiert
auf mehreren Bütten- und Vorsatzpapieren zur Darbietung kamen.
Alle diese Faktoren – Alfred Lichtwark nannte sie die »Toilette« der
Fotografie – trugen zum Gesamteindruck des Mediums als »Raum-
kunst« bei.

Es dauerte nur wenige Jahre, bis die künstlerischen Maximen der
Amateure in die Praxis der gewerblichen Atelierfotografie einflossen
und von den Fachfotografen übernommen wurden. Mit der zah-
lungskräftigen Kundschaft aus dem Bildungsbürgertum vor Augen

pseudonym of Madame d'Ora.[7] Trude Fleischmann worked at Atelier
d'Ora before she opened her own portrait studio in Vienna, which
soon developed into a meeting place for well-known contemporaries.[8]
Several portraits of the writer Karl Kraus were made from 1920 on-
wards; their image concept and their emphasis on hand and head
segments were aligned with Pictorialist aesthetics. Certainly Fleisch-
mann's staging with the editor of *Fackel* had been agreed in advance
because Kraus, other portraits of whom (by Lotte Jacobi amongst
others) are known, had specific ideas about the visual presence of his
person in public. He was a combative publicist and he vehemently
rejected photojournalistic representation, which in one case even led
to a legal dispute with the Jewish photographer Joseph Breitenbach.

warb man für das neuzeitliche Porträt mit aufwendig gestalteten Broschüren, illustriert mit ausgewählten Bildproben. In Deutschland waren es Wilhelm Weimer, Rudolf Dührkoop, Hugo Erfurth, Erwin Raupp, Nicola Perscheid, Aura Hertwig, Franz Grainer sowie Jacob und Theodor Hilsdorf, die erfolgreich Porträtateliers im Sinne der »modernen Richtung« betrieben. Während in Österreich Hans Watzek, Heinrich Kühn und Friedrich Spitzer in diesem Genre brillierten, waren es in den Vereinigten Staaten Edward Steichen, Fred Holland Day, Gertrude Käsebier, Frank Eugene, Clarence H. White und Alfred Stieglitz. In England und Frankreich stehen James Craig Annan und Robert Demachy exemplarisch für die neue Porträtauffassung. Einen beeindruckenden Überblick bot im Jahr 1903 die *Erste Internationale Ausstellung für Bildnisphotographie* in den Museen von Wiesbaden, Hagen, Krefeld und Breslau, in der mehr als dreihundert Porträts aus Europa und Nordamerika zu sehen waren.

In Paris und Wien fotografierte Dora Kallmus, die im Berliner Atelier von Nicola Perscheid als dessen Schülerin ausgebildet worden war, unter dem Künsternamen Madame d'Ora Porträts von Schauspielerinnen, Tänzerinnen und Adeligen im piktorialistischen Stil.[7] Trude Fleischmann wiederum hatte im Atelier d'Ora gearbeitet, bevor sie ein eigenes Porträtstudio in Wien eröffnete, das sich schon bald zum Treffpunkt prominenter Zeitgenossen entwickeln sollte.[8] Dort entstanden ab 1920 auch mehrere Bildnisse des Schriftstellers Karl Kraus, die sich in der Bildauffassung und Betonung von Hand- und Kopfpartie im Wesentlichen an der piktorialistischen Ästhetik orientierten. Sicherlich war Fleischmanns Inszenierung mit dem Herausgeber der *Fackel* vorab abgesprochen, denn Kraus, von dem weitere Bildnisse, unter anderem von Lotte Jacobi, bekannt sind, hatte präzise Vorstellungen von der visuellen Präsenz seiner Person in der Öffentlichkeit. Bildjournalistische Darstellungen lehnte der streitbare Publizist beispielsweise vehement ab, was in einem Fall sogar zu einer juristischen Auseinandersetzung mit dem jüdischen Fotografen Joseph Breitenbach führte. Dieser hatte den Dichter während einer Lesung in München überrascht und mit einigen Schnappschüssen beim Reden zu erfassen versuchte, was Kraus dazu veranlasste, Breitenbach auf Herausgabe der Bilder zu verklagen und deren Verbreitung zu untersagen.[9]

Auch Alfred Stieglitz verstand sich als Person des öffentlichen Lebens. Davon zeugen zahlreiche Porträts von Edward Steichen, Frank Eugene, Alvin Langdon Coburn, Dorothy Norman oder Hermann Landshoff, die innerhalb einer Zeitspanne von mehr als vier Jahrzehnten entstanden. Das bekannte Bildnis von Heinrich Kühn aus dem Jahr 1904 zeigt Stieglitz in einer für das Selbstverständnis der

Breitenbach had taken some snapshots of the writer at a lecture in Munich while he was talking, and this induced Kraus to sue Breitenbach for publishing the images and to prohibit their distribution.[9]

Alfred Stieglitz also saw himself as a public figure. Numerous portraits by Edward Steichen, Frank Eugene, Alvin Langdon Coburn, Dorothy Norman and Hermann Landshoff, which were created over a period of more than four decades, testify to this. The famous portrait by Heinrich Kühn from 1904 shows Stieglitz in a pose indicative of the self-image of art photographers. It identifies Stieglitz as an erudite connoisseur of the arts who simultaneously occupies a central position in the international exchange of art photography as an agile organizer of exhibitions and publisher of the magazine *Camera Work*.

Much of the preserved portraiture originated in the narrower context of the family and friends of the photographer. This is especially true of Heinrich Kühn, who created portraits of his children, his wife Emma and the nanny Mary Warner, who would later become his mistress. The pictures are not only the result of accomplished and sophisticated image techniques, they also convey a special level of intimate familiarity not spontaneously recorded, but carefully staged.[10]

Kunstfotografen bezeichnenden Pose. Es weist Stieglitz als gebildeten Connaisseur der Künste aus, der zugleich als agiler Organisator von Ausstellungen und als Herausgeber der Zeitschrift *Camera Work* eine zentrale Position in der internationalen Vermittlung der Kunstfotografie eingenommen hatte.

Ein Großteil der bis heute erhaltenen Porträtdarstellungen entstand im engeren Umfeld der Familie und Freunde der Fotografen. Das gilt insbesondere für Heinrich Kühn, vergegenwärtigt man sich die Bildnisse seiner Kinder, der Ehefrau Emma sowie des Kindermädchens, der späteren Geliebten Mary Warner. Die Aufnahmen sind nicht nur das Ergebnis vollendeter und ausgereifter Bildtechnik, sondern vermitteln auch ein besonderes Maß von intimer Vertrautheit, die aber keineswegs spontan fixiert wurde, sondern einer sorgfältigen Inszenierung geschuldet ist.[10]

Der Amerikaner Edward Steichen kannte hingegen keine Scheu, sich mit der Kamera auch Berühmtheiten aus Politik, Wirtschaft und Kultur zu nähern. Davon zeugen seine Porträts von Auguste Rodin, Franz von Lenbach, Franz von Stuck, John Pierpont Morgan oder Maurice Maeterlinck, um hier nur einige zu nennen. In diesen Bildnissen zelebriert Steichen die Dargestellten als Repräsentanten eines genialen wie heroischen Schöpfertums, was die Aufnahmen auch deutlich von den dekorativen Kompositionen mit Frauen unterscheidet. Ernst Schur differenziert hier zwischen dem »malerischen« und dem »zeichnerischen« Stil, den er mit dem Frauen- respektive Männerporträt in Verbindung bringt.[11] Nicht nur die Künstlerbildnisse Steichens wären ohne die Literatur und Malerei des Symbolismus undenkbar gewesen. Auch seine Frauenbildnisse – Porträts und Akte – verdanken in der Bildidee vieles dieser vorherrschenden Strömung des Fin de Siècle.[12] Als personifizierte Allegorien oder als Figuren aus der antiken Mythologie hatte Steichen Schauspielerinnen und andere weibliche Modelle in Szene gesetzt. Diese Frauenbildnisse verströmen zugleich Eleganz und Glamour und machen die besondere Fähigkeit und Begabung des Fotografen für das Modebildnis sichtbar, mit dem er sich bereits in der piktorialistischen Phase beschäftigte, bevor er sich diesem Genre in den nachfolgenden Jahrzehnten ausschließlich zuwenden sollte. Mit Rita Lydig saß Steichen eine für ihre Extravaganz und einen mondänen Lebensstil bekannte Person Modell, die sich für die Suffragetten-Bewegung einsetzte, mit Rodin, Degas und Debussy befreundet war und außerdem von den Gesellschaftsmalern Giovanni Boldini und John Singer Sargent porträtiert wurde. Die im Jahr 1905 entstandene Aufnahme fand 1913 auch als Druck unter dem Titel *Cyclamen – Mrs. Philip Lydig* Eingang in *Camera Work*.

Trude Fleischmann, *Alban Berg*, 1932
Silbergelatineprint / silver gelatin print, 25 × 19 cm
Sammlung FOTOGRAFIS Bank Austria /
FOTOGRAFIS Bank Austria Collection

By contrast, the American Edward Steichen got close to celebrities from politics, business and culture with his camera. His portraits of Auguste Rodin, Franz von Lenbach, Franz von Stuck, John Pierpont Morgan and Maurice Maeterlinck, to name just a few, testify to this. In these portraits, Steichen celebrates the persons portrayed as representatives of heroic creativeness, and the photographs also clearly differ from the decorative compositions depicting women. Ernst Schur differentiates here between the "picturesque" and the "graphic" style, which he associates with the portraits of women and men respectively.[11] But not only Steichen's artist portraits would have been unthinkable without the literature and painting of Symbolism; his photographs of women, too – portraits and nudes – owe many of the ideas behind the pictures to the prevailing current of the fin de siècle.[12] Steichen staged actresses and other female models as personified allegories or figures from ancient mythology. At the same time these images of women exude elegance and glamour and visualize the special skill and talent of the photographer for fashion photography, in which he was already interested in the Pictorialist phase, before he turned exclusively to this genre in the following decades.

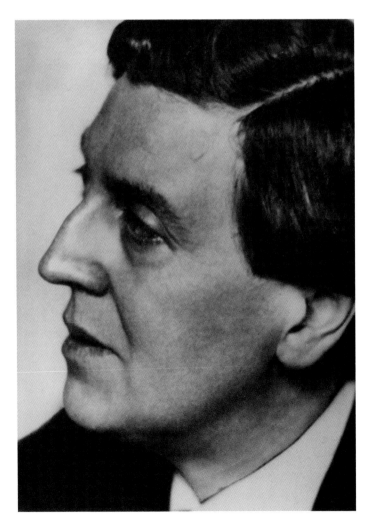

Parallel zur Abkehr von der traditionellen Atelierfotografie verlief die Wiederentdeckung von historischen Positionen künstlerischer Fotografie aus der Frühzeit des Mediums. Vor allem die Kalotypien der schottischen Maler-Fotografen Robert Adamson & David Octavius Hill sowie Julia Margaret Camerons großformatige Bildnisse von präraffaelitischen Künstlern und Wissenschaftlern aus den 1860er-Jahren sollten um die Jahrhundertwende eine kurze Renaissance erleben. Stilistisch verbindet beide Positionen die Konzentration des Bildausschnitts auf Gesicht und Hände als Ausdrucksträger der Persönlichkeit sowie die malerische Grundstimmung der Kompositionen, in denen die Dargestellten in zartem *sfumato* mit tonigen Hell-Dunkel-Kontrasten erfasst sind. Diese atmosphärischen Darstellungen wurden von den Kunstfotografen als besonders naturnah wertgeschätzt und in Ausstellungen und Publikationen auf dem europäischen Kontinent und in Nordamerika präsentiert. Erstmals waren 1895 im Londoner Camera Club moderne Pigmentdrucke nach Negativen von Adamson & Hill zusammen mit Fotografien von Cameron zu sehen. Für die positive Rezeption der Bilder im deutschsprachigen Raum war die Ausstellung zur künstlerischen Amateurfotografie in der Hamburger Kunsthalle im Jahr 1899 ausschlaggebend.[13] Dort waren in einem historischen Kabinett Beispiele der Porträtkunst Adamsons & Hills und Camerons untergebracht. Wir wissen nicht, ob sich unter diesen Motiven, die Camerons Sohn, der Londoner Berufsfotograf H. H. Hay Cameron, für die Hamburger Schau zur Verfügung gestellt hatte, auch das Bildnis von Camerons Nichte Julia Jackson befand. Doch dürfte diese Aufnahme die damaligen Erwartungen der Besucher an eine bildmäßige Fotografie in jeder Hinsicht erfüllt haben.

Kurz vor Ausbruch des Ersten Weltkriegs hatte sich der Piktorialismus als stilbildende Avantgarde in der künstlerischen Fotografie weitgehend überlebt. Die Forderung nach individuellem Ausdruck im Porträt hatte in der Praxis vielfach zu schablonenhaften, monoton wirkenden Bildformen geführt, die ähnlich stereotyp wirkten wie die der traditionellen Atelierfotografie im ausgehenden 19. Jahrhundert. Gleichwohl erfuhren die Gestaltungsprinzipien des Piktorialismus auch nach Ende der Hochphase in der Zwischenkriegszeit ein Weiterleben. Erfolgreiche Berufsfotografen wie Erfurth, d'Ora oder Fleischmann blieben von dieser Richtung entscheidend mitgeprägt. Auch wenn sich ihre Arbeiten weiterentwickelten und das zeitgenössische »Neue Sehen« absorbierten, blieben sie der piktorialistischen Porträtauffassung verwandt. In der medienhistorischen Rückschau nimmt die Kunstfotografie eine Zwitterstellung ein, wird vielfach als bloßes Echo auf die Malerei und die bildenden Künste kritisiert und als Irrweg abgelehnt, während der Aufbruch in die Moderne vor allem mit dem »Neuen Sehen« in Verbindung gebracht wird. Doch bleibt festzustellen, dass der Piktorialismus überhaupt erst das Bewusstsein für eine eigene Kompositionslehre weckte, eine solche

Steichen created a portrait of Rita Lydig, a person known for her extravagance and her glamorous lifestyle. She was an active participant in the women's-suffrage movement and was friends with Rodin, Degas and Debussy, and she was also portrayed by society painters Giovanni Boldini and John Singer Sargent. The photograph created in 1905 also appeared in 1913 as a print in *Camera Work*, entitled *Cyclamen – Mrs. Philip Lydig.*

Alongside the departure from traditional studio photography ran the rediscovery of historical approaches of artistic photography from the early days of the medium. A brief renaissance was experienced at the turn of the century with the calotypes of the Scottish painter-photographers Robert Adamson & David Octavius Hill in particular, and Julia Margaret Cameron's large-format portraits of Pre-Raphaelite artists and scientists from the 1860s. Stylistically, both approaches link the focus of photographic detail on the face and hands as a vehicle of expression of personality and the picturesque mood of the compositions in which the sitters are captured in delicate *sfumato* with clayey light-dark contrasts. Art photographers appreciated these atmospheric depictions as particularly natural and presented them in exhibitions and publications on the European continent and in North America. The first modern carbon prints from negatives by Adamson & Hill were seen together with Cameron's photographs in 1895 at the London Camera Club. The exhibition for amateur art-photography in the Hamburg Kunsthalle in 1899 was decisive for the positive reception of photographs in German-speaking regions.[13] Here a historic cabinet housed examples of the portraiture by Adamson & Hill and Cameron. We do not know whether any of these images, which Cameron's son, the London-based professional photographer H. H. Hay Cameron, made available for the Hamburg show, also included the portrait of Cameron's niece Julia Jackson. But this photograph is likely to have met in every respect the visitors' expectations of Pictorialist photography at that time.

Shortly before the outbreak of the First World War, Pictorialism had become largely obsolete as an avant-garde style in art photography. In practice, the demand for individual expression in portraiture had often led to stereotyped, monotonic pictorial forms similar to the clichéd traditional studio photography of the late nineteenth century. Nevertheless, the stylistic principles of Pictorialism also lived on after the heyday of the interwar period. Successful professional photographers like Erfurth, d'Ora or Fleischmann continued to remain decisively influenced by this trend. Even when their work continued to develop and absorbed the contemporary "New Vision", they remained loyal to Pictorialist portraiture. In media-historical retrospect, art photography has occupied a hybrid position and has often been criticized as a mere echo of painting and the visual arts and rejected as an aberration, while the dawn of Modernism is linked mainly to

entwickeln konnte und so das Publikum für bildästhetische Frage-stellungen sensibilisierte, für die die Fotografen der nachfolgenden Jahrzehnte andere Antworten finden sollten.

the "New Vision" movement. It should be noted however that it was Pictorialism that awakened an awareness of a particular theory of composition, and as such was able to stimulate sensibility for visual aesthetic issues for which the photographers of the following decades could find new and other solutions.

1 Fritz Matthies-Masuren (1908), zit. nach: Ulrich Pohlmann, »›Ein gutes Portrait ist kein Augenblicksbild.‹ Die Porträtfotografie von Theodor Hilsdorf im Spiegel der Zeit«, in: Hans-Michael Koetzle und Ulrich Pohlmann (Hrsg.), *Münchner Kreise. Der Fotograf Theodor Hilsdorf 1868–1944*, München und Bielefeld 2007, S. 74.

2 Fritz Matthies-Masuren, *Künstlerische Photographie. Entwicklung und Einfluss in Deutschland* (*Die Kunst,* Bd. 59, hrsg. von Richard Muther, Berlin 1907), Reprint, New York 1979, S. 55.

3 Ernst Schur, »Malerei und Zeichnung in der modernen Portraitphotographie«, in: Fritz Matthies-Masuren (Hrsg.), *Die Photographische Kunst im Jahre 1907*, 6. Jahrgang, Halle a.d. Saale, o.J., S. 65.

4 Vgl. Sadakichi Hartmann, »Portrait Painting and Portrait Photography« (1898), in: ders., *The Valiant Knights of Daguerre. Selected Critical Essays on Photography and Profiles of Photographic Pioneers,* hrsg. von Harold Walter Lawton, Berkeley/Kalifornien 1978, S. 35–55.

5 Sidney Allan (Sadakichi Hartmann), *Composition in Portraiture* (1909), Reprint, New York 1973; Charles Henry Caffin, *Photography As a Fine Art. The Achievements and Possibilities of Photographic Art in America* (1901), Reprint, New York 1971; Willi Warstat, *Allgemeine Ästhetik der photographischen Kunst auf psychologischer Grundlage,* Halle a.d. Saale 1909.

6 Fritz Matthies-Masuren (Hrsg.), *Die Photographische Kunst im Jahre 1908,* 7. Jahrgang, Halle a.d. Saale, o.J., S. 98f.

7 Monika Faber, *Madame d'Ora. Wien – Paris. Portraits aus Kunst und Gesellschaft 1907–1957,* Wien und München 1983.

8 Anton Holzer und Frauke Kreutler (Hrsg.), *Trude Fleischmann. Der selbstbewusste Blick/A Self-assured Eye* (Ausst.-Kat. Wien Museum, Wien), Ostfildern 2011.

9 Vgl. Dirk Halfbrodt, »München 1896–1933. Der Photograph auf der Bühne«, in: Theo O. Immisch, Ulrich Pohlmann und Klaus E. Göltz (Hrsg.), *Josef Breitenbach. Photographien,* München 1996, S. 33.

10 Monika Faber und Astrid Mahler (Hrsg.), *Heinrich Kühn. Die vollkommene Fotografie* (Ausst.-Kat. Albertina, Wien), Ostfildern 2010.

11 Vgl. Ernst Schur (wie Anm. 3), S. 76ff.

12 Dennis Longwell, *Steichen. Meisterphotographien 1895–1914* (Ausst.-Kat. Museum of Modern Art, New York), Tübingen 1978.

13 Für eine ausführliche Rezeptionsgeschichte siehe Enno Kaufhold, »›Wir trauten anfangs unseren Augen nicht.‹ David Octavius Hill: Legitimation der photographischen Unschärfe«, in: Bodo von Dewitz und Karin Schuller-Procopovici (Hrsg.), *David Octavius Hill & Robert Adamson. Von den Anfängen der künstlerischen Photographie im 19. Jahrhundert* (Ausst.-Kat. Museum Ludwig, Köln), Göttingen 2000, S. 33–44.

1 Fritz Matthies-Masuren (1908), cited in: Ulrich Pohlmann, "'Ein gutes Portrait ist kein Augenblicksbild.' Die Porträtfotografie von Theodor Hilsdorf im Spiegel der Zeit", in: Hans-Michael Koetzle and Ulrich Pohlmann (eds.), *Münchner Kreise. Photographer Theodor Hilsdorf 1868–1944*, Munich and Bielefeld 2007, p. 74.

2 Fritz Matthies-Masuren, *Künstlerische Photographie. Entwicklung und Einfluss in Deutschland* (*Die Kunst,* vol. 59, ed. by Richard Muther, Berlin 1907), reprint, New York 1979, p. 55.

3 Ernst Schur, "Malerei und Zeichnung in der modernen Portraitphotographie", in: Fritz Matthies-Masuren (ed.), *Die Photographische Kunst im Jahre 1907*, vol. 6, Halle a.d. Saale, n.d., p. 65.

4 Cf. Sadakichi Hartmann, "Portrait Painting and Portrait Photography" (1898), in: Sadakichi Hartmann, *The Valiant Knights of Daguerre. Selected Critical Essays on Photography and Profiles of Photographic Pioneers*, ed. by Harold Walter Lawton, Berkeley/California 1978, pp. 35–55.

5 Sidney Allan (Sadakichi Hartmann), *Composition in Portraiture* (1909), reprint, New York 1973; Charles Henry Caffin, *Photography As a Fine Art. The Achievements and Possibilities of Photographic Art in America* (1901), reprint, New York 1971; Willi Warstat, *Allgemeine Ästhetik der photographischen Kunst auf psychologischer Grundlage,* Halle a.d. Saale 1909.

6 Fritz Matthies-Masuren (ed.), *Die Photographische Kunst im Jahre 1908,* vol. 7, Halle a.d. Saale, n.d., pp. 98f.

7 Monika Faber, *Madame d'Ora. Wien – Paris. Portraits aus Kunst und Gesellschaft 1907–1957*, Vienna and Munich 1983.

8 Anton Holzer and Frauke Kreutler (eds.), *Trude Fleischmann. Der selbstbewusste Blick/A Self-assured Eye* (exh.cat. Wien Museum, Vienna), Ostfildern 2011.

9 Cf. Dirk Halfbrodt, "München 1896–1933. Der Photograph auf der Bühne", in: Theo O. Immisch, Ulrich Pohlmann and Klaus E. Göltz (eds.), *Josef Breitenbach. Photographien,* Munich 1996, p. 33.

10 Monika Faber and Astrid Mahler (eds.), *Heinrich Kühn. Die vollkommene Fotografie* (exh. cat. Albertina, Vienna), Ostfildern 2010.

11 Cf. Ernst Schur (cf. note 3), pp. 76ff.

12 Dennis Longwell, *Steichen. Meisterphotographien 1895–1914* (exh. cat. Museum of Modern Art, New York), Tübingen 1978.

13 For a detailed history of reception, see Enno Kaufhold, "'Wir trauten anfangs unseren Augen nicht.' David Octavius Hill: Legitimation der photographischen Unschärfe", in: Bodo von Dewitz and Karin Schuller-Procopovici (eds.), *David Octavius Hill & Robert Adamson. Von den Anfängen der künstlerischen Photographie im 19. Jahrhundert* (exh. cat. Museum Ludwig, Cologne), Göttingen 2000, pp. 33–44.

Edward Steichen

Geboren 1879 in Bivange/Luxemburg, verstorben 1973 in West Redding, Connecticut/USA. 1881 wanderte die Familie nach Amerika aus, wo Edward Steichen schon sehr früh zu fotografieren begann. Die Bekanntschaft mit Alfred Stieglitz war ausschlaggebend für Steichens Mitgliedschaft in der New Yorker Photo-Secession und gemeinsam gründeten Stieglitz und Steichen die Galerie 291. In der Zeit von 1900 bis 1902 lebte Steichen in Paris, dann bis 1906 in New York und von 1906 bis zum Ersten Weltkrieg wieder in Paris, wo er hauptsächlich als Maler tätig war. In den 1940er-Jahren war er Leiter der Fotografieabteilung der US-Marine. Als Beaumont Newhall 1947 sein Amt als Leiter der Fotoabteilung am Museum of Modern Art in New York niederlegte, übernahm Steichen die Nachfolge bis 1962. Seine universal angelegte Ausstellung *The Family of Man* tourte ab 1955 durch die Welt und wurde zu einem nicht unumstrittenen Meilenstein in der Geschichte der Fotografieausstellungen.

Dem ersten internationalen Stil der Fotografie, dem Piktorialismus, blieb Steichen als gesuchter Mode-, Gesellschafts-, Porträt- und Magazinfotograf bis zur Zeit des Ersten Weltkriegs treu. Er schätzte die weichtonige Technik der Edeldruckverfahren und deren malerische Valeurs, wie sie auch das symbolistisch anmutende Porträt von Mrs. Philip Lydig auszeichnen. Die Porträtierte ist Rita de Acosta, verheiratete Lydig, eine mondäne Dame der amerikanischen Décadence, die ihre Zeit in New York, London und Paris verbrachte und in der Bohème- und Künstlerszene verkehrte. Ihr extravaganter Stil war tonangebend. Sie engagierte sich zudem für die Emanzipationsbewegung und veröffentlichte einen melodramatischen Gesellschaftsroman.

Born in 1879 in Bivange/Luxembourg, died in 1973 in West Redding, Connecticut/USA. In 1881 the family immigrated to America, where Edward Steichen began to take photographs at a very young age. His acquaintance with Alfred Stieglitz was crucial for Steichen's membership in the New York Photo-Secession, and Stieglitz and Steichen together founded Gallery 291. From 1900 to 1902 Steichen lived in Paris, then in New York City until 1906 and from 1906 until the First World War in Paris again, where he worked mainly as a painter. In the 1940s he was head of the U.S. Navy photography department. When Beaumont Newhall resigned from his position as head of the Museum of Modern Art photography department in New York in 1947, Steichen succeeded him until 1962. His universally designed exhibition *The Family of Man* toured throughout the world starting in 1955 and became a somewhat controversial milestone in the history of photography exhibitions.

As a sought-after fashion, corporate, portrait and magazine photographer, Steichen remained faithful to the first international style of photography, Pictorialism, until the First World War. He cherished the soft-toned technique in the pigment-printing processes and their picturesque values, which also characterize the portrait with Symbolist overtones of Mrs Philip Lydig. The sitter is Rita de Acosta, whose married name was Lydig, a glamorous lady of the American *décadence* who spent her time in New York, London and Paris and associated with the bohemian and artist scenes. Her extravagant style set the tone. She was also committed to the emancipation movement and published a melodramatic society novel.

Edward Steichen
Cyclamen – Mrs. Philip Lydig. New York, 1905
Gummi-Bichromat-Abzug / gum bichromate print

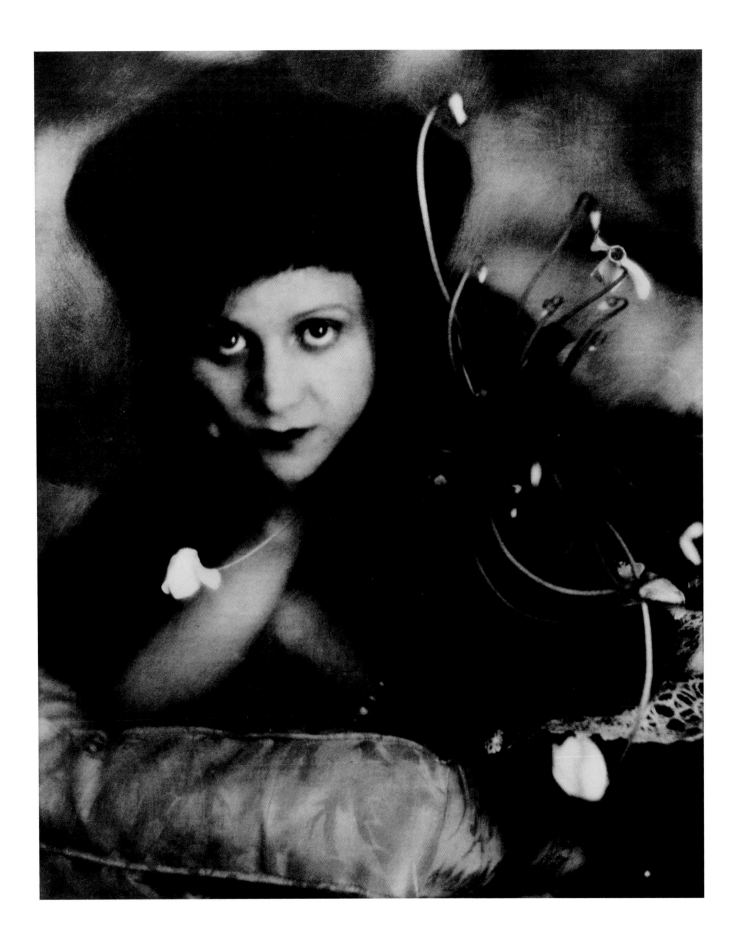

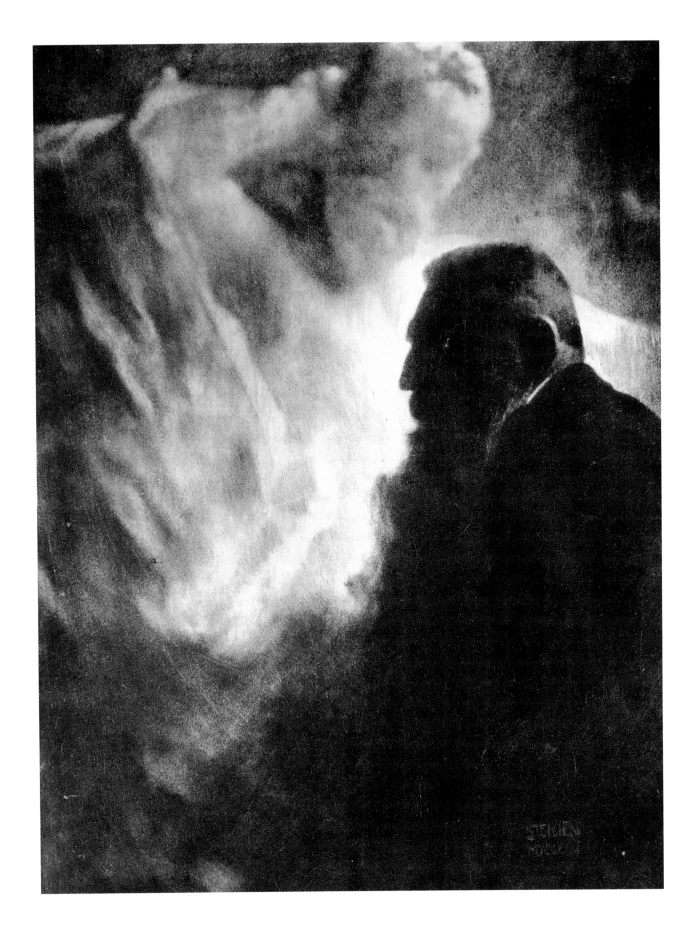

Während Edward Steichen in weiblichen Porträtaufnahmen Schönheit und Anmut der Porträtierten ansichtig machen wollte, dienen die männlichen Bildnisse, die in der Mehrzahl Künstlerpersönlichkeiten zeigen, zur Verkörperung des genialen, schöpferischen Potenzials. Den Bildhauer Auguste Rodin (1840–1917) hatte Steichen während seines ersten Parisaufenthaltes in den Jahren 1900 bis 1902 kennengelernt. Beeindruckt von der riesigen Gipsskulptur zur Vorbereitung des Gusses von Rodins Victor-Hugo-Monument fotografierte Steichen diese Plastik in der Nacht im Garten des Ateliers und kombinierte sie mit dem Porträt des Bildhauers in seinem Studio. Die symbolhafte Synthese von Künstler und Werk entsprach Steichens Vorstellung von der schöpferischen Kraft des künstlerischen Tuns, wie sie auch in der berühmten Fotografie von Rodin mit seiner Figur des *Denkers* zum Ausdruck kommt, aus der dieser Print einen Ausschnitt darstellt, der 1903 in *Camera Work* veröffentlicht wurde.

While Edward Steichen wanted to make the beauty and grace of the sitters in his female portraits visible, the male portraits mostly revealed artistic personalities embodying brilliant and creative potential. Steichen met the sculptor Auguste Rodin (1840 to 1917) during his first stay in Paris from 1900 to 1902. Impressed by the huge plaster sculpture in preparation for the casting of Rodin's Victor Hugo monument, Steichen photographed this sculpture at night in the studio garden and combined it with the portrait of the sculptor in his studio. The symbolic synthesis of artist and work of art corresponded to Steichen's idea of the creative power of artistic activity, as expressed in the famous photograph of Rodin with his figure of *The Thinker* from which this print is a cut-out, and which was published in *Camera Work* in 1903.

Literatur / Further reading: Dennis Longwell, *Steichen. Meisterphotographien / The Master Prints 1895–1914* (Ausst.-Kat. / exh. cat. Museum of Modern Art, New York), Tübingen 1978

Edward Steichen
Auguste Rodin, 1903
Fotogravüre auf Japanpapier / photogravure on Japanese tissue paper

Heinrich Kühn

Geboren 1866 in Dresden/Deutschland, verstorben 1944 in Birgitz bei Innsbruck/Österreich. Kühn studierte ab 1885 in Leipzig, Berlin und Freiburg im Breisgau Medizin und Naturwissenschaften und promovierte als Mediziner. Aus Gesundheitsgründen zog er nach Innsbruck, wo er sich dank eines Familienvermögens ganz der Fotografie in Theorie und Praxis widmen konnte. 1888 machte er erste fotografische Experimente und schloss sich 1894 mit Hans Watzek und Hugo Henneberg in der Künstlergruppe Wiener Kleeblatt zusammen. 1896 wurde Kühn Mitglied des Wiener Camera-Clubs. 1898 erfuhr er internationale Anerkennung auf der Secessions-Ausstellung in München. 1904 traf er Alfred Stieglitz, der Kühns Bilder mehrfach in *Camera Work* publizierte. 1914 gründete Kühn eine Schule für Fotografie in Innsbruck. Während des Kriegs setzte er sich mit technischen Fragen der Fotografie auseinander und publizierte Artikel in fotografischen Zeitschriften. Kühn hatte die Gummigravüre entwickelt; er arbeitete hauptsächlich mit Edeldruckverfahren, fertigte aber auch Autochrome, eine frühe Form der Farbfotografie, an.

Born in 1866 in Dresden/Germany, died in 1944 at Birgitz near Innsbruck/Austria. Starting in 1885 Kühn studied medicine and natural sciences in Leipzig, Berlin and Freiburg im Breisgau and graduated as a medical doctor. For health reasons, he moved to Innsbruck where, thanks to a family fortune, he could devote himself entirely to the theory and practice of photography. In 1888 he conducted his first photographic experiments and in 1894 he joined Hans Watzek and Hugo Henneberg in the Wiener Kleeblatt artist group. By 1896 Kühn was a member of the Vienna Camera Club. In 1898, he gained international recognition at the Secession exhibition in Munich. In 1904 he met Alfred Stieglitz, who published Kühn's photographs several times in *Camera Work*. Kühn founded a school of photography in 1914 in Innsbruck. During the war he continued to explore technical issues of photography and publish articles in photography journals. Kühn invented the *gummigravüre* technique; he mainly worked with pigment-printing methods, but also worked in autochrome, an early form of colour photography.

Mit Heinrich Kühn kann die österreichische Fotogeschichte auf eine Persönlichkeit von internationalem Renommee verweisen. Als Hauptvertreter der piktorialistischen Fotografie war er daran beteiligt, das neue Medium als autonome Kunsttechnik zu etablieren. Neben seinen stimmigen Landschaftsbildern und den poetischen Stillleben zählen die Porträts seiner Familienmitglieder zu den bedeutendsten Fotografien der Zeit um die Jahrhundertwende. Ab 1900 fotografierte Kühn oftmals seine Kinder Walther, Edeltrude, Hans und Charlotte – genannt Lotte –, wie auch hier: Die Aufnahme zeigt die drei älteren Geschwister, ganz zwanglos in ihrem kindlichen Miteinander in der Wohnung in Innsbruck. Walther, das älteste Kind, ist hier etwa elf Jahre alt und nicht mehr so kindlich. Die zurückhaltende Edeltrude ist zwei Jahre jünger als ihr Bruder. Der jüngste Bub, Hans, wird als lebhaftes Kind mit der damals üblichen Pagenfrisur gezeigt.

The history of Austrian photography can point to a person of international renown in Heinrich Kühn. As the main representative of the Pictorialist movement in photography, he was involved in establishing a new medium as an independent art technique. In addition to his harmonious landscape pictures and poetic still lifes, the portraits of his family members are among the most important photographs from the turn of the century. From 1900 Kühn often photographed his children Walther, Edeltrude, Hans and Charlotte – known as Lotte – as is shown here: the picture shows the three older siblings casually playing together as children in their home in Innsbruck. Walther, the eldest child, is about eleven years old here and not very childlike anymore. The reserved Edeltrude is two years younger than her brother. The youngest boy, Hans, is shown as a lively child with the pageboy hairstyle that was common at that time.

Heinrich Kühn
Walther, Edeltrude und Hans, um/ca. 1906
Gummidruck/gum print

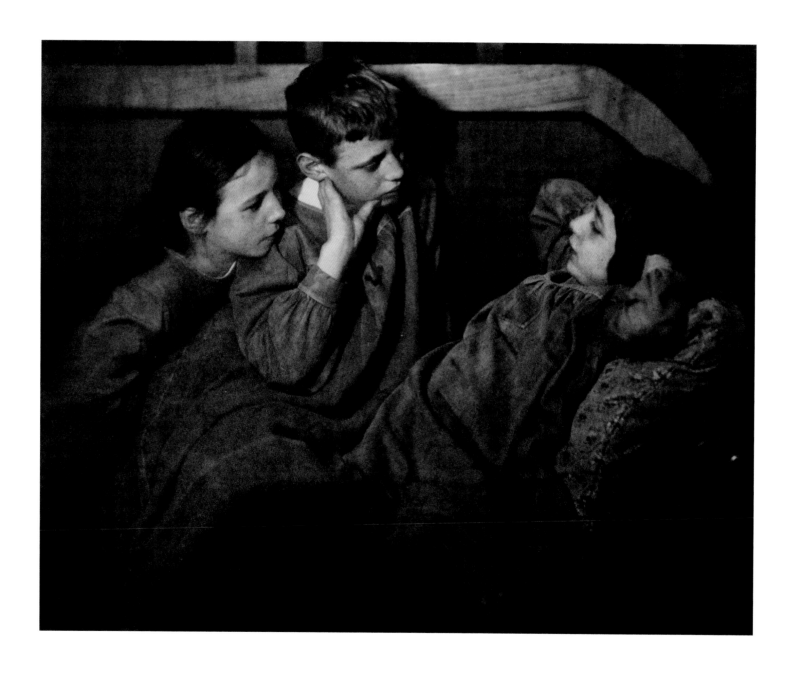

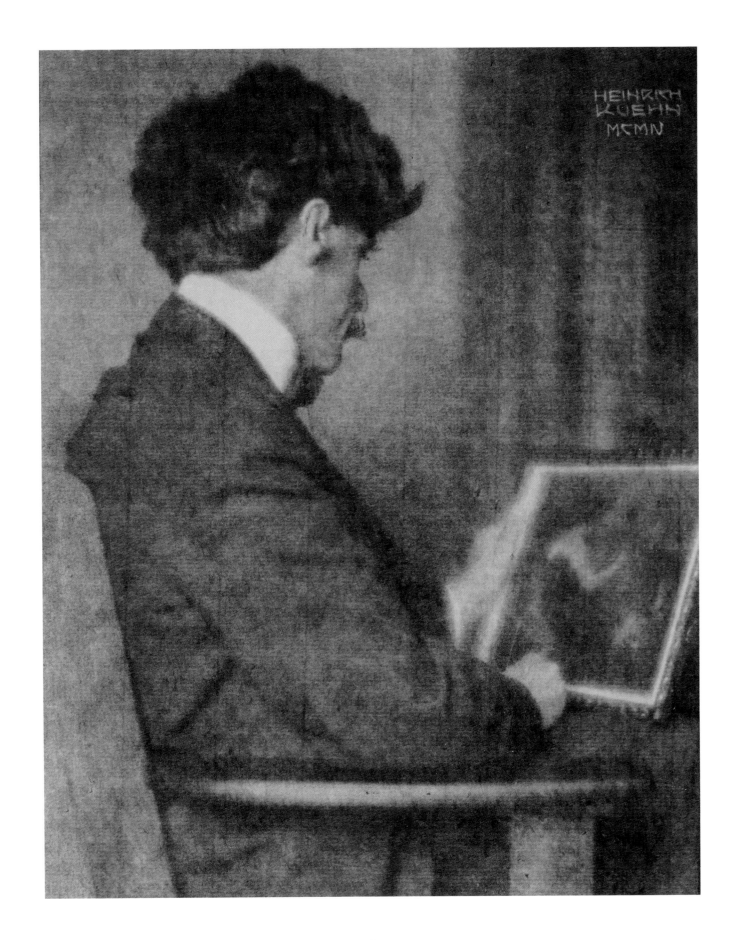

Das Porträt des großen amerikanischen Fotografen Alfred Stieglitz veranschaulicht in besonderer Weise die technische Fertigkeit und das fotografische Kompositionsprinzip von Heinrich Kühn. Er war bestrebt, einfache, klare Formen ins Bild zu setzen und in ausschnitthafter Nahsicht wiederzugeben. Er spielte mit der gesamten Palette von Tonwerten zwischen Schwarz und Weiß und erreichte damit einen vibrierenden, vielschichtigen Bildeindruck, wozu auch die matten Papiere und die aufwendigen Edeldruckverfahren beitrugen.

1904 reiste Stieglitz anlässlich einer Wiener Ausstellung von amerikanischer piktorialistischer Fotografie nach Österreich und besuchte Heinrich Kühn in Tirol. Stieglitz präsentierte Kühns Werke in seiner New Yorker Galerie und blieb dem österreichischen Fotografen als Freund und »Wegweiser« (Kühn) verbunden, wovon eine umfangreiche Korrespondenz Zeugnis gibt. Die Aufnahme zeigt den bewunderten amerikanischen Vorreiter der Moderne in Kühns Wohnung beim Betrachten einer gerahmten Fotografie.

The portrait of the great American photographer Alfred Stieglitz illustrates in a special way Heinrich Kühn's technical skill and photographic composition principle. He endeavoured to put simple, clear shapes in the picture and reflect a fragmentary close-up view. He played with the full range of tonal values between black and white, thus achieving a vibrant, multi-layered visual impression, to which the matte paper and pigment-printing processes also contributed.

In 1904 Stieglitz travelled to Austria for a Viennese exhibition of American Pictorialist photography, and he visited Heinrich Kühn in Tyrol. Stieglitz presented Kühn's works in his New York gallery and remained linked to the Austrian photographer as a friend and "guide" (Kühn), and their extensive correspondence bears witness to this. The photograph shows the admired American pioneer of Modernism in Kühn's apartment looking at a framed photograph.

Literatur/Further reading: Monika Faber und/and Astrid Mahler (Hrsg./eds.), *Heinrich Kühn. Die vollkommene Fotografie* (Ausst.-Kat./exh. cat. Albertina, Wien/Vienna), Ostfildern 2010

Heinrich Kühn
Alfred Stieglitz, 1904
Platinotypie/platinotype

Madame d'Ora

Geboren 1881 in Wien/Österreich, mit bürgerlichem Namen Dora Philippine Kallmus, verstorben 1963 in Frohnleiten, Steiermark/Österreich. Nach Kursen an der Wiener Graphischen Lehr- und Versuchsanstalt ging Dora Kallmus 1907 nach Berlin, wo ihr Nicola Perscheid die praktischen Grundlagen der Porträtfotografie vermittelte. Dort begegnete sie Arthur Benda, mit dem sie im selben Jahr in Wien ein Porträtstudio unter ihrem Künstlernamen eröffnete: das Atelier d'Ora. Sie wurde bekannt mit Porträtaufnahmen der Wiener Künstler- und Intellektuellenszene. 1925 verlagerte Madame d'Ora ihr Studio nach Paris, wo sie als Gesellschafts-, Künstler- und Modefotografin berühmt wurde. Nach dem Zweiten Weltkrieg kehrte sie nach Österreich zurück und fotografierte Flüchtlingslager und das zerstörte Wien. Sie änderte ihren Aufnahmestil, sodass in den 1950er-Jahren Fotos mit präziser Schärfe entstanden. Zu ihrem Spätwerk gehören auch die Fotografien von getöteten Tieren in Pariser Schlachthöfen von 1959, die in drastischen Bildern von Qual und Tod erzählen. Nach einem Autounfall in Paris zog sich Madame d'Ora 1961 nach Österreich zurück.

Born in 1881 as Dora Philippine Kallmus in Vienna/Austria, died in 1963 in Frohnleiten, Styria/Austria. After taking courses at Vienna's Graphische Lehr- und Versuchsanstalt, Dora Kallmus went to Berlin in 1907, where Nicola Perscheid taught her the practical basics of portrait photography. There she met Arthur Benda, with whom she opened a portrait studio in the same year in Vienna under her pseudonym: Atelier d'Ora. She was known for her portraits of members of the Viennese arts and intellectual scene. In 1925 Madame d'Ora moved her studio to Paris, where she became famous as a society, artist and fashion photographer. After the Second World War she returned to Austria and photographed refugee camps and the destruction in Vienna. She changed her style, and photographs with precision and sharp focus emerged in the 1950s. Her later works include the photographs of animals killed in Paris slaughterhouses in 1959, which tell of torture and death in dramatic images. After a car accident in Paris, Madame d'Ora moved back to Austria in 1961.

Die Porträtfotografie gehörte zu dem Bereich, auf den sich Madame d'Ora spezialisiert hatte. Vom Jugendstil inspiriert und dem Piktorialismus verpflichtet schuf sie in den 1920er-Jahren wunderbar elegante und von melancholischer Stimmung getragene Bilder voll samtiger Beleuchtung und ausgewogener Komposition. Die Fotografie von der unbekannten Dame in einem Kostüm mit hochgestelltem Kragen, großer Brosche und zart übereinandergelegten Händen ist ein Beispiel dieser statisch komponierten Porträtaufnahmen, in denen die weichen Tonabstufungen und die in sich gekehrte Mimik gleichermaßen am malerisch-lyrischen Ausdruck beteiligt sind. Es könnte sich um eine Modeaufnahme oder ein Rollenporträt einer Schauspielerin handeln.

Portrait photography was the area in which Madame d'Ora had specialized. Inspired by the Art Nouveau movement and committed to Pictorialism, she created wonderfully elegant pictures in the 1920s that carried a melancholic mood full of velvety lighting and balanced composition. The photograph of the unknown lady in a costume with a turned-up collar, large brooch and delicate hands laid on top of one another is an example of statically composed portraits in which the soft gradations of tone and introspective expressions are equally involved in the picturesque lyrical expression. It could be a fashion shot or a role portrait of an actress.

Literatur/Further reading: Monika Faber, *Madame d'Ora. Wien – Paris. Porträts aus Kunst und Gesellschaft 1907–1957*, Wien und München/Vienna and Munich 1983

Madame d'Ora
Ohne Titel/Untitled, 1925
Bromsilberprint, getont/
bromine silver print, toned

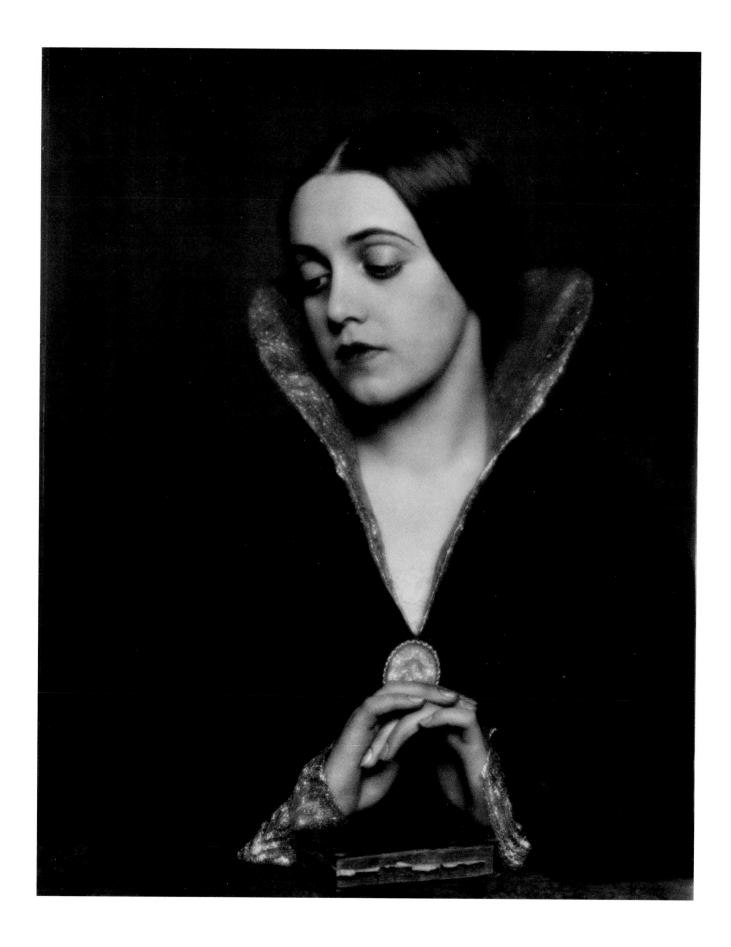

Trude Fleischmann

Geboren 1895 in Wien/Österreich, verstorben 1990 in Brewster, New York/USA. Von 1913 bis 1916 absolvierte Trude Fleischmann eine Fotografenausbildung an der Graphischen Lehr- und Versuchsanstalt in Wien. Sie arbeitete während dieser Zeit zudem bei Madame d'Ora als Retoucheuse und bis 1919 im Wiener Atelier von Hermann Schieberth. In diesem Jahr wurde sie Mitglied der Photographischen Gesellschaft Wien. Anfang 1920 eröffnete sie ihr eigenes Porträtstudio im 1. Wiener Bezirk und wurde schnell zu einer der gefragtesten Porträtfotografinnen der Stadt. In ihrem Atelier entstanden Aufnahmen von zahlreichen bekannten Persönlichkeiten aus Gesellschaft, Kunst und Kultur, darunter Max Reinhardt, Bruno Walter, Hedy Lamarr, Alban Berg, Wilhelm Furtwängler, Adolf Loos und Stefan Zweig. In den Jahren 1938 und 1939 emigrierte Fleischmann über Paris und London nach New York, wo sie von 1940 bis 1969 ein Atelier für Porträt- und Modefotografie unterhielt. Sie fotografierte für große Modemagazine wie *Vogue* und fertigte Porträts von prominenten Emigranten, Künstlern und Intellektuellen, aber auch Stadtansichten und Straßenszenen an. Nach 1969 zog sie sich aus dem Berufsleben zurück und lebte zeitweise in Lugano.

Born in 1895 in Vienna/Austria, died in 1990 in Brewster, New York/USA. From 1913 to 1916 Trude Fleischmann completed her training in photography at the Graphische Lehr- und Versuchsanstalt in Vienna. During this time, she also worked with Madame d'Ora as a retoucher and in the Viennese studio of Hermann Schieberth until 1919. In this year she became a member of the Vienna Photographic Society. Early in 1920 she opened her own portrait studio in the 1st District of Vienna and quickly became one of the most sought-after portrait photographers in the city. Photographs were taken in her studio of many famous society, arts and culture celebrities, including Max Reinhardt, Bruno Walter, Hedy Lamarr, Alban Berg, Wilhelm Furtwängler, Adolf Loos and Stefan Zweig. In 1938 and 1939 Fleischmann emigrated via Paris and London to New York, where she had a studio for portrait and fashion photography from 1940 to 1969. She took photographs for major fashion magazines such as *Vogue* and made portraits of prominent exiles, artists and intellectuals, and also of cityscapes and street scenes. After 1969, she retired from professional life and lived part of the time in Lugano.

Der 1874 in Böhmen geborene Schriftsteller Karl Kraus hatte 1899 in Wien die kritische Zeitschrift *Die Fackel* gegründet, in der auch sein Opus magnum *Die letzten Tage der Menschheit* im Vorabdruck erschien. Kraus war bekannt für seine beißenden Satiren. Ein Leben lang polarisierte er und konnte sich mit einer opportunistischen Politik nicht abfinden. Das Porträt von Fleischmann zeigt ihn acht Jahre vor seinem Tod in ungewohnt melancholischer Pose, geprägt von Resignation und Innenschau. Die Fotografin zeichnet ihn in spätestem piktorialistischem Stil vor samtig-dunklem Hintergrund mit drastisch akzentuiertem Lineament der Hände.

Born in Bohemia in 1874, writer Karl Kraus in 1899 in Vienna founded the critical journal *Die Fackel*, in which his magnum opus, *The Last Days of Mankind*, appeared as an advance publication. Kraus was known for his biting satire. He polarized all his life and could not come to terms with opportunistic politics. Fleischmann's portrait shows him eight years before his death in an unusually melancholic pose, marked by resignation and introspection. The photographer shows him in the latest Pictorialist style, against a velvety dark background and with dramatically accentuated hand features.

Literatur/Further reading: Anton Holzer und/and Frauke Kreutler (Hrsg./eds.), *Trude Fleischmann. Der selbstbewusste Blick/A Self-assured Eye* (Ausst.-Kat./exh. cat. Wien Museum), Ostfildern 2011

Trude Fleischmann
Karl Kraus, 1928
Silbergelatineprint/silver gelatin print

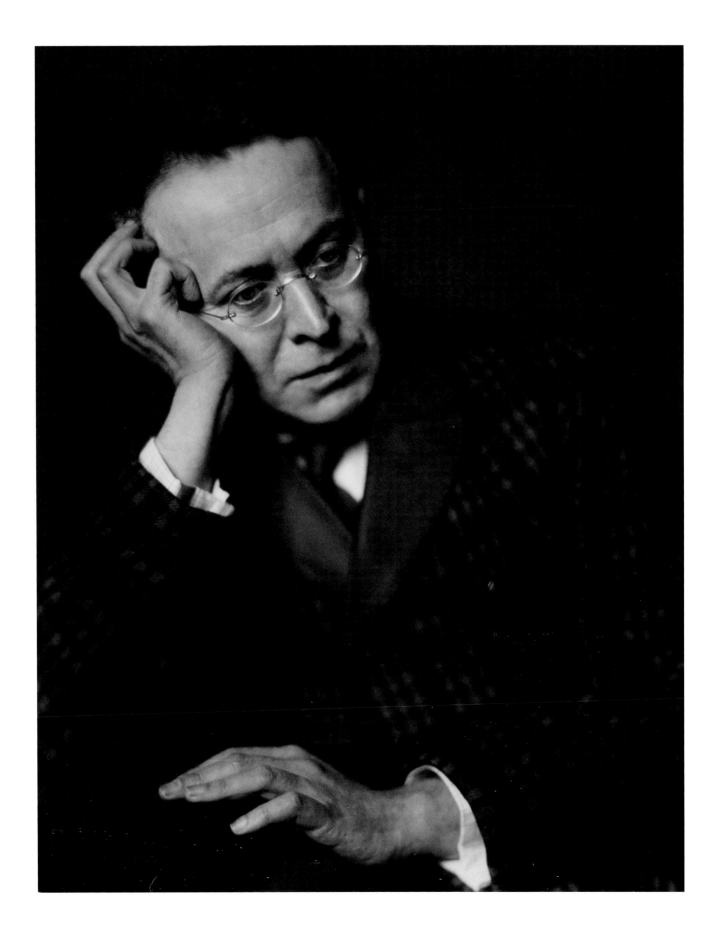

DIE TSCHECHISCHE FOTOGRAFIE
VOR DEM ZWEITEN WELTKRIEG

CZECH PHOTOGRAPHY
BEFORE WORLD WAR II

Vladimír Birgus

Keiner der professionellen tschechischen Fotografen des 19. Jahrhunderts erlangte internationale Berühmtheit. Es gab einige ausgezeichnete Porträtfotografen wie Jindřich Eckert, František Fridrich und Jan Langhans, aber die meisten Studioproduktionen waren von akademischer Routine bestimmt. Die Amateurfotografie florierte in der Zeit des Piktorialismus und unter den damaligen Amateurfotografen waren viele, die künstlerische Ambitionen an den Tag legten. Im Jahr 1889 wurde in Prag der Club der Amateurfotografen gegründet, die erste tschechische Fotografenvereinigung, die vier Jahre später auch die erste Ausgabe der Zeitschrift *Fotografický obzor* herausgab, welche über fünfzig Jahre lang bestehen sollte.

Die Fotografen des Piktorialismus wie Otto Šetele und Rudolf Špillar begannen mit Edeldruckverfahren zu experimentieren, erzeugten so wesentliche Interferenzen im fotografischen Abbild und ermöglichten dadurch die Wiedereinführung des einzigartigen kreativen Originals in der Fotografie. Prominente Vertreter im tschechischen Raum waren unter anderem der Landschafts- und Porträtfotograf Josef Binko sowie Graf Karel Maria Chotek, ein Mitglied des Wiener Camera-Clubs und Cousin der Gemahlin von Erzherzog Franz Ferdinand, dessen fotografisches Werk insbesondere vom Impressionismus beeinflusste Landschaften und Genreszenen enthielt, die bis vor Kurzem komplett in Vergessenheit geraten waren. Zu dieser Zeit schuf auch der berühmte tschechische Maler und Grafiker Alfons Mucha, der sich meist in Paris aufhielt, Akt- und Porträtfotos von außergewöhnlicher Qualität, obwohl diese eigentlich keine eigenständigen Werke waren, sondern eher Entwürfe für seine Gemälde, Plakate und Grafiken.

Zur Schlüsselfigur in der neuen Generation professioneller Fotografen mit künstlerischen Ambitionen wurde František Drtikol, der

None of the Czech professional photographers of the nineteenth century achieved international renown. There were some excellent portrait photographers such as Jindřich Eckert, František Fridrich and Jan Langhans, but most studio production remained constrained by academic routine. It was the amateur photographers who began to thrive, and many of them had artistic ambitions during the period of Pictorialism. The year 1889 saw the founding of the Amateur Photographers' Club in Prague, the first Czech photography club, which four years later started publishing the magazine *Fotografický obzor*, which was to continue for more than half a century.

Pictorialist photographers such as Otto Šetele, Rudolf Špillar and others began utilizing pigment processes, allowing substantial interference in the final photographic image and the re-introduction of a unique creative original. Prominent figures in photography in the Czech lands included the landscape and portrait photographer Josef Binko and Count Karel Maria Chotek, a member of the Viennese Camera-Club and a cousin of the wife of Archduke Franz Ferdinand, whose photographic artwork, featuring in particular landscapes and genre scenes influenced by Impressionism, had been completely forgotten until recently. This was also the time that the famous Czech painter and graphic artist Alphonse Mucha, who lived mainly in Paris, created photographic nudes and portraits of exceptional quality, though these were not final works but rather sketches for his paintings, posters and pieces of graphic art.

It was František Drtikol, now rightly regarded as the first Czech photographer of world renown, who became a crucial figure in the new generation of photographic professionals with artistic ambitions. In his youth, Drtikol graduated from the newly founded Lehr- und Versuchsanstalt für Photographie in Munich, where he took an in-

heute zu Recht als der erste weltweit bekannte tschechische Fotograf betrachtet wird. Als junger Mann studierte Drtikol an der kurz zuvor gegründeten Lehr- und Versuchsanstalt für Photographie in München, wo er sich intensiv mit dem Jugendstil und dem Symbolismus auseinandersetzte. Nach der Rückkehr in seine Heimat erlangte er wahre Meisterschaft im Bereich der Porträt- und Landschaftsfotografie, schuf aber auch in anderen Genres Herausragendes. Trotzdem war Drtikol in erster Linie für seine Aktfotografien berühmt. In seiner ersten Schaffensperiode vor dem Ersten Weltkrieg sind Konzepte wie das der Femme fatale der Romantik ebenso zu finden wie das der »verträumten Fee« des Symbolismus. Unter dem wachsenden Einfluss der Avantgarde-Fotografie veränderte sich sein fotografisches Arbeiten um 1923 radikal. Allmählich legte er sich einen ganz eigenen Stil zu, durch den er trotz einiger Hindernisse und mit einigen Jahren Verspätung seine Position innerhalb der progressiven – wenn auch nicht avantgardistischen – Strömung in der tschechischen Fotografie behaupten konnte. Geometrische Dekorationen und projizierte Schatten ersetzten gemalte Hintergründe und träumende Modelle machten Tänzern Platz. Nackte Körper wurden nicht mehr nur als reine Hüllen für die Seele empfunden, sondern als Formen, denen ästhetische Bedeutung zukam. Mit seinen bewusst eingesetzten scharfen Schatten versuchte Drtikol, flächige Kontraste zur Plastizität der Modelle und der kubischen Formen zu schaffen. Dies ist auch der Fall bei seinen relativ seltenen Aktfotografien von Knaben und Männern. Die Dynamik der Komposition wurde intensiviert und der Beleuchtung und Bewegung wurde in seinen Arbeiten ein immer höherer Stellenwert eingeräumt. Zwischen 1930 und 1935 schuf Drtikol eine Reihe von symbolischen Darstellungen geschnitzter Figuren, die vom Buddhismus und anderen östlichen Religionen und philosophischen Richtungen inspiriert waren. Im Jahr 1935 endete seine künstlerische Karriere weitestgehend.

Ein eigenes Kapitel könnte dem vielseitig talentierten Anton Josef Trčka, der wienerisch-tschechischer Herkunft war, sowie dem österreichischen Fotografen Rudolf Koppitz, der aus der Nähe der Stadt Rýmařov im tschechischen Schlesien stammte, gewidmet werden. Beide studierten Fotografie an der K. K. Graphischen Lehr- und Versuchsanstalt in Wien unter dem tschechischen Fotografen Karel Novák. Trčka verbrachte fast sein ganzes Leben in Wien, wo auch seine weltbekannten ausdrucksstarken Porträts von Egon Schiele, Gustav Klimt und anderen Künstlern entstanden. Koppitz, der hervorragende Porträts, Akte, symbolisch ausgerichtete Kompositionen und Fotografien von Naturszenen schuf, arbeitete mehrere Jahre in Fotostudios in Bruntál, Opava, Brünn und Liberec, bevor er nach Wien zog und dort ganz in die österreichische Fotoszene integriert wurde. Deutsche und österreichische Fotografen, die im tschechischen Raum lebten, fanden sich in eigenen Amateurfotografie-Clubs zusammen und veröffentlichten ihre eigenen Fachzeitschriften.

Alfons/Alphonse Mucha, Ohne Titel / Untitled, 1895
Silbergelatineprint / silver gelatin print, 18,1 × 24 cm
Sammlung FOTOGRAFIS Bank Austria /
FOTOGRAFIS Bank Austria Collection

tense interest in Art Nouveau and Symbolism. Having returned to his homeland, he gradually became an excellent photographer in portrait and landscape photography as well as other genres. Nevertheless, Drtikol became famous mainly for his nude photography. In his earliest period before World War I we can find the femme fatale of Romanticism as well as the visionary fairy of Symbolism. Under the growing influence of avant-garde photography, Drtikol's photographs changed radically around 1923. He gradually created an original style owing to which, after several years of delays and impediments, he resumed his position in the progressive – although not avant-garde – current of Czech photography. Geometrical decoration and projected shadows substituted for painted backgrounds, and dreaming models gave way to dancers. Naked bodies were no longer conceived as mere receptacles for the soul, but as forms bearing aesthetic significance. Drtikol used striking shadows, utilized to create planar contrasts to the plasticity of both the models and various cubes. This is also the case with the relatively sporadic nudes of boys and men. The dynamics of composition were intensified; lighting and movement came to play an increasingly important role in his work. In the period from 1930 to 1935, Drtikol created a series of symbolic depictions involving carved figures inspired by Buddhism and other Eastern religions and philosophical systems. The year 1935 practically marks the end of his artistic career.

A special chapter could be set aside for the multi-talented Viennese-Czech Anton Josef Trčka, and the Austrian photographer Rudolf Koppitz, from the environs of the town of Rýmařov in Czech Silesia. They both studied photography at the K. K. Graphische Lehr- und

Die im Oktober 1918 entstandene unabhängige Tschechoslowakei war eine blühende Demokratie mit einer Bevölkerung, die aus den verschiedensten Nationen stammte, und mit einem reichen Kulturleben. Die Fotografie wurde nun auch als Kunstform anerkannt. Ende 1921 wurden in den Räumlichkeiten des tschechischen Clubs der Amateurfotografen Werke von Drahomír Josef Růžička, einem Amerikaner tschechischer Herkunft, ausgestellt, der aktives Mitglied der amerikanischen Fotografiebewegung war und als einer der Ersten die von Alfred Stieglitz und Clarence H. White propagierte naturgetreue Fotografie förderte. Růžičkas eigenes Werk zeigte eine offensichtliche Neigung zu denselben Themen, Motiven und Kompositionen sowie eine Vorliebe für Beleuchtungseffekte und – beeinflusst vom Impressionismus und dem Piktorialismus des Jugendstils – für die Verwendung von weichzeichnenden Objektiven. Da er den Zusatz von Pigmenten bei der Entwicklung der Negative ablehnte, kann

František Drtikol, Ohne Titel / Untitled, 1911
Pigmentdruck / carbon print, 21,5 x 14,5 cm
Sammlung FOTOGRAFIS Bank Austria /
FOTOGRAFIS Bank Austria Collection

Versuchsanstalt in Vienna under the Czech photographer Karel Novák. Trčka lived almost his entire life in Vienna, where he produced his world-famous expressive portraits of Egon Schiele, Gustav Klimt and other artists. Rudolf Koppitz, the creator of outstanding portraits, nudes, symbolically staged compositions and photographs of nature, worked professionally for several years in photographic studios in Bruntál, Opava, Brno and Liberec, before moving to Vienna and becoming fully integrated into Austrian photography. Germans and Austrians living in the Czech lands organized themselves in their own amateur photography clubs and magazines.

Independent Czechoslovakia, established in October 1918, was a prosperous democratic country with a diverse mix of nationalities and a rich cultural life. Photography no longer lagged behind other art forms. At the end of 1921, the premises of the Czech Amateur Photographer's Club hosted an exhibition of work by Drahomír Josef Růžička, a Czech-American who as an active member of the US photographic movement pioneered the direct image photography promoted by Alfred Stieglitz and Clarence H. White. Růžička's own work showed an apparent inclination toward themes, motifs, composition, an emphasis on illumination effects and the employment of soft-focus objectives influenced by Impressionist and Art Nouveau Pictorialism, however; rejecting pigment processes and applying the non-interference principle to the process of working with negatives, his work may already be classified as Purist Pictorialism. Růžička's work strongly influenced his younger contemporaries in particular, who, following his example, began to favour gelatin silver prints.

Avant-garde trends, mainly Cubism and Expressionism, were already practised before World War I in the Czech lands. Intensive contacts with German, Russian and French avant-gardes were particularly influential. Founded in October 1920 as an association aiming for a revolutionary change in art and society, the Artistic Union Devětsil represented a particularly influential grouping. After a gradual shift from proletarian art, its artistic orientation formed two poles: Constructivism and mainly Poetism, the first avant-garde trend originating in the Czech lands. Photographs played an important role in the so-called picture poems from 1923 to 1927. These were specific poetic collages fulfilling the demand of the main Devětsil theorist, Karel Teige, for a fusion of poetry and fine arts. The authors of picture poems Karel Teige, Jindřich Štyrský, Evžen Markalous and Jaroslav Rössler were inspired by free associations, enthusiasm for a new civilisation, the hedonism of life, and a poetic vision of the world.

The beginnings of abstract photography in the Czech lands are connected to Jaroslav Rössler, Drtikol's student and, from 1923, a member of Devětsil. The first Czech photography fully conforming to

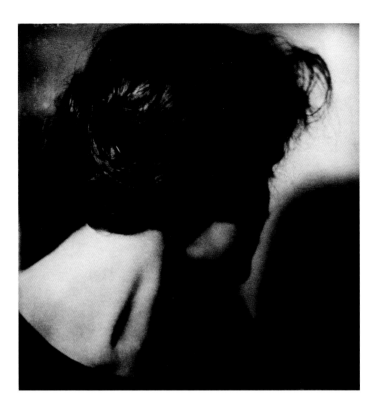

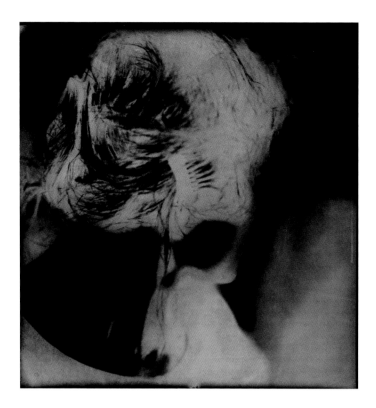

Jaroslav Rössler, *Gesichtsstudie I & II*, um / ca. 1927
Positiv- und Negativdruck / positive and negative print,
je 24 × 23,2 cm / 24 × 23.2 cm each
Sammlung FOTOGRAFIS Bank Austria /
FOTOGRAFIS Bank Austria Collection

sein Werk bereits dem sogenannten puristischen Piktorialismus zugeordnet werden. Růžičkas Arbeit beeinflusste besonders stark seine jüngeren Kollegen, die nach seinem Vorbild begannen, bei der Fotografie Filme zu verwenden, die mit einer lichtempfindlichen Silberschicht überzogen waren.

Avantgardistische Strömungen – in erster Linie Kubismus und Expressionismus – gab es im tschechischen Raum bereits vor dem Ersten Weltkrieg, wobei vor allem auch intensive Kontakte mit deutschen, russischen und französischen Avantgardisten eine wichtige Rolle spielten. Die im Oktober 1920 gegründete Künstlervereinigung Devětsil, deren Ziel eine revolutionäre Umwandlung der Kunst und der Gesellschaft war, erwies sich als besonders einflussreiche Gruppe. Von der proletarischen Kunst hatte sie sich allmählich abgewandt und ihre künstlerische Ausrichtung bildeten nun zwei Pole: der Konstruktivismus und vor allem der sogenannte Poetismus, die erste auf dem Gebiet der heutigen Tschechischen Republik entstandene avantgardistische Kunstrichtung. Eine wichtige Rolle spielte die Fotografie von 1923 bis 1927 in den sogenannten Bildgedichten, poetischen Collagen, die die Forderung von Karel Teige, dem wichtigsten Theoretiker von Devětsil, nach einer Verschmelzung von Poesie und bildenden Künsten erfüllten. Inspiration waren für die Autoren von Bildgedichten – unter ihnen Karel Teige selbst, Jindřich Štyrský, Evžen Markalous und Jaroslav Rössler – freie Assoziationen, das enthusiastische Streben nach einer neue Zivilisation, die Freude am Leben sowie eine poetisch orientierte Weltanschauung.

avant-garde principles, his still life composed on a diagonal section, known as *Opus 1,* dates back to as early as 1919. In 1923 he photographed light from moving reflector lamps with a lens intentionally out of focus. The result were pictures of blurred circles, lens-like objects, curves and light cones which suggested feverish visions as well as a luminous primary matter. He was one of the first photographers to position light, as playing a primary role in photography, in the focal point of interest. Rössler also created compositions with simple objects – an ashtray, candle, reel or wineglass – on a background of black and white cardboard, cut into distinct geometrical forms. He also used diagonal compositions and bold low-point views in a number of photographs. During his stay in Paris, from 1925 to 1935, Rössler created many photographs and photomontages of the Eiffel Tower as well as many advertising images. Rössler's work, which in many ways has a pioneering position, was for a long time known only to a narrow circle of experts. His first monograph was published as recently as 2001.

Jaromír Funke, the best-known representative of Czech avant-garde photography, made his transition from Pictorialist landscapes and genre scenes to compositions with abstract tendencies as early as

Die Anfänge der abstrakten Fotografie im tschechischen Raum gehen auf Jaroslav Rössler zurück, der Schüler von Drtikol und ab 1923 Mitglied von Devětsil war. Das erste tschechische Foto, das vollständig avantgardistischen Prinzipien entsprach, war seine schräg angeschnittene Stilllebenkomposition, bekannt als *Opus 1,* die bereits 1919 entstanden war. 1923 fotografierte er durch bewegliche Reflektoren erzeugte Lichteffekte mit einer absichtlich unscharf eingestellten Linse. Das Ergebnis waren Bilder von verschwommenen Kreisen, linsenartigen Objekten, Kurven und Lichtkegeln, die an fieberhafte Visionen und eine Art leuchtenden »Urstoff« denken lassen. Rössler war einer der ersten Fotografen, die das Licht selbst wegen der zentralen Rolle, die es in der Fotografie spielt, in den Mittelpunkt stellten. Er schuf auch Kompositionen mit Alltagsgegenständen – mit einem Aschenbecher, einer Kerze, einer Spule oder einem Weinglas –, die er vor einen Hintergrund aus geometrischen Formen stellte, welche aus schwarzem und weißem Karton ausgeschnitten waren. Ebenso wagte er bei zahlreichen Fotografien diagonale Kompositionen und spannende Untersichten. Während seines Parisaufenthaltes zwischen 1925 und 1935 fertigte Rössler viele Fotografien und Fotomontagen vom Eiffelturm an und schuf zahlreiche Werbebilder. Sein Werk, das in vielerlei Hinsicht eine Pionierrolle einnahm, war lange Zeit nur einem kleinen Kreis von Fachleuten bekannt. Die erste Rössler-Monografie wurde erst im Jahr 2001 veröffentlicht.

Jaromír Funke, der bekannteste Vertreter der tschechischen Avantgarde-Fotografie, wandte sich bereits 1923 und 1924 von piktorialistischen Landschaften und Genreszenen ab, um sich abstrakteren Kompositionen zuzuwenden, wobei er auf das Darstellen konkreter Gegenstände mehr und mehr verzichtete. In den Stillleben, die Funke ab 1923 anfertigte und die Glaswürfel, Flaschen oder Glasnegative zeigen, galt das visuelle Interesse zunehmend den Schatten, die diese Objekt auf den Hintergrund warfen. In diesen Werken spielt nicht mehr der Gegenstand selbst die Hauptrolle: Im Zentrum stehen das vom Gegenstand reflektierte Licht und sein Schatten. Themen wie Licht, Transparenz und Spiegelbild kulminierten in der zwischen 1927 und 1929 entstandenen Serie *Abstrakte Kompositionen,* in der verschiedene Zusammenstellungen von Schatten, direktem und reflektiertem Licht allmählich figurative Motive und Details von Glasobjekten ersetzten. Gleichzeitig schuf Funke Stillleben aus geometrischen Grundformen und Linien, weiters Fotografien, die den ästhetischen Wert industriell gefertigter Objekte offenbaren, sowie Architekturaufnahmen in Schrägansicht. Einflüsse des frühen Surrealismus lassen sich in seinen Werkserien *Reflexionen* (1929) und *Die Zeit dauert* (1930–1934) erkennen.

Das Werk von Funkes Freund Eugen Wiškovský ist vermutlich der originellste und radikalste Beitrag zur tschechischen Neuen Fotografie. Seine ausgeklügelten Kompositionen bilden visuell eindrucks-

Jaromír Funke, Ohne Titel / Untitled, 1936
Silbergelatineprint / silver gelatin print, 21 × 17,2 cm
Sammlung FOTOGRAFIS Bank Austria /
FOTOGRAFIS Bank Austria Collection

1923 to 1924, increasingly minimising the representations of particular subject matter. In his renditions of still lifes, which Funke started producing in 1923, featuring glass cubes, bottles or glass negatives, the essential visual emphasis is increasingly placed on the shadows they cast on the background. In these works, the main role is no longer played by the subject matter itself but by the reflection and shadow of the subject. The theme of light, transparency and reflections culminated in his series *Abstract Compositions* from 1927 to 1929, in which various configurations of cast shadows and direct and reflected light gradually supplant fine figurative motifs and details of glass objects. Simultaneously, Funke was producing still lifes with elemental shapes and lines, images revealing the aesthetic value of industrial subject matter and architectural photography arranged on a diagonal section. Early Surrealist influences appear in his series *Reflections* (1929) and *Time Persists* (1930–1934).

Work by Funke's friend Eugen Wiškovský is possibly the most original and radical expression of Czech New Photography. His ingenious compositions extract visually impressive shapes from concrete pipes,

volle Formen aus Betonrohren, elektrischen Isolatoren, Turbinen, Metallteilen, Schallplatten und anderen Industrie- und Alltagsobjekten. Indem er ungewöhnliche Bildausschnitte wählte, Details vergrößerte und diese außerhalb ihres Kontexts verwendete, die farbige Realität in Schwarz-Weiß-Fotografie umsetzte und die Motive rhythmisch wiederholte, gelang es Wiškovský, die konventionelle Wahrnehmung von Gegenständen zu verändern und deren oft unerwartete symbolische Bedeutungen zu entdecken. In der zweiten Hälfte der 1930er-Jahre interessierte Wiškovský sich verstärkt für Landschaften mit ihren eindrucksvollen geometrischen Formen, ungewöhnlichen Strukturen und fantasiereichen metaphorischen Bildern. Seine Fotografien, ergänzt um ein unwahrscheinlich originelles und progressives theoretisches Werk, sind nicht so sehr in ihren Zielen oder aufgrund ihrer thematischen Bandbreite außergewöhnlich, sondern eher ihrer Eigenständigkeit, ihrer Raffinesse und ihres geistigen Tiefgangs wegen.

Die Neue Fotografie leistete zudem einen wichtigen Beitrag zur fotografischen Interpretation der modernen Architektur und der modernen Werbung in der Zwischenkriegszeit. Josef Sudek, der sich seit seinem Studium an der Grafischen Schule in Prag intensiv mit Fotografie beschäftigte, schuf Werbebilder für Bücher, für Bedarfsgegenstände, Ausstellungen und Verkaufsveranstaltungen. Er konzentrierte sich in erster Linie auf die Darstellung von Glas, Porzellan und Metallobjekten, die er oft in diagonale Kompositionen einbaute. Seine wichtigsten Werke, zu denen die Serien *Blick aus meinem Fenster*, *Spaziergang durch den Zaubergarten* und *Prag panoramisch* sowie mehrere Serien von Stillleben gehören, schuf Sudek später, ab den 1940er-Jahren und noch bis zu seinem Tod im Jahr 1976. Alexandr Hackenschmied, Ladislav Emil Berka, und Jiří Lehovec, die die informelle Gruppe Aventinum Trio bildeten, sind gleichfalls wichtige Vertreter der Neuen Fotografie, ebenso wie Jan Lauschmann, einer der am stärksten zukunftsorientierten und auch international erfolgreichen tschechischen Amateurfotografen seiner Zeit, weiters Josef Voříšek, Emil Vepřek, Jiří Jeníček, Vladimír Hipman und Karel Kašpařík. Manche der in der Tschechoslowakei lebenden deutschen Fotografinnen und Fotografen, wie beispielsweise Heinrich Wicpalek, Ferry Klein und Grete Popper, waren ebenfalls erfolgreich mit Werken, die den Prinzipien der Neuen Fotografie folgten.

Die linksgerichtete Bewegung der sozialdokumentarischen Fotografie, die in der Tschechoslowakei während der Großen Depression in den frühen 1930er-Jahren weit verbreitet war, orientierte sich in erster Linie an der deutschen Arbeiterfotografie und den Zeitschriften *Arbeiter Illustrierte Zeitung* und *Der Arbeiter-Fotograf*. Ihr wichtigstes Fundament war die Levá fronta (Linke Front), eine im Oktober 1929 gegründete Organisation, die 1933 und 1934 zwei stark propagandistische internationale Ausstellungen über sozialdokumentarische

electrical insulators, turbines, metal and gramophone discs, and other industrial and everyday objects. Working with imaginative crops, enlarging details and using them out of context, translating colourful reality into black-and-white photography, and rhythmically repeating motifs, Wiškovský managed to alter the conventional perception of objects and often discovered their unexpected symbolic meanings. In the second half of the 1930s, Wiškovský's interest shifted to the landscape with its impressive geometric shapes, unusual surface structures and fanciful metaphorical images. His photographs, complemented by extremely original and progressive theoretical work, are outstanding not in their scope or thematic breadth, but rather in their originality, sophistication and intellectual depth.

New Photography also made an important contribution to the photographic interpretation of modern architecture and modern advertising of the interwar period. Josef Sudek, who had been intensely devoted to photography since his studies at the Graphic Arts School in Prague, produced advertising images for books, utensils and exhibitions and sales events. Sudek focused mostly on images of glass, porcelain and metal objects, which he frequently integrated into diagonal compositions. His major works, including the series *Window of My Studio*, *A Walk through a Magic Garden* and *Prague Panoramic* and several series of still lifes, were produced later, from the 1940s until his death in 1976. Alexandr Hackenschmied, Ladislav Emil Berka and Jiří Lehovec, who constituted the informal Aventinum Trio, are also important representatives of New Photography. Others are Jan Lauschmann, one of the most forward-looking and internationally successful Czech photo amateurs of the time, Josef Voříšek, Emil Vepřek, Jiří Jeníček, Vladimír Hipman and Karel Kašpařík. Some of the German photographers living in Czechoslovakia, for example Heinrich Wicpalek, Ferry Klein and Grete Popper, also successfully made works in the spirit of New Photography.

The leftist movement of social documentary photography, which spread in Czechoslovakia during the Great Depression in the early 1930s, was inspired above all by the German movement of workers' photography and the journals *Arbeiter Illustrierte Zeitung* and *Der Arbeiter-Fotograf*. Its most important base was the Levá fronta (Left Front), an organization founded in October 1929 that organized two markedly propagandistic international exhibitions of social documentary photography in 1933 and 1934. Among the proponents of social documentary photography as propaganda were Oldřich Straka, Vladimír Hnízdo, Jiří Lehovec and František Povolný. Some of the best social documentary photographs, often with a daring avant-garde conception, including large close-ups, views from below, and diagonal compositions, were made by Karel Kašpařík. Modern Czech reportage photography, represented by, for example, Karel Hájek, Pavel Altschul and Václav Jírů, centred on the magazines *Pestrý týden* and *Světozor*.

Fotografie organisierte. Unter den Vorreitern der sozialdokumentarischen Fotografie für Propagandazwecke befanden sich auch Oldřich Straka, Vladimír Hnízdo, Jiří Lehovec und František Povolný. Einige der besten sozialdokumentarischen Fotografien, bei denen oftmals gewagte avantgardistische Konzepte wie große Nahaufnahmen, Untersichten und diagonal angeordnete Kompositionen umgesetzt wurden, stammten von Karel Kašpařík. Moderne tschechische Reportagefotografien, wie etwa jene von Karel Hájek, Pavel Altschul oder Václav Jírů, erschienen in den Zeitschriften *Pestrý týden* und *Světozor.*

Die sogenannte Surrealistische Gruppe in der Tschechoslowakei wurde 1934 gegründet. Ihre Mitglieder strebten danach, durch das Studium von Träumen, des Unterbewusstseins, der Erotik und des psychischen Automatismus die Gesellschaft auf revolutionäre Weise zu verändern. Etliche Mitglieder der Surrealistischen Gruppe beschäftigten sich intensiv mit Fotografie. Der geradezu von der Fotografie besessene Jindřich Štyrský, ein Maler, Grafiker und Bühnenbildner, fand seine Motive in Geschäftsauslagen und Ladenschildern, Friedhöfen, Vergnügungsparks sowie in rissigen, mit Graffiti bedeckten Mauern. So entstanden in den Jahren 1934 und 1935 nichtmanipulierte Fotografien, die das zufällige Zusammentreffen banaler Gegenstände zeigen, dabei jedoch oft Sexualität und Tod thematisieren. 1932 veröffentlichte Štyrský auf eigene Kosten das Buch *Emilie přichází ke mně ve snu* (Emilie kommt im Traum zu mir), das gewagte erotische Collagen enthält, für die er Fragmente alter pornografischer Fotos in neue Kontexte stellte, ihnen neue Bedeutungen gab und damit Darstellungen von Erotik, Tod und Frustration schuf. 1935 begann der vielseitige Künstler und Kunsttheoretiker Karel Teige seine Arbeit an einer großen Serie von Collagen mit zahlreichen erotischen Anspielungen, für die er oft Fragmente von Aufnahmen berühmter Fotografen verwendete. Diese Arbeiten weisen nicht nur Parallelen zu den Collagen der französischen Surrealisten auf, sondern gelegentlich auch zu den antifaschistischen Fotomontagen von John Heartfield, einem deutschen Künstler, der von 1933 bis 1938 im tschechoslowakischen Exil lebte. Teige verwendete ähnliche Werke auch für seine Buchgestaltungen. Der Maler František Vobecký, der kein Mitglied der Surrealistischen Gruppe war, schuf fotografische Kompositionen, für die er sich der Technik der Material-Assemblage bediente. Mitte der 1930er-Jahre fertigte Miroslav Hák, ein Mitglied einer späteren Phase der Skupina 42 (Gruppe 42), viele metaphorische Fotografien der Prager Vororte an und verwendete fotografisches Material in etlichen ausdrucksstarken experimentellen Arbeiten, die er als »structages« bezeichnete. Tibor Honty, Václav

The Surrealist Group in Czechoslovakia was founded in 1934. Through the study of dreams, the subconscious, the erotic, and psychic automation, its members strove for revolutionary social change. Several members of the Surrealist Group intensively pursued photography. Obsessed with photography, Jindřich Štyrský, a painter, graphic artist and stage designer, found his subject matter in shop windows and shop signs, cemeteries and fairground attractions, as well as on cracked, graffiti-covered walls. This led to series of non-manipulated photographs, created between 1934 and 1935, depicting constellations of chance meetings between banal items, often featuring the theme of sex blended with death. In 1932 Štyrský published at his own expense the book *Emilie přichází ke mně ve snu* (Emily Comes to Me in a Dream) with audaciously erotic collages, employing fragments of old pornographic photographs in new contexts and meanings, with motifs of eroticism, death and frustration. In 1935 the versatile artist and theorist Karel Teige began to work on a large set of collages with frequently erotic allusions, often employing cropped details from photographs by famous photographers. The collages contain not only parallels to French Surrealist collages, but also, in some instances, even to the anti-fascist photomontages of John Heartfield, a German citizen who lived in Czechoslovak exile

Chochola und Jiří Sever richteten ihre Aufmerksamkeit ebenfalls auf die Prager Vorstädte. Der Surrealismus beeinflusste auch das Œuvre von Mitgliedern avantgardistischer Gruppen außerhalb von Prag, so etwa das der mährischen Avantgarde-Fotografen Hugo Táborský, Otakar Lenhart, Karel Kašpařík und Bohumil Němec sowie das der Mitglieder der Gruppe Fotolinie in Budweis, unter ihnen Josef Bartuška und Karel Valter. Die Leitfigur der Gruppe Ra war Václav Zykmund, der sich neben der Malerei auch surrealistischen Spielerei-en widmete, die in vielerlei Hinsicht als Vorläufer von Happenings und Body Art zu werten sind und von Miloš Koreček dokumentiert wurden. Während des Krieges nahmen viele der in den Vereinigun-gen organisierten Künstler an sogenannten Gelagen (řádění) teil. Lud-vík Kundera kombinierte in der maschinengeschriebenen Ausgabe von *Výhružný kompas* (Drohender Kompass; 1944) Fotografien mit Poesie. Vilém Reichmann folgte dem Beispiel von Štyrský; die Realität des Krieges, den er an der Front und in Gefangenschaft erlebt hatte, hatte sich ihm aber so tief eingeprägt, dass er nach der Befreiung darauf mit der rohen, imaginativen Serie *Zraněné město* (Die verletzte Stadt) reagierte. Die Atmosphäre der Zerstörung während der Kriegs-zeit wurde auch von Miloš Koreček und Josef Istler verarbeitet: Sie projizierten sie in *phocalques* hinein, ausgehend von der Technik der Dekalkomanie, einem Abklatschverfahren.

Die Bilder von tschechischen Fotografen in der Sammlung FOTO-GRAFIS stellen eine valide und wichtige Werkgruppe innerhalb eines klar umrissenen chronologischen und geografischen Kontexts dar. Die tschechische Fotografie entwickelte ihre charakteristischen Merk-male an der Schnittstelle von Piktorialismus und Neuer Sachlichkeit und fand zu einer eigenen, spielerischen Variante surrealistischer Rhe-torik. Zahlreiche Beispiele aus der Sammlung FOTOGRAFIS stehen für diese ebenso authentische wie symptomatische Bildsprache. Dass bereits in den späten 1970er- und in den 1980er-Jahren eine bedeu-tende Auswahl dieser Bilder in die Ankaufsstrategie der Sammlung integriert wurde, lässt eine bemerkenswerte Kenntnis der Entwick-lungen innerhalb der europäischen Kunst erkennen. Der Umstand, dass ein Sammlungsschwerpunkt auf eine zum damaligen Zeitpunkt noch recht unbekannte – wenn auch sehr einflussreiche – Strömung in der Fotografie gesetzt wurde, zeugt zudem von Courage. Sowohl die erzählerische, literaturgebundene Fotografie als auch die analytischen, bilderforschenden Haltungen wichtiger tschechischer Fotografen fanden in anderen künstlerischen Bereichen in Europa Widerhall.

from 1933 to 1938. Teige used similar works in his graphic design for books. The painter František Vobecký, not a member of the Sur-realist Group, made photographic compositions employing the tech-nique of material assemblage. In the mid-1930s, Miroslav Hák, a member of a later phase of Skupina 42 (Group 42), made many met-aphorical photographs of Prague's suburbs and conducted several expressive experiments with photographic materials, which he called "structages". Suburbs also attracted the attention of Tibor Honty, Václav Chochola and Jiří Sever. Surrealism influenced the oeuvre of members of avant-garde groups outside Prague as well, for example the Moravian avant-garde photographers Hugo Táborský, Otakar Lenhart, Karel Kašpařík and Bohumil Němec, and members of Foto-linie, from the town of České Budějovice, such as Josef Bartuška and Karel Valter. The leading figure of the Ra group was Václav Zykmund, who, apart from painting, devoted himself to Surrealist games, which in many respects anticipated happenings and Body Art, and were documented with Miloš Koreček. During the war many associated artists took part in so-called revelries (řádění). Photographs were used together with poetry by Ludvík Kundera in the typescript edi-tion *Výhružný kompas* (The Menacing Compass; 1944). Vilém Reich-mann followed on from Štyrský, but the reality of the war, which he experienced at the front and in captivity, was so powerfully imprinted on him that after liberation he reacted to it with a raw, imaginative series called *Zraněné město* (Wounded City). The atmosphere of war-time destruction was also projected into "phocalques" by Miloš Koreček and Josef Istler, based on the principle of decalcomania.

The selection of images by Czech photographers in the FOTO-GRAFIS collection is a valid and important body of work within a specific chronological and geographical context. Czech photography developed its characteristics at the crucial point between Pictorialism and New Objectivity, and found its own, playful variation of Surreal-ist rhetorics. Many examples in the FOTOGRAFIS collection repre-sent this authentic and symptomatic imagery. Integrating a major selection of these images in the acquisitions strategy for the collection as early as the late 1970s and 1980s stood for a knowledgeable over-view of European artistic developments and for the courage to put an emphasis on what was at the time not a very well known, although a very influential, tendency in photography. Both the narrative, litera-ture-bound photography and the analytic, image-exploring attitudes created by important Czech photographers elicited echoes and re-sponses in other European creative processes.

Drahomír Josef Růžička

Geboren 1870 in Trhová Kamenice/heutige Tschechische Republik, verstorben 1960 in New York/USA. 1876 immigrierte Drahomír Josef Růžička mit seiner Familie in die USA. 1894 beendete er sein Medizinstudium an der Universität in New York und war im Anschluss in New York als Arzt tätig. Ab 1909 absolvierte Růžička bei Clarence Hudson White einem Kurs in Fotografie. 1916 war Růžička Gründungsmitglied der Pictorial Photographers of America, deren Ehrenvorsitzender er 1940 wurde. 1921 reiste er erstmals wieder in die damalige Tschechoslowakische Republik und zeigte dort in einer Ausstellung Arbeiten im Stile der *straight photography*, für die er auf die Verwendung von Edeldrucktechniken verzichtete. Er gilt als der »Vater« einer eigenständigen tschechischen Fotografie.

Born in 1870 in Trhová Kamenice/present-day Czech Republic, died in 1960 in New York/USA. In 1876 Drahomír Josef Růžička immigrated to the United States with his family. In 1894 he finished his medical studies at university in New York and then worked as a doctor in New York. In 1909 he completed a course in photography with Clarence Hudson White. In 1916 Růžička was a founding member of the Pictorial Photographers of America and in 1940 he was honorary chairman. In 1921, he travelled for the first time to the former Republic of Czechoslovakia and in an exhibition there he showed works in the style of straight photography, for which he renounced the use of pigment-print processing techniques. He is considered the father of independent Czech photography.

Das frühere Gebäude der Pennsylvania Station im Herzen Manhattans war eine Kathedrale der Moderne, ein funktionaler Prachtbau zur Verherrlichung der neuen Mobilität. Růžičkas Fotografien seiner Stadt New York übermitteln ein Bild der bedeutendsten Metropole der damaligen Zeit mit einem sentimentalen Hang zur Tradition und einer Passion für radikale Modernisierung. So bilden seine preziösen Fotografien die Bauten der Moderne ab, weisen jedoch eine stilistische Handschrift auf, die zwischen Piktorialismus und Neuer Sachlichkeit angesiedelt ist.

The former building of Pennsylvania Station in midtown Manhattan was a cathedral of modernity, a functionally magnificent building made to glorify new mobility. Růžička's photographs of his city of New York convey a picture of the most important metropolis of that time with a sentimental penchant for tradition and a passion for radical modernization. Although his precious photographs depict modern buildings, they have a stylistic signature that is located between Pictorialism and New Objectivity.

Literatur/Further reading: Margit Zuckriegl (Hrsg./ed.), *Laterna Magica. Einblicke in eine tschechische Fotografie der Zwischenkriegszeit* (Ausst.-Kat./exh. cat. Rupertinum Salzburg), Salzburg 2000

Drahomír Josef Růžička
Pennsylvania Station, 1921
Print um/ca. 1936, Pigmentdruck/carbon print

František Drtikol

Geboren 1883 in Příbram/heutige Tschechische Republik, verstorben 1961 in Prag/ heutige Tschechische Republik. Von 1898 bis 1901 absolvierte František Drtikol eine Fotografenlehre in Příbam und besuchte die Lehr- und Versuchsanstalt für Photographie in München. Von 1901 bis 1903 studierte er an der Bayerischen Staatslehranstalt für Lichtbildwesen in München. In den Jahren von 1903 bis 1935 betrieb er jeweils ein Fotoatelier in Příbam und in Prag. Schwerpunkte seiner Arbeit waren Porträts und Aktaufnahmen, die stark von Jugendstil, Symbolismus und später auch von der modernen Fotografie beeinflusst wurden. Drtikol änderte seine Fotografie hin zu Expressivität, zu Art Déco und geometrischen Formen. Nach dem Zweiten Weltkrieg lehrte er kurzzeitig an der Staatlichen Graphischen Schule in Prag. In seinem letzten Lebensabschnitt entstanden Zeichnungen, Malereien und Skulpturen.

Drtikol war der erste tschechische Fotograf von internationaler Bedeutung. Er entwickelte aus einem allgemeinen und traditionellen Stil in der Fotografie eine neue Bildsprache, die prägend für die Zeit bis in die 1930er-Jahre und für die Kunstauffassung nicht nur in seiner Heimat werden sollte. Er nutzte die ganze Bandbreite der Lichteigenschaften des Mediums, die vom tiefsten Schwarz bis zum hellsten Weiß reicht, und modellierte seine Arrangements in gekonnt abschattierten Tonwerten. Seinen Bildern verlieh er damit eine malerisch-weiche Atmosphäre und unterstrich die rätselhafte Stimmung der symbolhaften Inszenierungen. Das Ideal der Schönheit spiegelt sich in den elegant proportionierten und effektvoll ausgeleuchteten Akten, bei denen die Modelle oft in tänzerischer Bewegung verharren oder zusammen mit geometrischen Objekten in Szene gesetzt werden.

Born in 1883 in Příbram/present-day Czech Republic, died in 1961 in Prague/ present-day Czech Republic. From 1898 to 1901 František Drtikol completed an apprenticeship in photography in Příbram and then attended the Lehr- und Versuchsanstalt für Photographie in Munich. From 1901 to 1903 he studied at the Bavarian Staatslehranstalt für Lichtbildwesen in Munich. In the years 1903 to 1935 he operated photography studios in Příbram and Prague. His work focused on portraits and nudes, and was strongly influenced by Art Nouveau, Symbolism, and later by modern photography. Drtikol's photography style developed towards expressiveness, Art Deco and geometric shapes. After the Second World War, he taught briefly at the State Graphic Arts School in Prague. In the last phase of his life he created drawings, paintings and sculptures.

Drtikol was the first internationally important Czech photographer. From a general and traditional style in photography, he developed a new visual language that was to become formative for the period up to the 1930s and for the concept of art, not only in his homeland. He took advantage of the full range of the medium's light properties, which extended from the deepest blacks to the brightest whites, and he modelled his arrangements in skilfully shaded tones. He gave his pictures a soft painting-like atmosphere and highlighted the enigmatic mood of symbolic staging. The ideal of beauty is reflected in the elegantly proportioned and effectively illuminated nudes who often posed in dance-like movements or formed a scene together with geometric objects.

Literatur/Further reading: Anna Fárová, *František Drtikol. Photograph des Art Déco*, hrsg. v. Manfred Heiting, München 1986/Anna Fárova, *František Drtikol. Art-Deco Photographer*, ed. by Manfred Heiting, Ann Arbor 1993

František Drtikol
Ohne Titel/Untitled, 1928
Pigmentdruck/carbon print

Jaroslav Rössler

Geboren 1902 in Smilov/heutige Tschechische Republik, verstorben 1990 in Prag/ heutige Tschechische Republik. 1907 begann Jaroslav Rössler seine Fotografenlehre im Atelier von František Drtikol. Ab 1923 war Rössler der einzige Fotograf der Künstlervereinigung Devětsil. 1925 übersiedelte er nach Paris und arbeitete dort bis 1926. Nach Prag zurückgekehrt, arbeitete er für die Zeitschrift *Pestrý týden* und fotografierte für das Theater. Von 1927 bis 1935 lebte und arbeitete er wieder in Paris. Rössler zählte zu den Vorreitern der tschechischen Avantgarde, sein Hauptwerk steht in enger Verbindung zur abstrakten Kunst und dem Konstruktivismus, auch starke Einflüsse der russischen Avantgarde sind zu erkennen. In den 1930er-Jahren widmete er sich intensiv der Werbe- und Gebrauchsfotografie im Stile der Neuen Sachlichkeit sowie dem Experimentieren mit Fotogrammen und Fotomontagen. 1935 wurde er aus Frankreich ausgewiesen und lebte wieder in Prag.

Born in 1902 in Smilov/present-day Czech Republic, died in 1990 in Prague/present-day Czech Republic. In 1907 Jaroslav Rössler began his photography apprenticeship in the studio of František Drtikol. From 1923 Rössler was the only photographer in the Devětsil artist association. In 1925 he moved to Paris and worked there until 1926. After returning to Prague, he worked for the magazine *Pestrý týden* and as a theatre photographer. From 1927 to 1935 he lived and worked in Paris again. Rössler was one of the pioneers of the Czech avant-garde: his major work is closely related to abstract art and Constructivism, and strong influences of the Russian avant-garde can also be seen. In the 1930s he intensively devoted himself to advertising and commercial photography in the style of New Objectivity and to experimenting with photograms and photomontages. In 1935 he was expelled from France and lived again in Prague.

Anders als sein spektakuläres angewandtes Werk für Werbe- und Publikationszwecke zeichnen sich Rösslers freie Arbeiten durch eine feine Poesie und einen fundamentalen Hang zum Experiment aus. Der Kopfstudie mit den starken Hell-Dunkel-Kontrasten liegt eine Untersuchung zu den Positiv-Negativ-Effekten des fotografischen Vergrößerungsverfahrens zugrunde, für die das abgewandte Gesicht von Rösslers Frau gleichsam nur als »Vorwurf« zur Sichtbarmachung von Licht und Schatten diente.

Unlike his spectacularly practical work for promotional and publication purposes, Rössler's independent works are characterized by a fine poetry and a fundamental inclination to experiment. The head study with strong light-dark contrasts is based on an exploration of the positive-negative effects of the photographic enlargement process in which the turned-away face of Rössler's wife only serves as a "subject" for the visualization of light and shadow.

Literatur/Further reading: Vladimír Birgus, *Jaroslav Rössler,* Prag/Prague 2001

Jaroslav Rössler
Gesichtsstudie I/Face Study I, um/ca. 1927
Pigmentdruck/carbon print

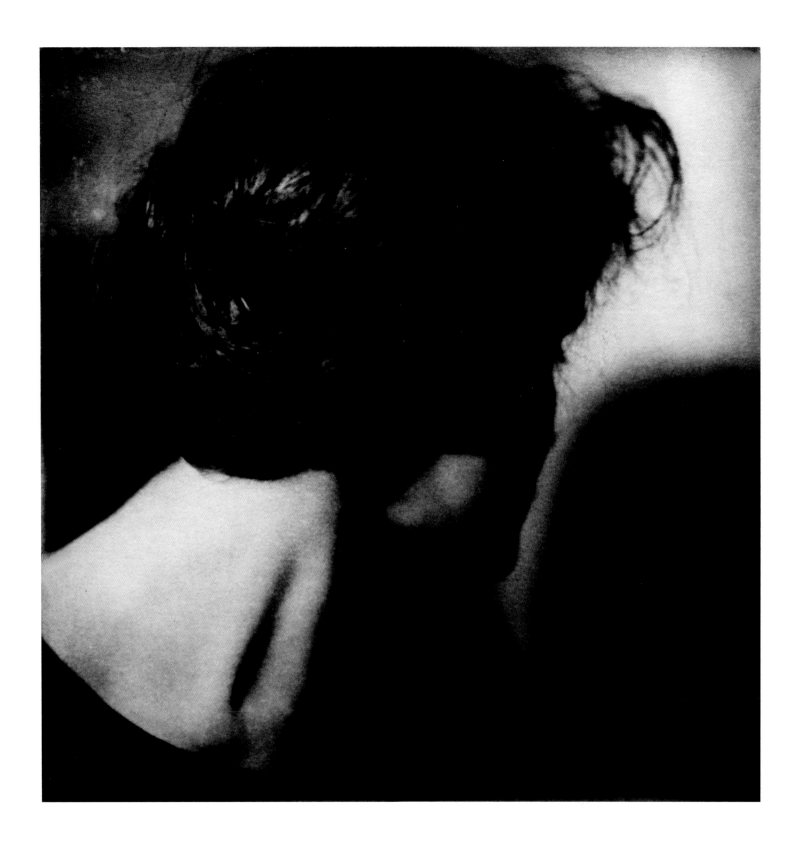

Hugo Táborský

Geboren 1911 in Brünn/heutige Tschechische Republik, verstorben 1991 in Brünn. Von 1926 bis 1932 studierte Hugo Táborský zunächst an der Handelsakademie, dann an der Kunstgewerbeschule in Brünn. Nach seinem Abschluss war er bis 1937 als Werbegrafiker tätig. Er war Mitglied der Gruppe f5. In seinen fotografischen Arbeiten orientierte er sich an Funktionalismus und Konstruktivismus. Fernand Légers Werk übte auf ihn einen ebenso großen Einfluss aus wie die Arbeiten des Werbegrafikers Jan Tschichold und des Bauhaus-Dozenten Lázló Moholy-Nagy. Táborský fertigte Fotogramme und Fotomontagen an, experimentierte mit außergewöhnlichen fotografischen Techniken und fotografierte für Werbeaufträge. Nach seinem Tod wurden Arbeiten von Táborský 2009 in der Ausstellung *Gegen jede Vernunft. Surrealismus Paris–Prag* des Wilhelm-Hack-Museums und des Kunstvereins Ludwigshafen am Rhein gezeigt.

Die rationalen Sichtweisen des Konstruktivismus, die auf geometrischen Grundformen und diagonal organisierten Kompositionen basieren, werden von Táborský in seinen Fotografien der 1930er-Jahre im Sinne der tschechischen Tradition umgedeutet: Weiche Abschattierungen und fließende Übergänge lassen den Frauenkopf trotz gewagter Untersicht zu einem piktorialistisch modellierten Gebilde im Dialog von Licht und Schatten werden.

Literatur/Further reading: Reinhard Spieler und/and Barbara Auer (Hrsg./eds.), *Gegen jede Vernunft. Surrealismus Paris–Prag/Against all Reason. Surrealism Paris–Prague* (Ausst.-Kat./exh. cat. Wilhelm-Hack-Museum, Ludwigshafen am Rhein, und/and Kunstverein Ludwigshafen am Rhein), Stuttgart 2009

Born in 1911 in Brno/present-day Czech Republic, died in 1991 in Brno. From 1926 to 1932 Hugo Táborský first studied at the Trade Academy and then at the Arts School in Brno. After graduating, he was active as a commercial artist until 1937. He was a member of Group f5. His photographic work focused on Functionalism and Constructivism. Fernand Léger's work also greatly influenced him, as did the work of the commercial artist Jan Tschichold and the Bauhaus lecturer László Moholy-Nagy. Táborský produced photograms and photomontages and experimented with unusual photographic techniques, focusing mainly on advertising work. After his death, works by Táborský were shown in 2009 in the exhibition *Against all Reason. Surrealism Paris–Prague* at the Wilhelm-Hack-Museum and the Kunstverein Ludwigshafen am Rhein.

In his photographs of the 1930s, Táborský reinterprets the rational perspectives of Constructivism, which are based on geometric shapes and diagonally organized compositions, in terms of Czech tradition: soft shadings and smooth transitions make the woman's head into a Pictorialist-modelled formation in a dialogue of light and shadows despite the bold low-angle shot.

Hugo Táborský
Ohne Titel/Untitled, 1934
Silbergelatineprint/silver gelatin print

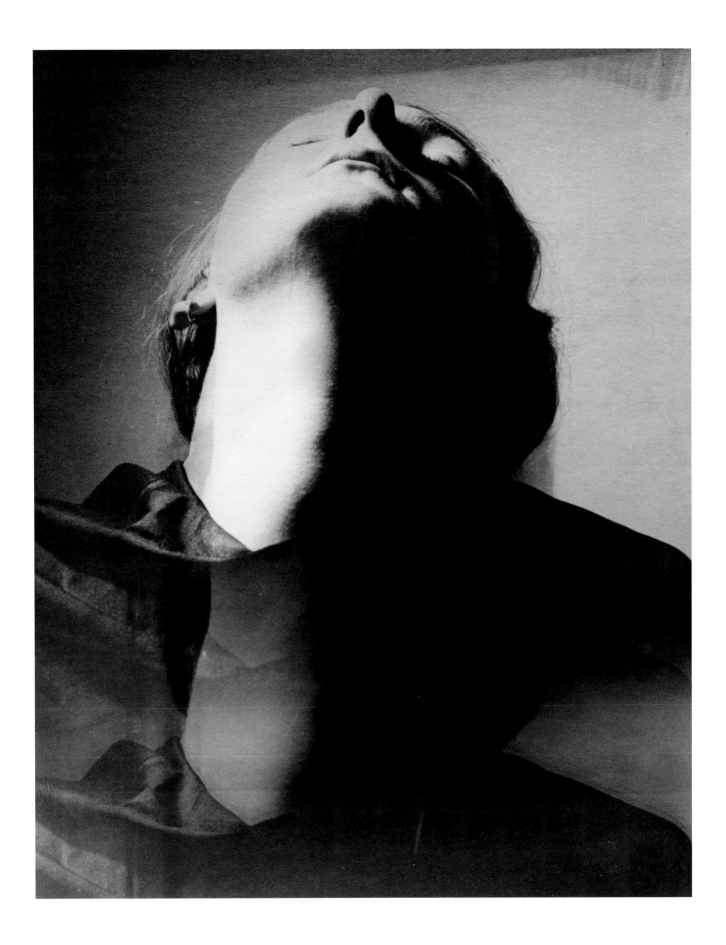

Karel Novák

Geboren 1875 in Horaschdowitz/heutige Tschechische Republik, verstorben 1950 in Prag/heutige Tschechische Republik. Novák besuchte die Graphische Lehr- und Versuchsanstalt in Wien. Ab 1910 war er dort als innovativer Lehrender tätig und vermittelte seinen Schülern – darunter Anton Josef Trčka, Rudolf Koppitz und Trude Fleischmann – das für den Jugendstil charakteristische Gefühl für dekorative Inszenierungen und effektvolle Linien- und Flächengestaltung. Er fand später hauptsächlich als Lehrer von Josef Sudek Erwähnung, der bei ihm von 1922 bis 1924 an der Staatlichen Grafikschule in Prag studierte. Novák arbeitete im Stile der damals in Wien aktiven Piktorialisten und bevorzugte die Edeldruckverfahren und Pigmentdrucktechniken. In späteren Jahren änderte er seinen Vornamen in Carol und war Mitglied des Wiener Camera-Clubs.

Das wenig bekannte fotografische Werk von Karel Novák steht in Zusammenhang mit seiner Lehrtätigkeit an der Wiener Graphischen Lehr- und Versuchsanstalt. Dazu gehören Landschaften, Porträts und Stilllebenarrangements, in denen sowohl eine stimmige, poetische Atmosphäre wie auch ein durch den differenzierten Umgang mit Licht und Schatten evozierter malerischer Eindruck erzeugt wird. Er verwendete matte Naturpapiere und zarte farbliche Tonungen.

Literatur/Further reading: Astrid Lechner, »Künstlerische Fotografie an der Graphischen Lehr- und Versuchsanstalt 1888–1955«, in: Monika Faber und/and Klaus A. Schröder (Hrsg./eds.), *Das Auge und der Apparat* (Ausst.-Kat./exh. cat. Albertina, Wien/Vienna, und/and Fotomuseum im Münchner Stadtmuseum, München/Munich), Paris 2003

Born in 1875 in Horaždovice/present-day Czech Republic, died in 1950 in Prague/present-day Czech Republic. Novák attended the Graphische Lehr- und Versuchsanstalt in Vienna. From 1910 he worked as an innovative teacher there and taught his pupils – including Anton Josef Trčka, Rudolf Koppitz and Trude Fleischmann – the characteristic sense of Art Nouveau for decorative staging and striking line and surface designs. He later gained recognition mainly as a teacher of Josef Sudek, who studied under him from 1922 to 1924 at the State Graphic Arts School in Prague. Novák worked in the style of the Pictorialists active in Vienna at that time and preferred pigment-printing processes and carbon print techniques. In later years, he changed his first name to Carol and was a member of the Vienna Camera Club.

The little-known photographic work of Karel Novák is related to his teaching work at Vienna's Graphische Lehr- und Versuchsanstalt. This includes landscapes, portraits and still-life arrangements in which he creates a harmonious, poetic atmosphere and a picturesque impression evoked by the sophisticated handling of light and shade. He used matte uncoated paper and delicate colour tones.

Karel Novák
Ohne Titel/Untitled, 1926
Gummidruck/gum print

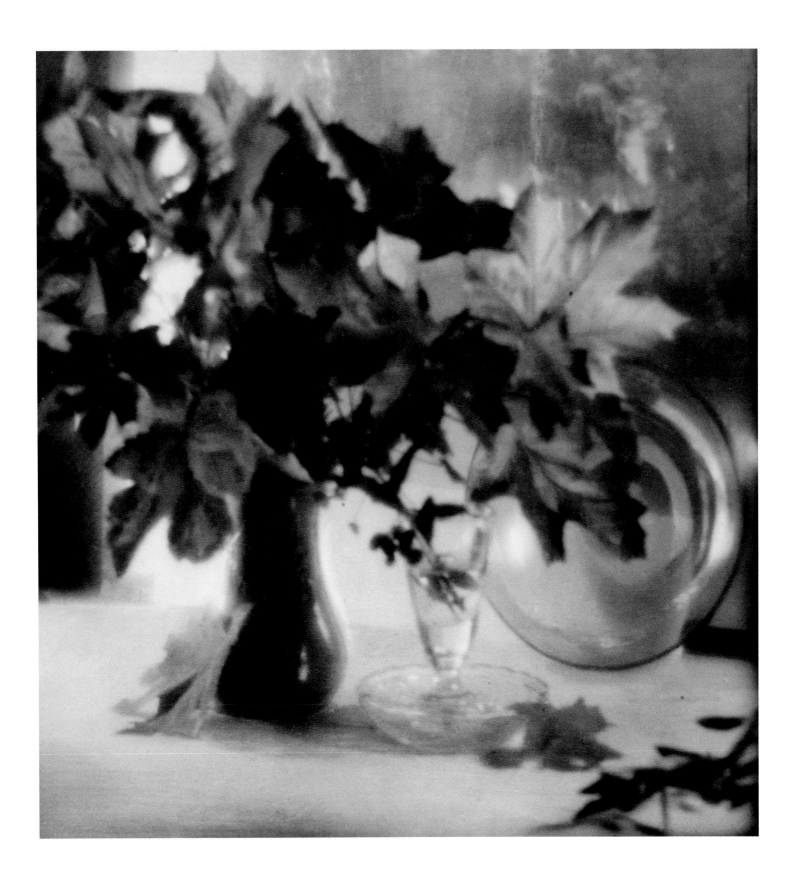

Jaromír Funke

Geboren 1896 in Skuteč/heutige Tschechische Republik, verstorben 1945 in Prag/heutige Tschechische Republik. Jaromír Funke studierte Medizin, Jura, Kunstgeschichte, Philosophie und Ästhetische Theorie. Ab 1920 widmete er sich der Fotografie und arbeitete ab 1922 als freiberuflicher Fotograf. 1924 war er Mitbegründer der Tschechischen Gesellschaft für Fotografie. 1931 lehrte er an Berufsschulen in Prag, in den Jahren 1934 und 1935 an der Kunstgewerbeschule in Bratislava. Von 1935 bis 1944 hatte Funke eine Professur an der Staatlichen Graphischen Schule in Prag inne. Von 1927 bis 1929 experimentierte er mit geometrischen Formen, die sich in abstrakten »Schattenspielen« abbildeten. Funke führte das konsequente Arbeiten in Serien und Zyklen in die tschechische Fotografie ein. Er versuchte, das Wechselspiel von Form und Licht in seinen Bildkompositionen darzustellen, wobei seine Arbeiten Anklänge an den Surrealismus enthalten. Von 1941 bis 1944 schuf er einen umfangreichen Fotografiekomplex unter dem Titel *Ungesättigte Erde* als Reaktion auf den Krieg.

Born in 1896 in Skuteč/present-day Czech Republic, died in 1945 in Prague/present-day Czech Republic. Jaromír Funke studied medicine, law, art history, philosophy and aesthetic theory. From 1920 onwards, he devoted himself to photography and in 1922 he started working as a freelance photographer. In 1924 he co-founded the Czech Photographic Society. He taught at vocational schools in Prague in 1931 and in 1934, and in 1935 at the School of Applied Arts in Bratislava. From 1935 to 1944 Funke was a professor at the State Graphic Arts School in Prague. Between 1927 and 1929 he experimented with geometric forms depicted in abstract "shadow play". Funke introduced his rigorous work to Czech photography in series and cycles. He tried to portray the interplay of form and light in his compositions, and his works are reminiscent of Surrealism. From 1941 to 1944 he created an extensive photograph portfolio entitled *The Unsated Earth* in response to the war.

Unter dem Einfluss von František Drtikol befasste sich Funke mit immanenten Charakteristika von Fotografie, die er mittels arrangierter Stillleben und einfacher Alltagsgegenstände erforschte: Spiegelungen und Reflexionen, Schatten und Silhouetten entstanden durch gezielte Beleuchtung und die Wahl extremer Perspektiven. Seine fotografischen Studien näherten sich der Abstraktion und ließen das Objekthafte der abgebildeten Gegenstände lediglich als Vorgaben für eine komplexe Licht- und Schattenregie zu.

Under the influence of František Drtikol, Funke dealt with inherent characteristics of photography, which he explored by means of arranged still lifes and simple everyday objects: mirrors and reflections, shadows and silhouettes created by targeted lighting and choosing extreme perspectives. His photographic studies approximated abstraction and allowed the object-likeness of the depicted items to act as mere guidelines for complex light and shadow direction.

Literatur/Further reading: Antonin Dufek, *Jaromír Funke*, Prag/Prague 2004

Jaromír Funke
Komposition/Composition, 1927
Silbergelatineprint, getont/silver gelatin print, toned

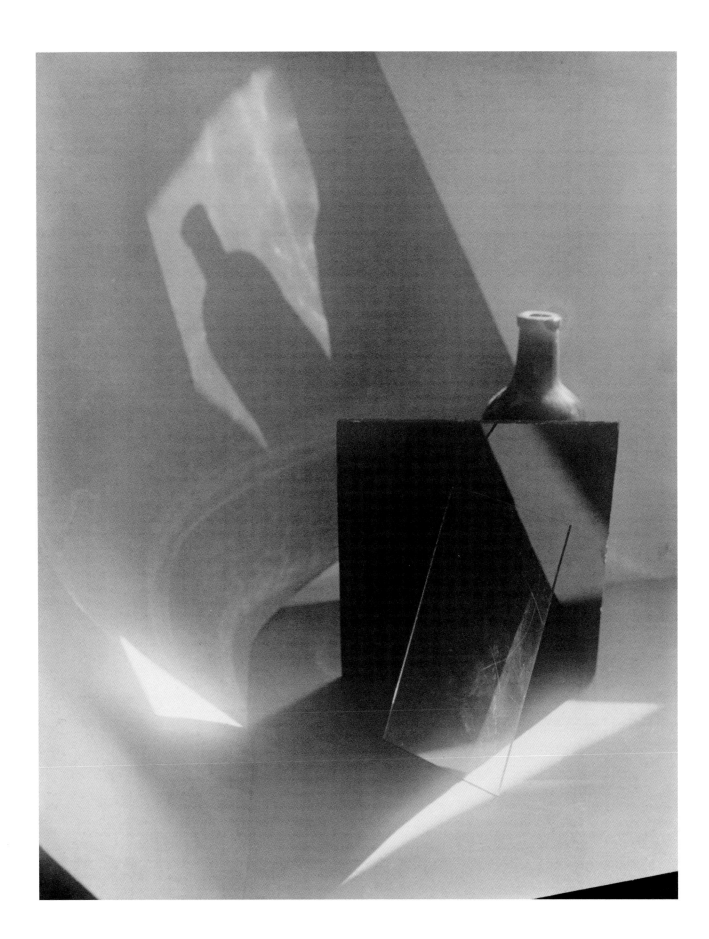

Josef Sudek

Geboren 1896 in Kolin an der Elbe/heutige Tschechische Republik, verstorben 1976 in Prag/heutige Tschechische Republik. Zunächst absolvierte Josef Sudek eine Buchbinderlehre und studierte anschließend von 1922 bis 1924 an der Grafischen Schule in Prag. 1924 war er Gründungsmitglied der Tschechischen Fotografischen Gesellschaft. Ab 1927 betrieb er in Prag ein eigenes Atelier und arbeitete mit Verlagen und Zeitschriften zusammen. Nachdem ihn anfänglich die Landschaftsfotografie mit einer Panoramakamera beschäftigt hatte, wurde er ein Meister des Stilllebens. In seinem Atelier genügten ihm wenige Gegenstände, um Fotografien »lichtplastisch« entstehen zu lassen. Während der 1930er-Jahre war sein Schaffen der Porträt- und Reklamefotografie gewidmet. Ab 1940 wandte Sudek sich der subjektiven Fotografie zu. Hier entstanden über Jahrzehnte hinweg Pflanzenstillleben, Objektstudien und Naturaufnahmen in Pigmentdrucktechnik. Zwischen 1940 und 1954 arbeitete Sudek an fotografischen Zyklen. Mit seinen Aufnahmen aus den beiden Weltkriegen, unter anderem von Verwundeten im Lazarett, trug Sudek wesentlich zur sozialkritschen Fotografie des 20. Jahrhunderts bei.

Born in 1896 in Kolín an der Elbe/present-day Czech Republic, died in 1976 in Prague/present-day Czech Republic. Josef Sudek first trained as a bookbinder and then studied at the Graphic Arts School in Prague from 1922 to 1924. In 1924 he was a founding member of the Czech Photographic Society. From 1927 he ran his own studio in Prague and worked with publishers and magazines. After initially working on landscape photography with a panorama camera, he became a master of still-life photography. The few items in his studio were sufficient to make "light sculpture" photographs. During the 1930s his work was dedicated to portrait and advertising photography. From 1940 Sudek turned to subjective photography. Throughout the next decades, it was in this area that he created still-life photographs of plants, object studies and nature shots in carbon print techniques. Between 1940 and 1954 Sudek worked on photographic cycles. With his photographs from the two world wars, including those of the wounded in a military hospital, Sudek significantly contributed to the socio-critical photography of the twentieth century.

Die Fotozyklen Josef Sudeks sind wie Essays komponierte Bild-Themen rund um seine häusliche Umgebung. Aus der Serie *Gläserne Labyrinthe* stammt das Stillleben mit Spiegel, Früchten und Gläsern, in dem er, noch in seinen späten Jahren der Tradition der tschechischen Fotografie der Moderne folgend, die Eigenschaften von Dingen und Lichteffekten im Bild untersuchte. Sudek subsumierte gegen Ende seines Lebens die Aspekte des Fotografischen, die ihn und seine Zeitgenossen seit der Jahrhundertwende interessiert hatten, und setzte mit seinen ikonischen Kommentaren zur Fotogeschichte gleichsam einen Schlusspunkt hinter die Entwicklung seit dem Piktorialismus.

Josef Sudek's photographic cycles are like essays composed on pictorial themes around his home environment. The still-life photograph with mirror, fruit and glasses comes from the series *Glass Labyrinths*, in which he still followed the tradition of modern Czech photography – even in his later years – by exploring the properties of objects and light effects in the picture. At the end of his life Sudek subsumed the aspects of photography that had interested him and his contemporaries since the turn of the century, and with his iconic comments on photographic history he in some ways drew a line underneath the development of photography since Pictorialism.

Literatur/Further reading: Anna Fárová, *Josef Sudek*, Prag/Prague 1995

Josef Sudek
aus dem Zyklus/from the cycle
Gläserne Labyrinthe/Glass Labyrinths, 1968–1972
Silbergelatineprint/silver gelatin print

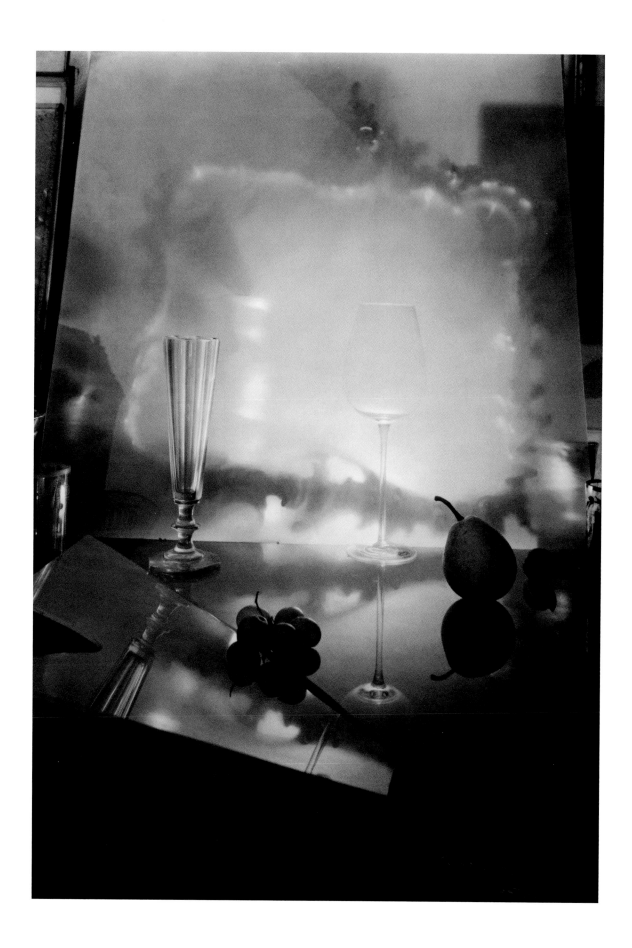

UMSTURZ DER BILDER.
DIE SURREALISTISCHEN BILDFINDUNGEN

THE REVOLUTION OF IMAGES.
SURREALIST IMAGE INVENTIONS

Uwe M. Schneede

Die surrealistische Bewegung der 1920er- und 1930er-Jahre wurde von Literaten und Malern begründet, stützte sich aber von vornherein auch auf Fotografen und wurde schließlich durch Filmemacher bereichert. Malende und filmende Fotografen wie Man Ray, fotografierende Maler wie René Magritte oder Zeichner wie Hans Bellmer und filmende Autoren wie Antonin Artaud brachten erstmals in einer Avantgardebewegung die unmittelbare Verzahnung der Gattungen zustande. Auch setzten die Literaten gezielt Fotografien in ihren Büchern und Zeitschriften ein. Das gleichwertige Wirken der verschiedenen Bildgattungen diente trotz aller stilistischen Unterschiede, die für diese Bewegung charakteristisch sind, einem gemeinsamen Ziel: dem surrealistischen Bild.

In jedweder Gattung – in der Literatur wie in der Malerei, in der Fotografie und im Film wie in der Objektkunst – galt also das Bestreben diesem surrealistischen Bild. Im Bewusstsein seiner Begründer und Schöpfer sollte es sich kategorial von allen anderen Bildern unterscheiden. Das surrealistische Bild ist nicht identisch mit der sprachlichen Wiedergabe oder der Abbildung surrealer Fantasien. Vielmehr hatte es der bildlichen Suche nach dem Surrealen in der Realität zu dienen. Um dieser Suche willen wurden die gattungsspezifischen – die literarischen wie die bildnerischen – Techniken konsequent erneuert oder ältere Verfahren zielgerichtet integriert. Max Ernst griff in der Zeichnung die Durchreibung als *Frottage* auf und entwickelte daraus für die Malerei die *Grattage* (Abschabung), während Óscar Domínguez die *Décalcomanie* (Abklatsch) kultivierte, Joan Miró die *Écriture automatique* (automatisches Schreiben) ausnutzte, Salvador Dalí von den Mehrfachbildern des Vexierbilds Gebrauch machte und man gemeinsam den *Cadavres exquis* frönte. In der Fotografie nutzte man deren spezifische Möglichkeiten, die Montage, die Solarisation, die Mehrfachbelichtung und das Fotogramm. Wie jeder surrealistischen Aktivität ging es der surrealistischen Fotografie und der vom

The Surrealist movement of the 1920s and 1930s was established by writers and painters but also counted on photographers from the start and was ultimately enriched by filmmakers. Painting and filming photographers such as Man Ray, photograph-taking painters such as René Magritte or graphic artists such as Hans Bellmer, and filming authors such as Antonin Artaud achieved the direct combination of art forms into an avant-garde movement for the first time. Writers inserted photographs into their books and magazines specifically. The equivalent works of various image forms served a common aim despite all of the stylistic differences that are characteristic of this movement: the Surrealist image.

No matter which art form – in literature and in painting, in photography, in film and in object art – this striving was important for the Surrealist image. In the eye of its founders and creators, it should be categorically different from all other images. The Surrealist image is not identical to the linguistic rendering or depiction of surreal fantasies. Rather, it must serve the figurative search for the surreal in reality. For the sake of this search, the techniques specific to art forms – literary and pictorial – were constantly renewed or old procedures were integrated specifically. Max Ernst took up rubbing as *frottage* in drawing and developed *grattage* (scraping) from it for painting, while Óscar Domínguez cultivated *decalcomania* (monotype print), Joan Miró used automatic writing, Salvador Dalí made use of multiple images of picture puzzles, and all cooperated on the *cadavres exquis*. In photography, its specific possibilities were used: montage, solarization, multiple exposure and the photogram. As in all Surrealist activities, Surrealist photography and photography influenced by Surrealism involves uncovering the unknown in the known and the wonderful in the everyday, making new experiences accessible and challenging the observer's imagination by means of inspiring image techniques.

Surrealismus beeinflussten Fotografie darum, das Unbekannte im Bekannten und das Wunderbare im Alltag aufzudecken und neuer Erfahrung zugänglich zu machen sowie mithilfe inspirierender Bildtechniken die Imagination der Betrachter herauszufordern.

Die Wirklichkeit empfanden die Surrealisten als ganz und gar unzulänglich. Sie müsse um das Imaginäre und das Überraschende, das Fremde und das Abgründige erweitert werden. Dabei spielte die Vorstellung des *merveilleux*, des Wunderbaren, eine entscheidende Rolle. Louis Aragon schrieb, der »tatsächliche Initiator« des »modernen Wunderbaren« sei Lautréamont, dessen mittlerweile häufig zitiertes Motto der Surrealisten in den *Chants de Maldoror (Gesänge des Maldoror)* steht: »Schön wie das zufällige Zusammentreffen einer Nähmaschine und eines Regenschirms auf einem Seziertisch«. Nach dem Verständnis der Surrealisten verleiht erst das Wunderbare dem Wirklichen seinen Sinn. Die wesentliche Triebfeder für die Wahrnehmung des Wunderbaren war für die Surrealisten *le désir*, die Begierde: das unstillbare Verlangen nach dem anderen, das heißt nach allem, was verborgen, verboten und tabu war und verschwiegen wurde. Das entscheidende Mittel war das surrealistische Bild. So schrieb Aragon 1926 in *Le Paysan de Paris:* »Dieses Laster, genannt Surrealismus, besteht in dem unmäßigen und leidenschaftlichen Gebrauch des Rauschgiftes *Bild* oder vielmehr in der unkontrollierten Beschwörung des Bildes um seiner selbst willen und auf dass es im Darstellungsbereich unvorhersehbare Umwälzungen und Metamorphosen bewirkt.«

Das surrealistische Bild ist inkongruent. Das bedeutet für die Fotografie: Ihre Autoren fühlten sich nicht an die Einheit des Orts und der Zeit gebunden, sie vermieden den direkten, ungebrochenen Wirklichkeitsbezug, wie er der Fotografie doch generell eigen war. Und wenn sie die Einheit der Szene aufgriffen oder die Nähe der sichtbaren Wirklichkeit suchten, dann durchbrachen sie sie sogleich mit fototechnischen Manipulationen, mit deren Hilfe sich das Bild nunmehr fragwürdig der Wirklichkeit entgegenstellte. Denn nach Auffassung André Bretons, der die Surrealistengruppe begründet hatte und zusammenhielt, sollte das visuelle wie das sprachliche Bild durch Fremdheit betören und zugleich durch eine Gegenwirklichkeit aufrühren, es sollte den Geist, die Sinne, aber möglichst auch den Körper erregen, es sollte erschüttern und dadurch eine plötzliche Erhellung des Wirklichen durch das Wunderbare bewirken. Bereits 1924, im *Ersten Manifest des Surrealismus*, präzisierte Breton die Eigenschaften des wirksamen surrealistischen Bildes: »Das stärkste Bild« sei für ihn »von einem höchsten Grad an Willkür gekennzeichnet« – womit er weniger die absichtslose als vielmehr die in Szene gesetzte Willkür, also den bewusst inszenierten Widerspruch meinte. Das stärkste Bild sei auch jenes, »für das man am längsten braucht, um es in die Alltagssprache zu übersetzen«, was verschiedene Gründe haben könne. Und dann zählte er die von der Regel abweichenden

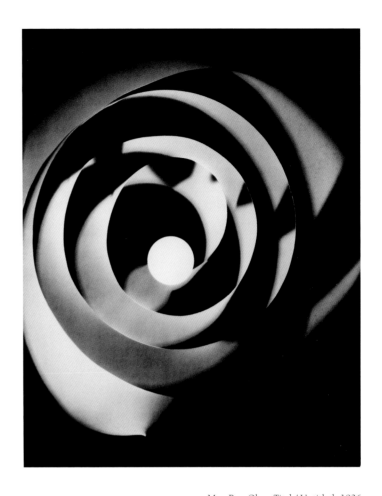

Man Ray, Ohne Titel / Untitled, 1926
Print 1966, Silbergelatineprint nach Rayogramm /
silver gelatin print of a Rayograph, 26,5 x 21,4 cm
Sammlung FOTOGRAFIS Bank Austria /
FOTOGRAFIS Bank Austria Collection

Surrealists felt reality as a fact to be utterly insufficient. It should be expanded by the imaginary and the surprising, the strange and the unfathomable. The notion of the *merveilleux*, the marvellous, played a crucial role. Louis Aragon wrote that the "actual initiator" of the "modern marvellous" was Lautréamont, whose frequently quoted motto of the Surrealists is to be found in the *Chants de Maldoror (Songs of Maldoror)*: "as beautiful as the chance encounter of a sewing machine and an umbrella on an operating table". According to the Surrealists' understanding, only the marvellous gives sense to reality. The essential driving force for perceiving the wonderful for Surrealists was *le désir*, desire: the unquenchable longing for the other, or for everything that was hidden, forbidden and taboo, and kept secret. The decisive means was the Surrealist image. In 1926, Aragon wrote in *Le Paysan de Paris:* "The vice called Surrealism is the immoderate and impassioned use of the stupefacient *image* or rather in the uncontrolled provocation of the image for its own sake and for the element of unpredictable perturbation and of metamorphosis which it introduces into the domain of representation."

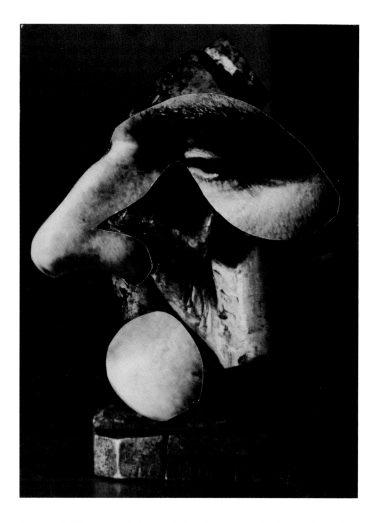

Raoul Hausmann, *L'Énigme*, 1946
Silbergelatineprint mit aufgeklebten Fotoausschnitten /
silver gelatin print with glued-on photograph cutouts, 23,5 x 17,2 cm
Sammlung FOTOGRAFIS Bank Austria /
FOTOGRAFIS Bank Austria Collection

The Surrealist image is incongruent. For photography, this means that its authors did not feel bound to the unity of location and time; they avoided the direct, unbroken relationship to reality, which was generally specific to photography. And when they picked up on the unity of the scene or sought proximity to visible reality, they broke through it immediately with photographic manipulations, by which the image is now doubtfully opposed to reality. In the view of André Breton, who had founded and held together the Surrealist group, the visual and linguistic image should bewitch through its strangeness and at the same time it should unsettle through a counter-reality; it should excite the spirit, the senses and also the body if possible; it should shock and thereby bring about a sudden illumination of the real through the wonderful. In 1924, in the *First Surrealist Manifesto*, Breton specified the properties of the effective Surrealist image: "the strongest image" for him is "characterized by the highest degree of arbitrariness" – by which he meant less the unintentional than the arbitrariness set in the scene, in other words the consciously staged contradiction. The strongest image is also the one that "requires the longest time to be translated into everyday language", which could have various bases. He then listed the pictorial possibilities generally diverging from the rule, which are also applicable to photography: it may be a "particularly high degree of obvious contrariness" or even "an insufficient formal justification in itself". Sometimes something hallucinatory would occur, sometimes "the abstract is given the mask of the concrete offhand [i.e. without reason, suddenly]", and sometimes, vice versa, "the negation of some fundamental physical property" is carried out; where possibly these deviations cause laughter. As a result, Breton had theoretically given Surrealist photography the authorization for varied experimentation with visual means.

Works by photographers of various backgrounds can be found in the FOTOGRAFIS collection. The American Man Ray was one of the great image creators among the Surrealists in Paris; the Hungarian André Kertész and his friend, the French artist Maurice Tabard, who was an acquaintance of René Magritte, were very close to them. The Austrian Herbert Bayer came from the Bauhaus, but during his time as a graphic designer working in advertising in the 1930s he adapted Surrealist practices when working freely, while Francis Bruguière took on board the Surrealist photogram processes without a camera in the USA. The Austrian Raoul Hausmann continued the tradition of the Dada collage, which lead the way in Surrealist visual material, with his grotesque heads. Even the Hungarian László Moholy-Nagy

Bildmöglichkeiten auf, die auch für die Fotografie ihre Geltung haben: Es könne sich um »einen besonders hohen Grad an offenkundiger Widersprüchlichkeit« handeln oder auch um »eine ungenügende formale Rechtfertigung in sich selbst«. Zuweilen träte »etwas Halluzinatorisches« auf, mal werde »ohne Weiteres [also ohne Begründung, plötzlich] dem Abstrakten die Maske des Konkreten« verliehen, mal werde umgekehrt »die Verneinung irgendeiner grundlegenden physischen Eigenschaft« vollzogen, womöglich würden solche Abweichungen Gelächter auslösen. Damit hatte Breton der surrealistischen Fotografie theoretisch die Ermächtigung zum vielseitigen Experiment mit den Bildmitteln gegeben.

In der Sammlung FOTOGRAFIS sind Arbeiten von Fotografen unterschiedlicher Herkunft zu finden. Der Amerikaner Man Ray gehörte zu den großen Bildschöpfern unter den Surrealisten in Paris; der Ungar André Kertész sowie der mit ihm wie mit René Magritte befreundete Franzose Maurice Tabard standen ihnen nahe. Der Österreicher Herbert Bayer kam aus dem Bauhaus, adaptierte aber in seiner Zeit als Werbegrafiker in den 1930er-Jahren beim freien Arbeiten surrealistische Praktiken, während sich Francis Bruguière in den USA

der surrealistischen Fotogramm-Verfahren ohne Kamera annahm. Der Österreicher Raoul Hausmann setzte mit seinen grotesken Köpfen die Tradition der Dada-Collage fort, die den surrealistischen Bildmitteln vorausging. Auch der Ungar László Moholy-Nagy und der Russe Alexander Rodtschenko arbeiteten auf dem Feld der Fotomontage.

Die surrealistische Fotografie ist stilistisch und technisch so wenig einheitlich wie die surrealistische Malerei. Generell – und auch in dieser kleinen Gruppe surrealistisch inspirierter Fotos – lassen sich vier unterschiedliche Verfahrensweisen ausmachen: Da ist zum einen *der verrätselnde Blick aufs Wirkliche*. Man Rays Porträt von Meret Oppenheim verleiht der Person nicht durch Inszenierung oder ateliertypische Lichteffekte die Aura einer ätherischen Persönlichkeit, sondern durch die Kombination von direkter Fotografie und Teilsolarisation. Den Ausschlag gibt also die raffinierte fotospezifische, also chemische Manipulation. André Kertész dagegen erreichte die Verzerrung, die Längung der Glieder und die Unschärfen durch die unübliche Kameraeinstellung, also nicht chemisch, sondern apparativ. Auslöser des verrätselten Bildes ist der begehrliche Blick des Fotografen auf das Wirkliche, das bei aller Verwandlung immer noch den Maßstab bildet.

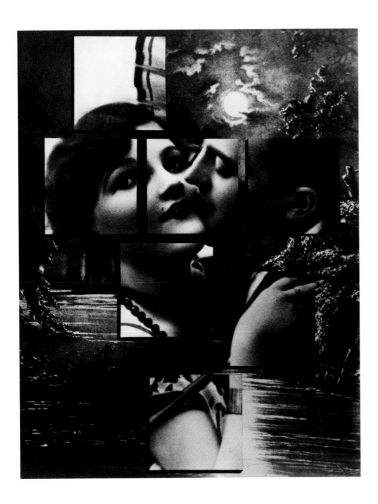

and the Russian Alexander Rodchenko worked in the field of photomontage.

Surrealist photography is stylistically and technically as far from uniform as Surrealist painting. In general – and even in this small group of photographs inspired by Surrealism – four different techniques can be made out. On the one hand there is *the puzzling view of reality*. Man Ray's portrait of Meret Oppenheim gives the person the aura of an ethereal personality not through staging or light effects typical of an artist's studio, but rather by combining direct photography and partial solarization. The refined, photograph-specific, and therefore chemical manipulation is the clincher. On the other hand, André Kertész achieved distortion, the elongation of limbs and blurring through the unusual camera setting, in a technique that was therefore based not on chemicals but on equipment. The motivation for the puzzling image is the photographer's covetous view of reality, which is still the benchmark in any transformation.

Herbert Bayer put things somewhat differently in his famous self-portrait of 1932. The man is horrified in front of a mirror at the slice of his arm that is cut out and which he is holding in his hand. The disconcerting – Surrealist – act of the *verification of the improbable* is achieved by means of a montage that for its part was photographed. The photograph itself is just a reproduction, not directed by any kind of viewpoint. It serves to confirm the improbable scene as true in a striking way because the photograph mirrors what the equipment records through the lens. The strange moments that dominate the image, which achieves the irritating and magical fusion of humans and puppets, are created through cutting, montage and retouching, in other words through a combination of mechanical processes.

Another process is the use of various techniques in one image. It causes the *indissoluble limitation of the levels of reality*. Maurice Tabard therefore liked to work with overlapping direct shots, double exposures, photograms, solarizations and additional mirror and shade effects. In a photograph series from 1929 to which the untitled work in this collection can be attributed, profile shots of a woman dressed in black are combined in different ways with another body, a portrait with a different scale or perspective, a grey-in-grey architectural view and various object silhouettes so that the levels of reality can no longer be separated. They have set up a coherent pictorial world according to their own laws because, as far as Max Ernst was concerned in 1934, it was only by toppling "the relationships between 'realities'" that the Surrealist movement was able to contribute to the

Herbert Bayer, *Der Mensch gewinnt / The Kiss*, 1932
Print 1969, Silbergelatineprint / silver gelatin print, 34 × 27 cm
Sammlung FOTOGRAFIS Bank Austria /
FOTOGRAFIS Bank Austria Collection

Etwa anders setzte Herbert Bayer bei seinem berühmt gewordenen Selbstbildnis von 1932 an. Der Mann erschrickt vor dem Spiegel über die herausgeschnittene Scheibe seines Arms, die er in der Hand hält. Der befremdliche – surrealistische – Akt ist *die Beglaubigung des Unwahrscheinlichen*, erreicht durch eine Montage, die ihrerseits fotografiert wurde. Das Foto selbst ist lediglich eine Reproduktion, nicht gelenkt von einem wie auch immer gearteten Blick. Es dient dazu, die unwahrscheinliche Szene frappierend als wahre Szene zu bestätigen, denn die Fotografie gibt wieder, was der Apparat durch das Objektiv aufnimmt. Die bildbestimmenden befremdlichen Momente, welche die irritierende und magisch wirkende Verschmelzung von Mensch und Puppe erreichen, werden durch Schnitt, Montage und Retusche, also durch eine Kombination mechanischer Vorgänge erzeugt.

Ein weiteres Verfahren ist der Einsatz verschiedener Techniken in einem Bild. Er bewirkt die *unauflösbare Verschränkung der Realitätsebenen*. So arbeitete Maurice Tabard gern mit der Überlagerung von Direktaufnahmen, mit Doppelbelichtungen, Fotogrammen, Solarisationen und zusätzlichen Spiegel- und Schatteneffekten. In einer Fotoserie von 1929, der die unbetitelte Arbeit aus dieser Sammlung zuzurechnen ist, sind Profilaufnahmen einer schwarz gekleideten Frau auf unterschiedliche Weise mit einem anderen Körper, einem im Maßstab oder in der Perspektive verschobenen Bildnis, einer grau-ingrauen Architekturansicht und verschiedenen Gegenstandssilhouetten so miteinander kombiniert, dass die Realitätsebenen sich nicht mehr trennen lassen. Sie haben eine in sich geschlossene Bildwelt nach eigenen Gesetzen errichtet. Denn, so befand Max Ernst 1934, nur indem die surrealistische Bewegung »die Beziehungen der ›Realitäten‹ untereinander umstürzte, konnte sie [...] zur Beschleunigung der allgemeinen Gewissens- und Bewusstseinskrise unserer Tage beisteuern«. Maßgeblich ist dabei das Verlangen, der sichtbaren Wirklichkeit oder den Bildern von der sichtbaren Wirklichkeit das Prinzip Irritation entgegenzusetzen. Dazu sind die Wirklichkeitselemente technisch verfremdet, in den Größenmaßstäben versetzt, auf verschiedenen Ebenen angeordnet und dann auf eine schwer durchschaubare Weise miteinander verschweißt. Auch Herbert Bayers Arbeiten in dieser Sammlung leben von der Kombinatorik oder der Übergängigkeit, der Metamorphose der Motive. Beide, Kombinatorik und Metamorphose, gelten als die hauptsächlichen methodischen Prinzipien des Surrealismus. Hier gehen Realität und Imagination, Bilder des Äußeren und Bilder aus dem Inneren unmittelbar und unauflösbar ineinander über. Dazu schrieb Max Ernst 1934, die Freude an jeder gelungenen Metamorphose oder Entfremdung entspräche nicht »einem elenden ästhetischen Distraktionstrieb«, sondern »dem uralten Bedürfnis des Intellekts nach Befreiung aus dem trügerischen und langweiligen Paradies der fixen Erinnerungen und nach Erforschung eines neuen, ungleich weiteren Erfahrungsgebiets, in welchem die Grenzen zwischen der sogenannten Innenwelt und

Man Ray, Ohne Titel / Untitled
(Waffe mit Buchstabenquadraten / Gun with Alphabet Squares), 1924
Print 1966, Silbergelatineprint nach Rayogramm /
silver gelatin print of a Rayograph, 26,4 × 21, 2 cm
Sammlung FOTOGRAFIS Bank Austria /
FOTOGRAFIS Bank Austria Collection

acceleration of the general crisis in conscience and awareness of our days." The desire to bring the principle of confusion to visible reality or to images of visible reality is crucial. The elements of reality are technically alienated, size scales are shifted, arranged on different levels and then fused together in a manner difficult to see through. Herbert Bayer's works in this collection also live off the combinatorics or transience, the metamorphosis of motifs. Both combinatorics and metamorphosis are considered the main methodological principles of Surrealism. Here reality and imagination, images of the exterior and images of the interior pass over each other directly and indissolubly. Max Ernst wrote in 1934 that "the joy for each successful metamorphosis or alienation does not correspond to a miserable aesthetic instinct for distraction but rather to the intellect's primeval need for freedom from the deceptive and boring paradise of fixed memories and its need to explore a new field of experience unlike

der Außenwelt [...] sich mehr und mehr verwischen und wahrscheinlich eines Tages [...] völlig verschwinden werden«. Daran arbeiteten die Surrealisten.

Schließlich ist die *Entkörperlichung der Objektwelt* durch kameralose Aufnahmen ein weiteres surrealistisches Prinzip in der Fotografie. Vor allem Man Ray kostete das Fotogramm seit Beginn der 1920er-Jahre in einer Fülle von Varianten der von ihm so genannten Rayogramme aus. Das Fotogramm macht mit seiner direkten Belichtung auf lichtempfindlichen Materialien die Silhouetten von Objekten sichtbar, überführt sie aber in der avancierten surrealistischen Praxis durch die Schwarz-Weiß-Umkehr und damit durch die Abstraktion sowie durch die Kombination einander fremder Bildgegenstände in verrätselte, mehrdeutige Formen und Gestalten. Ausschlaggebend für das endgültige Bild sind physikalische und chemische Manipulationen.

Der surrealistische, verrätselnde Blick aufs Wirkliche, die Beglaubigung des Unwahrscheinlichen, die unauflösbare Verschränkung der Realitätsebenen und die Entkörperlichung der Objektwelt führten zu dem, was die Surrealisten gern *dépaysement*, Entfremdung, nannten. In der Entfremdung des Wirklichen sahen sie den subversiven Akt, um dessentwillen das surrealistische Bild erfunden wurde. Erstes Resultat dieser gesuchten Entfremdung war – noch im Kunstbereich – die Neufassung der fotografischen Bildwelten, der »Umsturz der Bilder« (Paul Nougé). Das eigentliche Ziel des surrealistischen Bildschaffens aber sollte über den Kunstbereich hinausgehen und die vielfach von André Breton beschworene »allgemeine Bewusstseinskrise« auslösen. So lautete der Eingangssatz des *Zweiten surrealistischen Manifests* von 1929: »Ungeachtet der verschiedenen Unternehmungen all derer, die sich auf den Surrealismus berufen haben und sich noch auf ihn berufen, wird man letztlich doch zugestehen müssen, dass er nichts so sehr erstrebte, als in intellektueller und moralischer Hinsicht eine *Bewusstseinskrise* allgemeinster und schwerwiegendster Art auszulösen.« Die von den Surrealisten als gleichrangig anerkannte Fotografie sollte das Ihre dazu beitragen.

any other in which the borders between the interior world and the exterior world [...] become more and more blurred and perhaps one day [...] disappear completely". Surrealists worked on this.

Finally, the *disembodiment of the object world* through camera-less recording is another Surrealist principle in photography. In particular, Man Ray enjoyed making use of the photogram from the beginning of the 1920s in an abundance of varieties of "Rayograms", which he named himself. The photogram made the silhouettes of objects visible with its direct exposure on the light-sensitive material, but it was transferred into advanced Surrealist practice through the black-white switch, and thus into puzzling, ambiguous forms and shapes due to the abstraction and combination of strange images of objects. Physical and chemical manipulations are vital for the final image.

The Surrealists' puzzling view of reality, the confirmation of the improbable, the indissoluble restriction of levels of reality and the disembodiment of the object world led to what Surrealists liked to call *dépaysement*, estrangement. In estranging the real, they saw the subversive act for the sake of which the Surrealist image was created. The first result of this sought-after estrangement – still in the area of art – was the reformulation of photographic image worlds, the "revolution of images" (Paul Nougé). The actual aim of the Surrealist image-making process, however, should go beyond the field of art and provoke the general crisis of conscience uttered by André Breton. Thus the introductory sentence of the *Second Surrealist Manifesto* of 1929 is as follows: "In spite of the various efforts peculiar to each of those who used to claim kinship with Surrealism, or who still do, one must ultimately admit that, more than anything else, Surrealism attempted to provoke, from the intellectual and moral point of view, *a crisis of the conscience* of the most general and serious kind". The photography recognized as equal by the Surrealists should make its own contribution to this.

Alexander Rodtschenko

Geboren 1891 in Sankt Petersburg/Russland, verstorben 1956 in Moskau/Russland. Nach der Schulausbildung in Kasan in Tatarstan ging Alexander Rodtschenko 1914 nach Moskau, wo er sich nach der Ausbildung zum Bildhauer und Architekten der gegenstandslosen Malerei zuwandte. Frühe Erfolge im Kreis der Suprematisten und Konstruktivisten ermutigten ihn zur Entwicklung ungewöhnlicher, utopischer Raum- und Objektinstallationen. 1921 malte er sein letztes monochromes Bild und wandte sich dem Theater, der politischen Collage, der Typografie und der Fotografie zu, die er 1942 aufgab, um ein Spätwerk als Maler zu entwickeln.

Eine poetische, weniger beachtete Arbeit Rodtschenkos entstand in Zusammenarbeit mit seinem Dichterfreund Wladimir Majakowski für dessen romantisches Gedicht »Pro eto«, zu Deutsch »Das bewusste Thema«, in dem der Lyriker seine Liebe zu seiner Freundin Lilja Brik beschreibt. Die russische Originalausgabe erschien 1923. Rodtschenko verwendete für die insgesamt 21 Illustrationsblätter unterschiedliches Bildmaterial, darunter von ihm selbst und anderen angefertigte Porträts von Lilja und Majakowski, die er mit Text-Exzerpten aus in- und ausländischen Magazinen versah und collageartig kombinierte. In die Edition wurden acht Motive aufgenommen. Das vorliegende Blatt ist die fünfte Abbildung im Buch. Der Charakter der Collagen sollte das Neuartige und Moderne einer neuen Lyrik, die streng und faktisch vorgeht, sowie eine innovative Illustrationstechnik, die die traditionelle Zeichnung überwunden hat, subsumieren und dabei das Antibürgerliche einer bohemienhaften neuen Lebensweise anreißen. Die letzte Zeile der neben dieser Illustration stehenden Strophe lautet: »Und wieder/der Saalwand weißglühende Steppe/während der Twostep/schmachtseufzend sich wiegt.«

Born in 1891 in Saint Petersburg/Russia, died in 1956 in Moscow/Russia. After his schooling in Kazan, Tatarstan, Alexander Rodchenko went to Moscow in 1914, where he trained as a sculptor and architect and then turned to abstract painting. Early success in the circle of the Suprematist and Constructivist movements encouraged him to develop unusual utopian space and object installations. In 1921 he painted his last monochrome painting and turned to theatre, political collage, typography and photography, which he gave up in 1942 to develop a late work as a painter.

A poetic, less known work by Rodchenko was produced in collaboration with his poet-friend Vladimir Mayakovsky for his romantic poem "Pro eto" ("That's What"), in which the lyricist describes his love for his girlfriend Lilja Brik. The original Russian edition appeared in 1923. Rodchenko used various visual materials for a total of 21 illustrations, including portraits of Lilja and Mayakovsky by himself and others, which he provided with text excerpts from national and international magazines and collage-like combinations. Eight pictures were taken for the edition. This sheet is the fifth illustration in the book. The character of the collages was supposed to incorporate the novelty and modernity of a new poetry, which proceeds rigorously and factually, along with an innovative illustration technique that has overcome traditional drawings, subsumed and thereby touching on the anti-bourgeois aspects of a bohemian-style new way of life. The last line of verse next to this illustration is: "And again the walls/like a blistering steppe/sigh and ring/with the damned two-step."

Literatur/Further reading: Alexander Lavrentiev, *Alexander Rodchenko. Photography 1924–1954*, Köln/Cologne 1995

Wladimir Majakowski, *Pro eto. Das bewusste Thema*, mit Fotocollagen von Alexander Rodtschenko/Vladimir Mayakovsky, *Pro eto. That's What*, with photo collages by Alexander Rodchenko (Reprint der russischen Ausgabe von 1923 mit deutscher und englischer Übersetzung/reprint of the Russian edition of 1923 with German and English translations), Berlin 1994

Alexander Rodtschenko/Rodchenko
Die Jazz-Band/The Jazz Band, 1923
Silbergelatineprint/silver gelatin print

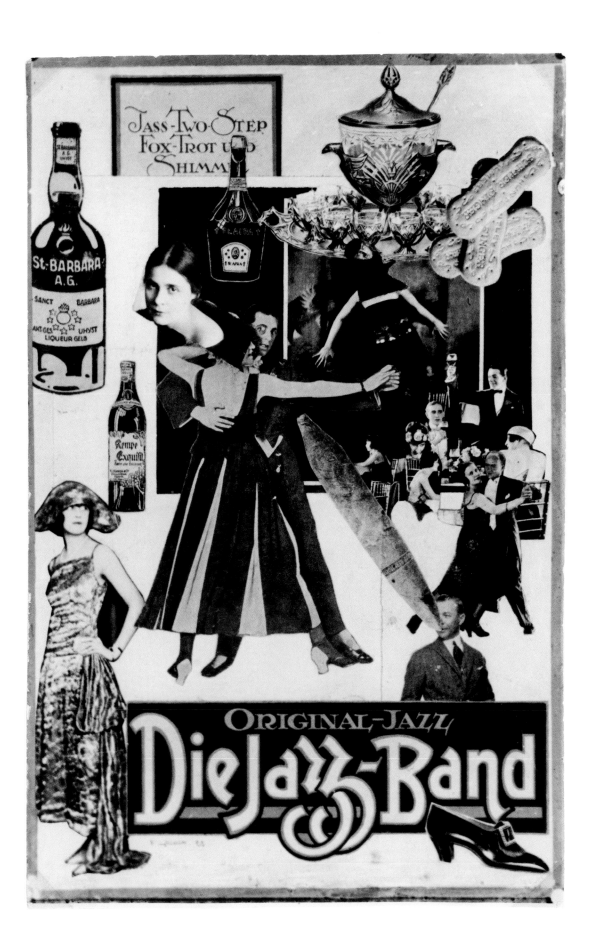

László Moholy-Nagy

Geboren 1895 in Bácsborsód/Ungarn, verstorben 1946 in Chicago/USA. Ab 1918 beschäftigte sich Moholy-Nagy mit Malerei. 1919 übersiedelte er nach Wien und 1920 nach Berlin. 1923 wurde er an das Bauhaus berufen, wo er Assistent von Walter Gropius und Spezialist für Typografie und Fotografie war und die Grundkurs- und Metallklasse übernahm. Ab 1924 gestaltete er die Bauhaus-Bücher. In dieser Zeit entstand sein umfangreiches fotografisches Werk, zu dem auch die Entwicklung der Idee des Fotogramms gehörte. Zudem schuf er Objekte wie den *Licht-Raum-Modulator* sowie Malereien und Collagen, in denen er die Materialität der Kunst untersuchte. 1928 verließ er das Bauhaus und gründete in Berlin sein eigenes Studio. Er revolutionierte die Maßstäbe in Typografie und Werbung, schuf Fotografien und ein filmisches Werk. Nach der Machtergreifung Hitlers emigrierte er zunächst nach Amsterdam, 1935 dann nach London und 1937 in die USA, wo er in Chicago das New Bauhaus und die School of Design gründete.

Im Sinne einer Verbindung von surrealer Kombinatorik und geometrischer Abstraktion beschritt Moholy-Nagy bisweilen das Terrain der poetischen Anspielung: Die nach einer Originalcollage entstandene Fotoarbeit *Zwischen Himmel und Erde* trägt auch den Titel *Das Auge des Gesetzes* und ist eine kombinierte Bilderzählung, in der die schrägen Bleistiftstriche Halt und Absturz gleichermaßen verkörpern und auf den Zustand des Menschen zwischen Schwerelosigkeit und Gehaltensein anspielen. Moholy-Nagy war 1926 einer der ersten Besucher des Zeiss-Planetariums in Jena und arbeitete mit dort angefertigten Fotos von Menschen, die sich in einer Netzkuppel befinden. Später brachte er seine Überlegungen zu Schwerelosigkeit und Raumauffassung auch als Bühnenbildner bei Erwin Piscator in Berlin ein. Ebenfalls in den Jahren um 1926 beschäftigte er sich mit der Idee von Produktion und Reproduktion und integrierte vielfach gefundenes fotografisches Material in seine Fotoplastiken.

Literatur/Further reading: Krisztina Passuth, *Moholy-Nagy*, Dresden 1982

Born in 1895 in Bácsborsód/Hungary, died in 1946 in Chicago/USA. From 1918 Moholy-Nagy dedicated himself to painting. In 1919 he moved to Vienna and in 1920 to Berlin. In 1923 he was appointed to the Bauhaus, where he was an assistant to Walter Gropius and a specialist in typography and photography and taught the introductory course as well as metal-working classes. From 1924 he designed the Bauhaus books. During this time he created his extensive photographic work, including the development of the idea of the photogram. In addition, he created objects such as the *Light-Space Modulator* as well as paintings and collages in which he examined the materiality of art. In 1928 he left the Bauhaus and founded his own studio in Berlin. He revolutionized typography and advertising standards, and created photographs and a cinematic work. After Hitler came to power, Moholy-Nagy emigrated first to Amsterdam and then to London in 1935 and to the USA in 1937, where he founded the New Bauhaus and the School of Design in Chicago.

In terms of a combination of surreal combinatorics and geometric abstraction, Moholy-Nagy sometimes walked the path of poetic allusion. Modelled after an original collage, the photographic work *Between Heaven and Earth* also carries the title *The Eye of the Law*, and is a combined pictorial narrative in which the oblique pencil lines embody fixing and falling and allude to the human condition between weightlessness and a feeling of being held. In 1926 Moholy-Nagy was one of the first visitors to the Zeiss Planetarium in Jena and worked with photographs taken there of people in a net dome. Later, as a set designer for Erwin Piscator in Berlin he also introduced his ideas on weightlessness and the notion of space. In the years around 1926, he was also interested in the idea of production and reproduction, and frequently integrated found photographic material into his photo-sculptures.

László Moholy-Nagy
Zwischen Himmel und Erde I, 1926
Abzug vermutlich von/print thought to be from 1971/72
Silbergelatineprint/silver gelatin print

Man Ray

Geboren 1890 in Philadelphia/USA, mit bürgerlichem Namen Emmanuel Rudnitzky (auch: Radnitzky), verstorben 1976 in Paris/Frankreich. Mit dem Künstlernamen Man Ray vollzog der Künstler eine dem Dadaismus und dem Surrealismus adäquate Persönlichkeitsänderung. Nach dem Besuch verschiedener Kunstschulen und Versuchen im Zeichnerischen und Malerischen begann er in den Jahren 1913 und 1914 zu fotografieren. Unter dem Einfluss der Freundschaft mit Marcel Duchamp entstanden Fotografien und verschiedene künstlerische Experimente, ab 1919/20 auch die sogenannten Rayographs oder Rayogramme. Ab 1921 lebte Man Ray in Paris im Kreis der Surrealisten; es entstanden Mode- und Porträtfotografien, ab 1922 auch Aktfotografien. Ab 1931 interessierte er sich für Solarisationsverfahren und den Sabattier-Effekt. Er schuf als Filmer und als Fotograf, unter anderem für *Vogue* und *Harper's Bazaar*, bedeutende Arbeiten. 1940 flüchtete er in die USA, kehrte jedoch 1951 wieder nach Paris zurück.

Born in 1890 as Emmanuel Rudnitzky (also: Radnitzky) in Philadelphia/USA, died in 1976 in Paris/France. With the adoption of the pseudonym Man Ray, the artist underwent a personality change appropriate to Dadaism and Surrealism. After visiting various art schools and experimenting in drawing and painting, he began to take photographs in 1913 and 1914. Under the influence of his friendship with Marcel Duchamp, he created photographs and various artistic experiments and, around 1919/20, the so-called Rayographs or Rayograms. From 1921 Man Ray lived in Paris in the circle of Surrealists; he also took fashion and portrait photographs and, from 1922, also nudes. From 1931 he was interested in solarization techniques and the Sabattier effect. As a filmmaker and photographer, he created important works for *Vogue* and *Harper's Bazaar*, among others. In 1940 he fled to the United States, but returned to Paris in 1951.

In den 1920er-Jahren war Man Rays Haupteinnahmequelle die Mode- und Porträtfotografie. So konnte er sich auch ein bescheidenes Studio leisten, in dem er seine Modelle vor dunklem Grund oder vor Vorhängen fotografierte. In der Phase des Experimentierens mit Licht und fotoimmanenten Charakteristika entstand auch das Foto einer unbekannten Dame in einem Schachbrettmuster-Kleid auf ebenso gemustertem Boden. Die Aufnahme war vermutlich als Modeaufnahme gedacht. Im Aufbau und der offensichtlichen Vorliebe für das Schachbrettmuster zeigt sie jedoch Ähnlichkeiten mit anderen Porträtbildern Man Rays, etwa jenen von Tänzern, die er in den Jahren 1924 und 1925 angefertigt hatte.

In the 1920s, Man Ray's main source of income came from fashion and portrait photography. Thus he could afford a modest studio in which he photographed his models against a dark background or in front of curtains. The photograph of an unknown woman in a checkerboard-patterned dress on a similar-looking floor emerged in the phase of experimentation with light and intrinsic photographic characteristics. The picture was probably intended as a fashion shot. However, with the structure and the obvious preference for the checkerboard pattern, it shows similarities with other portraits by Man Ray, for instance the photographs of dancers that he took in 1924 and 1925.

Literatur/Further reading: Sarane Alexandrian, *Man Ray*, Berlin 1973

Man Ray
Ohne Titel/Untitled
zwischen/between 1924 und/and 1929
Silbergelatineprint/silver gelatin print

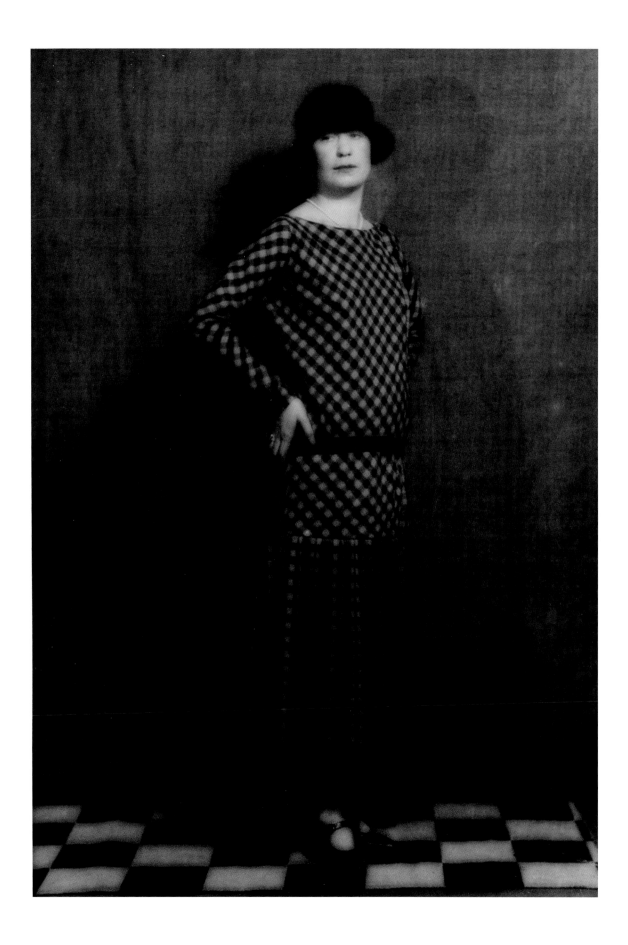

André Kertész

Geboren 1894 als Andor Kertész in Budapest/Ungarn, verstorben 1985 in New York/USA. Nach dem Studium an der Handelsakademie in Budapest arbeitete Kertész 1912 als Angestellter an der Börse und begann im selben Jahr als Autodidakt zu fotografieren. Von 1914 bis 1918 dokumentierte er das Kriegsgeschehen des Ersten Weltkriegs. Ab 1925 lebte er in Paris und fing an, für Zeitungen und Zeitschriften zu fotografieren. Er begegnete Man Ray, Nadar, Paul Outerbridge und den Surrealisten um André Breton. In dieser Zeit entwickelte er mit seinen experimentellen und spiegelverzerrten Aktfotos einen eigenwilligen Stil. Seine sozialdokumentarische Fotografie steht der Neuen Sachlichkeit sehr nahe. 1936 ging er nach New York und arbeitete fortan für große Magazine wie *Vogue* und *Harper's Bazaar*. 1963 erhielt er die Goldmedaille auf der Biennale in Venedig. In den darauffolgenden Jahren widmete er sich nur noch privat der Fotografie.

Durch die Begegnung mit den Ideen der Surrealisten entwickelte André Kertész um 1930 einen fotografischen Stil, der sich von seinen dokumentarischen Fotografien entfernte. Er überprüfte die Möglichkeiten der Wahrnehmung, indem er für seine Aktfotografien Spiegel und Objektive nutzte, die die menschlichen Proportionen ins Groteske und Unwirkliche verzerrten. Er lotete durch die Verwendung von optischen Hilfsmitteln die Möglichkeiten des fotografischen Bildes bis ins Extreme aus. Diese experimentellen Aufnahmen waren ihm sehr wichtig und er publizierte 1976 eine bedeutende Auswahl unter dem Titel *Distortions*.

Literatur/Further reading: Pierre Borhan, *André Kertész. His Life and Work*, Boston, New York, Toronto und/and London 1997

Born in 1894 as Andor Kertész in Budapest/Hungary, died in 1985 in New York/USA. After studying at the Academy of Commerce in Budapest, Kertész worked as a stock-market clerk in 1912 and began to take pictures as a self-taught photographer in the same year. From 1914 to 1918 he documented the events of the First World War. From 1925 he lived in Paris and began to take photographs for newspapers and magazines. He met Man Ray, Nadar, Paul Outerbridge and the Surrealists surrounding André Breton. During this time he developed his own style with his experimental and distorted-reflection nude photographs. His social-documentary photography is very similar to New Objectivity. In 1936 he went to New York and began working for major magazines such as *Vogue* and *Harper's Bazaar*. In 1963 he received the Gold Medal at the Venice Biennale. In the following years he devoted himself exclusively to personal photography.

Through the encounter with the ideas of the Surrealists, André Kertész developed a photographic style around 1930 that distanced him from his documentary photographs. He investigated the possibilities of perception by using mirrors and lenses that distorted the human proportions to the point of grotesqueness and the unreal in his nude photographs. By using visual aids, he explored the possibilities of the photographic image to the extreme. These experimental pictures were very important to him and in 1976 he published a major selection entitled *Distortions*.

André Kertész
Distortion no. 40, 1933
Silbergelatineprint/silver gelatin print

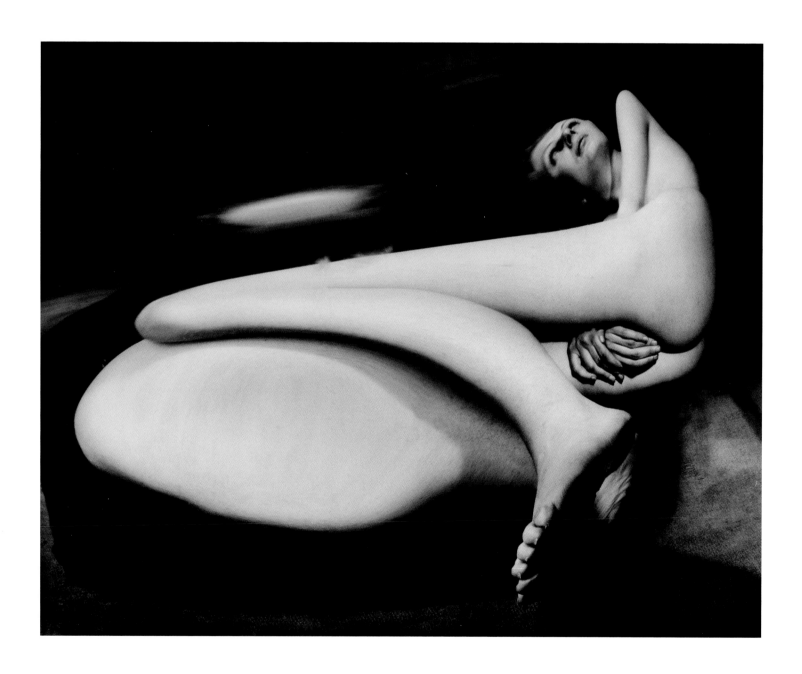

Francis Joseph Bruguière

Geboren 1879 in San Francisco/USA, verstorben 1945 in London/Großbritannien. Durch die Freundschaft zu Frank Eugene und Alfred Stieglitz wurde Francis Joseph Bruguière 1905 Mitglied der Photo-Secession in New York. 1906 eröffnete er sein eigenes Fotostudio in San Francisco. 1919 kehrte er nach New York zurück, um für Magazine wie *Vanity Fair* und *Harper's Bazaar* sowie für New Yorker Theater zu arbeiten. 1923 begann er, mit ausgeschnittenen Papieren und Schablonen dramatisch inszenierte Stillleben herzustellen. 1928 ging er nach London, wo er zunächst als Fotograf und Filmer, ab 1937 nur noch als Maler tätig war.

Die meistens *Untitled* oder *Abstract Study* betitelten Arbeiten der 1920er- bis 1930er-Jahre beruhen auf minutiös vorbereiteten Arrangements und deren dramatischer Ausleuchtung. Bruguière verwendete verschieden starke Papiere, die er mit Schnitten versah. Diese »Cut-outs« positionierte er silhouetten- und reliefhaft voreinander und erzeugte so in seinen stilllebenartigen Inszenierungen einen dem Kubismus angenäherten Eindruck von Simultaneität der Ansichten.

Literatur/Further reading: James Enyeart, *Bruguière. His Photographs and His Life*, New York 1977

Born in 1879 in San Francisco/USA, died in 1945 in London/Great Britain. Through his friendship with Frank Eugene and Alfred Stieglitz, Francis Joseph Bruguière became a member in 1905 of the Photo-Secession in New York and in 1906 he opened his own photography studio in San Francisco. He returned to New York in 1919 to work for magazines such as *Vanity Fair* and *Harper's Bazaar* and for New York theatres. In 1923 he started producing dramatically staged still lifes from cut-out papers and stencils. In 1928 he moved to London, where he first worked as a photographer and filmmaker, and then, after 1937, only as a painter.

Most of the works entitled *Untitled* or *Abstract Study* from the 1920s and 1930s are based on meticulously prepared arrangements and their dramatic lighting. Bruguière used different strengths of paper, which he decorated with cuts. He positioned these "cut-outs" like silhouettes and reliefs in front of one another and in this way his still-life-like staging generated an impression similar to the Cubist idea of the simultaneity of views.

Francis Joseph Bruguière
Flowers of White Light, um/ca. 1925
Bromsilberprint, getont/bromine silver print, toned

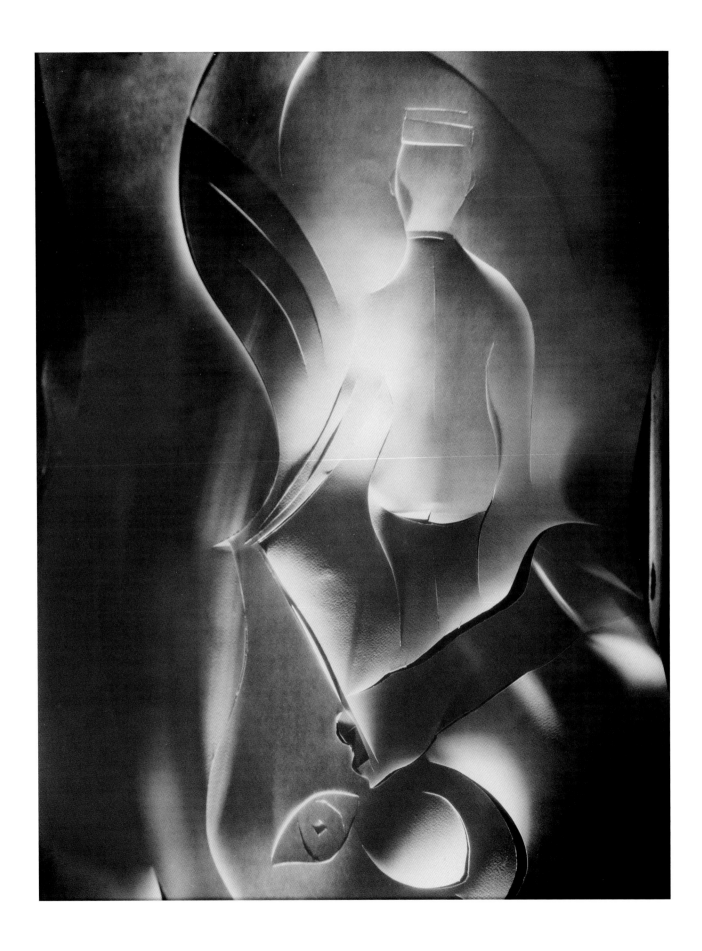

Maurice Tabard

Geboren 1897 in Lyon/Frankreich, verstorben 1984 in Nizza/Frankreich. 1914 emigrierte Maurice Tabard mit seiner Familie nach New York. Ab 1916 studierte er am New York Institute of Photography. Von 1916 bis 1922 beschäftigte er sich mit Malerei, Stoffmuster-Design, Musik und Fotografie. Seinen Lebensunterhalt verdiente er mit Porträt- und Reklamefotografie. 1928 ging Tabard nach Paris, wo er durch Kontakte zu Philippe Soupault, Man Ray und René Magritte verstärkt an seinen fotografischen Experimenten arbeitete, die er stets neben seinem Broterwerb betrieb. In Begleitung von Ethnografen schuf er Fotos und Dokumentarfilme in Nordafrika. 1946 musste er in die USA ausreisen, kehrte aber 1951 nach Frankreich zurück. Er unternahm zahlreiche Reisen und war als Lehrer im Bereich Fotografie tätig. 1966 zog er sich aus dem Berufsleben zurück.

Tabards Arbeiten bewegen sich im Spannungsfeld zwischen Dadaismus, Surrealismus und Dokumentation. Er arbeitete mit Solarisation, Negativ-Druck, Doppelbelichtungen, Fotogrammen und abstrakten Fotomontagen. Besonders die Effekte, die zu erzielen sind, wenn zwei oder mehr Fotos übereinanderkopiert werden, interessierten ihn. Seine Auffassung von Fotografie hielt Tabard auch in theoretischen Schriften fest: Die Fotografie sollte Medium der künstlerischen Umsetzung sein, wobei der Komposition die entscheidende Rolle zukam. So erweiterte Tabard die Aufnahme einer stehenden Frau um den umgebenden Raum und stellte sie mitten in ein Ambiente aus Dekorationsteilen, Tennisschlägern und Schatten, um ihr das Flair einer traumhaften, aber auch selbstbewussten Persönlichkeit zu verleihen.

Born in 1897 in Lyon/France, died in 1984 in Nice/France. Maurice Tabard and his family emigrated to New York in 1914. From 1916 he studied at the New York Institute of Photography. From 1916 to 1922 he was involved in painting, fabric design, music and photography. He earned his living with portraiture and advertising photography. In 1928 Tabard went to Paris where, after making contact with Philippe Soupault, Man Ray and René Magritte, he increasingly worked on his photographic experiments beside his commercial activity. Accompanying ethnographers, he took photographs and documentary films in North Africa. In 1946 he had to go back to the USA but returned to France in 1951. He went on numerous trips and worked as a teacher in the field of photography. He retired from professional life in 1966.

Tabard's work moves between the poles of Dadaism, Surrealism and documentation. He worked with solarization, negative prints, double exposures, photograms and abstract photomontages. He was particularly interested in the effects that can be achieved when two or more photographs are copied over each other. Tabard also expressed his views on photography in theoretical writings: the photograph should be a medium of artistic accomplishment and composition plays a decisive role. Thus Tabard expanded the photograph of a standing woman to the surrounding space, placing her in the middle of an ambience of decorative parts, tennis rackets and shadows in order to give her the flair of a dreamlike but also self-confident person.

Literatur/Further reading: Xavier Canonne, *Maurice Tabard. Le Géomètre* (Ausst.-Kat./exh. cat. Musée de la Photographie à Charleroi), Charleroi 2002

Maurice Tabard
Ohne Titel/Untitled, 1929
Silbergelatineprint/silver gelatin print

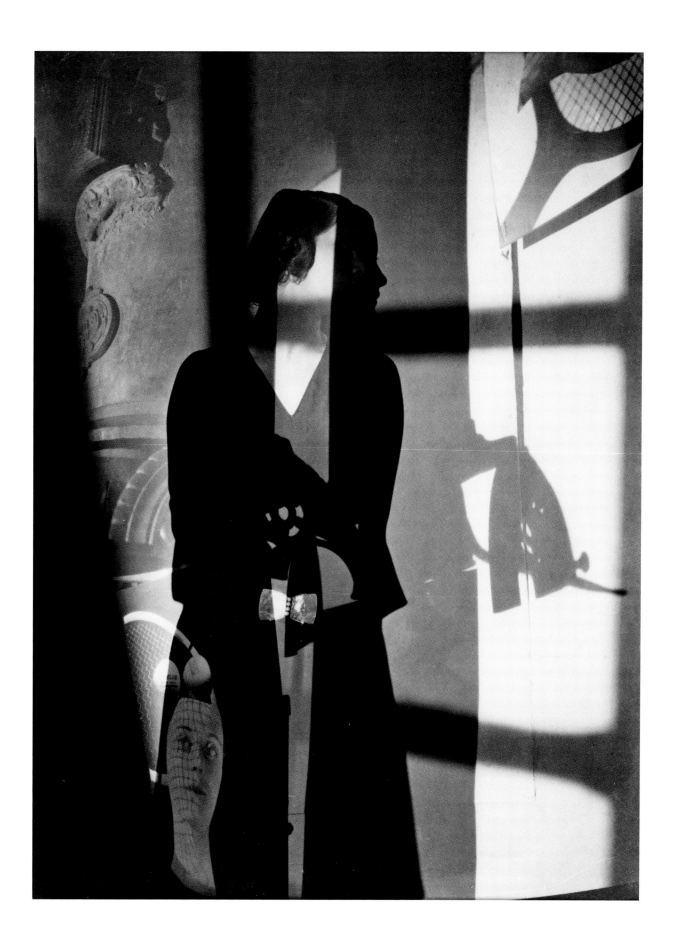

Herbert Bayer

Geboren 1900 in Haag am Hausruck/Österreich, verstorben 1985 in Montecito, Kalifornien/USA. Auf die Ausbildung in Architekturbüros und als Produktdesigner folgte bei Herbert Bayer die Zeit als Student am Bauhaus in Weimar und von 1925 bis 1928 die Leitung der Klasse Druck und Reklame am Bauhaus in Dessau. Ab 1928 lebte er für zehn Jahre als Maler, Fotograf und Grafiker in Berlin, wo 1932 die erste Edition der *Fotomontagen* mit elf Fotografien entstand, der 1936 die Mappe *Fotoplastiken* mit acht Fotografien folgte. Bayer nahm auch grafische Arbeiten für Publikationen der NSDAP an, musste jedoch 1938 in die USA emigrieren, nachdem seine Arbeiten bei der Ausstellung *Entartete Kunst* vertreten waren. Er lebte bis 1946 in New York, danach bis 1974 in Aspen, Colorado, und ab 1975 in Montecito, Kalifornien.

Das Hauptmotiv aus der Serie der *Fotomontagen* ist das *Selbstporträt* Herbert Bayers, das seine Position zwischen Neuer Sachlichkeit und Surrealismus belegt: Mit drastischer Genauigkeit und im kontrastreichen Hell-Dunkel-Stil des »Neuen Sehens« gibt er den Blick in den Spiegel auf sich selbst wieder – verfremdet, manipuliert, wie im Traum, dem Lieblingselement der Surrealisten. Es wird vermutet, dass die Bilder der *Fotomontagen* einer geplanten Bilderzählung zum Thema »Mensch und Traum« zugeordnet waren, die jedoch nicht realisiert wurde. Bayers Originalcollagen zu dieser Werkgruppe bestehen aus aufgeklebten Fotos, retuschierten und gespritzten malerischen Elementen sowie mehrmaligen Überlagerungen. Die späteren Editionen wurden 1968/69 von der Galerie Klihm in München besorgt.

Born in 1900 in Haag am Hausruck/Austria, died in 1985 in Montecito, California/ USA. After training in architectural offices and as a product designer, Herbert Bayer continued as a student at the Bauhaus in Weimar and then as director of Printing and Advertising at the Bauhaus in Dessau from 1925 to 1928. From 1928 he lived for ten years as a painter, photographer and graphic designer in Berlin, where the first edition of the *Fotomontagen* was printed in 1932 with eleven photographs, and the portfolio *Fotoplastiken* followed in 1936 with eight photographs. Bayer also designed graphic works for Nazi-party publications, but had to emigrate to the United States in 1938 after his work was shown at the *Degenerate Art* exhibition. He lived in New York until 1946, in Aspen/Colorado until 1974 and in Montecito/ California from 1975.

The main subject of the series of *Fotomontagen* is Herbert Bayer's *Selbstporträt*, which occupies a position between New Objectivity and Surrealism: with the dramatic accuracy and high-contrast chiaroscuro style of New Vision, he portrays himself looking in the mirror and seeing himself distorted and manipulated, as in a dream – the favourite element of Surrealists. It is assumed that the pictures from *Fotomontagen* were associated with a planned photo narrative on the theme of "Man and Dream" that was never realized. Bayer's original collages for this group of works consisted of glued photographs, retouched and sprayed scenic elements and multiple overlays. Galerie Klihm in Munich printed the later editions in 1968/69.

Literatur/Further reading: Elisabeth Nowak-Thaller (Hrsg./ed.), *Ahoi, Herbert! Bayer und die Moderne* (Ausst.-Kat./exh. cat. Lentos Kunstmuseum Linz), Weitra 2009

Herbert Bayer
Selbstporträt, 1932
Print 1969, Silbergelatineprint/silver gelatin print

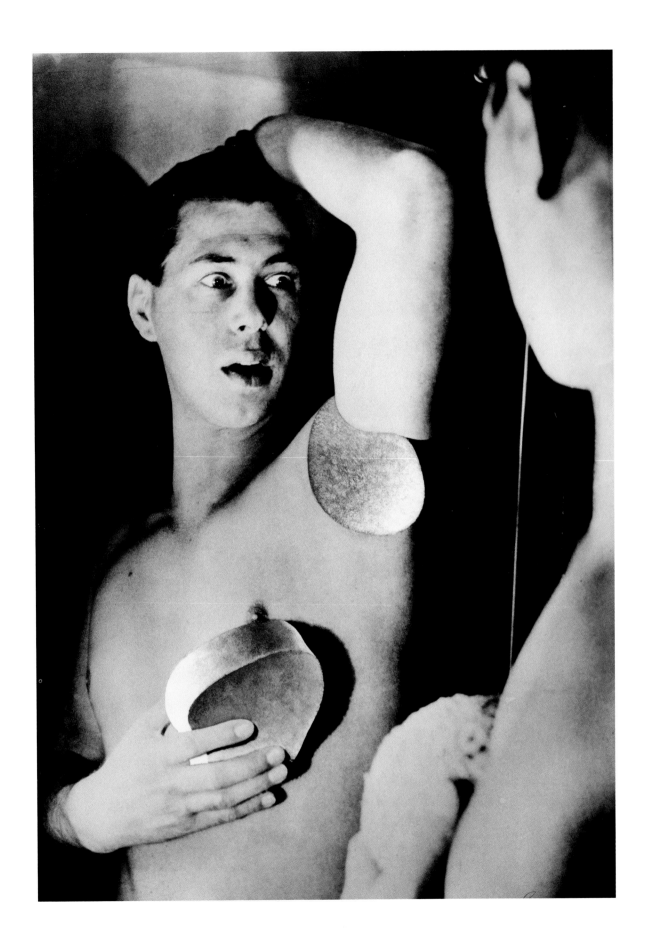

Raoul Hausmann

Geboren 1886 in Wien/Österreich, verstorben 1971 in Limoges/Frankreich. Nach dem Studium der Malerei und Plastik in Berlin von 1908 bis 1911 hatte Raoul Hausmann ab 1912 Kontakt zu avantgardistischen Künstlern und Literaten. Von 1918 bis 1922 gehörte er der Dada-Bewegung in Berlin an. 1919 gründete er die Zeitschrift *Der Dada* und war 1920 Mitorganisator der Ersten Internationalen Dada-Messe in Berlin. Ab 1927 widmete sich Hausmann systematisch der Fotografie. Ab 1931 veröffentlichte er in Zeitschriften regelmäßig Beiträge, die wahrnehmungs- und kunsttheoretischen Fragen sowie solchen zur Formdialektik von Fotomontage und Fotografie nachgingen. 1933 musste Hausmann emigrieren, da seine künstlerische Arbeit zur »entarteten Kunst« gezählt wurde. Seine Stationen waren Ibiza, Zürich, Prag und schließlich Paris, von wo aus er 1939 illegal nach Südfrankreich floh. Seit 1944 lebte und arbeitete Hausmann in Limoges, wo er 1971 an den Folgen einer Gelbsucht verstarb.

Für Hausmanns Schaffen ist das »lebendige Sehen« entscheidend, seine von ihm so bezeichnete Wahrnehmungstheorie, nach der aller Materie und dem Raum eine »kinetische Energie« innewohnt. Bewegung und Veränderung sind demnach Grundprinzipien der künstlerischen Tätigkeit, nach denen Hausmann auch seine Collagen und Fotobearbeitungen ausrichtete: Das Überkleben, Übereinanderkopieren und das Aus- und Einblenden mittels Rotfilter waren die Vorgänge, mit deren Hilfe er komplexe Bildkonstrukte entwarf, in denen sich heterogene Teile und Versatzstücke zu einem rätselhaften Ganzen zusammenfinden. Ein Frauenkopf wird – der fotografischen Dialektik von Abbilden und Assoziieren folgend – zu einem Verwirrspiel aus Schnipseln und Bildresten, die meist aus Hausmanns eigenen fotografischen Arbeiten stammen und vielfach das für sein Werk so typische Auge abbilden.

Literatur/Further reading: Andreas Haus, *Raoul Hausmann. Kamerafotografien 1927–1957*, München/Munich 1979

Born in 1886 in Vienna/Austria, died in 1971 in Limoges/France. After studying painting and sculpture in Berlin from 1908 to 1911, Raoul Hausmann was in contact with avant-garde artists and writers as of 1912. From 1918 to 1922 he was a member of the Dada movement in Berlin. In 1919 he founded the magazine *Der Dada* and was co-organizer of the first International Dada Fair in Berlin in 1920. Starting in 1927 Hausmann systematically devoted himself to photography. From 1931 he regularly published articles in magazines dealing with perception and art-theory questions, as well as questions related to the dialectic form of photomontage and photography. In 1933 Hausmann was forced to emigrate, as his artistic work was considered "degenerate art". He emigrated via Ibiza, Zurich and Prague to Paris, from where he illegally fled to southern France in 1939. From 1944 Hausmann lived and worked in Limoges, where he died from the effects of jaundice in 1971.

Lebendiges Sehen, or "animated seeing", is crucial to Hausmann's work and his theory of perception, according to which "kinetic energy" is inherent in all matter and space. Movement and change are thus fundamental principles of the artistic activity on which Hausmann based his collages and photo editing: pasting over and copying on top of each other, overlaying and blocking using red filters are the processes by which he created complex image constructs in which heterogeneous parts and set pieces come together to form an enigmatic whole. According to the dialectic of photographic imaging and association, a woman's head becomes a confusing scene of snippets and image fragments, which mostly come from Hausmann's own photographic work and often depict the eye that is so typical of his work.

Raoul Hausmann
Ohne Titel/Untitled, 1946
Silbergelatineprint mit aufgeklebten Fotoausschnitten/
silver gelatin print with glued-on photograph cuttings

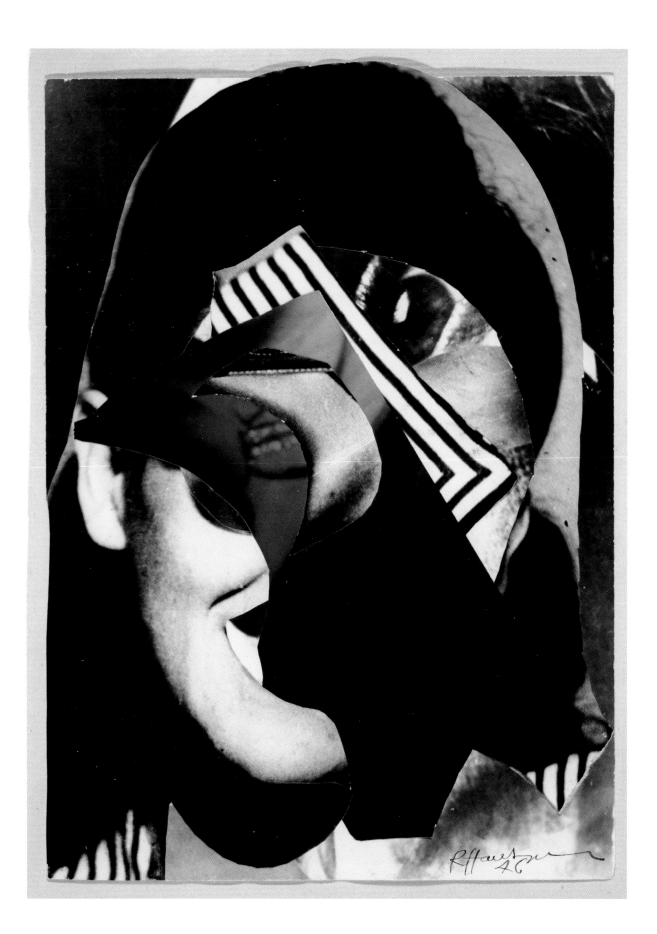

DAS ERKENNEN VON WIRKLICHKEIT.
NEUSACHLICHE FOTOGRAFIE

DISCERNING REALITY.
THE PHOTOGRAPHY OF NEW OBJECTIVITY

Margit Zuckriegl

Erstmals war in der Zeit zwischen den beiden Weltkriegen zu bemerken, dass die künstlerischen Orientierungen nicht nach einer fortschreitenden Innovation der bekannten Medien suchten, sondern nach der Neudefinition von Medialität ganz generell. Malerei und Grafik strebten nach einer »fotografisch genauen« Übertragung der wahrgenommenen Realität ins Bild, nach einer Übersetzung des Sichtbaren in ein wirklichkeitstreues Medium, dem die sinnliche Erfahrbarkeit zuzutrauen war.

Die Fotografie bemühte sich nicht mehr um Angleichung an malerische Elemente und Effekte wie noch in der Zeit des Piktorialismus, der mit seinen »konservativen« Ausläufern noch ein langes Nachspiel feierte. Die Fotografie war es nun ihrerseits, die ihre Regeln und Sichtweisen in der Malerei etablierte. Die Neue Sachlichkeit wäre demnach die erste künstlerische Richtung am Beginn des 20. Jahrhunderts, die mit Kriterien, die aus dem Kontext der Fotografie stammten, Innovationen in der Kunstgeschichte entwickelte. Wenn die theoretischen Konzepte zu Expressionismus und Kubismus noch von einem Verlassen herkömmlicher Sichtweisen und einer neuen, unverstellten Wahrnehmung von Wirklichkeit sprachen, so war es erst dem »Neuen Sehen« der 1920er-Jahre zu verdanken, dass das »Neue« am Sehen der Dinge nicht bloß eine andere, radikalisierte Seh-Weise war, sondern etwas fundamental Anderes: Es war ein Sehen wie durch eine Linse, es waren veränderte Perspektiven, Ansichten von unten, von oben, starke Nahsichten, weite Zusammenschauen, starke Kontraste und strenges kompositorisches Lineament – Charakteristika einer nun praktizierbaren Fotografie, die durch den Einsatz von Rollfilm und leichten Kameras »schnell« wurde, flexibel und zupackend: kein langwieriges Aufbauen der Equipments mehr, keine arrangierte Studiofotografie, kein effektvolles Setzen von Kunstlicht. Nun erlangte das fotografische Tun die Beweg-

A unique phenomenon in the period between the two world wars was that artistic orientations were not seeking progressive innovation in known media, but rather the redefinition of mediality in general. Painting and graphic design strove for photographic precision when transferring the perceived reality into an image, and for a translation of the visible into a realistic medium that was to be capable of providing a sensual experience.

Photography no longer struggled with the harmonization of picturesque elements and effects like in the era of Pictorialism, which continued to enjoy a long postlude with its conservative offshoots. For its part, photography was now about establishing its rules and perceptions in painting. Accordingly, New Objectivity would be the first artistic direction at the beginning of the twentieth century that developed innovations in art history with criteria stemming from the context of photography. If the theoretical concepts of Expressionism and Cubism still spoke of an abandonment of conventional views and a new undisguised perception of reality, it was actually down to the "New Vision" of the 1920s that the "New" in the vision of things was not just another, radicalized way of seeing, but rather something fundamentally different. It was like a vision through a lens, it was modified perspectives, views from below, from above, keen closeups, wide syntheses, strong contrasts and strict compositional lineament – characteristics of a now practicable photography, which was quick due to the use of roll film and light cameras, flexible and hands on. There was no more tedious assembly of equipment, no arranged studio photography, no dramatic positioning of artificial light. Now photographic action showed movement, which it had long since simulated, and the straightforwardness of which it had long since dreamed. Now photography could concentrate on the intrinsic properties of the new medium, on light and shadow, lines and spaces,

lichkeit, die es lange simuliert hatte und die Unkompliziertheit, von der es lange geträumt hatte. Nun konnte sich die Fotografie auf die immanenten Eigenschaften des neuen Mediums konzentrieren, auf Licht und Schatten, Linien und Flächen, Hell und Dunkel, Vordergrund, Hintergrund, Nahsicht, Fernsicht, Perspektiven. Diese Kriterien, an deren Abschaffung die Moderne seit dem Impressionismus gearbeitet hatte, kamen durch die fotografische Emanzipation wieder ins Bild und veränderten die Wahrnehmung und das Erkennen von Welt in der Kunst nachhaltig: Die Welt war nicht mehr ein Entwurf für wahrnehmungsorientierte Versuchsanordnungen, sondern der Inhalt von kognitiven Erfahrungsprozessen. Es wurde genau hingeschaut, es wurden Strukturen freigelegt, Perspektiven konstruiert, Dinge aus ihrem Umfeld herausseziert. Und dies – als Reaktion des malerisch-grafischen Gestus auf die fotografischen Sicht- und Arbeitsweisen – sowohl im Bereich der Malerei als auch – oder ganz besonders – im Bereich der Fotografie.

Otto Rudolf Schatz, *Fabrik*,
aus der Serie / from the series *Industrie*, 1927
Holzschnitt / woodcut, 28 × 35 cm

Die Vermessung der Dinge

Waren bisher fotografische Stillleben eine Art von Übertragung des gleichen Genres aus der Malerei ins Fotografische gewesen, so entwickelte nun der sachliche, nüchterne Gestus der Fotografie der 1920er-Jahre eine Vorliebe für unscheinbare Gegenstände aus der Welt des Alltags und des häuslichen Gebrauchs, aber auch für das »Wesentliche« der anvisierten Objekte. Es fand gleichsam eine Vermessung der Dinge mithilfe des Bildmediums statt, eine Untersuchung der Eigenschaften und der Präsenz der Dinge im Raum. Eine direkte Ausleuchtung und eine Isolierung des Dings aus dem Umraum ersetzte das bisher übliche artifizielle Arrangement. Ein idyllischer oder stimmungsvoller Charakter der *nature morte* wurde nun einer intensiven Beobachtung mittels Kameratechnik geopfert. Hier lotete man auch die neuen Möglichkeiten von Makro- und Mikro-

light and dark, foreground, background, close-ups, clear views, vistas. These criteria, on whose annulment Modernism had worked since the era of Impressionism, came back into effect due to photographic emancipation and changed the perception and recognition of the world in art in the long term. The world was no longer a blueprint for perception-oriented experimental setups, but the content of cognitive processes of experience. It was observed closely, structures were revealed, vistas constructed, things extracted from their surroundings. And this was a reaction to the painterly and graphical attitude towards the photographical way of seeing and working, both in the field of painting and, most notably, in the field of photography.

Surveying things

If the photographic still life was previously a way of transferring the same genre from painting into photography, now the factual, austere attitude of photography in the 1920s developed a penchant for plain objects from the world of everyday life and domestic use, as well as for the fundamentals of the objects in view. Effectively, a measurement of things took place with the help of the visual medium, an examination of the properties and the presence of the things in spatial coordinates. Direct lighting and an isolation of the thing from the

Fritz Henle, *Hochofenwerk, Dortmund*, 1929
Silbergelatineprint / silver gelatin print, 21 × 30,5 cm
Sammlung FOTOGRAFIS Bank Austria /
FOTOGRAFIS Bank Austria Collection

fotografie aus und bediente sich vervielfältigbarer Fotografien als Vorlage und Motivschatz. Karl Blossfeldt, dem seine stark vergrößerten Pflanzendetails und Bilder von vegetabilen Strukturen als Ansichtsmaterial für seinen Gestaltunterricht dienten, war gewissermaßen ein Vorläufer der neusachlichen Fotografie. Ihm ging es weniger um das Anlegen eines fotografischen Herbariums als um das Aufzeigen des unendlichen Formenreichtums der Natur, der die Schüler in ihren fantasievollen Dekorationsarbeiten nacheifern sollten. Albert Renger-Patzsch hingegen fasste 1925 in seinem Aufsatz »Das Photographieren von Blüten«, erschienen in der Zeitschrift *Deutscher Camera Almanach,* Pflanzenaufnahmen zusammen, die dem Interesse eines Botanikers entsprungen sein könnten. Auch in seinem Buch *Die Welt ist schön* von 1928 vereinte er die Dinge und Ansichten, die ihm wichtig und charakteristisch erschienen, selbst wenn sie vergleichsweise banale Maschinenteile oder einfache Trinkgläser abbildeten, um das Typische und Spezifische einer Form herauszuarbeiten. Carl Strüwe ging noch einen Schritt weiter, als er, um in das Wesen der Dinge einzudringen, die »elementaren Formen« – so betitelte er eine Werkgruppe – von in der Natur vorkommenden Substanzen und Organismen in vielhundertfachen Vergrößerungen freilegte. Seine Fotografie näherte sich damit der Abstraktion an, wobei die Charakteristika einer reich gegliederten plastischen Gestaltung wie Transparenz und Reflexion, Volumen und Oberfläche erhalten blieben – ebenso wie in Renger-Patzschs Bildern von industriell gefertigten Bauteilen und Apparaturen, die durch ihre skulpturhaft-plastische Wirkung die Aura dreidimensionaler Werke umgibt. Viel wesentlicher als kunstvolle Bildhauerarbeiten erschienen dem Fotografen nun Zeugnisse des technischen Fortschritts. Dies fand seine Fortführung in der archäologisch vorgehenden Fotografie von Bernd und Hilla Becher, verkehrte sich jedoch ins Gegenteil, als die stratigrafischen Schürfungen, welche die Bechers vornahmen, im Zeitalter einer obsolet gewordenen Industrialisierungseuphorie die skultpurhaften Überbleibsel dieser Zeit gleichsam bildhaft erretteten.

Raum-Konzepte

Dass Fotografie die Bildhauerkunst ersetzen könnte, scheint eine gewagte These zu sein. Dennoch war gerade das fortschrittliche Bauhaus in Weimar – beziehungsweise vollends das Bauhaus ab 1925 in Dessau – bestrebt, die Bildhauer-Klasse durch eine sogenannte Plastische Werkstatt zu ersetzen. Es wurden neue Raum-Konzepte entwickelt und plastisches Gestalten im Raum wurde unterrichtet, wobei auch die Klasse von Oskar Schlemmer mit Bauhaus-Bühne

surroundings replaced what was previously usually an artificial arrangement. An idyllic or atmospheric character of *nature morte* had now been sacrificed to an intensive observation using camera technology. Here new possibilities of macrophotography and microphotography were applied and reproducible photographs became templates for design repertoires. Karl Blossfeldt, whose greatly enlarged plant details and images of vegetable structures served as visual material for his design lessons, was to some extent a frontrunner of New Objectivity photography. For him, it was less about the creation of a photographic herbarium than the display of the endless wealth of forms of nature, which the students were to emulate in their imaginative decorative work. In 1925, Albert Renger-Patzsch, on the other hand, summarized plant photographs in his essay "Das Photographieren von Blüten", published in the *Deutscher Camera Almanach* journal, which could have been the product of the interest of a botanist. In his book *Die Welt ist schön* in 1928, he united the things and views that seemed important and characteristic to him in order to work out the typical and specific features of a form, even if they depicted comparably banal machine parts or simple drinking glasses. Carl Strüwe went a step further when he revealed the substances and organisms occurring in nature in several-hundredfold enlargements to penetrate the being of things, the "elementary forms" – as he entitled a group of works. His photography approached abstraction as a result, whereby the characteristics of a richly structured three-dimensional design, such as transparency and reflexion, volume and surface, were preserved – in the same way as in Renger-Patzsch's images of industrially produced components and equipment, which encircled the aura of three-dimensional works with their sculpture-like, three-dimensional effect. Evidence of technical advancement now seemed to be more important than artistic sculptures to photographers. This continued in the archaeologically oriented photography of Bernd and Hilla Becher, but switched to the opposite when the stratigraphical abrasions that the Bechers conducted in the era of obsolete euphoria of industrialization salvaged the sculptural remnants of this time almost metaphorically.

Spatial concepts

That photography could replace sculpture seems to be a courageous assumption. Nevertheless, the progressive Bauhaus in Weimar – and the entire Bauhaus movement in Dessau from 1925 – was striving to replace the category of sculpture with a *Plastische Werkstatt* (plastic-arts workshop). New spatial concepts were developed and three-dimensional design in space was taught, whereby the class of Oskar Schlemmer with Bauhaus scenes and wall painting was included alongside design in public space, such as the shape of neon advertising signs in city environments. The role of photography in

und Wandmalerei dazuzuzählen war, wie auch das Gestalten im öffentlichen Raum, etwa in Form von Lichtreklamen im städtischen Ambiente. Die Rolle der Fotografie in diesem Zusammenhang war vielfältig und wurde neu definiert. Oftmals wurden sogar – gleichsam als Vorgriff auf performative und interventionistische Kunststrategien der Nachkriegszeit – Ensembles und Szenen als Grundlage und Voraussetzung für das fotografische Bild geschaffen. Das Arbeiten im Raum war am Bauhaus also einerseits das Festhalten von *Bewegung im Raum* und andererseits das Erforschen des Dialogs von *Raum und Objekt*. Dass gerade hier die Fotografie von besonderer Bedeutung sein konnte, belegen die multiplen Arbeitsweisen von Lucia und László Moholy-Nagy, deren künstlerische Praxis sich an der Medialität ihrer Konzepte entlang entwickelte: Raum-Modulatoren und Fotogramme, Architekturfotografie und Bühnenbilder waren Ausdruck dieser komplexen Gestaltungen, zu denen ebenfalls die von Joost Schmidt und Heinz Loew in der Plastischen Werkstatt vorgeführten Fotoexperimente gehörten. Die Kamera konnte auch – wie etwa in den szenischen Arbeiten Xanti Schawinskys – Bewegung und

Bernd und / and Hilla Becher, *Förderturm/
Merthyr Vale Colliery, Schacht II*, 1966
Silbergelatineprint / silver gelatin print, 33 × 27 cm
Sammlung FOTOGRAFIS Bank Austria /
FOTOGRAFIS Bank Austria Collection

Albert Renger-Patzsch, *Zeche Zollverein*, *Essen*, 1932
Silbergelatineprint / silver gelatin print, 22,6 x 16,5 cm
Sammlung FOTOGRAFIS Bank Austria /
FOTOGRAFIS Bank Austria Collection

this context was diverse and was redefined. Often – virtually in anticipation of performative and interventional art strategies of the postwar era – ensembles and scenes were created as the base and prerequisite of the photographic image. In terms of Bauhaus, working in the space was the determination of *movement in space* on the one hand and the exploration of the dialogue of *space and object* on the other hand. The fact that photography could be of special significance here was proven by the varied ways of working of Lucia and László Moholy-Nagy, whose artistic practice developed alongside the mediality of their concepts. Space modulators and photograms, architectural photography and scenery were the expression of these complex designs, which included the photographic experiments carried out by Joost Schmidt and Heinz Loew in the *Plastische Werkstatt*. The camera could – like in scenic works by Xanti Schawinsky – also depict movement and depth, lightness and dark, silhouettes and spatiality, whereby the object in view emerged in the

Tiefe, Helligkeit und Dunkel, Silhouette und Räumlichkeit abbilden, wobei sich jeweils das anvisierte Objekt vor der unausmessbaren Raumfolie in der bekannten neusachlichen Dingqualität abzeichnete.

Der stark artikulierte Kontrast von hell moduliertem Objekt und dunkel zurückweichendem Grund ist eines der Kriterien der Fotografie des »Neuen Sehens«. Ein weiteres Kriterium ist die klare Trennung von unstrukturierten, planen Flächen und drastisch vorgeführtem Lineament. Nichts kam dem so entgegen wie die gleichzeitige Architektur mit ihren kubischen und modulartig gegliederten, von den Bauhaus-Prinzipien ausgehenden Bauformen. Die adäquate Fotosprache für diese Architektur war die neusachliche Fotografie der 1920er-Jahre mit ihrem Interesse an seriellen Reihungen, einfachen Flächenteilungen, drastischen Linienführungen, verkürzten Perspektiven und vehementen Kontrasten. Das neue Bauen wurde gleichermaßen begleitet von einer neuen Art von Fotografie, die sachlich vorging, sich nüchtern gab und doch einen eigenen, rationalen und dennoch ästhetisch ausgeklügelten Stil entwickelte. Die oft diagonalen oder in sich gestaffelten Anordnungen von Baukörpern in diesen Aufnahmen und die einfachen Zeichnungen in reinstem Schwarz-Weiß ohne Grauwerte sollten stilbildend werden und eine lange Tradition der Architekturfotografie begründen. Ab den 1970er-Jahren wurde dann durch eine radikale Ausschnittökonomie und ein an abstrakte Hard-Edge-Malerei gemahnendes konzeptuelles Vorgehen dieser Fotografie-Basis der 1920er-Jahre eine neue Dimension verliehen.

Mensch und Gesellschaft

Als August Sander 1924 das Konzept für sein großangelegtes Bilderkompendium *Menschen des 20. Jahrhunderts* entwarf, hatte Europa die Katastrophe des Ersten Weltkriegs hinter sich und steuerte auf die Apokalypse dieses Zeitalters zu, auf den Faschismus und den Zweiten Weltkrieg. Ob Weimarer Republik oder Ständestaat: Politik und Wirtschaft schufen radikale Strukturen, in denen herrschende Klasse und Unterdrückte, elegante Bohemiens und Arbeitslose, fortschrittliche Industrialisierung und soziale Ausbeutung aufeinandertrafen. In dieser labilen Atmosphäre gärten gesellschaftliche Umbrüche, ausgelöst von der Krise des Kapitals, von Inflation, von ideologischem wie ökonomischem Werteverfall.

Das Antlitz des Menschen drückt seine Sorgen und seine Mühsal aus, wie in den Porträts von August Sander abzulesen ist. Daneben rangieren Bürgerstolz und aristokratischer Dünkel, vorgeführt von Vertretern der Hochfinanz und der elitären Bourgeoisie. Sander zeichnete ein Panorama der Gesellschaft, in dem auch das Nicht-Repräsentative und das Vernachlässigte Sichtbarkeit erlangen – dem neusachlichen Stil entsprechend. Der Mensch in der Gesellschaft wird immer mehr

well-known New Objectivity quality of objects in front of the immeasurable backdrop.

The heavily articulated contrast of lightly modulated object and dark receding base is one of the criteria of photography in New Vision. Another criterion is the clear division of unstructured, flat surfaces and drastic lineament. Nothing obliged this as much as the architecture of the same era, with its cubic and module-like designs emanating from the Bauhaus principles. The appropriate language of photography for this architecture was the New Objectivity photography of the 1920s with its interest in serial sequences, the simple division of spaces, drastic lines, shortened perspectives and vehement contrasts. The *Neues Bauen* (New Building) movement of modern architecture was also accompanied by a new type of photography, which was objective and acted soberly while developing its own, rational but aesthetically sophisticated style. The often diagonal or graduated arrangements of bodies in these photographs and the simple drawings in the purest black and white without greys were intended to influence style and establish a long tradition of architectural photography. From the 1970s, a new dimension was imparted to this photographic basis of the 1920s through a radical economy of detail and a conceptual approach reminiscent of abstract hard-edge painting.

Heinz Loew, *Plastische Werkstatt*, 1927/28
Silbergelatineprint / silver gelatin print, 8,2 × 8 cm
Sammlung FOTOGRAFIS Bank Austria /
FOTOGRAFIS Bank Austria Collection

zu einem Bestandteil einer Masse, einer Untermenge von sozialen Kategorisierungen. Sander schuf ein kongeniales Dokument dieses Gesellschaftsbildes, in dem Zuordnungen glasklar definiert waren und keine Illusionen von Veränderung und Aufstieg, von Auflösung der Klassen oder Chancengleichheit aufkommen konnten. Die Zeit der 1920er-Jahre und der beginnenden 1930er-Jahre brachte diese brisanten gesellschaftlichen Gegensätze hervor, aber auch einen unverbrüchlichen Glauben an den Fortschritt, an die innovative Kraft von Industrie und Maschinen und ein Faible für alles Neue, vom Jazz bis zum Bubikopf. Gleichzeit zu Zeitschriften wie der *Arbeiter Illustrierten Zeitung* in Berlin, die mit beißenden Kommentaren politisch aufrütteln wollten, vermittelten Magazine wie *die neue linie* aus Leipzig ein modernes Gefühl für Lifestyle und Lebensart. Auf diesem Markt fanden die Fotografinnen und Fotografen der späten 1920er- und der 1930er-Jahre ein Betätigungsfeld für ihre Reportagen und Dokumentationen. Modefotografie und mondäne Studiofotografie boomten noch einmal – kurz bevor viele Persönlichkeiten aus Kunst und Wissenschaft vom Naziregime verfolgt wurden, emigrieren mussten oder den Tod fanden.

Mankind and society

When August Sander designed the concept for his large-scale image compendium *Menschen des 20. Jahrhunderts* in 1924, the catastrophe of the First World War lay behind Europe and the continent was heading for the apocalypse of this era, towards fascism and the Second World War. Be it the Weimar Republic or Ständestaat: Politics and the economy created radical structures, in which the prevailing class and the oppressed, elegant Bohemians and the unemployed, progressive industrialization and social exploitation clashed. In this unstable atmosphere, social upheaval fermented, triggered by the crisis of capital, of inflation, of ideological and economic declines in value.

The visage of mankind expresses its concerns and plight, as can be seen in the portraits of August Sander. Alongside there is civic pride and aristocratic conceit, exhibited by representatives of high finance and the elite bourgeoisie. Sander recorded a panorama of society, in which the unrepresented and neglected also demand visibility – in accordance with the style of New Objectivity. Humans in society increasingly become part of a mass, a subset of social categorizations. Sander created a congenial document of this image of society, in which relationships were defined with crystal clarity and no illusions of change and advancement or of the dissolution of the classes or of equal opportunities could occur. The time of the 1920s and the early 1930s produced these volatile social contrasts, as well as an indissoluble belief in progress, in the innovative force of industry and machinery, and a weakness for anything new, from jazz to the bob. At the same time as journals such as the *Arbeiter Illustrierte Zeitung* in Berlin, which wanted to arouse political action with its sharp commentaries, magazines such as *die neue linie* from Leipzig conveyed a modern feeling for lifestyle. On this market, photographers of the late 1920s and 1930s found a field of activity for their reports and documentation. Fashion photography and sophisticated studio photography boomed once more – shortly before many people from the worlds of art and science were persecuted by the Nazi regime, had to emigrate or were killed.

In the 1920s, a factual, documentary-like style emerged in photography, which was interested in the down-to-earth reproduction of objects, things, people and situations. The focus on "reality" in pictures left all staged, dramatic and emotional styles in the background and prescribed that they should report in a purely "factual" manner. Nevertheless, photographical aesthetics could be recognized in the

Andreas Müller-Pohle, Ohne Titel / Untitled, 1977
Silbergelatineprint / silver gelatin print, 30 × 21 cm
Sammlung FOTOGRAFIS Bank Austria /
FOTOGRAFIS Bank Austria Collection

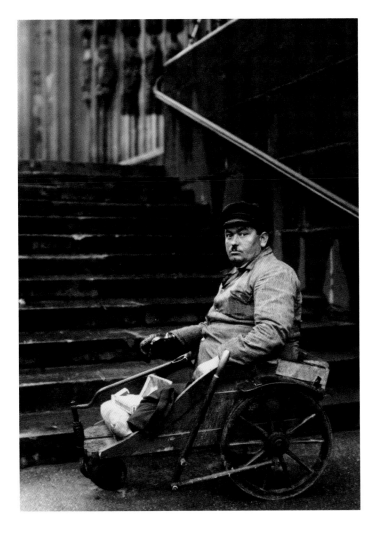

August Sander, *Kriegsinvalide*, 1929
Silbergelatineprint / silver gelatin print, 23 × 16,5 cm
Sammlung FOTOGRAFIS Bank Austria /
FOTOGRAFIS Bank Austria Collection

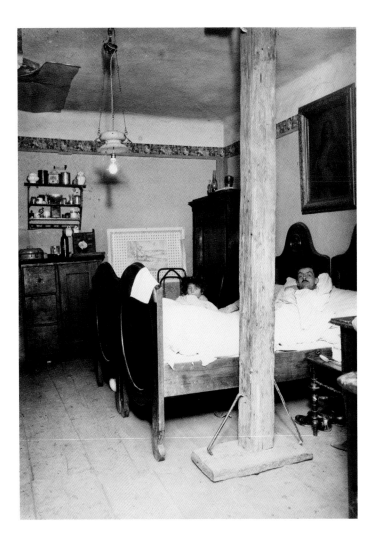

Lothar Rübelt, *Elendsquartier, Wien*, 1932
Print 1981, Silbergelatineprint / silver gelatin print, 50,4 × 37,4 cm
Sammlung FOTOGRAFIS Bank Austria /
FOTOGRAFIS Bank Austria Collection

In den 1920er-Jahren hatte sich ein sachlicher, dokumentarischer Stil in der Fotografie abgezeichnet, der an der nüchternen Wiedergabe von Objekten, Dingen, Menschen und Situationen interessiert war. Das Fokussieren auf die »Wirklichkeit« im Bild ließ alles Inszenatorische, Dramatische oder Pathetische in den Hintergrund rücken und gab vor, rein »sachlich« zu berichten. Gleichwohl war gerade in den beginnenden 1930er-Jahren eine fotografische Ästhetik auszumachen, die nur allzu leicht in den Dienst einer neuen Ideologie geraten konnte, denn was vom linientreuen Fotografen der Nazizeit verlangt wurde, konnte in den Bildlösungen der 1920er-Jahre schon als subkutan angelegt ausgemacht werden: klare Linien, steile Sichtachsen und betont kontrastreiche Lichtführung. Wenn dann heroische Sportlerfiguren und regimetreue Athleten ins Bild rückten, zeigten sich die Auswirkungen der Anwendung einer künstlerischen Sprache auf inhaltlich vorgegebene Motive.

early 1930s that could all too easily serve a new ideology, as what was required from hard-line photographers in the Nazi era could already be made out subliminally in the pictorial solutions of the 1920s: clear lines, steep visual axes and emphasized, high-contrast staged lighting. When heroic sports figures and athletes who were loyal to the regime moved into the picture, the effects of the use of artistic language on contextually prescribed subjects were seen.

Heinz Loew

Geboren 1903 in Leipzig/Deutschland, verstorben 1981 in London/Großbritannien. Heinz Loew war einer der Bauhaus-Künstler, die sich als Studierende ab 1926 mit der Idee des Plastischen beschäftigten. Ab Beginn seines Studiums fertigte er experimentelle Fotografien für die »Plastische Werkstatt« an und schuf zusammen mit Franz Ehrlich mittels Leuchtstoffröhren Lichtobjekte, Projektionen und Bauhaus-Werbung. In Zusammenarbeit mit Xanti Schawinsky, Kurt Schmidt und anderen entstanden Arbeiten für die Bauhaus-Bühne, Sketche, Kostüme und Theaterexperimente. Auch nach dem Studium beteiligte Loew sich an der »Plastischen Werkstatt« und war von 1927 bis 1930 Mitarbeiter am Bauhaus. Von 1931 bis 1936 war er Werbegrafiker und -fotograf in Berlin. 1936 emigrierte er nach England und war dort als Lehrer tätig. Nach seiner Internierung in den Jahren 1940 bis 1945 arbeitete er als selbstständiger Designer.

Die als Bildhauerei-Klasse bezeichnete Abteilung am Bauhaus war spätestens ab 1923 obsolet. Wegen interner Richtungsstreitigkeiten wurde sie jedoch erst mit dem Umzug nach Dessau 1925 in »Plastische Werkstatt« umbenannt. Hier ist die Krise des plastischen Arbeitens am Bauhaus zu orten: Dreidimensionalität im Schaffen bezog sich auf die Bühne, den urbanen Raum und auf Architektur. Nun fertigten Studierende Gips- und Glasobjekte nach geometrischen Grundformen an, deren Eigenschaften in Raum und Bewegung festgehalten wurden. Heinz Loews Fotografien »ersetzten« die plastischen Objekte und waren autonome fotografische Werke.

Literatur/Further reading: Anja Baumhoff und/and Magdalena Droste (Hrsg./eds.), *Mythos Bauhaus*, Berlin 2009

Born in 1903 in Leipzig/Germany, died in 1981 in London/Great Britain. Heinz Loew was one of the Bauhaus artists interested in the idea of plastic values as a student in 1926. From the beginning of his studies he made experimental photographs for the Plastic Arts Workshop and together with Franz Ehrlich created light objects, projected images and Bauhaus advertising using fluorescent lamps. In collaboration with Xanti Schawinsky, Kurt Schmidt and others, works were created for the Bauhaus stage, including sketches, costumes and theatre experiments. Loew continued to participate in the Plastic Arts Workshop after his studies and was an employee at the Bauhaus from 1927 to 1930. From 1931 to 1936 he was a graphic designer and photographer in Berlin. In 1936 he emigrated to England, where he worked as a teacher. After his internment in the years 1940 to 1945, he worked as a freelance designer.

The department formerly known as the sculpture class at the Bauhaus was obsolete by 1923 at the latest. Due to internal disputes, it was renamed "Plastic Arts Workshop" only after the move to Dessau in 1925. This is where the crisis of sculptural work at the Bauhaus took place: three-dimensionality in the creations involved the stage, urban space and architecture. Students now made plaster and glass objects according to basic geometric forms, whose properties were confined to space and movement. Heinz Loew's photographs "replaced" the sculpted objects and were autonomous photographic works.

Xanti Schawinsky

Geboren 1904 in Basel/Schweiz, mit bürgerlichem Namen Alexander Schawinsky, verstorben 1979 in Locarno/Schweiz. Xanti Schawinsky hatte Architektur und Malerei studiert, bevor er sich ab 1924 am Bauhaus in Weimar als Grafiker und Fotograf betätigte und sich ab 1925 im Kreis um Walter Gropius den theatralen Aspekten der Bauhaus-Philosophie in Dessau widmete. 1933 ging er nach Mailand, wo er ein gesuchter und bekannter Werbedesigner wurde. Einer Einladung ans Black Mountain College in North Carolina folgend, übersiedelte er in die USA, wo bis ins Jahr 1950 seine wichtigsten grafischen Arbeiten, unter anderem auch für das Museum of Modern Art in New York, entstanden. Ab den 1960er-Jahren war er hauptsächlich als Maler tätig und orientierte sich künstlerisch wieder nach Europa.

Die Bühnengestaltung nahm in der Bauhaus-Idee einen breiten Raum ein. Auch der als Grafiker und Typograf erfolgreiche Xanti Schawinsky bediente dieses neue Format, in dem räumliche Gestaltung, Handlungsaspekte, Kostüme, Requisiten und Dekorelemente zum ganzheitlichen Gefüge gehörten. Die von Schawinsky konzipierte Szenenfolge *Circus* – hier in einer Aufnahme eines unbekannten Fotografen – formulierte diese Bauhaus-Ideale in einer Art von Figurentheater mittels stilllebenartiger Momentaufnahmen aus, indem die geometrisch gebauten Menschen- und Tier-Figuren vor neutralem, dunklem Hintergrund gleichsam frei im Raum agieren: Der »Dompteur«, dargestellt von Schawinsky, trifft auf das »Untier«, in dem sich der Bauhaus-Kollege Herbert von Fritsch verbirgt.

Born in 1904 as Alexander Schawinsky in Basel/Switzerland, died in 1979 in Locarno/Switzerland. Xanti Schawinsky studied architecture and painting before working at the Bauhaus in Weimar in 1924 as a graphic designer and photographer. From 1925 he dedicated himself to theatrical aspects of the Bauhaus philosophy in Dessau in the circle of Walter Gropius. In 1933 he went to Milan, where he became a sought-after and well-known advertising designer. After receiving an invitation to Black Mountain College in North Carolina, he moved to the United States, where his most important graphic works originated until 1950, including works for the Museum of Modern Art in New York City. From the 1960s he worked mainly as a painter and focused artistically on Europe again.

Stage design was an important part of the Bauhaus movement. A successful graphic designer and typographer, Xanti Schawinsky also worked in this new format, in which spatial design, aspects of action, costumes, props and decorative elements were part of a holistic framework. Conceived by Schawinsky, the sequence of scenes titled *Circus* – captured here in a picture by an unknown photographer – formulated this Bauhaus ideal in a kind of figurine theatre by means of still-life-like snapshots while geometrically constructed human and animal figures perform freely in space as it were, against a neutral, dark background. The Animal Tamer, represented by Schawinsky, meets the Beast, which conceals Bauhaus colleague Herbert von Fritsch.

Literatur/Further reading: Roswitha Fricke (Hrsg./ed.), *Bauhaus Fotografie*, Düsseldorf 1982

Xanti Schawinsky
Bauhaus-Bühne, Szene aus dem Stück »Circus«, 1924
Silbergelatineprint/silver gelatin print
Druck der Postkarte/postcard printing: Atelier Eckner, Weimar

Otto Steinert

Geboren 1915 in Saarbrücken/Deutschland, verstorben 1978 in Essen/Deutschland. Schon als 14-Jähriger begann Otto Steinert zu fotografieren und baute sich selbst eine Kamera. Von 1934 bis 1939 studierte er Medizin an verschiedenen deutschen Universitäten und promovierte in Berlin. Während des Zweiten Weltkriegs nahm er als Stabsarzt am Russlandfeldzug teil. 1947 beendete er seine Mediziner-Karriere und wandte sich gänzlich der Fotografie zu. In den Jahren 1947 und 1948 arbeitete er in der Foto- und Kinohandlung von Franz Altenkirch. 1947 gründete Steinert zudem sein Atelier für künstlerische Fotografie. Ab 1948 lehrte er an der Staatlichen Saarländischen Schule für Kunst und Handwerk in Saarbrücken, deren Direktor er 1952 wurde. Zwischen 1949 und 1952 reiste er oft nach Paris, wo er Man Ray, Edward Steichen und Willy Maywald begegnete. 1953 war Steinert Mitbegründer der Arbeitsgemeinschaft Fotoform. Er organisierte die Ausstellungsreihe *subjektive fotografie I–III* von 1951 bis 1960. Von 1959 bis zu seinem Tod lehrte er an der Folkwangschule für Gestaltung in Essen. 1973 wurde er zum Professor ernannt. Steinerts Nachlass wird in der Fotografischen Sammlung des Museums Folkwang in Essen aufbewahrt.

Born in 1915 in Saarbrücken/Germany, died in 1978 in Essen/Germany. Otto Steinert already began taking photographs as a 14-year-old and built himself a camera. From 1934 to 1939 he studied medicine at various German universities and completed his doctorate in Berlin. During the Second World War, he participated in the Russian campaign as a medical officer. In 1947 he ended his medical career and turned entirely to photography. In 1947 and 1948 he worked in Franz Altenkirch's photo and film lab. In 1947 Steinert, in addition, established his own studio for artistic photography. Starting in 1948 he taught at the Staatliche Saarländische Schule für Kunst und Handwerk in Saarbrücken, of which he became the director in 1952. Between 1949 and 1952 he frequently travelled to Paris, where he met Man Ray, Edward Steichen and Willy Maywald. In 1953 Steinert was co-founder of the Fotoform association. From 1951 to 1960 he organized the exhibition series *subjektive fotografie I-III*. From 1959 until his death he taught at the Folkwangschule für Gestaltung in Essen and was appointed professor in 1973. Steinert's estate is preserved in the photographic collection of the Museum Folkwang in Essen.

Die geometrisch organisierte Fotografie entstand ursprünglich durch Kombination von Langzeitbelichtung und Fotogramm. Anhand einer Drahtfigurine, die ihm im Kunstunterricht als Anschauungsmaterial diente, stellte Steinert zwei Phasen von Bewegung dar: einmal die Figur in Rotation, einmal statisch. Sie erreicht dadurch ein »virtuelles Volumen«, also eine Plastizität, die erst im fotografischen Bild sichtbar wird. Das räumliche Liniensystem stammt von auf das Fotopapier gelegten Glasplatten und thematisiert die Integration des Menschen in ein technoides Bezugsfeld – gleichermaßen als Anleihe beim mechanistischen Menschenbild der Bauhaus-Künstler und als Appell an die Selbstbestimmtheit des modernen Menschen, der diese Gebundenheit überwinden kann.

The geometrically arranged photograph originally emerged from a combination of time exposure and photogram. Using a wire figurine, which served as illustrative material in his art class, Steinert represented two phases of movement: one with the figure in rotation and one with it static. Through this it achieves a "virtual volume", a plasticity that is visible only in the photographic image. The spatial line system comes from glass plates laid on the photographic paper and it focuses on the integration of a person into a technoid field of reference – both as a bond in the mechanistic idea of humanity of the Bauhaus artists and as an appeal to the self-determination of the modern person who can overcome this constraint.

Literatur/Further reading: Ute Eskildsen (Hrsg./ed.), *Der Fotograf Otto Steinert* (Ausst.-Kat./exh. cat. Museum Folkwang, Essen), Göttingen 1999

Otto Steinert
Strenges Ballett (Hommage à Oskar Schlemmer), 1949
Silbergelatineprint/silver gelatin print

Werner Mantz

Geboren 1901 in Köln/Deutschland, verstorben 1983 in Eijsden/Niederlande. In den Jahren 1920 und 1921 studierte Werner Mantz Fotografie an der Lehr- und Versuchsanstalt für Photographie, Chemie, Lichtdruck und Gravüren in München. 1921 richtete er sein erstes Atelier in Köln ein. Seine Aufträge kamen in erster Linie von Kölner Firmen, von Kunden aus Politik, Wissenschaft und aus Künstlerkreisen. Durch den Architekten Wilhelm Riphahn avancierte Mantz zu einem gefragten Architekturfotografen, der im Stil der Neuen Sachlichkeit arbeitete. Seine Fotografien dokumentieren das »Neue Bauen« und wurden zwischen 1927 und 1932 in zahlreichen Architektenzeitschriften veröffentlicht. 1932 eröffnete Mantz ein zweites Fotoatelier in Maastricht, wo Architekturaufträge jedoch ausblieben und er sich der Kinderfotografie widmete. 1971 setzte er sich in Eijsden bei Maastricht zur Ruhe. 1978 wurden Mantz' Arbeiten in der Ausstellung *Vom Dadamax zum Grüngürtel* im Kunstverein Köln wiederentdeckt und im selben Jahr vom Rheinischen Landesmuseum in Bonn und 1982 im Museum Ludwig in Köln gezeigt.

Die Dokumentationen über die Siedlungen der GAG, der Gemeinnützigen Aktiengesellschaft für Wohnungsbau in Köln, sind Mantz' am häufigsten gewürdigte dokumentarische Werke. Die »Weiße Stadt« am Kalker Feld in Köln – heute Köln-Buchforst – wurde in den Jahren 1927 bis 1932 als Teil der 1913 gegründeten GAG-Siedlung gebaut und ist eines der Module des großangelegten Projektes zum sozialen Wohnungsbau. Mantz verwendete eine für den Bauhaus-Stil charakteristische Fotosprache mit diagonal angelegten Perspektiven und klarer Linienführung.

Literatur/Further reading: *Großstadt in der Großstadt. 100 Jahre GAG in Köln*, Köln/Cologne 2013

Born in 1901 in Cologne/Germany, died in 1983 in Eijsden/The Netherlands. In 1920 and 1921 Werner Mantz studied photography at the Lehr- und Versuchsanstalt für Photographie, Chemie, Lichtdruck und Gravüren in Munich. In 1921 he set up his first studio in Cologne. His orders came mainly from Cologne-based companies and from clients in politics, science and arts circles. Through the architect William Riphahn, Mantz became a sought-after architectural photographer who worked in the style of New Objectivity. His photographs document the New Building movement and were published in numerous architectural magazines between 1927 and 1932. Mantz opened a second photo studio in Maastricht in 1932, but here he received no architectural commissions, and instead devoted himself to children's photography. In 1971, he retired in Eijsden near Maastricht. In 1978 Mantz's works were rediscovered in the exhibition *Vom Dadamax zum Grüngürtel* at the Kunstverein Cologne and they were shown in the same year at the Rheinisches Landesmuseum in Bonn and in 1982 at the Museum Ludwig in Cologne.

The documentations of the settlements of the GAG, a nonprofit corporation for housing in Cologne, are Mantz's most widely admired documentary works. The "White City" in the Kalker Feld in Cologne – today Cologne-Buchforst – was built from 1927 to 1932 as part of the GAG settlement founded in 1913 and is part of a large-scale social housing project. Mantz used a photographic language characteristic of the Bauhaus style with its diagonally laid out perspectives and clear lines.

Werner Mantz
Siedlung Köln – Kalker Feld, 1928
Silbergelatineprint/silver gelatin print

Karl Blossfeldt

Geboren 1865 in Schielo/Deutschland, verstorben 1932 in Berlin/Deutschland. Blossfeldt war Bildhauer und Modelleur in einer Kunstgießerei. Als Fotograf war er Autodidakt. Er fertigte in den 1890er-Jahren zahlreiche Fotografien von Pflanzen als Modelliervorlagen an. 1899 arbeitete er an der Unterrichtsanstalt des Königlichen Kunstgewerbemuseums in Berlin, 1921 wurde er zum Professor ernannt, ab 1924 lehrte er an den Vereinigten Staatsschulen für Freie und Angewandte Kunst in Berlin, dem Vorläuferinstitut der Universität der Künste Berlin. 1928 publizierte er sein bekanntestes Buch, *Urformen der Kunst*.

Born in 1865 in Schielo/Germany, died in 1932 in Berlin/Germany. Blossfeldt was a sculptor and modeller in an art foundry. He was a self-taught photographer. In the 1890s he took numerous photographs of plants as modelling designs. In 1899 he worked at the Teaching Institute of the Königliches Kunstgewerbemuseum Berlin and in 1921 he was appointed professor; in 1924 he taught at the Vereinigte Staatsschulen für Freie und Angewandte Kunst in Berlin, the forerunner of the Universität der Künste Berlin. In 1928 he published his most famous book, *Urformen der Kunst* (Archetypes of Art).

Das Foto von *Dipsacus laciniatus*, der Weberkarde oder Weberdistel, stammt aus dem Portfolio mit 12 Pflanzenaufnahmen, das von der Galerie Wilde in Köln 1975 in einer Auflage von 50 Exemplaren verlegt wurde. Die Originalfotografie zeigt einen Stängel der spitzblättrigen Karde mit eingetrockneten Blättern in vierfacher Vergrößerung. Blossfeldts Interesse galt den Strukturen und Spezifika der vegetabilen Motive, die er in minutenlanger Belichtung im Atelier mit einer selbst gebauten Plattenkamera aufnahm. Die Bilder dienten als Vorlagen für den Unterricht in der Kunstgewerbeschule und für die Schüler als Anregung zur Gestaltung von dekorativen Motiven und Verzierungen. 1984 wurde ein Konvolut von Blossfeldts eigenhändigen Papierprints überraschend in der Universität der Künste Berlin gefunden.

The photograph of *Dipsacus laciniatus*, the Indian teasel or Fuller's thistle, is from the portfolio of 12 photographs of plants published by Galerie Wilde in Cologne in 1975 in an edition of 50. The original photograph shows the spiky stalk of a teasel with dried leaves in fourfold magnification. Blossfeldt was interested in the structures and specifics of vegetal motifs, which he captured over several minutes of exposure time in the studio with a homemade plate camera. The pictures served as templates for teaching at the Kunstgewerbeschule and for the students as an inspiration to design decorative motifs and embellishments. In 1984 a bundle of Blossfeldt's handmade paper prints was surprisingly found at the Universität der Künste Berlin.

Literatur/Further reading: Karl Blossfeldt, *Urformen der Kunst – Wundergarten der Natur. Das fotografische Werk in einem Band*, mit einem Text von/with a text by Gert Mattenklott, botanische Bearbeitung von/botanical processing by Harald Kilias, München/Munich, Paris und/and London 1994

Karl Blossfeldt
Dipsacus laciniatus, vor 1926/pre-1926, Print 1975
Silbergelatine/Baryt/silver gelatin/barite

Carl Strüwe

Geboren 1898 in Bielefeld/Deutschland, verstorben 1988 in Bielefeld. Carl Strüwe arbeitete als Lithograf bei der E. Gundlach AG und übte daneben eine freie künstlerische Tätigkeit als Zeichner und Druckgrafiker aus. Ab den 1920er-Jahren interessierte er sich vermehrt für Fotografie und fertigte in den Jahren 1926 bis 1956 Mikroaufnahmen, Reisefotografien und Aufnahmen von Kunstdenkmälern an. Ab 1933 musste er seine Mitgliedschaft bei der Sozialistischen Partei zurücklegen. Er wurde zum Kriegsdienst eingezogen und 1940 aus der Wehrmacht entlassen. Nach dem Krieg arbeitete er wieder als Lithograf und war erneut künstlerisch tätig, später auch als Maler.

Born in 1898 in Bielefeld/Germany, died in 1988 in Bielefeld. Carl Strüwe worked as a lithographer at E. Gundlach AG and also performed freelance artistic work as an illustrator and printmaker. From the 1920s he became increasingly interested in photography and from 1926 to 1956 produced photomicrographs, travel photographs and photographs of art monuments. In 1933 he had to resign his membership of the Socialist Party. The armed forces drafted him for military service and then dismissed him in 1940. After the war, he again worked as a lithographer and was once more active as an artist, and later as a painter.

Carl Strüwes besondere Verwendung der Fotografie in einem naturwissenschaftlichen Kontext beruht auch auf dem Interesse für das Objekt an sich, wie es für das »Neue Sehen« in den 1920er- und 1930er-Jahren charakteristisch war. Strüwe allerdings verschrieb sich einer radikal ins Ungegenständliche tendierenden Mikrofotografie, die mit seinen genauen Angaben und Beschriftungen den Charakter von wissenschaftlichen Kompendien annahm. In den Jahren 1926 bis 1956 entstanden seine *Formen des Mikrokosmos*, sensible Wiedergaben von in der Natur vorgefundenen Substanzen und Organismen. Aus dem Jahr 1928 stammen die *Bau- und Bewegungsformen*, zu denen auch das vorliegende Blatt gehört, das einen Ausschnitt aus einem Schmetterlingsflügel im Maßstab 720:1 zeigt.

Carl Strüwe's special use of photography in the context of the natural sciences was based on an interest in the object itself, as was typical of the New Vision movement in the 1920s and 1930s. However, Strüwe devoted himself entirely to the abstract trend of photomicrography, which, with its precise information and labelling, assumed the character of scientific collections. In the years from 1926 to 1956 his *Formen des Mikrokosmos* series emerged with his sensitive renditions of substances and organisms found in nature. Originating in 1928, the *Bau- und Bewegungsformen* to which the present sheet also belongs shows a section of a butterfly wing at a scale of 720:1.

Literatur/Further reading: Jutta Hülsewig-Johnen, Gottfried Jäger und/and Thomas Thiel (Hrsg./eds.), *Carl Strüwe. Reisen in unbekannte Welten* (Ausst.-Kat./exh. cat. Kunsthalle Bielefeld), München/Munich 2012

Carl Strüwe
Schuppen auf einem Schmetterlingsflügel (Admiral, Ala papilionis), 1928
Silbergelatineprint nach Mikrofotografie auf Glasnegativ/
silver gelatin print of a microphotograph on glass negative

Friedrich Seidenstücker

Geboren 1882 in Unna/Deutschland, verstorben 1966 in Berlin/Deutschland. Von 1901 bis 1903 studierte Friedrich Seidenstücker Maschinenbau in Hagen und anschließend an der Königlich Technischen Hochschule zu Berlin in Charlottenburg. Erst nach dem Ersten Weltkrieg widmete er sich künstlerischen Tätigkeiten, vor allem der Bildhauerei und der Zeichnung. Ab 1923 beschäftigte er sich mit Fotografie als Vorlage für Skulpturen und als begeisterter Zoobesucher mit Tierfotografie. Bekannt wurde er mit seinen enzyklopädisch angelegten Fotos aus dem Zoologischen Garten Berlin, mit Berliner Straßenszenen, Bildern von Amateursportlerinnen und -sportlern und seiner Serie über das zerstörte Berlin der Nachkriegszeit. Sein Werk geriet in Vergessenheit, wurde jedoch 1971 zufällig wiederentdeckt und vom Bildarchiv Preußischer Kulturbesitz angekauft.

Der See-Elefant Roland war eines von Friedrich Seidenstückers Lieblingsmotiven bei seinen Streifzügen durch den Berliner Zoologischen Garten. Roland lebte von 1930 bis 1935 und wurde nach seinem Tod präpariert. Ihm sollte eine ganze Reihe von See-Elefanten – jeweils mit Namen Roland – im Berliner Zoo folgen. Seidenstückers humorvollem Blick auf das Verhältnis von Mensch und Tier entgingen keine Parallelitäten, keine Zufälligkeiten, keine seltsamen Konstellationen. Er ging nie ohne Kamera aus dem Haus und war an den unbemerkten Seiten des Alltags interessiert. Mit seinem direkten, sachlichen Stil, mit seiner zupackenden und unmittelbaren Sichtweise bediente er sich der dokumentarischen Handschrift des »Neuen Sehens«, fügte ihr aber eine Nuance ins Menschlich-Anekdotische hinzu.

Literatur/Further reading: *Friedrich Seidenstücker. Von Nilpferden und anderen Menschen. Fotografien 1925–1958* (Ausst.-Kat./exh. cat. Berlinische Galerie, Berlin), Ostfildern 2011

Born in 1882 in Unna/Germany, died in 1966 in Berlin/Germany. From 1901 to 1903 Friedrich Seidenstücker studied mechanical engineering at Hagen and then at the Königlich Technische Hochschule zu Berlin in Charlottenburg. It was only after the First World War that he devoted himself to artistic activities, especially sculpture and drawing. From 1923 he worked with photography as a template for sculptures and, as an avid zoo visitor, with animal photography. He became known for his encyclopaedia-like photographs of the Berlin Zoological Garden, Berlin street scenes, pictures of amateur athletes and his series depicting the destruction that characterized postwar Berlin. Although his work was forgotten, it was rediscovered by chance in 1971 and purchased by the Bildarchiv Preußischer Kulturbesitz.

The elephant seal Roland was a favourite subject of Frederick Seidenstücker's ramblings through the Berlin Zoological Garden. Roland lived from 1930 to 1935 and was dissected after his death. A number of elephant seals – each with the name Roland – would follow him at the Berlin Zoo. Seidenstücker's humorous look at the relationship between man and animal ignored none of its parallels, coincidences and strange constellations. He never left the house without a camera and was interested in the unnoticed sides of everyday life. With his straightforward, factual style and his hard-hitting and direct point of view, he followed the documentary style of the New Vision movement, but added a human anecdotal nuance.

Friedrich Seidenstücker
Ohne Titel (See-Elefant Roland)/Untitled
(Roland the Elephant Seal), um/ca. 1935
Silbergelatineprint/silver gelatin print

August Sander

Geboren 1876 in Herdorf/Deutschland, verstorben 1964 in Köln/Deutschland. Von 1890 bis 1896 arbeitete August Sander in der Herdorfer Eisengrube und kaufte in dieser Zeit seine erste Fotoausrüstung. In den Jahren 1897 und 1898 erlernte er bei dem Fotografen Georg Jung in Trier das Fotografieren. Die anschließenden Wanderjahre von 1899 bis 1901 führten ihn als Fotografengehilfe nach Berlin, Magdeburg, Dresden und Leipzig. 1901 zog er nach Linz, Österreich, und arbeitete in der Photographischen Kunstanstalt Greif, die er 1902 mit einem Partner übernahm und ab 1904 selbstständig führte. 1910 übersiedelte er nach Köln und unterhielt dort ein Atelier für Fotografie. Ab den frühen 1920er-Jahren stand er in Kontakt mit der Gruppe Progressiver Künstler in Köln und begann mit dem Kulturwerk *Menschen des 20. Jahrhunderts*. Diese Mappen bilden sein enzyklopädisches Lebenswerk, das er über die Jahre immer wieder überarbeitete und das ihn bis zu seinem Tode beschäftigte. Neben Porträts schuf Sander Landschaftsaufnahmen und Naturstudien und arbeitete für die Industrie, für Künstler und Architekten. Sein Buch *Antlitz der Zeit*, das 1929 erschien, wurde 1936 beschlagnahmt und die Druckstöcke wurden vernichtet. Ab 1942 zogen Sander und seine Frau von Köln nach Kuchhausen im Westerwald um und mit ihnen nach und nach auch Tausende seiner wertvollsten Negative, die so gerettet werden konnten, denn das Kölner Atelier wurde zerstört, alle noch im Keller verbliebenen Negative und Materialien fielen kurz nach dem Krieg einem Brand zum Opfer. 1953 verkaufte Sander sein Mappenwerk *Köln wie es war* mit Aufnahmen aus der noch unzerstörten Rheinmetropole an die Stadt Köln. 1961 erhielt er den Kulturpreis der Deutschen Gesellschaft für Photographie.

Aus dem um 1924 entworfenen Kompendium *Menschen des 20. Jahrhunderts*, in dem Sander mehrere Hundert seiner Porträts von Menschen aus verschiedenen Gesellschaftsschichten und Berufsgruppen gleichsam als Archetypen des Menschlichen und als Soziologie der Bilder versammelte, stammt auch die Fotografie des Töpfermeisters, der für die lange Tradition einer der ersten Kulturtechniken der Menschheit steht. Sander zeigt einen gealterten Mann, der gewissermaßen an einer Zeitenwende steht, da die voranschreitende industrielle Fertigung das manuelle Handwerk zu verdrängen beginnt.

Born in 1876 in Herdorf/Germany, died in 1964 in Cologne/Germany. From 1890 to 1896, August Sander worked in the Herdorf iron mine and bought his first photographic equipment at this time. In 1897 and 1898 he learned about photography with the photographer Georg Jung in Trier. The subsequent years of travel from 1899 to 1901 took him to Berlin, Magdeburg, Dresden and Leipzig as a photographer's assistant. In 1901 he moved to Linz, Austria, and worked at the Photographische Kunstanstalt Greif, which he and a partner ran together from 1902, and which he managed independently from 1904 onwards. In 1910 he moved to Cologne and maintained a studio for photography there. From the 1920s onwards he was in contact with the Gruppe Progressiver Künstler group in Cologne and started the cultural work *Menschen des 20. Jahrhunderts*. These portfolios constitute his encyclopaedic life's work, which he revised repeatedly over the course of the years and which continued to exercise him until his death. In addition to portraits Sander created landscape compositions and nature studies, and worked for industrial corporations, for artists and architects. His book *Antlitz der Zeit*, which was published in 1929, was confiscated in 1936, and the printing plates destroyed. From 1942 Sander and his wife moved from Cologne to Kuchhausen in the Westerwald region. They gradually brought thousands of his most precious negatives with them, so that these were saved; the Cologne studio was destroyed and all of the negatives and materials that remained in the cellar were destroyed in a fire shortly after the war. In 1953 Sander sold his portfolio work *Köln wie es war*, which featured photographs of the Rhine metropolis before its destruction, to the city of Cologne. In 1961 he received the Culture Prize from the German Society for Photography.

In the compendium *Menschen des 20. Jahrhunderts*, designed around 1924, Sander gathered several hundred of his portraits of people from different social classes and professions as human archetypes and as a sociology of images. These also include the photograph of the master potter, who represents the long tradition of one of humankind's first cultural techniques. Sander shows an aged man who appears to be standing at a turning point, as advancing industrial production starts to replace the manual handicrafts.

Literatur/Further reading: Manfred Heiting (Hrsg./ed.), *August Sander. 1876–1964*, Köln/Cologne 1999

August Sander
Der Töpfermeister, 1926
Silbergelatineprint/silver gelatin print

Albert Renger-Patzsch

Geboren 1897 in Würzburg/Deutschland, verstorben 1966 in Wamel bei Soest/ Deutschland. Schon als Kind erlernte Albert Renger-Patzsch das Fotografieren. Nach einem abgebrochenen Chemiestudium arbeitete er im Archiv des Folkwang-Verlags in Hagen und in einer Bildagentur. 1925 machte er sich als Fotograf selbstständig und konnte ab 1929 in eigenen Atelierräumen im Folkwang-Museum in Essen arbeiten. In dieser Zeit war die Industriefotografie sein Hauptanliegen und durch Beauftragungen aus dem Unternehmerbereich seine wichtigste Einnahmequelle. Seinen Lehrauftrag für Fotografie an der Folkwangschule beendete er 1933 auf eigenen Wunsch. Nach der Zerstörung seines Fotoarchivs durch einen Bombenangriff im Jahr 1944 widmete er sich vermehrt der Naturfotografie, übernahm aber auch noch in den 1950er- und 1960er-Jahren Aufträge aus der Industrie. Sein 1928 publiziertes Fotobuch *Die Welt ist schön* wurde zu einer Grundlage der modernen Fotogeschichte. Renger-Patzsch publizierte noch in seinen späteren Lebensjahren viele Bände über Architektur- und Landschaftsfotografie.

Die hier gezeigte Aufnahme wurde in einem Konvolut mit zehn Fotografien Renger-Patzschs angekauft, von denen eine die Bezeichnung *Zeche Scholven bei Buer* trägt. Es ist anzunehmen, dass die vorliegende Ansicht in derselben Industrieanlage entstand. Die 1908 gegründete Zeche Scholven in Gelsenkirchen wurde in den 1920er-Jahren ausgebaut, um 1928 kamen die Zentralkokerei der Hibernia AG und ein Stickstoffwerk hinzu. Sie galten als die innovativsten Industriebauten der Zeit und waren für Renger-Patzsch gerade durch die große Massigkeit und die klaren Strukturen von besonderem Interesse. Die Aufnahme ist nicht datiert, da der Ort Buer aber im Jahr 1928 durch Eingemeindung seinen Namen verlor, dürfte sie vor 1928 entstanden sein.

Literatur/Further reading: Ann und/and Jürgen Wilde und/and Thomas Weski (Hrsg./eds.), *Albert Renger-Patzsch. Meisterwerke* (Ausst.-Kat./exh. cat. Sprengel Museum Hannover, Württembergischer Kunstverein Stuttgart, u.a./and others), München/Munich 1997

Born in 1897 in Würzburg/Germany, died in 1966 in Wamel bei Soest/Germany. Albert Renger-Patzsch learned photography skills as a child. After discontinuing his chemistry studies, he worked in the archives of the Folkwang publishing house in Hagen and in a photo agency. In 1925 he started his own business as a photographer and from 1929 was able to work in his own studio space in the Folkwang Museum in Essen. During this time he focused mainly on industrial photography, and commissions from the business world were his main source of income. His teaching contract for photography at the Folkwang School ended in 1933 at his own request. After the destruction of his photo archives in a bombing raid in 1944, he increasingly devoted himself to nature photography, but still took industrial commissions in the 1950s and 1960s. Published in 1928, his photo book *Die Welt ist schön* became a cornerstone of modern photographic history. Renger-Patzsch published many books on architecture and landscape photography in his later years.

The photograph shown here was purchased in a bundle with ten photographs by Renger-Patzsch, one of which bears the name *Zeche Scholven bei Buer*. It is likely that this photograph was taken at the same industrial plant. Founded in 1908, the Zeche Scholven mine in Gelsenkirchen was expanded in the 1920s and in 1928, the central coking plant of Hibernia AG and a nitrogen plant were added. They were considered the most innovative industrial buildings of the time and for Renger-Patzsch they were of particular interest due to their massiveness and clear structures. Since the photograph is undated and the town of Buer lost its name in 1928 through amalgamation, it was probably taken before 1928.

Albert Renger-Patzsch
Ohne Titel/Untitled (Zeche/coal mine Scholven
bei/near Buer), um/ca. 1926
Silbergelatineprint/silver gelatin print

Jan Lukas

Geboren 1915 in Budweis/heutige Tschechische Republik, verstorben 2006 in New York/USA. Jan Lukas studierte Fotografie bei Rudolf Koppitz in Wien. Von 1936 bis 1938 war er in Zlín, der Modellstadt der Firma Bata, als Kameramann und Dokumentarist tätig. Wie viele seiner Zeitgenossen eignete er sich über die dokumentarische und berufsmäßig ausgeübte Fotografie einen spezifischen, atmosphärischen Stil an. Die Verwendung der Fotografien für die Veröffentlichung stand hierbei im Vordergrund. Mit seinem *Prager Tagebuch 1938–1965* legte er ein Bilddokument der historisch wichtigsten Momente in seiner Heimat an. Aus politischen Gründen ging er 1964 erstmals und ab 1965 endgültig nach New York, wo er bis zu seinem Tod arbeitete.

Die Ansicht des Wiener Opern Cafés ist eine der frühen Fotografien von Jan Lukas, die er noch während seines Studiums an der Graphischen Lehr- und Versuchsanstalt in Wien anfertigte. Im Stile einer neusachlichen Fotografie, die sich vom Piktorialismus wegentwickelte und Interesse an alltäglichen Szenen, an Technik, aber auch am urbanen Leben zeigte, hielt Lukas mit effektvoller Lichtsetzung einen Ausschnitt aus dem Treiben der Großstadt fest. Das moderne Leben der Zwischenkriegszeit präsentiert sich von seiner sorglosen Seite, mit einem Faible für schicke Autos und einen mondänen Lebensstil. Architektur, Design und Atmosphäre verschmelzen zu einer stimmungsvollen Nachtaufnahme des damals neuen, heute nicht mehr bestehenden Kaffeehauses im Gebäude am Opernring 4, an dem sich der Wandel der Idee des Wiener Kaffeehauses in Richtung eines eleganten, modernen »Cafés« ablesen lässt.

Literatur/Further reading: Josef Moucha (Hrsg./ed.), *Jan Lukas*, Prag/Prague 2003

Born in 1915 in Budweis/present-day Czech Republic, died in 2006 in New York/USA. Jan Lukas studied photography with Rudolf Koppitz in Vienna. From 1936 to 1938 he worked as a cameraman and documentary filmmaker in Zlín, the model city of the Bata company. Like many of his contemporaries, he acquired a specific atmospheric style while doing his documentary and professional photography. The use of photographs for publication was at the forefront of this work. With his *Prague Diary 1938-1965* he created a visual document of historically important moments in his homeland. For political reasons, he went to New York for the first time in 1964 and then for good in 1965, where he worked until his death.

The view of the Opern Café in Vienna is one of the early photographs by Jan Lukas that he took during his studies at the Graphische Lehr- und Versuchsanstalt in Vienna. In the style of New Objectivity photography, whose development moved away from Pictorialism and instead showed an interest in everyday scenes, technology and urban life, Lukas used effective lighting to record an excerpt from the bustle of city life. Modern life during the interwar period is shown from its carefree side, with a penchant for fancy cars and a sophisticated lifestyle. Architecture, design and ambiance merge into an atmospheric night shot of the then-new but now defunct coffee house in the building at Opernring 4, in which the change in the idea of a Viennese coffee house towards an elegant, modern café can be seen.

Jan Lukas
Die Terrasse des Opern Cafés, um/ca. 1935
Silbergelatineprint/silver gelatin print

Kitty Hoffmann

Geboren 1900 in Wien/Österreich, mit bürgerlichem Namen Katy Sarah Hoffmann, verstorben 1968 in Wien. Nach der Ausbildung an der Graphischen Lehr- und Versuchsanstalt in Wien war Kitty Hoffmann dort von 1922 bis 1924 als Assistentin tätig. Sie gehörte zu den ersten Fotografinnen, die in Wien ein Fotostudio einrichteten: Ab 1927 hatte sie ihr eigenes Atelier. Sie fertigte hauptsächlich Porträt- und Modeaufnahmen als Auftragsarbeiten an, vor allem für *die neue linie*, die zwischen 1929 und 1943 in Leipzig erschien und die erste deutsche Lifestyle-Zeitschrift war. Dieses Magazin war zunächst vom Bauhaus beeinflusst und unter Mitwirkung von Herbert Bayer international und innovativ ausgerichtet; ab 1938 passte sich das Blatt jedoch vermehrt der nationalsozialistischen Linie an und wurde 1943 eingestellt. Hoffmann setzte ihre fotografische Arbeit auch nach 1938 fort und war in den 1940er-Jahren eine der bekanntesten Modefotografinnen Wiens.

Born in 1900 as Katy Sarah Hoffmann in Vienna/Austria, died in Vienna in 1968. After her training at the Graphische Lehr- und Versuchsanstalt in Vienna, Kitty Hoffman worked there as an assistant from 1922 until 1924. She was one of the first photographers to set up a photo studio in Vienna and in 1927 she had her own studio. She produced mainly portrait and fashion photographs as commissioned work, especially for *neue linie*, the first German lifestyle magazine, published in Leipzig between 1929 and 1943. This magazine was initially influenced by the Bauhaus movement and, with the involvement of Herbert Bayer, was internationally oriented and innovative. From 1938 the journal increasingly towed the National Socialist line and it was discontinued in 1943. Hoffmann continued her photographic work after 1938 and was one of the most well known fashion photographers in Vienna in the 1940s.

Der Ästhetik rund um die 1930er-Jahre entsprechend stellt sich das ideale Männerbild dar: eine sportlich-elegante Erscheinung mit den maskulin konnotierten Attributen des Schäferhundes und des kraftstrotzenden Automobils. Wie ihre Tanz- und Modefotos ist auch diese Aufnahme Kitty Hoffmanns perfekt choreografiert und ausgeleuchtet. Der minutiös konstruierte Stil und die artifiziell erscheinende Inszenierung eines trendigen Lebensgefühls lassen die Nähe zu Auftragsarbeiten im Zeitschriftensektor vermuten.

The image of the ideal male that appeared around the 1930s combined a sporty and elegant appearance with the attributes associated with masculinity of the German shepherd dog and a powerful car. As in her dance and fashion photographs, the choreography and lighting in this photograph by Kitty Hoffmann are perfect. The meticulously designed style and the seemingly artificial staging of a trendy lifestyle suggest an affinity with commissioned work in the magazine business.

Literatur/Further reading: Anton Holzer und/and Frauke Kreutler (Hrsg./eds.), *Trude Fleischmann. Der selbstbewusste Blick/A Self-assured Eye* (Ausst.-Kat./exh. cat. Wien Museum, Wien/Vienna), Ostfildern 2011

Kitty Hoffmann
Ohne Titel/Untitled, 1929
Bromsilberprint/bromine silver print

Lothar Rübelt

Geboren 1901 in Wien/Österreich, verstorben 1990 in Klagenfurt/Österreich. Lothar Rübelt war ein erfolgreicher Leistungssportler, bevor er sich 1919 dem Fotojournalismus zuwandte. Von 1919 bis 1927 studierte er an der Technischen Hochschule in Wien und drehte gemeinsam mit seinem Bruder den Film *Mit dem Motorrad über die Wolken*, der 1927 in Wien uraufgeführt wurde. 1936 fotografierte er als offizieller Fotograf für die *Berliner Illustrirte Zeitung* die Olympischen Spiele in Berlin. In den Jahren 1938 und 1939 dokumentierte Rübelt als Pressefotograf den Anschluss Österreichs, die Sudetenkrise und den Polenfeldzug. Ab 1945 wandte er sich wieder der Sportberichterstattung zu. Rübelt erhielt 1985 den Preis der Stadt Wien für Bildende Kunst.

Lothar Rübelt gilt als einer der bedeutendsten Fotografen, die Sport und athletischen Wettkampf ins fotografische Genre einführten. Er war als Fotojournalist im Dienste der Ideologie des Nationalsozialismus tätig, aber auch als »Bildberichterstatter« des sozialen Lebens und als Chronist der Moderne, die er ab den 1920er-Jahren mit der Kamera festhielt. Mit »Perlen der Großstadt« ist der erste Fußgängerübergang gemeint, der 1929 auf der Kreuzung auf dem Wiener Michaelerplatz wegen des zunehmenden Autoverkehrs eingeführt wurde: Rübelts Foto zeigt einen mit runden Metallknöpfen im Boden bezeichneten Fahrbahnstreifen, auf dem sich zwei Passanten bewegen und drastische Schlagschatten werfen. Der Fokus der Aufnahme liegt nicht auf den Personen, sondern auf dem Bild der Straße.

Born in 1901 in Vienna/Austria, died in 1990 in Klagenfurt/Austria. Lothar Rübelt was a successful athlete before turning to photojournalism in 1919. From 1919 to 1927 he studied at the Technische Hochschule in Vienna and together with his brother made the film *Mit dem Motorrad über die Wolken*, which premiered in Vienna in 1927. In 1936 he photographed the Olympic Games in Berlin as the official photographer for the newspaper *Berliner Illustrirte Zeitung*. In the years 1938 and 1939 Rübelt documented the annexation of Austria, the Sudetenland crisis and the Polish campaign as a press photographer. After 1945 he went back to sports coverage. Rübelt received a prize for visual arts from the city of Vienna in 1985.

Lothar Rübelt is one of the most important photographers to introduce sports and athletic competition to the photographic genre. He worked as a photojournalist in the service of the ideology of National Socialism, but also as a photojournalist of social life and as a chronicler of modernity, which he recorded with the camera starting in the 1920s. "Perlen der Großstadt" refers to the first pedestrian crossing, which was established in 1929 at the intersection at Vienna's Michaelerplatz because of the increase in car traffic. Rübelt's photograph shows a section of the street delimited with round metal caps on the road on which two passers-by are walking and casting drastic drop shadows. The focus of the photograph is not on the people, but on the image of the road.

Literatur/Further reading: Christian Brandstätter (Hrsg./ed.), *Lothar Rübelt. Österreich zwischen den Kriegen. Zeitdokumente eines Photopioniers der 20er und 30er Jahre*, Text von/by Gerhard Jagschitz, Wien, München und Zürich/Vienna, Munich and Zurich 1979

Lothar Rübelt
»Perlen der Großstadt«, Wien, Michaelerplatz, 1932
Silbergelatineprint/silver gelatin print

Bernd und/and Hilla Becher

Bernd Becher: geboren 1931 in Siegen/Deutschland, verstorben 2007 in Rostock/ Deutschland. Hilla Becher: geboren als Hilla Wobeser 1934 in Potsdam/Deutschland. Bernd Becher studierte von 1953 bis 1956 an der Staatlichen Akademie der Bildenden Künste in Stuttgart Malerei und Grafik. Hilla Becher studierte von 1958 bis 1961 an der Düsseldorfer Kunstakademie Fotografie. Das Künstlerpaar arbeitete ab 1959 zusammen und heiratete 1961. Von 1976 bis 1996 hatte Bernd Becher die Professur für Fotografie an der Kunstakademie Düsseldorf inne. Von Bernd und Hilla Becher wurde die Düsseldorfer Fotoschule begründet.

Bernd und Hilla Becher erarbeiteten sich mit seriellen Schwarz-Weiß-Fotografien von Fachwerkhäusern und Industriebauten wie Fördertürmen, Hochöfen, Kohlebunkern, Fabrikhallen, Gasometern, Getreidesilos und komplexen Industrielandschaften ab den späten 1950er-Jahren internationales Renommee. Der Förderturm im Ort Merthyr Vale in Wales gehört zu einer Kohlebergbauanlage, die 1873 errichtet worden war. Die Mine, die 1966 von einer Bergbaukatastrophe betroffen war, wurde 1989 endgültig stillgelegt. Der sachliche Stil des Fotografierens und das Interesse an einer bisher übersehenen Industriearchäologie machten Bernd und Hilla Becher zu international anerkannten Persönlichkeiten der zeitgenössischen Kunst.

Literatur/Further reading: Heinz Liesbrock, *Bernd & Hilla Becher. Coal Mines and Steel Mills*, München/Munich 2010

Bernd Becher: born in 1931 in Siegen/Germany, died in 2007 in Rostock/Germany. Hilla Becher: born in 1934 as Hilla Wobeser in Potsdam/Germany. Bernd Becher studied painting and graphic design at the Staatliche Akademie der Bildenden Künste in Stuttgart from 1953 to 1956. Hilla Becher studied photography at the Kunstakademie Düsseldorf from 1958 to 1961. The artist couple worked together from 1959 and was married in 1961. From 1976 to 1996 Bernd Becher was professor of photography at the Kunstakademie Düsseldorf. Bernd and Hilla Becher founded the Düsseldorfer Fotoschule school.

Bernd and Hilla Becher achieved international renown from the late 1950s onwards with black-and-white photographic series of timbered houses and industrial buildings such as winding towers, blast furnaces, coal bunkers, factory buildings, gasometres, grain silos and complex-industrial landscapes. The winding tower in the village of Merthyr Vale in Wales is part of a coal-mining facility built in 1873. The mine, which was affected by a mining disaster in 1966, was finally shut down in 1989. The factual style of photography and the interest in a previously overlooked industrial archaeology made Bernd and Hilla Becher internationally recognized figures in contemporary art.

Bernd und/and Hilla Becher
Förderturm/Merthyr Vale Colliery, Schacht II, 1966
Silbergelatineprint/silver gelatin print

PRÄGENDE MOMENTE.
ZUR US-AMERIKANISCHEN
FOTOGRAFIE IN DER SAMMLUNG FOTOGRAFIS

FORMATIVE MOMENTS.
ON AMERICAN PHOTOGRAPHY IN
THE FOTOGRAFIS COLLECTION

Walter Moser

Als die Sammlung FOTOGRAFIS 1976 auf Anregung von Anna Auer durch die damalige Länderbank gegründet wurde, fanden rasch Arbeiten der wichtigsten Vertreter US-amerikanischer Fotografie Eingang in diesen Bestand. Die Fotografien von Edward Weston, Weegee und Diane Arbus bilden besonders wichtige Werkgruppen innerhalb der Sammlung, sie umfasst aber auch Aufnahmen des historischen Landschaftsfotografen Carleton E. Watkins sowie des bekanntesten Vertreters der sogenannten *straight photography,* Paul Strand. Das Interesse an aus den USA stammenden Fotografinnen und Fotografen war bereits im Ausstellungsprogramm von Auers Galerie Die Brücke, welche sie 1970 gemeinsam mit Werner H. Mraz gegründet hatte, angelegt. Arbeiten bedeutsamer Fotografen wie etwa Walker Evans, Edward S. Curtis und Duane Michals wurden hier gezeigt. Auch in den Programmen der zwischen 1976 und 1981 von Auer und Mraz veranstalteten Symposien der Sammlung FOTOGRAFIS selbst spiegelt sich dieses Interesse an amerikanischer Fotografie wider. So befanden sich mit Vortragenden wie John Coplans, Van Deren Coke, Weston J. Naef und Beaumont Newhall prägende Museumsfiguren und Theoretiker – und nicht zuletzt auch Fotografen – aus den USA unter den Teilnehmern. Newhall hatte zudem eine Sammlungsstrategie für eine amerikanische Bank entwickelt, die der FOTOGRAFIS als Beispiel diente, wobei jedoch die inhaltliche Struktur der österreichischen Sammlung anders definiert wurde als jene der amerikanischen Kollegen.[1] Die offizielle Sammlungspolitik der FOTOGRAFIS richtete ihren Fokus auf historische, piktorialistische und sachliche Fotografien, die um relevante Einzelleistungen der Sozial-, Porträt- und Reportagefotografie ergänzt werden sollten.[2] Diese Beschreibung erscheint in Hinblick auf die in der Sammlung

When the former Länderbank established the FOTOGRAFIS collection in 1976 at the suggestion of Anna Auer, works by the most important representatives of American photography quickly found their way into this inventory. The photographs of Edward Weston, Weegee and Diane Arbus form particularly important groups of works in the collection, but it also includes photographs by the historic landscape photographer Carleton E. Watkins and the most famous representative of so-called straight photography, Paul Strand. The interest in photographers from the United States was already apparent in the exhibition programmes at Auer's gallery Die Brücke, which she founded together with Werner H. Mraz in 1970. Works by important photographers such as Walker Evans, Edward S. Curtis and Duane Michals were shown here. Symposium programmes organized by Auer and Mraz between 1976 and 1981 based on the FOTOGRAFIS collection also reflect this interest in American photography. Thus influential museum figures and theorists – and last but not least photographers – from the United States such as the lecturers John Coplans, Van Deren Coke, Weston J. Naef and Beaumont Newhall were among the participants. Newhall also developed a collection strategy for an American bank for which FOTOGRAFIS served as a model, but the content structure of the Austrian collection was defined differently than that of the American colleagues.[1] The official policy of the FOTOGRAFIS collection directed its focus on historical, pictorial and objective photography, which was to be supplemented by relevant individual achievements in social, portrait and reportage photography.[2] This description appears to be very limiting with respect to the American photographs in the collection however, as the artists represented here are key figures in the history of photography

verwahrten amerikanischen Fotografien jedoch überaus verkürzt zu sein, handelt es sich bei den dort vertretenen Künstlerinnen und Künstlern doch um Schlüsselfiguren der Fotogeschichte, die zueinander in engen und feinen Verbindungen stehen und prägende Strömungen und Entwicklungen verdeutlichen.

Landschaft im Fokus

Zu den frühesten Beständen der Sammlung FOTOGRAFIS zählen Werke des Fotografen Carleton E. Watkins. Er wandte sich in seinen Bildern einem Thema zu, das für das kulturelle Selbstverständnis der USA ebenso prägend ist wie für die Arbeiten nachfolgender Fotografen: der Landschaft. Neben Eadweard Muybridge und Timothy O'Sullivan gehörte er zu jener frühen Generation, die die Topografie des amerikanischen Westens, insbesondere Kaliforniens, visuell entdeckte und erschloss. Ab 1858 fotografierte Watkins etwa das Yosemite-Gebiet. Die Bilder, die er von dort mitnahm, um sie in seinem

that relate to each other through close and subtle connections and illustrate formative trends and developments.

A focus on landscapes

Among the earliest holdings of the FOTOGRAFIS collection are works by the photographer Carleton E. Watkins. In his pictures he focused on a topic that is as decisive for the cultural identity of the United States as for the work of subsequent photographers: the landscape. In addition to Eadweard Muybridge and Timothy O'Sullivan, he was one of those from the early generation who visually discovered and exploited the topography of the American West, especially California. In 1858 for instance Watkins photographed the Yosemite region. He worked very hard to produce the pictures he took there to then sell in his shop in San Francisco: not only did he take photographs with a Mammoth Camera, whose negatives were extremely large, but the plates had to be prepared and developed directly on location. On these expeditions he had to bring along his own darkroom in addition to the camera, plates and chemicals. Watkins worked systematically on his photographs, thus producing landscape images at regular intervals through which extensive local contexts are visualized.[3] His precise, sharp and detailed reproduction of the landscape was mostly interpreted as a pure interest in factual aspects and regarded as an interest in the "authentic" reflection of a subject but not as its representation in the image. In this sense, the photographs reflect an unmediated view of the landscape. However, this seems too simplistic, as subject and image are never congruent. How much Watkins's photographs are influenced by a subjective view of the landscape can be seen for example in his choice of camera position, which – as Weston J. Naef noted – maximizes the visual potential of the subjects in the image.[4] In addition, Watkins composed his images on the basis of picturesque motifs, such as portraying reflections in water.[5]

Watkins created incunabula of landscape photography that were to become central reference points for the works of subsequent photographers. Thus Ansel Adams, for example, chose the same viewpoints as his predecessor to achieve a picturesque effect wherever possible in his photographs of the Yosemite area in the 1920s and 1930s.[6] Like his colleague Edward Weston, he overstated the landscape even more than Watkins had with extremely formal staging. His early landscape photographs are not free from ideological considerations: a pioneering spirit, a will to expand and a spirit of discovery are the values

Carleton E. Watkins, *Mirror View El Cápitan,*
3600 Feet, Yosemite Valley, um / ca. 1866
Albuminabzug / albumen print, 31,5 × 21 cm
Sammlung FOTOGRAFIS Bank Austria /
FOTOGRAFIS Bank Austria Collection

Joel Sternfeld, *Abandoned Refinery near Tuba City, Arizona, Navajo Nation*, 1982, C-Print, 122 × 149 cm Albertina, Wien / Vienna, Dauerleihgabe / Permanent loan from Österreichische Ludwig-Stiftung für Kunst und Wissenschaft

Laden in San Francisco zu verkaufen, waren mühevoll erkämpft: Nicht nur fotografierte er mit einer sogenannten Mammut-Kamera, deren Negative äußerst groß waren, die Platten mussten auch direkt vor Ort präpariert und entwickelt werden. Bei den Expeditionen musste dementsprechend neben der Kamera, den Platten und Chemikalien auch eine eigene Dunkelkammer mitgeführt werden. Watkins ging bei seinen Aufnahmen systematisch vor. So fertigte er in regelmäßigen Intervallen Bilder der Landschaft an, wodurch übergreifende örtliche Zusammenhänge visualisiert werden sollten.[3] Seine präzise, scharfe und detailreiche Wiedergabe der Landschaft wurde zumeist als pures Interesse am Faktischen gedeutet sowie als Interesse an dem »authentischen« Abbild eines Motivs gewertet, jedoch nicht als dessen Repräsentation im Bild. Die Fotos geben in diesem Sinne einen nicht mediatisierten Blick auf die Landschaft wieder. Dies erscheint jedoch zu simpel, sind doch Motiv und Abbild niemals deckungsgleich. Wie sehr Watkins' Fotografien durch einen subjektiven Blick auf die Landschaft geprägt sind, ist beispielsweise an der Wahl seines Kamerastandpunktes ersichtlich, der – wie Weston J. Naef feststellte – das visuelle Potenzial der Motive im Bild maximierte.[4] Des Weiteren komponierte Watkins seine Bilder anhand pittoresker Motive, wie etwa durch die Darstellung von Reflexionen im Wasser.[5]

Watkins schuf Inkunabeln der Landschaftsfotografie, die zu zentralen Referenzpunkten für die Werke nachfolgender Fotografen werden

inherent in his photographs and Adams's later photographs in particular became an essential part of the cultural identity of the United States.[7] Photographers in the second half of the twentieth century critically explored these aspects. Joel Sternfeld's *American Prospects* series, created in the 1970s, is interesting in relation to this in that it no longer shows views of the American landscape as sublime, utopian and untouched by humans, but instead visualizes the problematic effects of a changed and industrialized landscape. While Watkins and Adams portrayed Yosemite as a pristine Garden of Eden, Sternfeld shows the National Park as a place of entertainment that has been prepared for tourists and commercialized. A similarly critical view can also be read into the photographs from the 1960s taken by the Californian Lewis Baltz, a representative of the New Topographics movement. In objective, minimalist and extremely precise imagery, he photographed urban sprawl and spoiled landscapes that represent a clear rejection of the grandiose portrayals of nature by early West Coast photographers. Against the backdrop of the Cold War and with the disastrous effects of the industrialized consumer society of the postwar period, the landscape had lost its innocence.

New ways of seeing the world

Although the successors to Adams and Weston saw their landscape photographs as old-fashioned,[8] in their own photographs they solidi-

sollten. So wählte Ansel Adams beispielsweise für seine Fotos des Yosemite-Gebiets in den 1920er- und 1930er-Jahren die gleichen Standpunkte wie sein Vorgänger, um eine möglichst pittoreske Bildwirkung zu erzielen.[6] Wie sein Kollege Edward Weston überhöhte er die Landschaft durch ihre äußerst formale Inszenierung im Bild noch stärker als Watkins. Dessen frühe Landschaftsfotografien sind nicht frei von ideologischen Überlegungen: Pioniergeist, Expansionswille und Entdeckerdrang sind Werte, die seinen Fotos inhärent sind und speziell auch über die späteren Bilder von Adams essenzieller Bestandteil des kulturellen Selbstverständnisses der USA wurden.[7] Fotografen in der zweiten Hälfte des 20. Jahrhunderts setzten sich mit diesen Aspekten kritisch auseinander. Joel Sternfelds in den 1970er-Jahren entstandene Serie *American Prospects* ist hier insofern interessant, als sie die amerikanische Landschaft nicht mehr in sublimen, utopischen und vom Menschen unberührten Ansichten zeigt, sondern vielmehr die problematischen Auswirkungen einer veränderten und industrialisierten Landschaft visualisiert. Hatten Watkins und Adams Yosemite als unberührten Garten Eden dargestellt, zeigt Sternfeld den Nationalpark als eine für Touristen aufbereitete und kommerzialisierte Vergnügungsstätte. Als gleichermaßen kritisch können die ab den 1960er-Jahren entstandenen Fotografien des Kaliforniers Lewis Baltz, eines Vertreters der *New-Topographics*-Bewegung, gewertet werden.

fied new demands on photography that were to radically renew the visual aesthetic and self-conception of the photographer. With a group of photographs by Weston, the FOTOGRAFIS collection possesses formative works by photographers in this respect. In the 1920s Weston reconciled a formalist aesthetic with the specific medium of photography. Until then the trend of Pictorialism, which with the soft-focus blurring and manual manipulation of the print represented a painterly and thus "artistic" visual language, had dominated. Weston made his photographs in direct opposition to this. Crystal clarity, clear contours and precise details characterize his pictures. These design elements are thus classified as decidedly "photographic", as they illustrate specific qualities of photography. A group of artists founded in 1932 called f64, to which Weston and Imogen Cunningham belonged, reflected these new ambitions in photography, as f/64 refers to a small aperture setting, allowing for incredible depth of field.

Weston's photographs, and also those of colleagues such as Paul Outerbridge, Charles Sheeler and Beaumont Newhall, should be assessed

Lewis Baltz, *Kelvin between Derian and Jamboree Road looking towards Newport Center*, aus / from *The Prototype Works*, 1974
Silbergelatineprint / silver gelatin print, 15,2 × 22,9 cm
Albertina, Wien / Vienna

In einer sachlichen, minimalistischen und äußerst präzisen Bildsprache lichtete er zersiedelte und verunstaltete Landschaften ab, die eine klare Absage an die grandiosen Naturdarstellungen der frühen Westküstenfotografen darstellen. Vor dem Hintergrund des Kalten Kriegs und durch die desaströsen Auswirkungen der industrialisierten Konsumgesellschaft der Nachkriegszeit hatte die Landschaft ihre Unschuld verloren.

Neue Blickweisen auf die Welt

Auch wenn die Landschaftsfotografien von Adams und Weston von ihren Nachfolgern als unmodern wahrgenommen wurden,[8] verdichteten sich in ihren Aufnahmen neue Ansprüche an die Fotografie, die die Bildästhetik und das Selbstverständnis des Fotografen radikal erneuern sollten. Mit einer Gruppe von Bildern von Weston besitzt die Sammlung FOTOGRAFIS Werke eines in dieser Hinsicht prägenden Fotografen. Weston söhnte in den 1920er-Jahren eine formalistische Ästhetik mit den Medienspezifika der Fotografie aus. Hatte bis dahin die Strömung des Piktorialismus dominiert, die durch weichzeichnerische Unschärfe und manuelle Manipulation des Abzugs eine malerische und damit »künstlerische« Bildsprache vertrat, fertigte Weston seine Bilder in direkter Opposition dazu an. Gestochene Schärfe, klare Konturen und präzise Details charakterisieren seine Bilder. Diese Gestaltungsmittel sind insofern als dezidiert »fotografisch« zu werten, als sie spezifische Qualitäten der Fotografie veranschaulichen. Dass sich eine 1932 gegründete Künstlergruppe, der neben Weston auch Imogen Cunningham angehörte, den Namen f/64 gab, spiegelt diese neuen Ambitionen in der Fotografie wider, bezeichnet f/64 doch eine kleine Blendeneinstellung, die eine enorme Schärfentiefe erlaubt.

Die Bilder Westons, aber auch die seiner Kollegen, wie Paul Outerbridge, Charles Sheeler und Beaumont Newhall, sind als Resultat eines neuen Blicks auf die moderne und zeitgenössische Lebensrealität zu werten, in der Industrie, Konsumgüter und Großstädte wesentlich werden. Diese Motive wurden durch neue Stilrichtungen – etwa durch das »Neue Sehen«, bei dem steile Perspektiven von oben oder unten dynamische Bildkompositionen ergeben – festgehalten. Die Abkehr von der Bauchnabelperspektive ist speziell in Bildern US-amerikanischer Großstädte ersichtlich. Beaumont Newhall fotografierte etwa Wolkenkratzer, die diese Perspektiven geradezu erzwingen.

Es wäre freilich ein Fehler, die Erneuerungen in der Fotografie in den USA als isoliertes Phänomen zu begreifen. Speziell die legendäre Ausstellung Film und Foto, die 1929 in Stuttgart eröffnet wurde, veranschaulichte die neue fotografische Programmatik im internationalen Kontext. Von Mitteleuropa bis Russland reichten die progressiven

as the result of a new view of the modern and contemporary reality of life in which industry, consumer goods and large cities are essential. These subjects were adhered to with new styles – for example with the New Vision, in which steep perspectives from above or below resulted in dynamic image compositions. This move away from the navel perspective is especially apparent in pictures of American cities. For instance, Beaumont Newhall photographed skyscrapers that almost force these perspectives on the viewer.

It would certainly be a mistake to see the innovations in photography in the USA as an isolated phenomenon. Specifically, the legendary exhibition Film und Foto, which opened in Stuttgart in 1929, illustrated the new photographic approach in an international context. The progressive aspirations in photography, subsumed under catch phrases such as New Vision and New Objectivity, extended from Central Europe to Russia. Edward Weston and Edward Steichen, whose photographs were also shown, put together the section of American photographs in the exhibition. Their style is usually summarized under the concept of "straight photography", which refers to a photographic practice where subjects are photographed directly – thus "straight" – and not edited. Although the photographers defined straight photography – at least theoretically – as pure photography, the imagery in which objects were often considered abstract was nevertheless influenced by the European and Cubist paintings that Alfred Stieglitz exhibited in the USA.[9]

With Stieglitz's photograph The Steerage, the FOTOGRAFIS collection has an icon of the era marking the transition from Pictorialism to straight photography. This photograph was taken in 1907 on a ship travelling from the USA to Europe and shows socially disadvantaged travellers in steerage observed by the wealthy people from the deck above. Stieglitz noted that he recognized the social implications of this image only at second glance; his primary interest was in those shapes and structures whose direct and accurate reproduction divided the image into abstract lines and surfaces.

No photographer typifies the claims of straight photography as clearly as Paul Strand, two of whose photographs from 1916 are in the FOTOGRAFIS collection. He made a case in the 1920s for increased use of the mechanical possibilities of the camera, which should not be used like a paintbrush in Pictorialism.[10] For Strand, photography was defined by its "absolute and indefinite objectivity", which he expressed in his photographs in sharp and unmanipulated imagery.[11] Strand combined his formal aesthetic issues with socio-political issues. This is particularly evident in his pictures of socially marginalized groups, such as in the portrait of a blind man, which he reflects directly and immediately with a frontal close-up view.

Paul Strand, *Blind Woman*, 1916
Fotogravüre / photogravure, 22 × 17 cm
Sammlung FOTOGRAFIS Bank Austria /
FOTOGRAFIS Bank Austria Collection

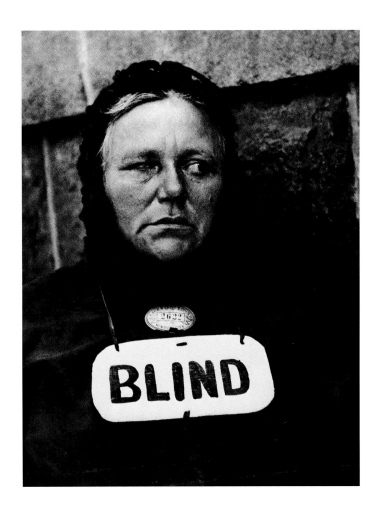

Bestrebungen in der Fotografie, die unter Schlagwörtern wie »Neues Sehen« und »Neue Sachlichkeit« subsumiert wurden. Die Sektion amerikanischer Fotografien in der Schau wurde von Edward Weston und Edward Steichen zusammengestellt, die selbst mit Bildern vertreten waren. Ihr Stil wird zumeist unter dem Begriff *straight photography* zusammengefasst, der eine fotografische Praxis bezeichnet, bei der Motive unumwunden, direkt – also *straight* – abgelichtet und nicht nachbearbeitet werden. Obwohl die Fotografen die *straight photography* zumindest theoretisch als medienreine Fotografie definierten, wurde die Bildsprache, bei der Objekte oftmals abstrakt aufgelöst wurden, dennoch von jener europäischen und kubistischen Malerei beeinflusst, die Alfred Stieglitz in den USA ausstellte.[9]

Mit Stieglitz' Bild *The Steerage* besitzt die Sammlung FOTOGRAFIS eine Ikone jener Epoche, die den Übergang vom Piktorialismus zur *straight photography* markiert. Dieses Foto entstand 1907 auf einer Schiffsreise von den USA nach Europa und zeigt sozial benachteiligte Reisende auf einem Zwischendeck – englisch *steerage* –, die von wohlhabenden Personen auf dem Deck darüber beobachtet werden. Die sozialen Implikationen dieses Bildes erkannte Stieglitz eigenen Aussagen zufolge erst auf den zweiten Blick; sein primäres Interesse galt jenen Formen und Strukturen, deren direkte und präzise Wiedergabe das Bild in abstrakte Linien und Flächen unterteilte.

Kein Fotograf verkörpert die Ansprüche der *straight photography* jedoch so klar wie Paul Strand, von dem sich zwei Bilder von 1916 in der Sammlung FOTOGRAFIS befinden. Er sprach sich in den 1920er-Jahren für eine verstärkte Nutzung der mechanischen Möglichkeiten des Fotoapparates aus, der nicht mehr wie im Piktorialismus wie ein Pinsel verwendet werden solle.[10] Für Strand definierte sich Fotografie durch ihre »absolute und unbestimmte Objektivität«, was sich in seinen Fotos in einer scharfen und unmanipulierten Bildsprache äußerte.[11] Strand verband seine formalästhetischen Fragen mit sozialpolitischen Themen. Dies zeigt sich speziell in seinen Bildern gesellschaftlicher Randgruppen, wie etwa in dem Porträt einer Blinden, das er durch eine frontale Nahansicht direkt und unmittelbar wiedergibt.

Sozialdokumentarische Fotografie

Als eines der bedeutendsten Vorbilder für die politischen Ambitionen Paul Strands kann der amerikanische Soziologe und Fotograf Lewis Hine gelten, eine Schlüsselfigur der amerikanischen Dokumentar-

Social documentary photography

The American sociologist and photographer Lewis Hine – a key figure of American documentary photography – is one of the most important paragons for the political ambitions of Paul Strand. Like the police reporter Jacob A. Riis before him, Hine photographed the socially underprivileged in the first three decades of the twentieth century. His photographs of immigrants and child labourers are evidence of social ills, visual indictments and messages that were supposed to help eliminate social injustice. Last but not least, they are also specifically composed, formally aesthetic images. This dialectic of form and content proved to be essential, and this can be seen in Hine's famous photographs of child labourers from the period between 1908 and 1918. In these photographs, Hine concentrated on the relationship between the large machines and the very small child labourers in order to point out the absurdity of their work situation. He was aware of the propagandistic presentation of his photographs. He spoke of his paintings as "photo-interpretations" rather than documentations, which demonstrates a discursive and methodological approach to the camera because what the viewer perceives as "documentary" is ultimately always due to the subjective view of the photographer.

fotografie. Wie bereits der Polizeireporter Jacob A. Riis vor ihm fotografierte Hine in den ersten drei Jahrzehnten des 20. Jahrhunderts sozial Unterprivilegierte. Seine Fotos von Immigranten und Kinderarbeitern sind Belege sozialer Missstände, visuelle Anklagen und Botschaften, die gesellschaftliche Ungerechtigkeit beseitigen sollten. Nicht zuletzt sind sie aber auch spezifisch komponierte, formalästhetische Bilder. Diese Dialektik von Inhalt und Form erweist sich als essenziell, was etwa in Hines berühmten Fotos von arbeitenden Kindern aus der Zeit zwischen 1908 und 1918 ersichtlich wird. Hine konzentrierte sich bei diesen Aufnahmen formal geschickt auf die Relationen zwischen den großen Maschinen und den im Vergleich überaus klein wirkenden Kindern, um auf die Absurdität ihrer Arbeitssituation hinzuweisen. Er war sich der propagandistischen Inszenierung seiner Fotos bewusst. So sprach er von seinen Bildern als »Foto-Interpretationen« und nicht als Dokumentationen, was von einem diskursiven und methodischen Umgang mit der Kamera zeugt. Denn das, was der Betrachter als »dokumentarisch« wahrnimmt, ist letztlich immer dem subjektiven Blick eines Fotografen geschuldet.

Die sozialdokumentarischen Fotografien, die gesellschaftliche und politische Umbrüche in den USA am deutlichsten visualisierten, stammen von jenen Fotografinnen und Fotografen, die zwischen 1935 und 1944 im Auftrag der Farm Security Administration (FSA) eine Reportage über die von der Wirtschaftsdepression betroffenen Gegenden im Süden des Landes anfertigten. Diese Fotos hatten zwei klare Funktionen: Sie sollten zum einen die katastrophalen Auswirkungen der Wirtschaftsdepression veranschaulichen und zum anderen Propaganda für Franklin D. Roosevelts »New Deal«-Politik sein. Neben Dorothea Lange gehörte Walker Evans zu den bekanntesten und einflussreichsten Teilnehmern an diesem Projekt. Er fertigte Porträts von Farmern ebenso an wie Aufnahmen alltäglicher Architekturen und Objekte. Motive wie Schaufenster, Straßenzüge, Hausfassaden und Straßenschilder wurden auf jene nüchterne und prosaische Art festgehalten, die unter dem Schlagwort »Dokumentarischer Stil« in die Fotogeschichte einging. Im Falle von Evans besteht dieser Stil in einer bewusst »unkünstlerischen« Bildsprache, die aufgrund der frontalen und sachlichen Wiedergabe von Objekten die faktische Qualität der Fotografie betont. Durch die scheinbar unmittelbare Übertragung des Objektes auf das Negativ scheinen der Bildgegenstand und seine Abbildung identisch zu sein.

Die harte Realität der Wirtschaftskrise der USA war nicht nur Thema der Fotografen der FSA. Sie wird auch in den Fotos von Margaret Bourke-White, einer der ersten Frauen im Fotojournalismus, ersichtlich. Sie fertigte Bilder von Farmpächtern an, die sie 1937 in dem Buch *You Have Seen Their Faces* zusammen mit Texten des Schriftstellers Erskine Caldwell publizierte. Bourke-Whites Zugang zur Dokumentarfotografie ist ein völlig anderer als etwa jener von Walker

The social documentary photographs that most clearly visualize the social and political upheavals in the USA were taken by those photographers commissioned by the Farm Security Administration (FSA) between 1935 and 1944 to produce a documentary on the regions affected by the economic depression in the south of the country. These photographs had two clear functions: they were supposed to illustrate the catastrophic effects of the economic depression and to act as propaganda for Franklin D. Roosevelt's New Deal policy. In addition to Dorothea Lange, Walker Evans was one of the most famous and influential participants in this project. He made portraits of farmers as well as pictures of ordinary architecture and objects. Subjects such as shop windows, streets, building façades and street signs were recorded in a sober and prosaic style received into photographic history under the heading "documentary style". In the case of Evans this style exists in intentionally "un-artistic" imagery, emphasizing the factual quality of photography due to the frontal and objective representation of objects. With the seemingly direct transfer of an object to the negative, the object depicted and its reproduction appear to be identical.

The harsh reality of the economic crisis in the USA was not only a topic for the photographers of the FSA. It is also seen in the pictures of Margaret Bourke-White, one of the first women in photojournalism. She prepared images of sharecroppers in the book *You Have Seen Their Faces*, which she published in 1937 together with texts by the writer Erskine Caldwell. Bourke-White's approach to documentary photography is entirely different than that of Walker Evans because she stages the scene with her models – often in series – in their living

Robert Frank, *Rodeo, Detroit, Michigan*, 1955
Silbergelatineprint / silver gelatin print, 27,8 × 35,4 cm
Albertina, Wien / Vienna, Dauerleihgabe / Permanent loan
from Österreichische Ludwig-Stiftung für Kunst und Wissenschaft

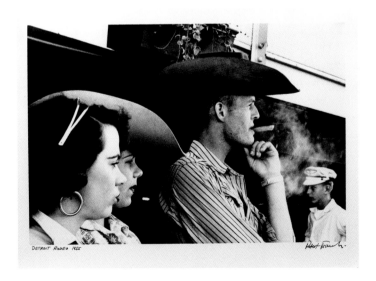

Evans: Da sie ihre Modelle – oftmals in Serien – in ihren Wohnräumen mithilfe von Blitzlampen und Reflektoren durch dramatische Schatten, Close-ups und ungewöhnliche Perspektiven in Szene setzte, sind ihre Bilder wesentlich narrativer und theatralischer.

Amerikas soziale Landschaft

Die soziale Landschaft der USA mit ihren Bewohnern und Eigenheiten sollte – oftmals in Anlehnung an Walker Evans – zu einem der wesentlichsten Themen der amerikanischen Fotografie werden. Unterschiedlichste Vertreter der sogenannten *street photography* konzentrierten sich in ihren Bildern auf menschliche Interaktionen, um dadurch gesellschaftliche Strukturen aufzuzeigen. Ihre Motive fanden die Fotografen in Großstädten genauso wie auf *road trips* durch das Land, einem spezifisch US-amerikanischen Phänomen. Fotografen und Fotografinnen schreckten auch hier nicht vor der kritischen Darstellung umstrittener oder pessimistischer Inhalte zurück. Der aus der Schweiz in die USA migrierte Fotograf und Filmemacher Robert Frank zeigte beispielsweise in seinen Fotos düstere Szenen, die 1959 unter dem Titel *The Americans* als Buch publiziert wurden. Seine körnigen Bilder sozialer Außenseiter und gesellschaftlicher Randgruppen abseits des »American Dreams« entstanden, als der Kalte Krieg sich auf dem Höhepunkt befand, und zeigen Inhalte wie Rassismus oder Armut.

Auf sarkastische und voyeuristische Art und Weise visualisierte auch der Reportagefotograf Weegee ab den späten 1930er-Jahren die Schattenseiten amerikanischer Großstädte. John Coplans bezeichnete den ursprünglich aus der heutigen Ukraine stammenden Fotografen als »unerschrockenen, rabiaten, sich selbst anpreisenden Voyeur«[12]. Mit seiner Speed-Graphic-Kamera fotografierte Weegee das alltägliche Leben der Bewohner ebenso wie Morde und Verbrechen, denen er sich oftmals so stark näherte, dass der Betrachter gleichsam als Voyeur unmittelbar an die Szene herangerückt wird. Diesen Effekt verstärkte Weegee durch die Nachbearbeitung der Fotos, indem er häufig nachträglich einen engen Bildausschnitt wählte, um die zentrale Szene zu betonen. Die Unmittelbarkeit seiner Szenen wird durch grelles Blitzlicht unterstrichen, betont dies doch den Akt der Aufnahme, bei dem im Bruchteil einer Sekunde ein Moment der Bewegung entrissen wird. Auch wenn Weegee seinen Zeitgenossen Lewis Hine kannte und sie beide in Kinderarbeitern ein wichtiges Motiv fanden, haben seine Fotos nichts mit den Ansprüchen Hines gemein. Sind Hines Fotos klar durchdacht, wird in Weegees Bildern Spontaneität einer überlegten Komposition vorgezogen. Seine unmittelbare und intuitive Art zu fotografieren wurde für eine Vielzahl von Fotografinnen und Fotografen wegweisend, die das amerikanische Leben mit einem neuen Blick festhielten.

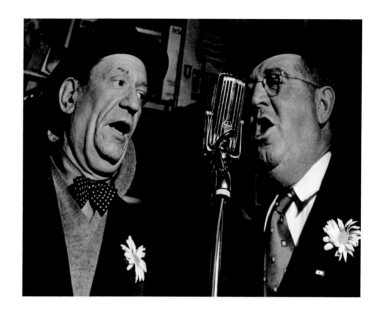

Lisette Model, *Sammy's Bar, New York*, 1944
Silbergelatineprint / silver gelatin print, 37,8 × 49 cm
Albertina, Wien / Vienna, Dauerleihgabe / Permanent loan
from Österreichische Ludwig-Stiftung für Kunst und Wissenschaft

rooms using flashes and reflectors with dramatic shadows, close-ups and unusual perspectives, and her images are essentially more narrative and theatrical.

America's social landscape

The social landscape of the USA with its inhabitants and idiosyncrasies – often in the style of Walker Evans – was to become one of the most important issues in American photography. Different representatives of street photography focused their pictures on human interactions in order to draw attention to social structures. The photographers found their subjects in big cities as well as on road trips across the country, a specifically American phenomenon. The photographers did not shy away from a critical or pessimistic view of controversial content here either. For instance, the photographer and filmmaker Robert Frank, who emigrated from Switzerland to the USA, shows gloomy scenes in his photographs, which were published in 1959 as a book entitled *The Americans*. These grainy images of social misfits and social groups outside the American Dream emerged when the Cold War was at its peak, and show content such as racism or poverty.

The photojournalist Weegee visualized the dark side of American cities from the late 1930s in a sarcastic and voyeuristic way. John Coplans described the photographer who was originally from what is now the Ukraine as a "fearless, ruthless, self-laudatory voyeur"[12].

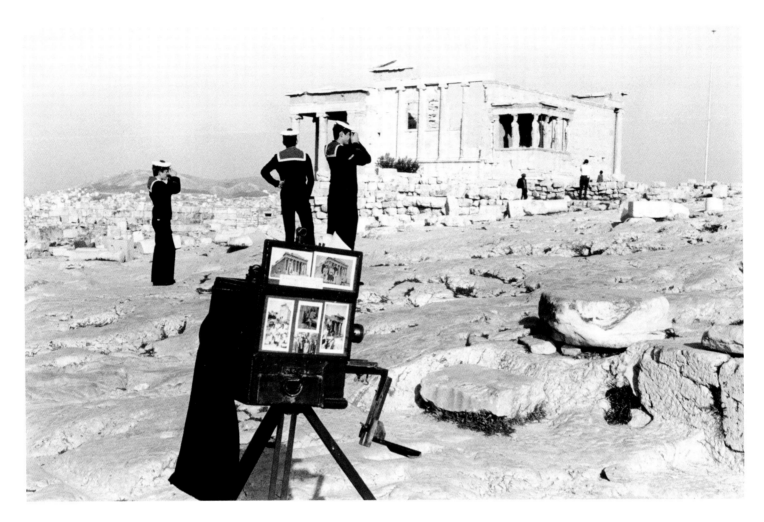

Kenneth Josephson, *Acropolis*, 1972
aus dem Portfolio / from the portfolio *Ken Josephson*, 1975
Silbergelatineprint / silver gelatin print, 15,6 × 23 cm
Sammlung FOTOGRAFIS Bank Austria /
FOTOGRAFIS Bank Austria Collection

Eine Kameradin fand Weegee in der 1901 in Wien geborenen Foto-
grafin Lisette Model. Ihre Bilder der skurrilen Bewohner New Yorks
sind mit seinen Fotografien durchaus verwandt. Gleichermaßen
spontan und unmittelbar wie ihr Kollege setzte Model ihre grell ge-
blitzten Porträts ins Bild. Die schrägen und dynamischen Perspekti-
ven von unten sind der Handhabung ihrer Rolleiflex geschuldet, die
üblicherweise vor der Brust gehalten wird, da sich der Sucher an der
Oberseite der Kamera befindet. Im Kontext der klassischen *street
photography* und Sozialdokumentation sind Models Werke insofern
unorthodox, als sie sowohl dem sozialreformatorischen Humanismus
eines Lewis Hine widersprechen als auch mit den perfekt komponier-
ten Bildern entscheidender Augenblicke brechen.

Wie nahe dokumentarischer Blick und Voyeurismus in dieser Art zu
fotografieren beieinander liegen, wurde anhand keines Œuvres so

With his Speed Graphic camera, Weegee photographed the everyday
life of the population, as well as murders and crimes, and he often got
so close that the viewer is directly drawn into the scene as a voyeur,
so to speak. Weegee achieved this effect through the post-processing
of photographs in which he often later chose a narrow image section
to emphasize a pivotal scene. The immediacy of his scenes is under-
scored by the bright flash, which emphasizes the act of taking the
photograph when a moment of movement is torn apart in a fraction
of a second. Although Weegee knew his contemporary Lewis Hine
and the two found an important subject in child labourers, his pho-
tographs have nothing in common with the assertions of Hine. While
Hine's photographs are clearly carefully considered, Weegee's images
prefer the spontaneity of a deliberate composition. His immediate
and intuitive photographic approach was groundbreaking for a num-
ber of photographers who captured American life with a new vision.

Weegee found a partner in the photographer Lisette Model, who was
born in Vienna in 1901. Her pictures of the absurd inhabitants of
New York related to his photographs perfectly. Spontaneous and
immediate like her colleague, Model captured her portraits in pic-

intensiv diskutiert wie an demjenigen von Diane Arbus, der bekanntesten Schülerin Lisette Models. Arbus fertigte in den 1950er- und 1960er-Jahren konsequent Porträts sozialer Außenseiter an, wie etwa von kleinwüchsigen oder körperlich beeinträchtigten Menschen, die sie zumeist in symmetrischen Frontalansichten festhielt. Arbus wurde vor allem vorgeworfen, dass sie ihre Modelle ausnutze und als Spektakel inszeniere. Während Weegees und Models Bilder klar durch einen invasiven Blick geprägt sind, ist die Sachlage bei Arbus' Werken komplizierter: Nicht nur wussten ihre Modelle, mit denen sie zum Teil auch befreundet war, dass sie fotografiert wurden, auch ließ ihnen die Fotografin Zeit, sich selbst in Pose zu setzen. Letztendlich begründet sich die Frage nach den voyeuristischen Aspekten von Arbus' Werk in der Komplizenschaft des Betrachters mit dem fotografischen Bild, das ihn anstelle der Fotografin vor die oftmals äußerst privaten Szenen setzt.

Konstruierte Bildwelten

Ab den 1970er-Jahren begannen sich in der US-amerikanischen Fotografie konzeptuelle Tendenzen durchzusetzen, die sich durch ein neues Verhältnis der Fotografen zur Realität auszeichneten. Im Vordergrund stand nicht mehr die Wiedergabe authentischer Szenen, sondern die Konstruktion von Bildern. Motive wurden wie für den Film in Szene gesetzt, Akteure und Ausstattung als Bildvokabular verstanden, das beliebig arrangiert werden konnte. Inszenierte Fotografie gab es seit der Frühzeit des Mediums, neu war jedoch, dass gleichzeitig der Authentizitätsanspruch der Fotografie auf einer theoretischen Ebene infrage gestellt wurde. Besonders deutlich visualisieren dies etwa die Arbeiten des Konzeptfotografen Kenneth Josephson, der Fotos anfertigt, in denen er bestimmte Orte oder Gegenstände mit relationalen Bildern als »Bild im Bild« abfotografiert. Wenn er etwa ein Schloss in Schweden und gleichzeitig ein Foto ebendieses Schlosses so fotografiert, dass die Darstellung beider Bilder übereinstimmt, thematisiert er, dass die fotografische Repräsentation per se eine durch Ausschnitte und Blickachsen konstruierte ist.

Die Beziehung zwischen Realität und Kamera ist auch für die Arbeiten von Duane Michals wesentlich. Ab den 1970er-Jahren fertigte er Fotografien an, für die er Modelle zumeist in Innenräumen in Szene setzte. Michals konzipierte seine Fotos nicht als Einzelbilder, sondern als sequenzielle Abfolge, die durch gestalterische Variationen übergreifende narrative Zusammenhänge veranschaulicht. Wesentlich ist hierbei, dass die in den Fotos sichtbaren Szenen nicht der Realität entstammen, sondern vom Fotografen konstruiert sind. Seine oftmals mit Text versehenen Arbeiten dienen der Visualisierung subjektiver Erfahrungen. Diesen Zugang erläuterte Michals auch bei seinem

tures using a bright flash. The oblique and dynamic perspectives from below are due to the handling of her Rolleiflex, which is usually held in front of the chest, as the viewfinder is at the top of the camera. In the context of classic street photography and the social documentary, Model's works are unorthodox, as they contradict both the social-reform humanism of Lewis Hine and the decisive moment of perfectly composed pictures.

How close a documentary view and voyeurism are to each other in this kind of photography has never been discussed more intensely in any oeuvre than with that of Diane Arbus, who was the most famous student of Lisette Model. In the 1950s and 1960s, Arbus consistently made portraits of social outsiders, including persons short in stature or physically disabled, whom she mostly recorded in symmetrical frontal views. Arbus was accused of exploiting her models and staging a spectacle. While Weegee and Model's pictures are clearly marked by an invasive gaze, the situation in Arbus's works is more complicated: not only did her models, with whom she was sometimes friends, know they were being photographed, the photographer also gave them time to set their own pose. Ultimately, the question of the voyeuristic aspects of Arbus's work is explained in the complicity of the viewer with the photographic image that frequently puts the viewer in the place of the photographer in what are often very private scenes.

Constructed image worlds

From the 1970s, American photography began to assert conceptual tendencies characterized by a new relationship of the photographer with reality. The focus was no longer on the reproduction of authentic scenes but on the construction of images. Subjects were set like a scene in a film with actors and equipment understood as visual vocabulary that could be arranged as desired. Staged photography had existed since the early days of the medium, but now the simultaneous claim to authenticity of the photography was called into question at a theoretical level. This is very clearly visualized in the work of the concept photographer Kenneth Josephson, who made pictures in which he photographed certain places or objects with relational photographs as images within images. For instance, he would photograph a castle in Sweden and then match it with a photograph of the same castle, and in so doing he addressed the fact that photographic representation per se is constructed by framings and sightlines.

The relationship between reality and the camera is also crucial to the work of Duane Michals. From the 1970s he produced photographs in which he usually had the models sit indoors. Michals did not conceive his photographs as individual images, but as sequential

Vortrag auf einem in Wien von der FOTOGRAFIS veranstalteten Symposium: Seine Bilder gäben wieder, was er denke, und nicht, was er sehe.[13] Seine Strategie, in seriellen Arbeiten eine subjektive Idee beziehungsweise ein Konzept umzusetzen, erwies sich als sehr inspirierend für jüngere europäische und amerikanische Fotografen.

Gleichermaßen narrativ, aber wesentlich surrealer als die Fotos von Michals sind beispielsweise die fotografischen Inszenierungen von Les Krims. In oftmals seriell konzipierten *Tableaux vivants* zeigt er groteske Szenen, die sich einer der Pop-Art, Werbung und Pornografie entlehnten Ikonografie bedienen. Diese klar kodierten Zeichen werden gemeinsam mit zumeist nackten Modellen, die absurde Posen einnehmen, fotografiert. Die sich daraus ergebende surreale Bilderwelt wurde gleichermaßen als Kritik an der amerikanischen Konsumkultur wie als Visualisierung subjektiven Begehrens interpretiert.

Innerhalb der Sammlung FOTOGRAFIS veranschaulichen Les Krims und Duane Michals einen weiteren wesentlichen Paradigmenwechsel in der US-amerikanischen Fotografie: Suchten Watkins, Arbus, Model und die Vertreter der *straight photography* wie Paul Strand – wenn auch auf völlig unterschiedliche Art und Weise – ihre Motive in realen Lebenswelten, so konstruierten Michals und Krims diese für die Kamera. Freilich: Auch Fotografen wie Strand, Weston und Arbus interpretierten durch die Wahl des Ausschnitts, des Motivs, der Beleuchtung und der Perspektive die Wirklichkeit entsprechend ihren Zwecken.[14] Im Unterschied dazu inszenierten die Fotografen der 1970er-Jahre ihre Bilder jedoch nicht anhand maschineller Parameter der Kamera, sondern dadurch, dass sie die Wirklichkeit wie Filmregisseure als formbares Ausgangsmaterial begriffen. Die Realität wurde als durch das mediale Bild konstruiert aufgefasst, ihre authentische Wiedergabe, die seit jeher ein Anliegen der Fotografie gewesen war, hatte jedoch ausgedient.

series for which he used design variations to illustrate broad narrative contexts. What is important here is that the scenes visible in the photographs do not come from reality but are constructed by the photographer. Often accompanied by text, his works help visualize subjective experiences. Michals explained this approach during his presentation at a symposium in Vienna organized by FOTOGRAFIS: his pictures reflect what he thinks and not what he sees.[13] His strategy to realize a subjective idea or a concept in serial work proved to be very inspiring for young European and American photographers.

The photographic productions of Les Krims are similarly narrative, but much more surreal than the photographs by Michals. Often conceived in serial *tableaux vivants* he shows grotesque scenes borrowed from the iconography of Pop Art, advertising and pornography. These clearly coded symbols are photographed with mostly naked models in absurd poses. The resulting surreal imagery was simultaneously interpreted as a critique of American consumer culture and as the visualization of subjective desire.

In the FOTOGRAFIS collection, Les Krims and Duane Michals illustrate another significant paradigm shift in American photography: while Watkins, Arbus, Model and representatives of straight photography such as Paul Strand searched for their subjects in real-life environments – albeit in completely different ways – Michals and Krims constructed them for the camera. Of course photographers such as Strand, Weston and Arbus also interpreted reality for their own purposes through the choice of cut, motif, lighting and perspective.[14] By contrast, the photographers of the 1970s did not stage their pictures on the basis of the mechanical parameters of the camera, but on the fact that, like film directors, they saw reality as malleable raw material. Reality was perceived to be constructed by the media image; its authentic reflection, which had always been a concern of photography, had become obsolete, however.

1 Vgl. Anna Auer, *Die Wiener Galerie Die Brücke – Ihr internationaler Weg zur Sammlung Fotografis,* Passau 1999, S. 151/152.

2 Vgl. ebenda, S. 152/153.

3 Vgl. John Coplans, »C.E. Watkins at Yosemite« (1978), in: Stuart Morgan (Hrsg.), *John Coplans. Provocations,* London 1996, S. 218.

4 Vgl. Weston J. Naef, »Gustave Le Gray, Carleton E. Watkins und die Ästhetik der visuellen Wahrnehmung«, in: Margret Stuffmann (Hrsg.), *Pioniere der Landschaftsphotographie. Gustave Le Gray, Carleton E. Watkins. Beispiele aus der Sammlung des J. Paul Getty Museums, Malibu/Pioneers of Landscape Photography. Gustave Le Gray, Carleton E. Watkins. Photographs from the Collection of the J. Paul Getty Museum, Malibu* (Ausst.-Kat. Städtische Galerie im Städelschen Kunstinstitut, Frankfurt am Main), Mainz 1993, S. 7–9, 83–88.

5 Vgl. Coplans 1978 (wie Anm. 3), S. 220–223.

6 Vgl. Weston J. Naef und Christine Hult-Lewis (Hrsg.), *Carleton Watkins. The Complete Mammoth Photographs,* Los Angeles 2011.

7 Vgl. hierzu Liz Wells, *Land Matters. Landscape Photography, Culture and Identity,* London 2011.

8 Vgl. Lewis Baltz, »Landscape Problems«, in: ders., *Texts,* Göttingen 2012, S. 19.

9 Vgl. hierzu John Pultz und Catherine B. Sallen (Hrsg.), *Cubism and American Photography 1910–1930* (Ausst.-Kat. Sterling and Francine Clark Art Institute, Williamstown, Massachusetts, u.a.), Williamstown, Massachusetts, 1981.

10 Vgl. Paul Strand, »Fotografie und der neue Gott« (1922), in: Wolfgang Kemp (Hrsg.), *Theorie der Fotografie,* Bd. 2, München 1999, S. 61.

11 Paul Strand, »Fotografie« (1917), in: Kemp 2/1999 (wie Anm. 10), S. 59.

12 John Coplans, »Weegee – Der Berühmte«, in: *Weegee. Täter und Opfer. 85 Photographien,* mit einer Einleitung von John Coplans, München 1984, S. 7.

13 Vgl. Duane Michals, »This is a real Dream«, in: Ivo Stanek (Hrsg.), *Zusammenfassung von Vorträgen der Sammlung Fotografis von 1976–1978,* Wien 1979, S. 13.

14 Für eine genaue Definition inszenierter Fotografie siehe A.D. Coleman, »Inszenierende Fotografie. Annäherung an eine Definition« (1976), in: Wolfgang Kemp (Hrsg.), *Theorie der Fotografie,* Bd. 3, München 1999, S. 239–243.

1 Cf. Anna Auer, *Die Wiener Galerie Die Brücke – Ihr internationaler Weg zur Sammlung Fotografis,* Passau 1999, pp. 151/152.

2 Cf. ibid, pp. 152/153.

3 Cf. John Coplans, "C.E. Watkins at Yosemite" (1978), in: Stuart Morgan (ed.), *John Coplans. Provocations,* London 1996, p. 218.

4 Cf. Weston J. Naef, "Gustave Le Gray, Carleton E. Watkins and the esthetic of perception", in: Margret Stuffmann (ed.), *Pioniere der Landschaftsphotographie. Gustave Le Gray, Carleton E. Watkins. Beispiele aus der Sammlung des J. Paul Getty Museums, Malibu/Pioneers of Landscape Photography. Gustave Le Gray, Carleton E. Watkins. Photographs from the Collection of the J. Paul Getty Museum, Malibu* (exh. cat. Städtische Galerie im Städelschen Kunstinstitut, Frankfurt am Main), Mainz 1993, pp. 7–9, 83–88.

5 Cf. Coplans 1978 (cf. note 3), pp. 220–223.

6 Cf. Weston J. Naef and Christine Hult-Lewis (eds.), *Carleton Watkins. The Complete Mammoth Photographs,* Los Angeles 2011.

7 Cf. Liz Wells, *Land Matters. Landscape Photography, Culture and Identity,* London 2011.

8 Cf. Lewis Baltz, "Landscape Problems", in: Lewis Baltz, *Texts,* Göttingen 2012, p. 19.

9 Cf. John Pultz and Catherine B. Sallen (eds.), *Cubism and American Photography 1910–1930* (exh. cat. Sterling and Francine Clark Art Institute, Williamstown, Massachusetts, et al.), Williamstown, Massachusetts, 1981.

10 Cf. Paul Strand, "Photography and the New God" (1922), in: Wolfgang Kemp (ed.), *Theorie der Fotografie,* vol. 2, Munich 1999, p. 61.

11 Paul Strand, "Fotografie" (1917), in: Kemp 2/1999 (cf. note 10), p. 59.

12 John Coplans, "Weegee – Der Berühmte", in: *Weegee. Täter und Opfer. 85 Photographien,* with an introduction by John Coplans, Munich 1984, p. 7.

13 Cf. Duane Michals, "This is a real Dream", in: Ivo Stanek (ed.), *Zusammenfassung von Vorträgen der Sammlung Fotografis von 1976–1978,* Vienna 1979, p. 13.

14 For a precise definition of staged photography see A.D. Coleman, "Inszenierende Fotografie. Annäherung an eine Definition" (1976), in: Wolfgang Kemp (ed.), *Theorie der Fotografie,* vol. 3, Munich 1999, pp. 239–243.

Ernest Joseph Bellocq

Geboren 1873 in New Orleans, Louisiana/USA, verstorben 1949 in New Orleans. Ernest Joseph Bellocq war zunächst als gewerblicher Fotograf für Unternehmen tätig und fertigte vermutlich nur für sich Fotografien im Ambiente von Storyville an, dem Vergnügungs- und Jazz-Viertel von New Orleans, das 1917 von den Bundesbehörden geschlossen wurde. Bellocqs exzentrisches Leben wurde durch einen Unfall jäh beendet, erst Jahre nach seinem Tod wurden seine Fotografien entdeckt.

Die Storyville-Porträts sind Bilder von Damen des Rotlichtmilieus. Bellocq fotografierte in den Jahren 1912 und 1913 mittels Glasplattennegativen und dürfte nur wenige, private Abzüge gemacht haben. Einige der Fotos zeigen Kratzspuren oder Beschädigungen auf dem Negativ; 89 dieser Porträts wurden vom Fotografen Lee Friedlander im Kunsthandel entdeckt und in den Jahren 1970 bis 1973 als *modern prints* abgezogen. Bellocq zeigte die Halbwelt der Prostituierten als eine schwüle Szenerie von Jahrhundertwendeerotik in einer weichen, sanften Tonalität. Seine Modelle posieren teils bekleidet, teils nackt, sie sind sich stets der Anwesenheit der Kamera bewusst. Ausdruck der lasziven Entspanntheit ist das odaliskenhaft posierende Mädchen auf einer Wicker Chaise Longue, einer für die Südstaaten charakteristischen Liege aus Weidengeflecht.

Literatur/Further reading: Mark Holborn (Hrsg./ed.), *Bellocq. Photographs from Storyville, The Red-Light District of New Orleans*, New York 1996

Born in 1873 in New Orleans, Louisiana/USA, died in 1949 in New Orleans. Ernest Joseph Bellocq initially worked as a commercial photographer for companies, and probably only took personal photographs in the area of Storyville, the entertainment and jazz quarter of New Orleans shut down by federal authorities in 1917. Bellocq's eccentric life was abruptly ended by an accident and it was not until years after his death that his photographs were discovered.

The Storyville portraits are photographs of ladies of the red-light district. In 1912 and 1913 Bellocq took photographs using glass-plate negatives and made only a few personal copies. Some of the photographs have scratches or damage to the negative; photographer Lee Friedlander discovered 89 of these portraits on the art market and then printed them as modern prints from 1970 to 1973. Bellocq depicted the demimonde of prostitution as a sultry scene of turn-of-the-century eroticism in a soft, gentle tonality. His models sometimes pose clothed and sometimes naked, but are always aware of the presence of the camera. Expressing a wanton manner, the girl poses odalisque-like on a wicker chaise longue, a characteristic lounge chair of the southern states made from woven wicker.

Ernest Joseph Bellocq
Girl on the Wicker Chaise Longue, aus der Serie/ from the series *Storyville Portraits*, 1912/13, Print 1970–1973
Silbergelatineprint/silver gelatin print

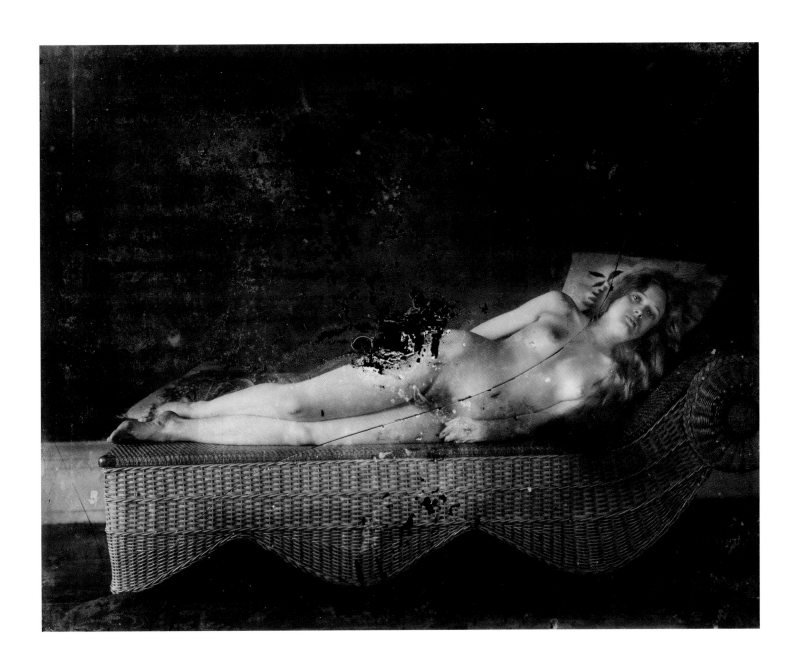

Lewis Hine

Geboren 1874 in Oshkosh, Wisconsin/USA, verstorben 1940 in Hastings-on-Hudson, New York/USA. Lewis Hine studierte Soziologie in Chicago, daneben verdiente er in der Zeit der Depression seinen Lebensunterhalt als einfacher Arbeiter. Als Fotograf war er Autodidakt. Ab 1906 fotografierte er für das National Child Labor Committee und kämpfte für die Änderung der Gesetzgebung zu Kinderarbeit und Ausbeutung. Im Ersten Weltkrieg ging er nach Paris, wo er für das Rote Kreuz arbeitete. In den 1920er- und 1930er-Jahren entstanden in den USA Fotografien von Arbeitern. Besonders die Dokumentation über den Bau des Empire State Buildings aus den Jahren 1930 bis 1932 machte ihn berühmt. Werke von Hine sind im Besitz des Museum of Modern Art in New York; seinen Nachlass verwaltet das George Eastman House in Rochester, USA.

Lewis Hine trug mit seiner Fotoserie über Kinder- und Frauenarbeit dazu bei, dass die unmenschlichen Arbeitsbedingungen verbessert und Kinderarbeit letztlich abgeschafft wurde. Oftmals führte er die Namen, Tätigkeiten und Lebensumstände der Kinder, ihr Alter und ihren Wohnort an, um ihre Ausbeutung direkt und individuell zu dokumentieren und seinem Appell durch das Aufzeigen von Einzelschicksalen Gewicht zu verleihen. Er erstellte große Serienkonvolute nach Orten oder Berufsgruppen und versah diese mit ausführlichen Beschriftungen wie der zur hier gezeigten Fotografie: »(Junge rechts) John Campbell, (Box 294 Gastonia N. C.) 10 Jahre alt. Arbeitete drei Jahre in der Fabrik. Schulbesuch nur zeitweilig. (Junge links) Roy Little. Angeblich 12 Jahre alt. 2 Jahre in der Fabrik und arbeitete 9 Monate in Nachtschicht. Handlanger am Webstuhl. Ort: Gastonia, North Carolina«.

Literatur/Further reading: Karl Steinorth (Hrsg./ed.), *Lewis Hine. Die Kamera als Zeuge – Fotografien 1905–1937*, Kilchberg 1996

Born in 1874 in Oshkosh, Wisconsin/USA, died in 1940 in Hastings-on-Hudson, New York/USA. Lewis Hine studied sociology in Chicago while earning his livelihood as a labourer during the Depression. He was a self-taught photographer. In 1906 he took photographs for the National Child Labor Committee and fought for change in legislation with respect to child labour and exploitation. During the First World War, he went to Paris, where he worked for the Red Cross. In the 1920s and 1930s his photographs of workers in the USA emerged. His documentation of the construction of the Empire State Building from 1930 to 1932 made him famous. The Museum of Modern Art in New York owns works by Hine and the George Eastman House in Rochester in the United States manages his estate.

With his series of photographs of children and women working, Lewis Hine contributed to improving inhumane working conditions, and child labour was finally abolished. He often cited the names, occupations and living conditions of children, their age and their place of residence in order to document their exploitation directly and individually, and to lend weight to his appeal by identifying individual fates. He created large series of photographs according to places or professional groups and provided them with detailed captions as shown on the photograph here: "(Right hand boy) John Campbell, (Box 294 Gastonia N.C.) 10 years old. Been three years in mill. In school part of this time. (Left hand boy) Roy Little. Said 12 years old. 2 years in mill and worked nights 9 months. Doffer. Location: Gastonia, North Carolina".

Lewis Hine
Gastonia, North Carolina, 1911–1915
Silbergelatineprint/silver gelatin print

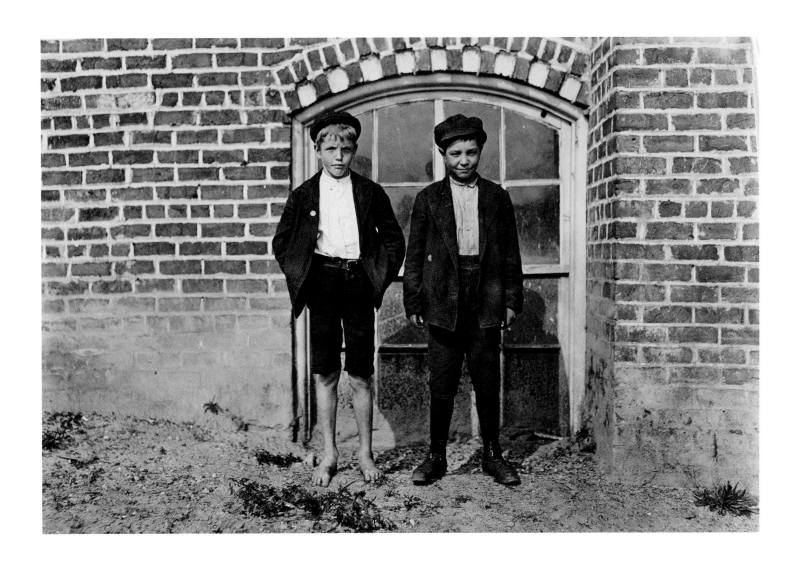

Alfred Stieglitz

Geboren 1864 in Hoboken, New Jersey/USA, verstorben 1946 in New York/USA. Schon im Alter von 16 Jahren bereiste Alfred Stieglitz Europa und studierte von 1881 bis 1890 an der Technischen Hochschule in Berlin Ingenieurwesen und Fotografie. Seine frühen Werke waren vom Piktorialismus beeinflusst. 1890 kehrte er in die USA zurück, wo er in New York Partner bei der Photochrome Engraving Company wurde. Von 1892 bis 1896 wirkte er an dem Journal *The American Amateur Photographer* mit. Er gehörte 1902 zu den Gründungsvätern der Photo-Secession in New York und eröffnete seine erste Galerie. Er präsentierte der Öffentlichkeit die Einflüsse der europäischen Avantgarde auf die amerikanische Kunst. Dazu nutzte er auch seine Tätigkeit als Herausgeber der Zeitschrift *Camera Work*, mit der er die Fotografie fördern und sie als Kunstform etablieren konnte. Er gründete zusammen mit Edward Steichen die Galerie 291, die von 1905 bis 1917 bestand, und lernte Georgia O'Keeffe kennen, die seine Lebensgefährtin, sein Modell und seine Muse wurde. Stieglitz führte von 1925 bis 1929 die Intimate Gallery und von 1929 bis 1946 An American Place, in denen vor allem Gemälde, Skulpturen und Grafiken ausgestellt wurden. Sein späteres Werk umfasst unter anderem zahlreiche Aufnahmen von Georgia O'Keeffe und Ansichten New Yorks.

Die Fotografien von Alfred Stieglitz gehören zu den klassischen Beispielen der Fotogeschichte. Seine fotografische Handschrift veränderte sich vom weichzeichnerischen Piktorialismus in Richtung einer sozial engagierten, sachlichen Fotosprache, ohne je die ganz spezifische, individuelle Charakteristik zu verlieren. *The Steerage*, zu Deutsch *Das Zwischendeck*, wurde 1907 aufgenommen und erlangte nach der Publikation 1911 in *Camera Work* Weltruhm. Der Blick des Fotografen fällt aus dem Passagierdeck der ersten Klasse des Dampfers Kaiser Wilhelm II. auf der Überfahrt von New York nach Bremen in den Bereich zwischen zweiter und dritter Klasse. Ob es sich bei den Personen um nach Europa zurückkehrende Arbeiter und deren Familien oder abgewiesene Einwanderungswillige handelt, ist nicht festzustellen. Stieglitz' Interesse galt der Menschenmenge und ihrer Dynamik, aber auch den Unterschieden in der Erscheinung der Personen. Auch die Bildlichkeit des Ensembles mit der starken Diagonale des Reeps als Teilung der Komposition und den Akzenten durch weiße Partien vor schwarzem Grund und durch schwarze, silhouettierte Bildteile vor weißem Fond zeichnen die Fotografie aus. Sie ist eine Momentaufnahme, in der die malerischen Elemente des Piktorialismus mitschwingen, obwohl Thema und Stil schon auf die Kompositionen der Neuen Sachlichkeit vorausweisen.

Born in 1864 in Hoboken, New Jersey/USA, died in 1946 in New York/USA. At the age of 16, Alfred Stieglitz visited Europe and from 1881 to 1890 studied engineering and photography at the Technical College in Berlin. Pictorialism influenced his early works. In 1890 he returned to the USA where he became a partner in the Photochrome Engraving Company in New York. From 1892 to 1896 he worked at *The American Amateur Photographer* journal. In 1902 he was part of the founding fathers of the Photo-Secession in New York and opened his first gallery. He presented the influences of the European avant-garde on American art to the public. In addition to this, he also used his position as editor of *Camera Work* magazine to promote and establish photography as an art form. He and Edward Steichen founded Gallery 291, which existed from 1905 to 1917, and he met Georgia O'Keeffe, who became his companion, model and muse. From 1925 to 1929 Stieglitz ran the Intimate Gallery and from 1929 to 1946 An American Place, where mainly paintings, sculptures and graphic works were exhibited. His later work includes numerous photographs of Georgia O'Keeffe and views of New York.

The photographs of Alfred Stieglitz are classic examples of photographic history. His photographic style changed from the soft-focus effects of Pictorialism to a socially engaged, objective photographic language without ever losing the very specific individual characteristics. *The Steerage* was taken in 1907 and became world famous after its publication in *Camera Work* in 1911. The photographer's view looks down from the first-class passenger deck of the steamer Kaiser Wilhelm II on the crossing from New York to Bremen to the area between second and third class. It is not clear whether the photograph involves workers and their families returning to Europe or rejected immigrants. Stieglitz's interest was in crowds and their dynamics, and also in the differences in people's appearances. The photograph is characterized by the imagery of the ensemble with the strong diagonal aspects of the ropes acting as a division of the composition and the accents caused by the white sections against a black background and by the black, silhouetted sections of the picture against a white background. It is a snapshot in which the picturesque elements of Pictorialism resonate, although the theme and style already foreshadow the compositions of New Objectivity.

Literatur/Further reading: Sarah Greenough und/and Juan Hamilton, *Alfred Stieglitz: Photographs & Writings*, New York 1983

Alfred Stieglitz
The Steerage, 1907
Fotogravüre auf Japanpapier/
photogravure on Japanese tissue paper

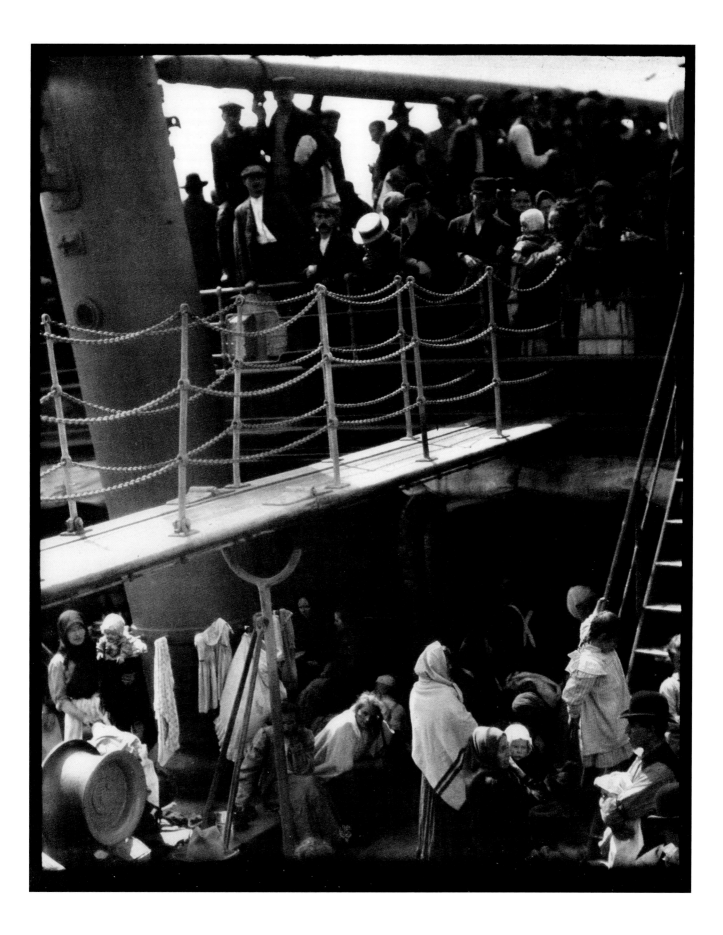

Paul Strand

Geboren 1890 in New York/USA, verstorben 1976 in Orgeval/Frankreich. Von 1904 bis 1909 studierte Paul Strand bei Lewis Hine an der Ethical Culture School in New York und war ab 1911 als freischaffender Künstler tätig. In seiner Frühphase, in den Jahren 1911 bis 1918, arbeitete er als Gebrauchsfotograf in der Tradition des Piktorialismus mit Weichzeichnerlinsen und experimentierte mit Gummidrucken und vergrößerten Negativen. 1916 traf er Alfred Stieglitz, der ihm seine erste Einzelausstellung in der Galerie 291 einrichtete. Ab 1921 war Strand in den USA und in Mexiko als Kameramann tätig. In den Jahren von 1917 bis 1929 galt sein fotografisches Interesse vermehrt der Natur, aber auch einer stilllebenhaften Sicht auf Maschinenteile, Felsen und Landschaftsformationen. Zahlreiche Reisen führten ihn in den 1930er- und 1940er-Jahren in unbekannte Gebiete der USA, nach Kanada, Mexiko und in die Sowjetunion. 1951 übersiedelte er nach Frankreich und erwarb 1955 ein Haus in Orgeval, in einem ländlichen Gebiet in der Nähe von Paris, wo er bis zu seinem Tod lebte.

Born in 1890 in New York/USA, died in 1976 in Orgeval/France. From 1904 to 1909 Paul Strand studied with Lewis Hine at the Ethical Culture School in New York and from 1911 he worked as a freelance artist. In his early phase, he worked from 1911 to 1918 as a commercial photographer in the tradition of Pictorialism with soft-focus lenses, and experimented with rubber printing and enlarged negatives. In 1916 he met Alfred Stieglitz, who arranged his first solo exhibition for him at Gallery 291. From 1921 Strand worked as a cameraman in the USA and Mexico. Although his photographic interest increasingly turned to nature from 1917 to 1929, he was also interested in a still-life-like view of machine parts, rocks and landscape formations. Numerous trips in the 1930s and 1940s took him to unknown areas of the USA, Canada, Mexico and the Soviet Union. In 1951 he moved to France and in 1955 he bought his house in Orgeval in a rural area near Paris, where he lived until his death.

Die ersten Aufnahmen, die Paul Strand während seiner Aufenthalte auf dem Land anfertigte, wie jene von Häusern und Gärten in Connecticut, zeigen sein Interesse für die Kombination von einfachen Landschaftsaufnahmen mit abstrahierenden Stilmitteln. Rasterformen, Schattenwürfe und musterartig gereihte Motive vor planen Flächen ergeben ein geometrisch organisiertes Ganzes, in dem Struktur und Komposition von besonderer Bedeutung sind. Dennoch fängt der Blick in die Anlage einer typischen Ostküstenvorstadt in sachlicher Bildsprache das Charakteristische dieses Ortes zwischen Wohnsiedlung und domestizierter Natur ein. Der weiße Zaun in Port Kent im Bundesstaat New York ist ein Beispiel für diese stille, subtile Fotografie von Paul Strand.

The first photographs Paul Strand produced during his visits to the countryside – like those of houses and gardens in Connecticut – show his interest in combining simple landscape shots with an abstract stylistic rhetoric. Grid shapes, shadows and pattern-like motifs against flat surfaces result in a geometrically organized whole in which structure and composition are of particular importance. Nevertheless, the view of the structure of a typical East Coast suburb with its objective imagery captures the characteristics of this place between urbanization and domesticated nature. White Fence, Port Kent, New York is an example of Paul Strand's silent, subtle photography.

Literatur/Further reading: Calvin Tomkins (Hrsg./ed.), *Paul Strand. Sixty Years of Photographs*, New York 1976

Paul Strand
White Fence, 1916
Fotogravüre/photogravure

Edward Weston

Geboren 1886 in Highland Park, Illinois/USA, verstorben 1958 in Carmel-by-the-Sea, Kalifornien/USA. Als 16-Jähriger bekam Edward Weston seine erste Kamera und schon 1903 wurden seine Bilder am Art Institute of Chicago ausgestellt. Seine fotografische Ausbildung erhielt er von 1907 bis 1911 am Illinois College of Photography. Von 1911 bis 1922 arbeitete Weston erfolgreich in seinem Fotostudio in Kalifornien, zuerst im piktorialistischen Stil, später tauschte er den Weichzeichner gegen eine scharf fokussierende Linse aus. Durch die Bekanntschaften mit Alfred Stieglitz und Paul Strand wurde ab 1922 sein stilistischer Wandel bestärkt und Weston wurde zum Verfechter der *straight photography* und des Realismus. 1923 übersiedelte Weston mit Tina Modotti und seinem Sohn nach Mexiko-Stadt, wo er bis 1926 ein Porträtstudio unterhielt. 1928 gründete er ein Atelier in Carmel-by-the-Sea, in dem er seinen Sohn zum Fotografen ausbildete. 1932 war er Mitbegründer der Gruppe f/64. Eine Retrospektive zeigte 1946 seine Arbeiten im Museum of Modern Art in New York. 1948 erkrankte Weston an Parkinson, was ihn zur Aufgabe seiner fotografischen Tätigkeit zwang.

Die Fotografin Margrethe Mather und Edward Weston trafen sich 1913 in Los Angeles und waren acht Jahre lang ein Paar. Die künstlerische Kooperation mit Gemeinschaftsarbeiten und inspirierendem Austausch dauerte bis etwa 1925 an. Mather war mehr als Muse und Modell für Weston: Sie eröffnete ihm neue Sichtweisen in der fotografischen Praxis und Theorie und vermittelte ihm ein modernes Gesellschaftsbild. In diesen Jahren befasste sich Weston mit den Bildmöglichkeiten und technischen Innovationen einer neuen Fotografie: Licht und Schatten, Hell-Dunkel-Kontraste, Nahsichtigkeit und Close-ups fanden Einzug in seine Bildsprache. Oft waren es allein die vom Licht gezeichneten Effekte, die er herausarbeitete, später dann die ganz engen Ausschnitte und der Blick auf Alltagsobjekte, ihre Beschaffenheit und ihre Oberfläche – so wurde aus einer einfachen Paprikaschote ein erstaunliches Kunstwerk oder aus einem Kohlblatt eine fein strukturierte »Skulptur«. Margrethe vor der Wand eines landwirtschaftlichen Gebäudes und der Schatten eines Baumes stehen als Bild für die ersten richtungsweisenden Schritte, Szenen oder Dinge in einer fotografisch-authentischen Weise wiederzugeben und die Poesie und Stringenz des Unscheinbaren vorzustellen.

Born in 1886 in Highland Park, Illinois/USA, died in 1958 in Carmel-by-the-Sea, California/USA. Edward Weston got his first camera as a 16-year-old and his pictures were already exhibited in 1903 at the Art Institute of Chicago. He received his photographic training at the Illinois College of Photography from 1907 to 1911. From 1911 to 1922 Weston successfully worked in his photo studio in California, first in the Pictorialist style, before he exchanged the soft-focus filter for a sharp-focusing lens. Through his acquaintance with Alfred Stieglitz and Paul Strand his stylistic change intensified in 1922 and Weston became an advocate of straight photography and realism. In 1923 Weston moved with Tina Modotti and his son to Mexico City, where he maintained a portrait studio until 1926. In 1928 he founded a studio in Carmel-by-the-Sea, where he trained his son as a photographer. In 1932 he co-founded the group f/64. A retrospective showed his work at the Museum of Modern Art in New York in 1946. In 1948 Weston began to suffer from Parkinson's disease, which forced him to give up his photographic activity.

The photographer Margrethe Mather and Edward Weston met in 1913 in Los Angeles, and they were a couple for eight years. Their artistic collaboration with joint work and an inspiring exchange lasted until about 1925. Mather was more than just a muse and model for Weston: she opened up new perspectives in photographic practice and theory to him and imparted a modern view of society to him. During these years, Weston focused on visual possibilities and technical innovations of a new photography: light and shadows, chiaroscuro contrasts and close-ups found their way into his visual language. Often it was only the effects shaped by light that he developed, and later the very narrow sections and views of everyday objects, their properties and their surfaces – thus a simple pepper became an amazing work of art and a cabbage leaf became a finely structured "sculpture". Margrethe in front of the wall of a barn with the shadow of a tree represent the first trend-setting steps to reproduce a picture of scenes and objects in a photographically authentic way and to present the poetry and stringency of the insignificant.

Edward Weston
Shadow on a Barn and Margrethe, 1920
Silbergelatineprint / silver gelatin print

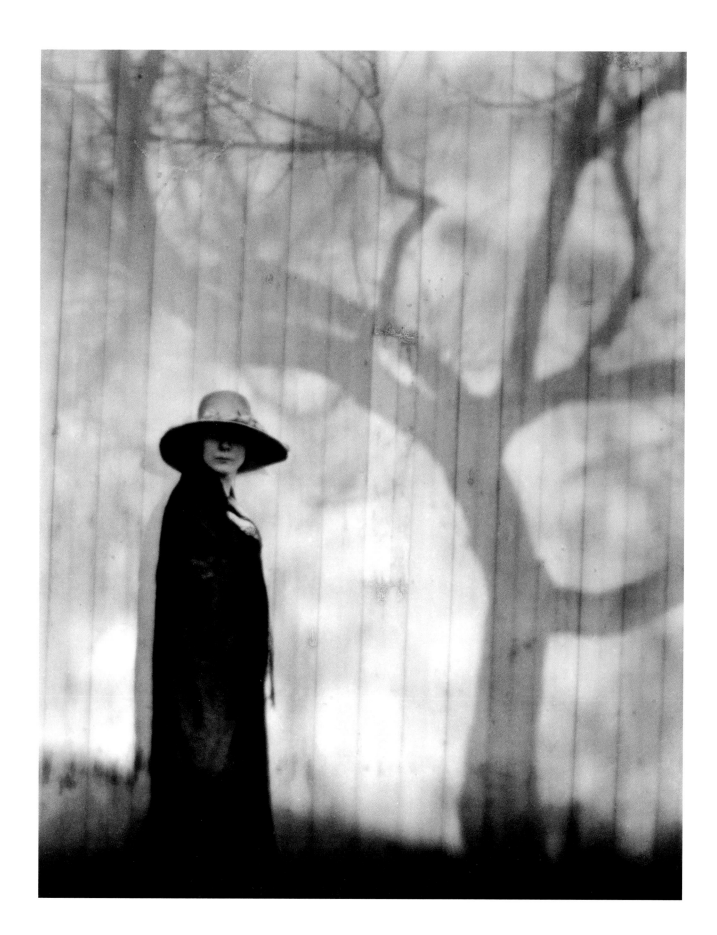

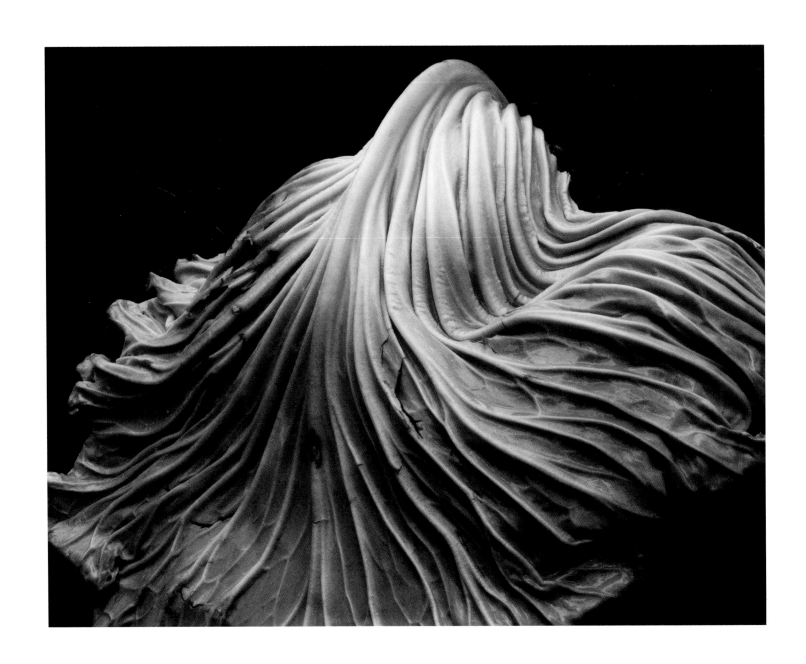

Schon während seines Mexiko-Aufenthaltes hatte sich Edward Weston mit dem Fotografieren von Gegenständen des Alltags und des Kunsthandwerks beschäftigt. Für ihn war es das ureigenste Potenzial der fotografischen Technik, Dinge unverfälscht und authentisch abbilden zu können. Dafür bediente er sich eines präzisen Aufnahmeverfahrens mit großer Schärfentiefe und nutzte die Möglichkeit, mittels Schwarz-Weiß-Druckpapieren harte Kontraste und genaue Details herauszuarbeiten.

Zwischen 1927 und den frühen 1930er-Jahren entstanden die Stilllebenfotografien, die zu Westons Hauptwerken gehören: Er isolierte eine Frucht, eine Pfefferschote, ein Kohlblatt, eine Muschel oder eine Wurzel und arbeitete mittels Licht und Schatten, mittels genauester Wiedergabe der Oberfläche und des Volumens die typischen Eigenschaften des Objektes heraus. Er verlieh seinen dinghaften Sujets damit eine skulpturale, dreidimensionale Präsenz jenseits von Maßstäblichkeit oder Funktion.

During his stay in Mexico, Edward Weston was already interested in taking photographs of everyday items and handicrafts. For him the ability to represent things genuinely and authentically was the inherent potential of photographic technology. He used a precise recording process for this, operating with a great depth of field and using black-and-white printing paper in order to achieve sharp contrasts and accurate details.

Between 1927 and the early 1930s, still-life photography formed Weston's major body of work: he isolated a piece of fruit, a chili pepper, a cabbage leaf, a shell or a root, and worked with light and shadow and with a highly accurate reproduction of the surface and volume to reveal the typical properties of the object. He gave his material subjects a sculptural, three-dimensional presence transcending scale or function.

Literatur/Further reading: Manfred Heiting (Hrsg./ed.), *Edward Weston. 1886–1958*, Köln/Cologne 1999

Edward Weston, *Cabbage Leaf,* 1931
Silbergelatineprint/silver gelatin print

Paul Outerbridge

Geboren 1896 in New York/USA, verstorben 1958 in Laguna Beach, Kalifornien/ USA. Outerbridge studierte ab 1915 Anatomie, Ästhetik und Zeichnung an der Art Students League in New York und begann 1921 ein Studium an der Clarence White School of Photography, ebenfalls in New York. Seit 1922 arbeitete Outerbridge in der Produkt- und Werbefotografie und veröffentlichte Fotos in Modezeitschriften wie *Vanity Fair* und *Harper's Bazaar*. Nach kurzer Zwischenstation 1925 in London lebte er in Paris, wo er Kontakte zu Man Ray, Marcel Duchamp, Pablo Picasso und Francis Picabia pflegte. 1929 kehrte er nach New York zurück und wurde einer der großen Pioniere der Farbfotografie. Er war hauptsächlich in den Bereichen Mode-, Reise- und Reportagefotografie tätig. Nach einer Kontroverse über seine erotischen Fotografien erfolgte 1943 der Umzug nach Hollywood und er begann eine freiberufliche Fotografentätigkeit. Ab 1954 arbeitete Outerbridge als freier Autor für das Magazin *U.S. Camera*.

Outerbridges Interesse galt vornehmlich den plastischen Formen von Gegenständen und der Objektqualität seiner Motive. Diese sachlich-distanzierte Sichtweise zeigte er schon in den frühen Produktfotos und den fotografischen Küchenstillleben mit unscheinbaren Dingen wie Milchflaschen oder Eiern und behielt sie auch später in seinen berühmten Aktaufnahmen bei. Es sind vor allem das nüchterne Schildern, das kühl kalkulierte Präsentieren der Bildinhalte und die effektvoll inszenierte Erscheinung, die seine Fotosprache ausmachen. Besonders die Eigenschaften von transparenten Materialien, von Licht und Schatten und schimmernden Oberflächen interessierten den Fotografen in den 1920er-Jahren.

Literatur/Futher reading: *Paul Outerbridge Jr. Photographien 1921–1939*, mit Texten von/with texts by Graham Howe und/and Jacqueline Markham, München/Munich 1981

Born in 1896 in New York City/USA, died in 1958 in Laguna Beach, California/ USA. From 1915 Outerbridge studied anatomy, aesthetics and drawing at the Art Students League in New York and in 1921 he began studying at the Clarence White School of Photography, also in New York. In 1922 Outerbridge started working in product and advertising photography and published photographs in fashion magazines such as *Vanity Fair* and *Harper's Bazaar*. After a short stopover in London in 1925, he lived in Paris, where he maintained contact with Man Ray, Marcel Duchamp, Pablo Picasso and Francis Picabia. He returned to New York in 1929 and became one of the great pioneers of colour photography. He was active mainly in the fields of fashion, travel and photojournalism. After a controversy over his erotic photographs, he moved to Hollywood in 1943 and began freelance photography work. From 1954 Outerbridge worked as a freelance writer for the magazine *U.S. Camera*.

Outerbridge's interest was primarily in the sculptural shapes of objects and the object-like quality of his subjects. He showed this objective and detached perspective in the early product photographs and his kitchen still-life photography with inconspicuous things like bottles of milk or eggs, and retained them in his famous nude photographs later on. His photographic language consists mainly of austere depictions, a cool and calculated presentation of image content and effectively staged appearances. In the 1920s, the photographer was particularly interested in the properties of transparent materials, in light and shadow and shimmering surfaces.

Paul Outerbridge
Inkwell and Stamp Holder, 1924
Platinprint/platinum print

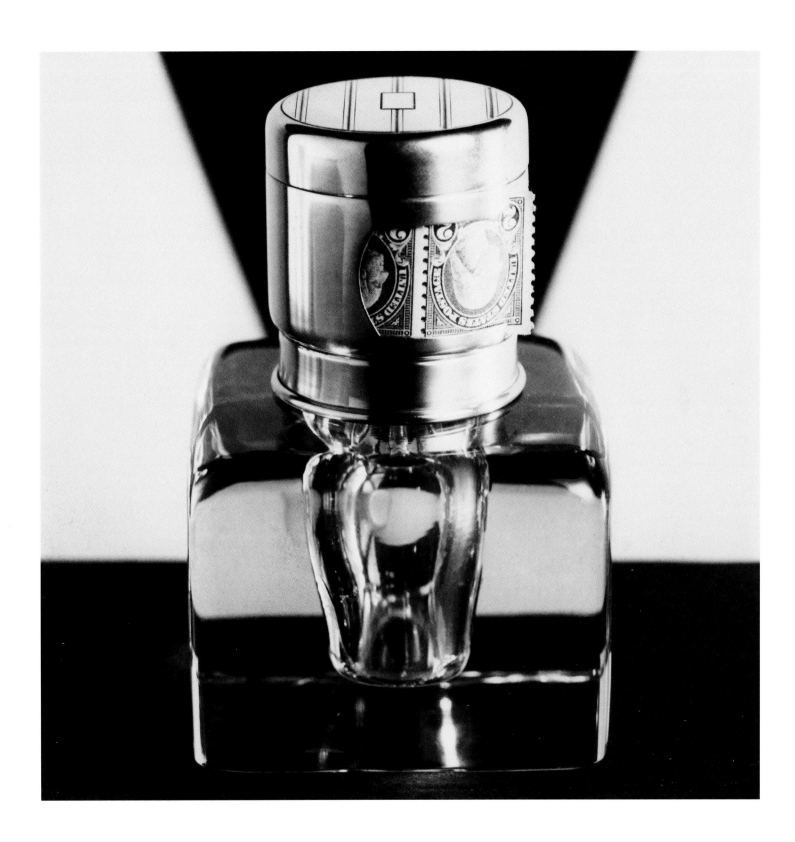

Beaumont Newhall

Geboren 1908 in Lynn, Massachusetts/USA, verstorben 1993 in Santa Fe, New Mexico/USA. Newhall studierte Kunstgeschichte an der Harvard University sowie in London und Paris. In den 1940er-Jahren diente er in der US-Marine und war in Europa stationiert. Er war wesentlich beteiligt an der Etablierung der Abteilung für Fotografie am Museum of Modern Art in New York, deren Leiter er von 1940 bis 1947 war, und setzte darüber hinaus mit seiner 1937 erstmals publizierten *Geschichte der Fotografie* Maßstäbe für die Rezeption von Fotografie als Kunstform und für deren wissenschaftliche Bearbeitung. Von 1948 bis 1958 legte er am George Eastman House in Rochester im Bundesstaat New York die Grundsteine für die damals umfangreichste Sammlung von Fotokunst und war dort bis 1971 als Direktor tätig. Erst nach seinem Rückzug aus dem musealen Bereich wurde seine eigene fotografische Tätigkeit entdeckt, die durch seine Begeisterung für die deutsche neusachliche Fotografie geprägt ist.

Born in 1908 in Lynn, Massachusetts/USA, died in 1993 in Santa Fe, New Mexico/USA. Newhall studied art history at Harvard University and in London and Paris. In the 1940s he served in the U.S. Navy and was stationed in Europe. He was the leading figure in establishing the Department of Photography at the Museum of Modern Art in New York, of which he was director from 1940 to 1947. With his *History of Photography*, first published in 1937, he set the standard for the reception of photography as an art form and for its scientific analysis. From 1948 to 1958 he laid the foundation at the George Eastman House in Rochester, New York for the most extensive collection of photo art of its time, and he worked there as its director until 1971. His own photographic work, which is marked by his enthusiasm for German New Objectivity photography, was discovered only after his retirement from working in the museum world.

Die Chase National Bank wurde 1877 gegründet; von 1926 bis 1928 wurde das neue, in einem klassizistisch-ruhigen Stil errichtete Gebäude im Financial District in New York realisiert. Ab den 1930er-Jahren wurde die Chase National Bank durch weitere Zukäufe und Inkorporierungen anderer Bankhäuser zur damals größten Bank der USA. In den 1950er-Jahren wurde sie Teil der Chase Manhattan Bank, welche wiederum seit 2000 Teil der JPMorgan Chase ist. Für Fotografen wie Beaumont Newhall waren es die geraden Linien, die klaren Flächen und geometrischen Aufteilungen im Bild, die den Blick vom Straßenniveau in die Höhe zum interessanten Motiv machten und dieses einer fein strukturierten Abstraktion annäherten.

The Chase National Bank was founded in 1877. The new building, designed in a calm classicist style, was constructed from 1926 to 1928 in the Financial District of New York City. From the 1930s, the Chase National Bank became the largest bank in the United States through further acquisitions and the incorporation of other banks. In the 1950s it became part of Chase Manhattan Bank, which in turn has been part of JPMorgan Chase since 2000. For photographers like Beaumont Newhall, the straight lines, clear surfaces and geometric divisions in the picture made the view from street level upward an interesting subject, causing it to resemble a finely structured abstraction.

Literatur/Further reading: *In Plain Sight. The Photographs of Beaumont Newhall*, mit einem Vorwort von/with a foreword by Ansel Adams, Salt Lake City 1983

Beaumont Newhall
The Chase National Bank, 1928
Silbergelatineprint/silver gelatin print

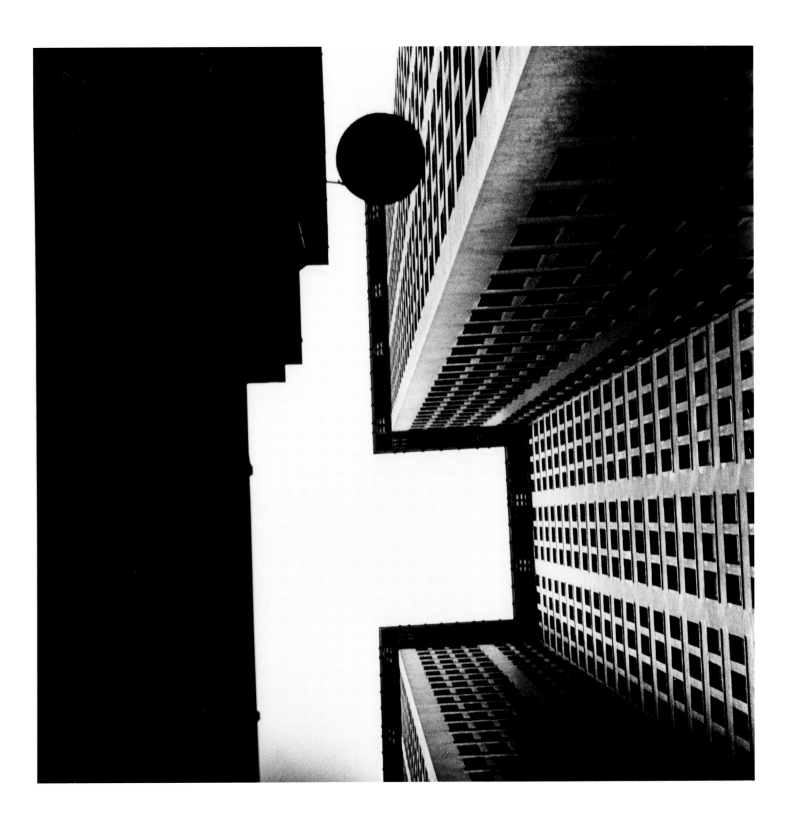

Weegee

Geboren 1899 als Usher Fellig in Solotschiw bei Lwiw (Lemberg)/heute Ukraine, seit 1910 mit bürgerlichem Namen Arthur Fellig, verstorben 1968 in New York/USA. Arthur Felligs Familie wanderte 1910 in die USA aus ließ sich in der New Yorker East Side nieder. Mit 14 Jahren verließ er die Schule, wurde Straßenfotograf und Assistent bei einem Fotohändler. Ab 1920 arbeitete er als Fotolaborant und Aushilfsreporter bei der Bildagentur Acme Newspictures und gelegentlich als Pressefotograf, meist bei nächtlichen Katastrophenfällen. 1935 begann er seine freie Fotografentätigkeit. Er hatte zehn Jahre lang eine Wohnung in dem Haus, in dem sich auch das Manhattan Police Headquater befand, und war durch das Abhören des Polizeifunks meist der Erste an Ort und Stelle bei Verkehrsunfällen, Brandkatastrophen, Verhaftungen und Gewaltdelikten, um mit den dabei entstandenen Fotos die Boulevardpresse zu bedienen. Mit seinem Pseudonym »Weegee« signierte er die Fotos. In der von ihm herausgebrachten Publikation *Naked City* kombinierte er seine Bilder von Verbrechen und Unfällen mit seinen Aufnahmen von Armen und Obdachlosen, etwa in Lower Manhattan, und wurde damit schlagartig berühmt. Mitte der 1940er-Jahre gab er die Reportagefotografie auf und arbeitete als Werbefotograf für verschiedene Magazine, als Berater für Filmprojekte und widmete sich in den *Distortions* speziellen Fotoverzerrungseffekten.

Born in 1899 as Usher Fellig in Zolochiv in Lviv (Lemberg)/present-day Ukraine, changed his name in 1910 to Arthur Fellig, died in 1968 in New York/USA. Arthur Fellig's family emigrated to the USA in 1910, settling on New York's East Side. At the age of 14 he left school and became a street photographer and assistant in a photography shop. From 1920 he worked as a photo lab technician and part-time reporter at the Acme Newspictures photo agency and occasionally as a press photographer, mostly for nocturnal disasters. In 1935 he began his freelance photography work. He lived for ten years in an apartment in the building that also housed the Manhattan Police headquarters and by listening to police radio was usually the first one at the scene of traffic accidents, fires, arrests and violent offences in order to take photographs for the tabloids to use. He signed the photographs with his pseudonym "Weegee". In the documentation he published called *Naked City*, he combined his images of crime and accidents with his photographs of the poor and homeless around Lower Manhattan, and he instantly became famous. In the mid-1940s he gave up photojournalism and worked as a commercial photographer for several magazines and as a consultant for film projects, and devoted himself to special photographic distortion effects in his *Distortions*.

Aus Weegees zweitem Buch, der 1946 erschienenen Publikation *Weegee's People* stammt die Textzeile »Buy a rose for your honey …«, die das Foto *The Flower Peddler* kommentiert, das Bild des Blumenverkäufers, der auf den Straßen rund um das alte Metropolitan Opernhaus am Broadway südlich des Times Square nach den Vorstellungen unterwegs war. Das Foto steht stellvertretend für die sozial orientierte Fotografie von Weegee, der mit Mitgefühl und Wehmut die Unglücklichen, die Ausgestoßenen der Gesellschaft und die Benachteiligten in einer an Profit orientierten und nach Ruhm gierenden Welt beobachtete. Mit seiner Speed Graphic Camera war Weegee Nacht für Nacht in den Straßen Manhattans auf Beutezug und auch die unscheinbaren Gefährten der Nacht, die ihren Geschäften und Tätigkeiten nachgingen, gehörten zum Panorama seiner Welt; sie hielt er in eindringlichen, durch das Blitzlicht charakterisierten Bildern fest.

It is in Weegee's second book, the 1946 publication *Weegee's People*, that the line "Buy a rose for your honey ..." originated. It refers to the photograph *The Flower Peddler*, which portrays a flower seller walking around the streets near the old Metropolitan Opera House on Broadway south of Times Square after the performances. The photograph is representative of the socially oriented photography of Weegee, who observed with sympathy and sadness the unfortunates and outcasts of society, along with the disadvantaged in a world that is profit-oriented and greedy for fame. With his Speed Graphic camera, Weegee was on the prowl night after night in the streets of Manhattan, pursuing the inconspicuous companions of the night as they went about their business and activities and became part of the panorama of the world he captured in vivid images characterized by the flash.

Literatur/Further reading: Weegee (Arthur Fellig), *Weegee's People*, New York 1975

Weegee
The Flower Peddler, um/ca. 1940
Silbergelatineprint/silver gelatin print

Margaret Bourke-White

Geboren 1904 in New York/USA, verstorben 1971 in Stamford, Connecticut/USA. Von 1922 bis 1927 studierte Margaret Bourke-White gleichzeitig Reptilienkunde und Fotografie in New York. 1927 zog sie nach Cleveland, Ohio, um, wo sie sich als Berufsfotografin mit einer eigenen Agentur der Industriefotografie widmete. 1930 reiste Bourke-White mit dem Auftrag in die Sowjetunion, Industrieanlagen aufzunehmen. 1935 war sie Gründungsmitglied des Magazins *Life*. In den Jahren 1941 und 1942 reiste sie als Kriegsberichterstatterin durch Nordafrika, Italien und Deutschland und fotografierte 1945 die Befreiung des Konzentrationslagers Buchenwald. 1946 dokumentierte sie den Befreiungskampf in Indien, 1949 entstanden Bilder zum Apartheit-Problem in Südafrika sowie zum Koreakrieg. Mitte der 1950er-Jahre erkrankte sie an Parkinson und konnte nur noch eingeschränkt arbeiten.

Born in 1904 in New York/USA, died in 1971 in Stamford, Connecticut/USA. From 1922 to 1927 Margaret Bourke-White simultaneously studied herpetology and photography in New York. In 1927 she moved to Cleveland, Ohio, where she devoted herself to industrial photography as a professional photographer in her own studio. In 1930 Bourke-White travelled to the Soviet Union with the assignment of taking photographs of industrial plants. In 1935 she was a founding member of *Life* magazine. In the years 1941 and 1942 she travelled as a war correspondent through North Africa, Italy and Germany, and in 1945 she photographed the liberation of the Buchenwald concentration camp. In 1946 she documented the liberation struggle in India; in 1949 she took photographs of the apartheid problems in South Africa, and of the Korean War. She developed Parkinson's disease in the mid-1950s and could then work only on a limited basis.

Die 1930er-Jahre in den USA waren geprägt durch die Große Depression. Fotografen wie Margaret Bourke-White bereisten im Sinne des »New Deal« der Regierung die weniger entwickelten Südstaaten und schufen ein Bilderkonvolut vor allem des Landlebens in der »Dust Bowl«, dem auch die Fotografie *Southern Revival* zuzuordnen ist. Neben den Sozialreformen der Roosevelt-Ära bestimmte die Zeit nach der großen Wirtschaftskrise vor allem das Aufleben religiöser Strömungen, die sich besonders in den ländlichen Gegenden durch Erweckungsgottesdienste, Bibelstudium und Gesangsveranstaltungen auszeichneten.

The Great Depression shaped the United States in the 1930s. Photographers such as Margaret Bourke-White travelled to less developed southern states as part of the government's New Deal programme and created a photographic portfolio of rural life in the "Dust Bowl", where the photograph *Southern Revival* is thought to have been taken. In addition to the social reforms of the Roosevelt era, the period after the Great Depression was marked by the resurgence of religious movements, particularly characterized by revival meetings, Bible studies and singing events in rural areas.

Literatur/Further reading: Oliva Mariá Rubio (Hrsg./ed.), *Margaret Bourke-White. Moments in History* (Ausst.-Kat./exh. cat. La Fábrica, Madrid, Martin-Gropius-Bau, Berlin, u.a./and others), Madrid 2013

Margaret Bourke-White
Southern Revival, 1937, Print 1975
Silbergelatineprint, getont/silver gelatin print, toned

Walker Evans

Geboren 1903 in St. Louis, Missouri/USA, verstorben 1975 in New Haven, Connecticut/USA. 1926 begann Walker Evans ein Literaturstudium an der Sorbonne in Paris. Von 1927 bis 1929 arbeitete er bei einem Börsenmakler in New York. Als Autodidakt machte er 1928 seine ersten Architekturfotos und dokumentierte in den 1930er-Jahren als »Chronist der Depressionszeit« das Amerika der Weltwirtschaftskrise. Seine sozialkritischen Aufnahmen der einfachen, unterprivilegierten amerikanischen Bevölkerung übten nachhaltigen Einfluss auf die Nachkriegsfotografie aus. 1933 veröffentlichte Evans nach einem Kuba-Aufenthalt den Fotoband *Crime of Cuba*. Ab 1935 war er freiberuflich tätig, unter anderem für das Projekt der Farm Security Administration (FSA), für das er vor allem in den Südstaaten unterwegs war. Ein im Bundesstaat Alabama entstandenes Fotokonvolut über drei Farmerfamilien erschien 1941 unter dem Titel *Let Us Now Praise Famous Men*. Von 1943 bis 1945 arbeitete Evans als Fotojournalist beim *Time Magazine* und von 1945 bis 1965 bei *Fortune*. Von 1965 bis 1974 unterrichtete er als Professor an der Yale School of Art and Architecture in New Haven, Connecticut.

Born in 1903 in St. Louis, Missouri/USA, died in 1975 in New Haven, Connecticut/USA. In 1926 Walker Evans began studying literature at the Sorbonne in Paris. From 1927 to 1929 he worked with a stockbroker in New York. Self-taught, he took his first architectural photographs in 1928 and in the 1930s documented the America of the world economic crisis as a "chronicler of the Great Depression". His socio-critical images of the simple, underprivileged American population exerted an enduring influence on post-war photography. After a stay in Cuba in 1933, Evans published a photo book called *The Crime of Cuba*. From 1935 he worked as a freelancer, including a project for the Farm Security Administration (FSA) for which he travelled in the southern states in particular. A volume of photographs that originated in the state of Alabama about three farmer families was published in 1941 under the title *Let Us Now Praise Famous Men*. From 1943 to 1945 Evans worked as a photojournalist for *TIME Magazine*, and from 1945 to 1965 for *Fortune*. From 1965 to 1974 he taught as a professor at the Yale School of Art and Architecture in New Haven, Connecticut.

Im Kontext des FSA-Projektes entstanden auch zahlreiche Aufnahmen von Plakaten, Anschlagtafeln, Reklameschildern und Ladenbeschriftungen aus dem provinziellen Amerika, die Evans' Interesse an der Idee des »Bilds im Bild« belegen. In seiner realistisch dokumentierenden Handschrift lassen sich immer eine symmetrisch ausgewogene Komposition und ein Sinn für das Unwillkürliche finden, wie hier auf dem Ladenschild einer Reinigung: Die fast surreale Positionierung des gemalten Sakkos in der angedeuteten Landschaft spielt mit der Lesbarkeit von Bild-Botschaften. Es ist das rationale (technische) Mittel der Kamera, das durch den Medientransfer von Malerei in Fotografie die Naivität und das bemüht Illusionistische dieses Reklameschilds entlarvt.

In the context of the FSA project, Evans also took numerous photographs of posters, billboards, advertising signs and shop signs from provincial America, demonstrating his interest in the idea of the "picture in a picture". In his realistic documentary style, there was always a symmetrically balanced composition and a sense of the unintended, as seen here on the shop sign of a dry cleaner's: the almost surreal positioning of the painted jacket in the suggested landscape plays with the readability of pictorial messages. It is the rational (technical) medium of the camera that exposes in the transferal from painting to photography the naivety and the attempt at illusionism of this advertising sign.

Literatur/Further reading: Michael Brix und/and Birgit Mayer (Hrsg./eds.), *Walker Evans. Amerika. Bilder aus den Jahren der Depression*, München/Munich 1990

Walker Evans
Outdoor Advertising Sign (Dry Cleaning)
near Baton Rouge, Louisiana, 1936
Print 1971, Silbergelatineprint/silver gelatin print

Elliott Erwitt

Geboren 1928 in Paris/Frankreich, lebt in New York/USA. Erwitt wuchs als Sohn jüdischer Einwanderer in Mailand und Paris auf und emigrierte 1939 in die USA. Nach seinem Studium am Los Angeles City College arbeitete er von 1947 bis 1948 als Fotolaborant in Los Angeles. 1948 übersiedelte er nach New York und begegnete dort Edward Steichen und Robert Capa. Von 1948 bis 1950 studierte Erwitt Film an der New York School for Social Research. Zunächst war er bei der Standard Oil Company in New York und Pittsburgh beschäftigt. 1953 begann er für die Fotoagentur Magnum zu arbeiten, deren Präsident er von 1966 bis 1969 war. Ab 1953 fotografierte er auch als freier Mitarbeiter für Zeitschriften wie *Life, Look* und *Holiday* und war in der Werbung tätig. 1959 entstand seine psychologisch sensible Fotoreportage *kitchen debate* über das Zusammentreffen von Chruschtschow und Nixon in Moskau. Ab 1970 drehte er mehrere Filme und war von 1974 bis 1980 Vizepräsident von Magnum.

Erwitt war höchst erfolgreich als Fotograf für Werbung und Reportagen sowie als Regisseur von Dokumentationen und Fernsehfilmen. Er blieb dabei stets ein Beobachter der subtilen Ironie von Begegnungen, wie etwa denen zwischen Mensch und Hund, zwischen Museumsbesuchern und Exponaten, zwischen Passanten und Flaneuren auf der Straße oder am Strand. Seine besondere Liebe gilt Hunden, die er oft in ihrem Zusammensein mit Menschen zeigt, aber auch anderen Tieren, an denen ihn das Ungekünstelte und Autonome der Kreatur interessiert. Im Aufeinandertreffen von Männern, die einen Lkw zu reparieren versuchen, und einem isoliert stehenden Pferd öffnet sich ein Raum zwischen den Zeiten: Das für den Fortschritt stehende Auto und das betriebsame Werken der Arbeiter werden durch das stoische Tier ironisch konterkariert.

Literatur/Further reading: *EE 60/60. Fotografías de Elliott Erwitt* (Ausst.-Kat./ exh. cat. Museo Nacional Centro de Arte Reina Sofía, Madrid), Madrid 2002

Born in 1928 in Paris/France, lives in New York/USA. The son of Jewish immigrants, Erwitt grew up in Milan and Paris, and immigrated to the USA in 1939. After his studies at Los Angeles City College, he worked from 1947 to 1948 as a photo lab technician in Los Angeles. In 1948 he moved to New York and met Edward Steichen and Robert Capa. From 1948 to 1950 Erwitt studied film at the New York School for Social Research. The Standard Oil Company first employed him in New York and Pittsburgh. In 1953 he started working for the Magnum photo agency, of which he was president from 1966 to 1969. He also worked as a freelance photographer for magazines such as *Life, Look* and *Holiday* in 1953, and worked in advertising. In 1959 he created the psychologically sensitive photo essay *kitchen debate* about the meeting of Khrushchev and Nixon in Moscow. After 1970 he made several films and was vice president of Magnum from 1974 to 1980.

Erwitt was highly successful as a photographer for advertising and reporting, as well as a director of documentaries and television movies. He has always remained an observer of the subtle irony of encounters, such as those between man and dog, between visitors and museum exhibits, between passersby and strollers on the street or on the beach. He is especially fond of dogs, which he often depicts together with people, but also shows his interest in the unaffectedness and autonomy of creatures with other animals. In the encounter of men who try to repair a truck and an isolated standing horse, a space opens between the times: the car stands for progress and the bustling effort of the workers is contradicted by the stoic animal.

Elliott Erwitt
Brasilia, 1961
Silbergelatineprint/silver gelatin print

Lee Friedlander

Geboren 1934 in Aberdeen, Washington/USA, lebt in New York/USA. Von 1953 bis 1955 studierte Lee Friedlander Fotografie an der Art Center School in Los Angeles und übersiedelte nach New York, wo er sich als kritischer Chronist mit *street photography* einen Namen machte und zusammen mit Diane Arbus und Garry Winogrand ausstellte. In den 1950er-Jahren entstanden Musikerporträts, etwa von Ray Charles und Duke Ellington. Ende der 1970er-Jahre arbeitete er an Reportagen zu vergessenen Denkmälern der amerikanischen Geschichte, beschäftigte sich mit Akt- und Landschaftsfotografie und mit sozialkritischen Dokumentationen zur Arbeitslosigkeit. Friedlander unterrichtete unter anderem an der University of Minnesota.

Der Kreuzungspunkt von urbanem Gefüge und menschlichem Leben ist oft eine problematische Nahtstelle – und genau darauf richtet Friedlander sein Augenmerk, indem er banale, alltägliche Situationen in ihrer Charakteristik und Virulenz erfasst. Seine »social landscapes« zeichnen ein Bild der amerikanischen Gesellschaft zwischen Trostlosigkeit und Nationalstolz, zwischen unwillkürlicher Ironie und achselzuckender Sachlichkeit. Er akzentuiert die Perspektive und die Zusammenschau durch gerade Linien, starke Schlagschatten und punktuell gesetzte Kontraste.

Literatur / Further reading: *Lee Friedlander* (Ausst.-Kat. / exh. cat. IVAM Centre Julio González, Valencia), Valencia 1992

Born in 1934 in Aberdeen, Washington/USA, lives in New York/USA. From 1953 to 1955 Lee Friedlander studied photography at the Art Center School in Los Angeles and then moved to New York, where he became known as a critical chronicler with his street photography, and exhibited together with Diane Arbus and Garry Winogrand. In the 1950s he created portraits of musicians such as Ray Charles and Duke Ellington. At the end of the 1970s he worked on reports on the forgotten monuments of American history and was preoccupied with nude and landscape photography and with socio-critical documentaries on unemployment. Friedlander taught at the University of Minnesota, amongst others.

The intersection of urban structures and human life is often a problematic interface – and this is precisely where Friedlander directed his attention by capturing mundane, everyday situations and their characteristics and virulence. His "social landscapes" paint a picture of American society between despair and national pride, between spontaneous irony and shrugging practicality. He accentuates the perspective and overall view with straight lines, strong hard shadows and selectively set contrasts.

Lee Friedlander
Albuquerque. New Mexico, 1972
Silbergelatineprint / silver gelatin print

Diane Arbus

Geboren 1923 als Diane Nemerov in New York/USA, verstorben 1971 in New York. Diane Arbus begann in den frühen 1940er-Jahren, sich mit Fotografie zu beschäftigen, und verfolgte, auch während sie mit ihrem Ehemann Allan Arbus im Bereich Modefotografie zusammenarbeitete, eine eigenständige Karriere als Fotografin. Im Jahr 1956 nahm sie an einem Workshop bei Lisette Model teil, beendete die Zusammenarbeit mit ihrem Ehemann und widmete sich ernsthaft jenen fotografischen Projekten, für die sie letztlich bekannt wurde. Sie konnte erste Fotografien 1960 unter dem Titel *The Vertical Journey* im Magazin *Esquire* veröffentlichen. Während des nächsten Jahrzehnts arbeitete Arbus für *Esquire*, *Harper's Bazaar* und andere Zeitschriften und veröffentlichte dabei mehr als hundert Fotos, darunter Porträts und fotografische Aufsätze, die teilweise aus ihren persönlichen Projekten hervorgingen und die oftmals von ihren eigenen Kommentaren begleitet wurden. In den Jahren 1963 und 1966 wurden Arbus Guggenheim-Stipendien für ihr Projekt *American Rites, Manners und Customs* verliehen. 1967 war sie unter den nur drei Fotografen, die an der bahnbrechenden Ausstellung *New Documents* im Museum of Modern Art teilnahmen. 1970 stellte sie das Portfolio *A box of ten photographs* zusammen, eine in limitierter Auflage erscheinende, einzeln gefertigte, signierte und von ihr selbst kommentierte Edition von zehn Fotografien. Zwei Jahre später, nach ihrem Freitod im Jahr 1971, wurden diese zehn Fotografien für eine Einzelausstellung auf der Biennale in Venedig ausgewählt, was Arbus zur ersten amerikanischen Fotografin machte, der diese Ehre zuteilwurde.

Born in 1923 as Diane Nemerov in New York/USA, died in 1971 in New York. Diane Arbus first began taking pictures in the early 1940s and, while working in partnership with her husband Allan Arbus in their fashion photography business, continued to take pictures on her own. In 1956, she enrolled in Lisette Model's photographic workshop, ended her collaboration with her husband, and began seriously pursuing the work for which she has come to be known. Her first published photographs appeared in *Esquire* in 1960 under the title *The Vertical Journey*. During the next decade, working for *Esquire*, *Harper's Bazaar* and other magazines, she published more than a hundred pictures, including portraits and photographic essays, some of which originated as personal projects, occasionally accompanied by her own writing. Arbus was awarded Guggenheim Fellowships in 1963 and 1966 for her project *American Rites, Manners and Customs*, and was one of only three photographers featured in the Museum of Modern Art's ground-breaking 1967 show *New Documents*. In 1970 she made a limited-edition portfolio entitled *A box of ten photographs*, individually printed, signed and annotated by her. Two years later, following her death by suicide in 1971, those ten photographs were selected for a solo show at the Venice Biennale, making Arbus the first American photographer ever to be so honoured.

Die Fotografien, die Diane Arbus für das Portfolio auswählte, stammen aus den Jahren 1963 bis 1970. Sie zeigen viele der Protagonisten (Paare, Kinder, Nudisten, Schausteller, Mittelstandsfamilien, Transvestiten, religiöse Fanatiker und Exzentriker) und der Themen (das Verhältnis zwischen Erscheinungsbild und Identität, Illusion und Glaube, Theater und Realität), die sie während ihres gesamten fotografischen Schaffens faszinierten. Das Porträt der eineiigen Zwillinge Cathleen und Colleen, das auf einer Weihnachtsparty für Zwillinge in Roselle, New Jersey, entstand, gehört zu den Ikonen im Medium der Fotografie. Je genauer man die Details studiert, die die Mädchen vermeintlich gleich erscheinen lassen, desto mehr verwirrende Unterschiede entdeckt man, die jedes von ihnen einzigartig machen.

The images Arbus chose for her portfolio span the years between 1963 and 1970. They include many of the subjects (couples, children, nudists, carnival performers, middle-class families, transvestites, zealots and eccentrics) and many of the themes (the relationship between appearance and identity, illusion and belief, theatre and reality) that fascinated her throughout her photographic career. The portrait of identical twins Cathleen and Colleen, taken at a twins Christmas party Arbus attended in Roselle, New Jersey, may be one of the most iconic images the medium has ever produced. The more one studies the details that seem to make these two girls similar, the more one encounters the confounding differences that ultimately make each of them unique.

Literatur/Further reading: *Diane Arbus. Revelations*, mit Beiträgen von/with texts by Sandra S. Phillips, Doon Arbus u.a./and others, München/Munich 2003

Diane Arbus
Identical Twins, Roselle, N.J. 1967, Print 1970
Silbergelatineprint/silver gelatin print

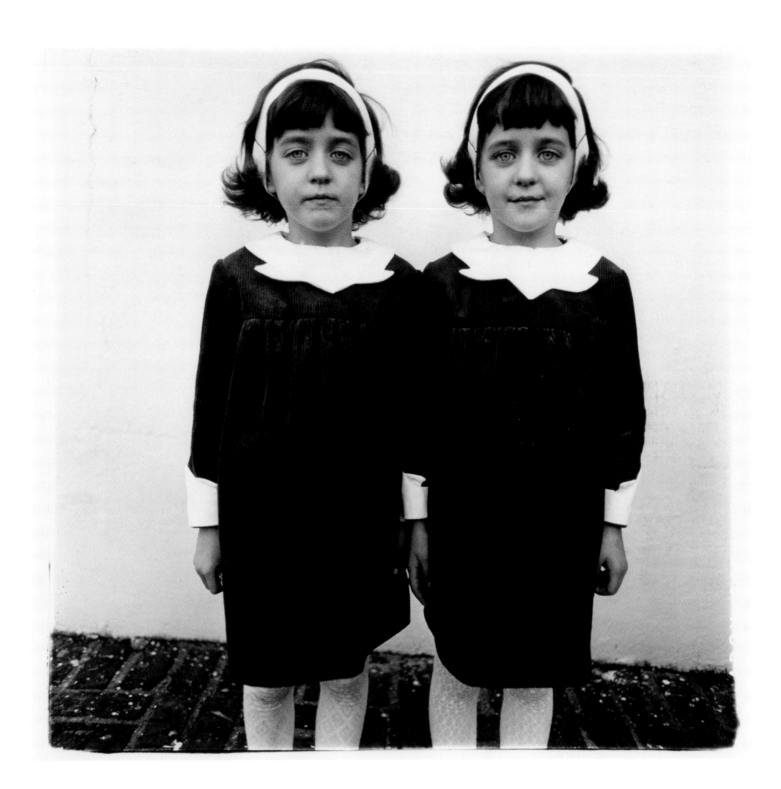

Judy Dater

Geboren 1941 als Judy Rose Lichtenfeld in Los Angeles, Kalifornien/USA, lebt in Berkeley, Kalifornien/USA. Von 1959 bis 1962 studierte Judy Dater an der UCLA in Los Angeles Kunst, von 1962 bis 1966 Fotografie an der San Francisco State University. 1964 traf sie Imogen Cunningham, von der sie wesentlich inspiriert wurde. Ab 1967 arbeitete sie als freie Fotografin sowohl im Bereich der klassischen Porträtfotografie als auch mit weiblicher und männlicher Aktfotografie. Von 1974 bis 1978 lehrte Dater am San Francisco Art Institut. Auf einer Ägyptenreise in den Jahren 1979 und 1980 entstanden Serien von Farbfotografien. Von 1980 bis 1984 widmete sich Dater einer Reihe von Selbstporträts. Von 1987 bis 1990 war sie als Dozentin am International Center of Photography in New York tätig. Von 1998 bis 2006 schuf sie in Rom Porträtaufnahmen von Italienern und fertigte eine umfangreiche Werkgruppe mit Porträts von Menschen in Kalifornien an. Bei ihrem aktuellsten Projekt handelt es sich um eine fotografische Denkschrift.

Born in 1941 as Judy Rose Lichtenfeld in Los Angeles, California/USA, lives in Berkeley, California/USA. From 1959 to 1962 Judy Dater studied art at UCLA in Los Angeles, and from 1962 to 1966 she studied photography at San Francisco State University. In 1964 she met Imogen Cunningham, who was a great inspiration to her. From 1967 she worked as a freelance photographer, with both traditional portraiture and the female and male nude. From 1974 to 1978 Dater taught at the San Francisco Art Institute. She created a series of colour photographs on a trip to Egypt in 1979 and 1980. From 1980 to 1984 Dater devoted herself to a series of self-portraits. From 1987 to 1990 she worked as a lecturer at the International Center of Photography in New York. From 1998 to 2006 she made portraits of Italians in Rome and an extensive group of portraits of Californians. Her most current project is a photo-based memoir.

Für Judy Dater war die Fotografie immer auch eine Möglichkeit, Menschen in ihrer intimen Umgebung und ihrem gesellschaftlichen Kontext zu sehen. Daraus entstand auch ihr Einsatz für feministische und emanzipatorische Anliegen, die besonders in den USA der 1970er-Jahre mit sehr persönlichen und individuellen Statements unterstützt wurden. Die Frauen, die Dater für ihr Portfolio aussuchte, strahlen trotz ihrer Verschiedenheit das Selbstbewusstsein moderner, selbstbestimmter Persönlichkeiten aus. Joyce Goldstein präsentiert sich in ihrer Küche, an ihrem Lieblingsort, und somit in einem Ambiente, das unpathetisch, aber bestimmt ihre Identität unterstreicht. Bezeichnenderweise wurde Joyce Goldstein später zu einer der berühmtesten Persönlichkeiten in einer elaborierten Gastronomieszene in den USA, führte ein eigenes Gourmetrestaurant in San Francisco und veröffentlichte zahlreiche auflagenstarke Kochbücher.

For Judy Dater, photography was always a chance to see people in their intimate environments and their social contexts. Out of this grew her commitment to feminist and emancipatory concerns, which were supported especially in the United States in the 1970s. Despite their diversity, the women whom Dater chose for her portfolios radiate the self-awareness of modern self-determined individuals. Joyce Goldstein presents herself in her kitchen, her favourite place, and thus in an atmosphere that unemotionally but specifically highlights her identity. Tellingly, Joyce Goldstein later became one of the most famous personalities in an elaborate gastronomic scene in the United States, running a gourmet restaurant in San Francisco and publishing numerous successful cookbooks.

Literatur/Further reading: Judy Dater, *Cycles*, Pasadena 1994

Judy Dater
Joyce Goldstein in Her Kitchen, 1969
aus dem Portfolio/from the portfolio *Ten Photographs*, 1974
Silbergelatineprint/silver gelatin print

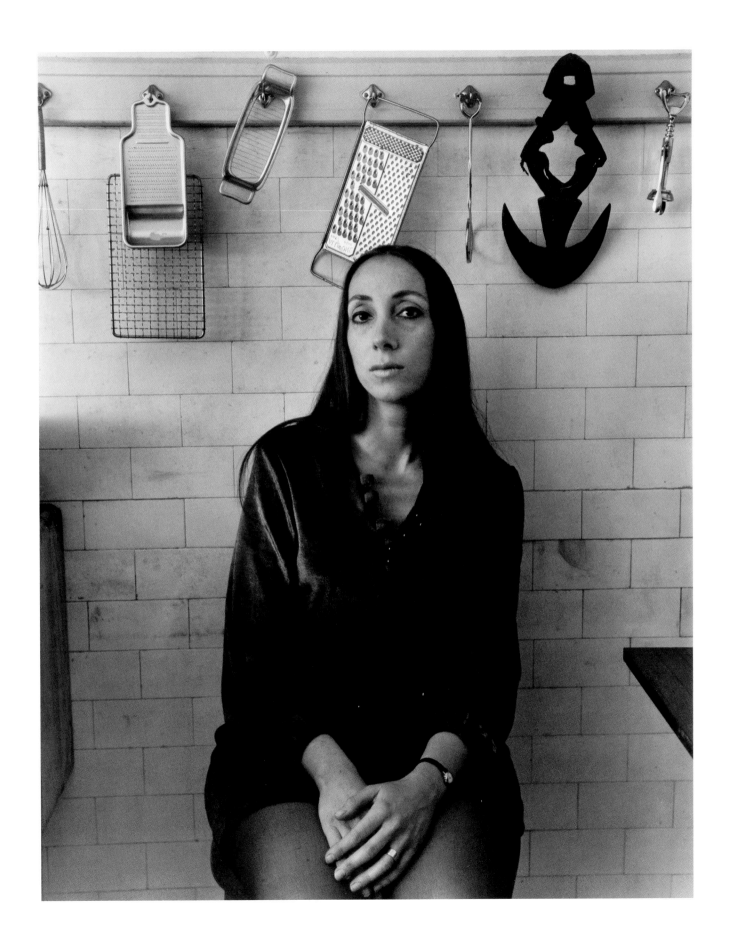

Duane Michals

Geboren 1932 in McKeesport, Pennsylvania/USA, lebt in New York/USA. Im Jahr 1953 erwarb Michals an der University of Denver den Abschluss Bachelor of Arts. 1956 begann er ein Grafikdesign-Studium an der Parsons School of Design in New York, schloss es jedoch nicht ab. Auf einer Reise durch die Sowjetunion entdeckte er die Fotografie für sich und fertigte erste Fotosequenzen an. 1968 beauftragte ihn die mexikanische Regierung, die Olympischen Sommerspiele in Mexiko-Stadt zu fotografieren. Das Museum of Modern Art in New York zeigte 1970 seine Werke erstmals in einer Einzelausstellung. Im Jahr 1976 erhielt Michals ein Stipendium des National Endowment for the Arts. Die Porträts, die zwischen 1958 und 1988 entstanden, bilden die Basis für sein Buch *Album*.

Duane Michals veränderte das fotografische Arbeiten grundlegend, indem er ohne Fotoatelier arbeitete: Er porträtierte Menschen nicht, sondern fotografierte auf der Straße, erzählte Geschichten mit Fotosequenzen und stellte handschriftliche Texte zu seinen oder sogar in seine Fotografien. In seinen mehrteiligen Fotoserien treffen sich konzeptuelle Ansätze und surreale Bildfindungen, die oft ins Literarische hineinspielen. Die Überlagerung von Realitätsebenen, in denen Bilder wieder als Motive für neue Bilder fungieren, ermöglicht eine absurde Kombination verschiedener Größenmaßstäbe in einer Komposition. Der schwer deduzierbare Wahrheitsgehalt rückt die Geschichte über die »seltsamen Dinge« in den Bereich des Traumhaften, Irrealen und logisch Unfassbaren.

Literatur/Further reading: Ann und/and Jürgen Wilde (Hrsg./eds.), *Chance Meeting. Photographs by Duane Michals*, Köln/Cologne 1973

Born in 1932 in McKeesport, Pennsylvania/USA, lives in New York/USA. In 1953 Michals received his Bachelor of Arts degree from the University of Denver. In 1956 he began to study graphic design at Parsons School of Design in New York, but did not complete the programme. He discovered photography on a trip through the Soviet Union and made his first photo series. In 1968 the Mexican government commissioned him to photograph the Summer Olympic Games in Mexico City. The Museum of Modern Art in New York showed his works for the first time in a solo exhibition in 1970. In 1976 Michals received a grant from the National Endowment for the Arts. The portraits created between 1958 and 1988 form the basis for his book *Album*.

Duane Michals fundamentally changed photographic work by working without a photo studio: he did not take portrait photographs, but photographed people in the street. Stories are told with photo sequences and handwritten texts are found on or even in his photographs. In his multi-part photo series, he combines the conceptual approaches and surreal imagery that so often grows into literary connotation. The superimposing of layers of reality, in which images again act as subjects for new images, enable an absurd combination of different-sized scales in a composition. The hard-to-deduce truth shifts the story about "queer things" to the realm of the dreamlike, unreal and logically incomprehensible.

Duane Michals
Things are Queer, 1973
9 Silbergelatineprints/9 silver gelatin prints

Les Krims

Geboren 1943 als Leslie Robert Krims in New York/USA, lebt in New York. 1960 begann Krims, Kunst an der Cooper Union School of Art and Architecture sowie am Pratt Institute in New York zu studieren. 1966 und 1967 war er Lehrer für Fotografie am Pratt Institute. Von 1969 an lehrte er vierzig Jahre lang als Professor für bildende Künste an der State University of New York in Buffalo. Seit 1967 arbeitet Krims als freischaffender Künstler. Seit den 1970er-Jahren widmet er sich konzeptuellen Fotoserien, etwa der Polaroid-Serie der *Fictcryptokrimsographs* über sexuelle Fantasien. Seine frühen kleinformatigen Schwarz-Weiß-Serien zeichnen sich durch Sarkasmus und Ironie aus. Ab den 1980er-Jahren bediente er sich eines größeren Formats und verstärkte den appellativen, aggressiven Charakter seiner Bilder. Krims ist ein Provokateur, der die typisch amerikanische Lebenskultur bloßstellt und kritisch kommentiert. Seine Arbeiten zeichnen sich zum Teil durch einen dunklen Humor und eine verstörende Destruktivität aus.

Born in 1943 as Leslie Robert Krims in New York City/USA, lives in New York. In 1960 Krims began to study art at the Cooper Union School of Art and Architecture and at the Pratt Institute in New York. In 1966 and 1967 he was a teacher of photography at the Pratt Institute. Starting in 1969, he taught for forty years as a professor of fine arts at the State University of New York at Buffalo. Krims has worked, since 1967, as a freelance artist. Since the 1970s, he has devoted himself to conceptual photo series such as the Polaroid series of *Fictcryptokrimsographs* about sexual fantasies. Sarcasm and irony characterize his early small-format black-and-white series. Starting in the 1980s he used a larger format and put a focus on the appellative, aggressive character of his images. Krims is a provocateur who exposes and critically comments on the typical American lifestyle. A dark humour and a disturbing destructiveness also characterize some of his works.

Seine komplizierten, formal und inhaltlich verschränkten Bildkompositionen nennt Les Krims *fictions* – sie sind also »Geschichten«, erfundene Erzählungen und zugleich Bildkonstrukte, die das Fabulieren zum Motiv machen. Mit der Fotografie *Human Being as a Piece of Sculpture* spielt er auf die Präsenz des »menschlichen Wesens als skulpturales Werk« an, aber ebenso auf Hybridformen fantastischen Ursprungs, in denen Skulpturen unwillkürlich ein eigenes, erschreckendes Leben besitzen. Seine Fotobilder kommentieren gleichsam als bittere Satiren den »American Way of Life« und den bourgeoisen Hang zu Idylle und Harmonie. Die verstörenden Bilder scheinen surrealen Filmen entsprungen zu sein, sie wirken wie Science-Fiction-Szenen im heimischen Wohnzimmer.

Les Krims calls his complicated, formally and contextually entangled compositions "fictions" – they are thus stories, fictional narratives and simultaneous image constructs that make inventing stories the guiding motif. With the photograph *Human Being as a Piece of Sculpture*, he alludes to the presence of a human being as a sculptural work, but also to hybrid forms of fantastic origin, in which sculptures involuntarily show their own terrifying lifelikeness. To a certain degree his photographic images provide commentaries as bitter satires of the American Way of Life and the bourgeois penchant for idyll and harmony. The disturbing images appear to come from surreal films and look like science fiction scenes set in a living room.

Literatur/Further reading: Robert Delpire (Hrsg./ed.), *Les Krims*, Arles 2005

Les Krims
Human Being as a Piece of Sculpture, 1970
Bromsilberprint, getont/bromine silver print, toned

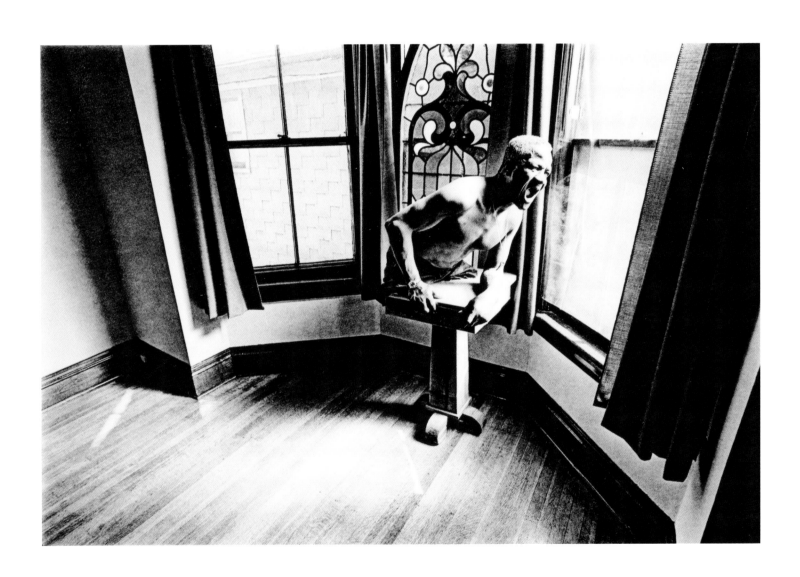

Ron Stark

Geboren 1944 in Denver, Colorado/USA, verstorben 2013 in Santa Fe, New Mexico/USA. Als Maler und Fotograf entfaltete Ron Stark schon ab dem Alter von zwanzig Jahren eine intensive Ausstellungstätigkeit, unter anderem mit einer Einzelausstellung 1972 in der Corcoran Gallery of Art in Washington. 1974 kam er als Fulbright-Stipendiat nach Österreich, wo er ebenfalls ausstellte und unterrichtete. Ab den 1980er-Jahren fertigte er Gummidrucke, Akt- und Landschaftsfotografien an, war jedoch hauptsächlich als Maler tätig. 2011 war er an einer Themenausstellung im Los Angeles County Museum of Art beteiligt.

Born in 1944 in Denver, Colorado/USA, died in 2013 in Santa Fe, New Mexico/USA. As a painter and photographer, Ron Stark started to participate in intensive exhibition activity at the young age of 20, including a solo exhibition in 1972 at the Corcoran Gallery of Art in Washington. In 1974 he went as a Fulbright scholar to Austria, where he also exhibited and taught. From the 1980s he produced gum prints, nudes and landscape photography, but worked primarily as a painter. In 2011 he participated in a thematic exhibition at the Los Angeles County Museum of Art.

Seinen Stellenwert in der Fotografie eroberte sich Ron Stark in den 1970er-Jahren mit seiner klassisch angelegten, umfangreichen Serie von Lebensmittel-Stillleben. Er arbeitete mit einem hochempfindlichen Kontakt-Vergrößerungspapier, das ihm die Möglichkeit zur feinen Modulation von abgestuften Grauwerten und präzisen Kontrasten bot. Der Umgang mit einfachen Gegenständen, wie er sie in der Küche vorfand – mit einem Stück Brot, einer Tomate oder Pilzen in einer Schüssel etwa –, erlaubte ihm die Konzentration auf Form und Licht in einer nüchternen Sichtweise, wie sie in der Neuen Sachlichkeit der 1920er-Jahre entwickelt worden war.

Ron Stark established his place in photography in the 1970s with his classically oriented, extensive series of still-life photographs of food objects. He worked with highly sensitive contact-enlargement paper, which gave him the opportunity to finely modulate scaled grey tones and precise contrasts. Dealing with simple objects like those he found in the kitchen – a piece of bread, a tomato or mushrooms in a bowl – allowed him to concentrate on form and light with an unemotional perspective, as had developed in the New Objectivity of the 1920s.

Literatur/Further reading: Ron Stark, *Delicacies: A Personal View of Food Through the Art of Photography*, New York 1978

Ron Stark
Egg Mirrored, 1971
Kontaktprint/Silbergelatineprint auf Azo-Papier/
contact print/silver gelatin print on Azo paper

BACK TO THE FUTURE. DIE SAMMLUNG FOTOGRAFIS AUF DEM WEG IN DIE GEGENWART

BACK TO THE FUTURE. THE FOTOGRAFIS COLLECTION EN ROUTE TO THE PRESENT

Walter Guadagnini

Seit ihrem frühesten Bestehen präsentiert sich die Sammlung FOTO-GRAFIS als Verkörperung des Sammlergeistes unserer Zeit: Sie zeigt exemplarisch – wie eine Art Lackmustest – auf, aus welchen Gründen und insbesondere auf welche Art und Weise man in Europa Mitte der 1970er-Jahre Fotografien sammelte. Man braucht nur eine Liste der ersten Ankäufe zwischen Oktober 1975 und September 1976 aufzustellen, um erkennen zu können, dass dieses Projekt in zweierlei Hinsicht bedeutend ist: Zu den »historischen« Namen wie Eugène Atget, Robert Adamson & David Octavius Hill, Julia Margaret Cameron, Lewis Hine, Emil Otto Hoppé, Edward Weston und Margaret Bourke-White gesellen sich die zeitgenössischer Fotografen wie Diane Arbus – mit dem berühmten Portfolio *A Box of Ten Photographs* von 1970 – und Duane Michals – mit der 1973 geschaffenen Fotosequenz *Things are Queer*. Hier verschmelzen Geschichte und Gegenwart in der Absicht, das Sammlungskonzept nicht in einer – wenngleich beachtlichen – Kollektion früherer Zeugnisse aufgehen zu lassen, sondern von Anfang an die Suche nach dem Neuartigen und den neuen Ausdrucksformen des Mediums zur grundlegenden Aufgabe zu machen.

Tatsächlich ist das Projekt FOTOGRAFIS wie eine Art Wettstreit zu sehen, eine Herausforderung, ein bisher praktisch nie umgesetztes Sammlerziel zu erreichen: Das Konzept von Anna Auer, Werner H. Mraz und Ivo Stanek war in kommerzieller und vielmehr noch in ökonomischer Hinsicht mutig, bewegte es sich doch in einem damals absolut undefinierten Raum, in einer Situation, in der die Grundlagen und Regeln zur Schaffung eines fortwährenden und stabilen Fotografiemarktes noch im Werden begriffen und alles andere als festgelegt waren. Es ist kein Zufall, dass dieser Markt, der noch in den 1970er-Jahren enorm expandierte, just zu Beginn des folgenden Jahrzehnts eine Krise erlebte. Sie erklärt sich durch das Überangebot an *modern prints* von Meisterfotografen, welche von Händlern in Umlauf gebracht wurden, die sich von diesem Segment

Since its earliest existence, the FOTOGRAFIS collection has presented itself as the epitome of our zeitgeist for collecting. It demonstrates – like a kind of litmus test – for what reasons and, particularly, how photographs in Europe were collected during the mid-1970s. One need only compose a list of the very first purchases between October 1975 and September 1976 to be able to recognize that this project is important in two ways. Historically prominent artists such as Eugène Atget, Robert Adamson & David Octavius Hill, Julia Margaret Cameron, Lewis Hine, Emil Otto Hoppé, Edward Weston and Margaret Bourke-White are joined by contemporary photographers such as Diane Arbus, with her famous 1970 portfolio *A Box of Ten Photographs*, and Duane Michals, with his 1973 series *Things are Queer*. Past and present blend not to conceive the collection as an assortment of past testimonials, however striking, but to make the search for innovative works and new forms of expression in this medium its fundamental purpose.

As a matter of fact, the FOTOGRAFIS project should be seen as a contest, a challenge to reach a collector's goal, which until now has practically never been reached. Anna Auer, Werner H. Mraz and Ivo Stanek's concept was more courageous from a commercial and, even more so, from an economic point of view. It took off into what were then completely undefined parameters in a situation in which the fundamentals and the rules for creating a lasting and stable market for photography were still in the making and anything but set. It is no coincidence that this market, which was still growing at a tremendous rate in the 1970s, went into crisis at exactly the beginning of the next decade. This can be explained by the surplus of modern prints by master photographers, circulated by dealers who expected all too quick an opportunity for profit from this area of the market. Nobody at that time could have predicted the fact that a regulated and fair market situation would finally develop as a direct consequence of this

eine allzu schnelle Verdienstmöglichkeit erwarteten. Die Tatsache, dass gerade aus dieser Krise heraus letztendlich jene geregelte, ordentliche Marktsituation entstand, die ab den 1990er-Jahren ständig wachsende Marktwerte für historische und zeitgenössische Fotografie bewirkte, konnte damals niemand voraussehen, ebenso wenig wie die beeindruckenden Rekordergebnisse für Fotografie in den letzten Jahren – weder eine Händlerin wie Anna Auer, noch ein illustrer Bankier wie Ivo Stanek. Beider Antrieb beruhte auf einer künstlerischen Leidenschaft, deren Resultate sich – auf ökonomischer Ebene – erst viele Jahre später zeigen sollten. Es war eine Investition in die Zukunft, ausgehend von Gegebenheiten der Gegenwart, die notwendigerweise in der Vergangenheit verankert waren – auch und vor allen Dingen in kultureller Hinsicht.

Die Sammlung FOTOGRAFIS entstand zu einem Zeitpunkt, zu dem die Fotografie schon längst begonnen hatte, Geschichte zu schreiben – ihre eigene Geschichte, deren Kriterien sich offensichtlich an der Kunstgeschichte orientieren. Andererseits entstanden gerade in den 1970er-Jahren weitere bewährte Elemente zur notwendigen Institutionalisierung der Fotografie, die den seit mehr als hundert Jahren beschrittenen Weg vollendeten: die Gründung von öffentlichen Sammlungen, die spezifisch der Fotografie gewidmet sind, die Verbreitung der Fotografie als Unterrichtsfach an den Kunstakademien und Universitäten sowie der zunehmende Einsatz von Fotografie als Ausdrucksmittel unterschiedlicher künstlerischer Konzepte. Dadurch standen ihr alle Möglichkeiten zum Einzug in die zeitgenössische Kunst offen und es wurde ihr in weiterer Folge sowohl kulturelle wie wirtschaftliche Anerkennung gezollt. Somit war es nicht mehr nur die historische Betrachtungsweise, die den Status von Fotografie bestimmte: Es war die Geschichte selbst, die sich als Mittel zum Verständnis der Gegenwart, als Antwort auf die stattfindende Veränderung in der Wahrnehmung der Rolle der Fotografie innerhalb der bildenden Künste anbot, was einen bemerkenswerten Paradigmenwechsel darstellte.

Unter diesem Gesichtspunkt ist hervorzuheben, dass von 1976 bis 1981 – in der Anfangszeit der Sammlung und gleichzeitig auch in der produktivsten Ankaufsperiode – in Wien immerhin sechs von Anna Auer organisierte Tagungen abgehalten wurden, je eine pro Jahr, die den unterschiedlichen Thematiken im Zusammenhang mit der Fotografie gewidmet waren. Die Teilnehmer waren unter anderem Künstler und Kunsttheoretiker wie Duane Michals, Van Deren Coke und Victor Burgin sowie Historiker und Gelehrte wie Helmut Gernsheim, Beaumont Newhall, Vilém Flusser, Klaus Honnef und Rosalind Krauss – wobei die Letzteren heute weltberühmt sind und gelegentlich sogar zum Mythos erhoben werden, damals aber schlicht Vertreter der jungen Generation waren; mit der Diversität der Referenten wurde eindringlich unter Beweis gestellt, dass die vielfältigen Möglichkeiten zur Annäherung an die Materie Fotografie immer noch in

crisis, causing steady growth in the market value of historic and contemporary photography from the 1990s, let alone the impressive record sales in photography over the last few years. Neither a dealer like Anna Auer, nor an illustrious banker like Ivo Stanek could have predicted that. It all started with their passion for art; the economic success came much later. It was an investment in the future, emanating from present conditions that were necessarily anchored in the past, but first and foremost in a cultural sense.

The FOTOGRAFIS collection came into being at a time when photography had long since begun to write history, its own history whose criteria clearly gravitate around the history of art. Other criteria to institutionalize photography particularly emerged in the 1970s and proved successful, bringing to an end a path that had been trodden for more than a hundred years: the establishment of public collections devoted exclusively to photography, the expansion of photography as a subject in art academies and universities, and the increasing use of photography as a form of expression for various artistic concepts. As a result, all sorts of possibilities for entering into contemporary art opened up, and, as a further consequence, photography was given cultural as well as financial recognition. Photography's status affirmed more than just a way of looking at history. It was history itself that presented itself as a way of understanding the present, an answer to the never-ending changes in appreciating the role of photography within fine art, which presented a remarkable paradigm shift.

In this context, it must be emphasized that, from 1976 to 1981, right at the beginning of the collection and when most of the works were acquired, six of the meetings addressing different topics in the context of photography and arranged by Anna Auer took place in Vienna: one every year. The participants included artists and art theorists such as Duane Michals, Van Deren Coke and Victor Burgin, as well as historians and teachers such as Helmut Gernsheim, Beaumont Newhall, Vilém Flusser, Klaus Honnef and Rosalind Krauss. The latter are now world famous and occasionally elevated to the level of myth; back then they were, however, simply ambassadors of the young generation. It was proven emphatically by the diversity of contributors that the multifarious ways of approaching the subject matter of photography are still consolidated into a global vision, as is characteristic of a transition period moving from the early stages into a structurally complex phase in which specializations are more defined and less transparent.

In principle, one could label the situation of the FOTOGRAFIS collection at that time as typical of an avant-garde movement. The collection was born out of the resolve of a few individualists who believed in what was initially a seemingly utopian, though innovative project. The collection grew thanks to the – not purely – financial support of

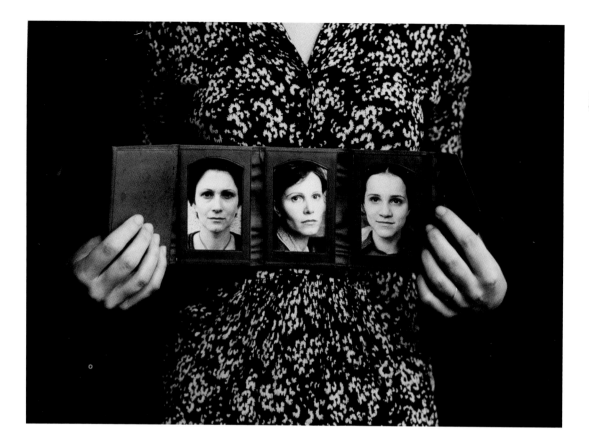

Karin Mack, zweites Foto aus der
fünfteiligen Serie *Die Zeit in der
Tasche* / second photograph from the
five-part series *Time in a Pocket*, 1978
Silbergelatineprint / silver gelatin
print, 18 × 24 cm, Sammlung FOTO-
GRAFIS Bank Austria / FOTOGRAFIS
Bank Austria Collection

einer globalen Vision zusammengefasst sind, wie es für die Momente des Übergangs von einer Anfangsphase in eine komplexer strukturierte Phase, in der die Spezialisierungen genauer definiert und weniger durchlässig sind, charakteristisch ist.

Im Prinzip kann man die damalige Situation der Sammlung FOTOGRAFIS als typisch für eine Avantgarde-Bewegung bezeichnen: Die Sammlung entstand aus dem Entschluss einiger weniger Individualisten heraus, die an ein anfänglich utopisch anmutendes, jedenfalls innovatives Projekt glaubten; sie wuchs dank der – nicht nur – finanziellen Unterstützung durch andere Personen, die bereit waren, für diese Idee ein Risiko einzugehen, und heute ist sie Teil und gleichzeitig Ausdruck eines bestimmten kulturellen Klimas. Sie hatte zunächst nur auf lokaler Ebene Einfluss, dieser weitet sich aber sehr bald über alle Grenzen hinweg aus. Sie versah sich gleichsam mit Verstärkern, welche in der Lage waren, Überzeugungen sowohl innerhalb als auch außerhalb der eigenen Reihen zu vertreten und zu verbreiten. Dies alles war von relativ kurzer Dauer, hinterließ aber dauerhafte Spuren. Bei einem Projekt dieser Art war gar nicht zu vermeiden, dass zumindest ein Teil der Aufmerksamkeit auf das Zeitgenössische gelenkt wurde, auf die künstlerischen Sprachen, die sich genau in dieser Zeit Ausdruck verschafften. So sind hier Diane Arbus und Duane Michals zu nennen, aber insbesondere auch eine Reihe von österreichischen Künstlern – einige bereits bekannt, andere noch an ihrem künstleri-

other people who were prepared to take a risk for this idea, and is today part, as well as the expression, of a specific cultural climate. At first, the collection had influence only on a local scale, but it soon spilled over into all echelons. The collection soon achieved a position that allowed it to represent and spread convictions both within and outside of this particular inner circle. This all happened in a relatively short time, but left a considerable and lasting impact. It goes without saying that, with a project of this kind, at least some of the attention would inevitably be drawn to the contemporary aspect and to the artistic languages that found their expression during that very time. In this context, Diane Arbus and Duane Michals should be mentioned, but especially a range of Austrian artists, some of whom were already well known, whereas others were still at the beginning of their artistic endeavours. Their approaches also forge a geographical relationship to their country's cultural context, in which the project also has its roots, and the wish but also the necessity to make it a subject of discussion.

In this context, it is interesting to point out an element that, from a historical perspective, characterizes the FOTOGRAFIS collection and makes it a perfect example of a particular period – one might even call it a sort of founding period, at least when referring to Europe – when entrepreneurs were in their collecting element. There are at least three reasons for the motivation to purchase historic works of art. First is

schen Anfang –, deren Positionen auch eine geografische Verbindung mit dem kulturellen Kontext des Landes herstellen, in dem das Projekt selbst seine Wurzeln hat und mit dem es sich auseinandersetzen will und notwendigerweise auch auseinandersetzen muss.

In diesem Zusammenhang ist es interessant, auf etwas hinzuweisen, das die Sammlung FOTOGRAFIS aus historischer Sicht charakterisiert und sie für eine bestimmte Zeitspanne – eine Art Gründerzeit, jedenfalls in Europa – für die Sammlungstätigkeit von Unternehmen exemplarisch werden lässt. Zumindest drei Gründe lassen sich finden für die Motivation, historische Kunstwerke anzukaufen: An erster Stelle steht der Wille – und somit auch das Anliegen –, eine universelle Sammlung zusammenzustellen, die anhand von erlesenen Meisterwerken die Geschichte der Fotografie von ihren Anfängen bis zu den 1930er-Jahren erzählen kann, so wie es auch die Intention fast aller öffentlichen und privaten Sammlungen war, die um die 1970er-Jahre herum entstanden. An zweiter Stelle steht die Reaktion auf eine Möglichkeit, die sich um die Mitte der 1970er-Jahre tatsächlich bot und die heute undenkbar wäre: Es ließen sich noch erstklassige Werke zu erschwinglichen Preisen auf dem Markt finden. Dies stellte eine ideale Voraussetzung dar – besonders aus der Sicht der 2010er-Jahre, in denen der Markt immer weniger hochwertige Werke anbieten kann und die Preise unerschwinglich geworden sind. Der dritte Grund hingegen war von der Notwendigkeit des Überzeugens getragen: Um ein Bankinstitut davon zu überzeugen, sein Geld in ein Segment zu investieren, das – wie das Sammeln von Fotografien – praktisch inexistent war, war es notwendig, mit der Garantie der Geschichtsträchtigkeit eines Materials zu argumentieren: Dieses sollte auf jeden Fall durch die Zeit, wenn nicht gar durch breite gesellschaftliche Anerkennung, wie sie den traditionellen Kunstsparten zuteil wurde, nobilitiert werden.

Wille, Möglichkeit, Notwendigkeit: Aus allen drei Beweggründen heraus entstand die Sammlung FOTOGRAFIS und stellt damit ein Paradebeispiel für den Beginn des europäischen *corporate collecting* dar. Diese Anfangsperiode endet in den 1990er-Jahren, um das Terrain der nächsten Phase zu überlassen, die auf die zeitgenössische Kunst und Fotografie ausgerichtet ist und in der das letztgenannte der drei Motive für das Sammeln vorherrschend ist. Denn auch heute noch besteht der Wille, eine Sammlung zu gründen, die sich sehr stark auf ein Thema oder eine Epoche konzentriert und damit von der früher vorherrschenden universalistischen Denkweise abweicht. Daran geknüpft ist die Möglichkeit, erstklassige Arbeiten anzukaufen. An dritter Stelle steht die Notwendigkeit, sich mit in- und externen

the will, and therefore also the desire, to put together a cyclopaedic collection which, with the aid of distinguished masterpieces, can tell the story of photography from its beginnings up until the 1930s. This was also the intention of almost all public and private collections that emerged in the 1970s. Second is the reaction to an opportunity that effectively arose during the mid-1970s and would be unthinkable today; first-class works were available on the market at affordable prices. This constituted an ideal situation, especially looking at it from the perspective of the 2010s, when the market offers fewer and fewer premium works and the prices have become unaffordable. The third reason, however, was born out of the need for conviction. In order to convince a bank to invest its money in an area of the market that practically did not exist – in the same way that photograph collections did not really exist – it was necessary to assure them that the material would be of historical importance. The objective was to celebrate this material as much as the traditional arts by allowing it to unfold and by paying tribute to it across all sections of society.

Thomas Reinhold, *Niagara falls asleep*, 1979
Silbergelatineprint, Bleistift, Polaroid /
silver gelatin print, pencil, Polaroid print, 30 × 39,4 cm
Sammlung FOTOGRAFIS Bank Austria /
FOTOGRAFIS Bank Austria Collection

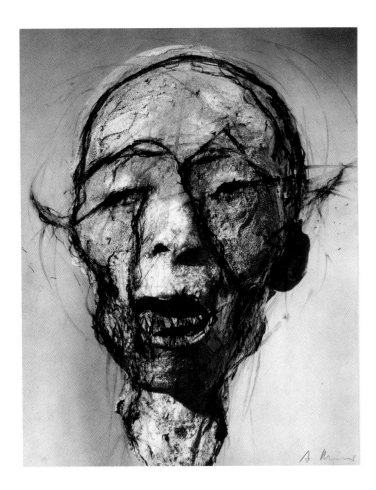

Arnulf Rainer, Ohne Titel / Untitled, 1980
Silbergelatineprint, Kreide / silver gelatin print, chalk, 30,5 × 25 cm
Sammlung FOTOGRAFIS Bank Austria /
FOTOGRAFIS Bank Austria Collection

Dialogpartnern austauschen zu können – und zwar mittels zeitgenössischer Ausdrucksformen und nicht mittels historischer.

Heute sind Künstlerpersönlichkeiten wie Arnulf Rainer, VALIE EXPORT, Christian Wachter, Sepp Dreissinger, Manfred Willmann, Verena von Gagern und selbst Werner H. Mraz – der treue Weggefährte von Anna Auer seit der abenteuerreichen Zeit rund um die Galerie Die Brücke – ein fest integrierter und fundamentaler Bestandteil der österreichischen Geschichte der Kunst und Fotografie der späten 1960er-Jahre. Und die in der Sammlung enthaltenen Arbeiten stellen einen kleinen, aber repräsentativen Querschnitt jener Werke dar, welche die wichtigsten Tendenzen der künstlerischen Entwicklung in diesen Jahren verkörpern. Insbesondere sind sie auch Zeugnisse der dominierenden Strömungen in der internationalen Kunstszene der Zeit zwischen den 1970er- und den frühen 1980er-Jahren, die von diesen Protagonisten geformt wurde und die gerade in Österreich im Anschluss an spezielle fotografische Traditionen gesehen werden kann. Dabei ist nicht zu übersehen, dass diese Fotografie seit Anfang

Will, opportunity and need. The FOTOGRAFIS collection was born out of all three of these motives and constituted a prime example of the beginning of European corporate collecting. This early period came to an end in the 1990s, leaving room for the next phase, one that is oriented towards contemporary art and photography and more predominantly along the lines of the last of the three aforementioned reasons for collecting. Indeed, the desire to establish a collection that focuses specifically on one subject or epoch, and which veers away from earlier and more predominantly cyclopaedic approaches, still exists today. Linked to this is the opportunity to purchase first-class pieces. And finally, there is the need to be able to enter into conversation with internal and external partners, and this by means of contemporary, not historical, forms of expression.

Today, personalities in the art world such as Arnulf Rainer, VALIE EXPORT, Christian Wachter, Sepp Dreissinger, Manfred Willmann, Verena von Gagern and even Werner H. Mraz (Anna Auer's loyal partner since their adventurous time at the Die Brücke gallery) are fully integrated, fundamental constituents of the Austrian history of art and photography of the late 1960s. Indeed, the works that constitute the collection give a small but representative profile of those that epitomize the most important trends in artistic development during these years. They stand as a particular testament to the dominant currents on the international art scene between the 1970s and early 1980s, which were formed by these same personalities and can be seen specifically in Austria as being connected to particular photographic traditions. We cannot overlook the fact that since the beginning of the twentieth century this photography has had its own identity, interrupted solely by the terrors of National Socialism and the Second World War. Arnulf Rainer and VALIE EXPORT, the two Austrian artists most famous internationally, represent individual as well as universal aspects of actionism, performance and art strongly influenced by feminism to the highest degree, making Vienna a centre of influence and innovation from the 1960s onwards. The virulent language and blunt expressive nature of these works marked the break with previous conceptions of art, in such a way that it was definitely not taken for granted, as it might seem today, that the bank that funded the collection would make these kinds of purchases. This opening up of the mind and a "can-do" attitude towards the present, and indeed even more so towards the future, which would later inform the whole context of the FOTOGRAFIS collection, are apparent in Rainer and EXPORT's work. There is even evidence of them beyond the individual artistic works and approaches, whose individual value cannot be overstated, namely in places where they can be interpreted as a "declaration of intent" of the people in charge of the collection.

Manfred Willmann, Sepp Dreissinger and Christian Wachter's research makes the spirited mood that characterized Austrian photo-

des 20. Jahrhunderts ihre eigenständige Identität hat – unterbrochen nur durch die Schreckenszeit des Nationalsozialismus und des Zweiten Weltkriegs. Die beiden international bekanntesten österreichischen Künstler, Arnulf Rainer und VALIE EXPORT, vertreten auf höchstem Niveau individuelle wie auch allgemeingültige Positionen des Aktionismus, der Performance und stark feministisch geprägter Kunst, die Wien bereits ab den 1960er-Jahren zu einem neuralgischen Punkt in der europäischen Kunstlandschaft machten. Die direkte Ausdruckskraft und die virulente Sprache dieser Werke markierten in jedem Fall auch den Bruch mit bisherigen Kunstauffassungen, sodass es für eine von einer Bank finanzierte Sammlung damals sicherlich nicht so selbstverständlich war, wie es heute scheinen mag, deren Ankauf zu bewerkstelligen. Diese mentale Öffnung und dieses Ja zur Gegenwart und noch mehr zur Zukunft, die das gesamte Umfeld der Sammlung FOTOGRAFIS prägten, werden in den Werken von Rainer und EXPORT greifbar, ja sie sind sogar jenseits der einzelnen künstlerischen Werke und Positionen – deren individueller Wert nicht hoch genug eingeschätzt werden kann – spürbar: dort nämlich, wo sie als eine Art Absichtserklärung der Verantwortlichen für die Sammlung zu verstehen sind.

Die Recherchen von Manfred Willmann, Sepp Dreissinger und Christian Wachter machen ihrerseits das sprühende Klima wieder erfahrbar, in dem die österreichische Fotografie zu Beginn der 1980er-Jahre gedieh: Es entstanden die erfolgreichen Künstlervereinigungen Forum Stadtpark in Graz und Fotohof in Salzburg sowie die Zeitschrift *Camera Austria*, die in die Geschichte eingehen sollte. Für eine kleine, aber ungemein aktive Künstlergemeinschaft, die fest entschlossen war, die österreichische Fotografie zu jenem Höchstniveau zurückzuführen, das sie ein halbes Jahrhundert zuvor für sich beanspruchen konnte, waren dies schicksalsträchtige Momente. An der Spitze dieser Gemeinschaft standen die Begründer einer Vorgehensweise, die die – stark an persönliche Erfahrung gebundene – Fotografie beeinflusste und ihr mit explizitem methodischem Ansatz ein strenges Konzept auferlegte. So versteht sich auch die zu Beginn getroffene Entscheidung, einen Künstler wie Duane Michals in die Sammlung aufzunehmen, dessen spannungsreiche Fotoserien mit autobiografischen Bezugsmomenten sich demselben kulturellen Horizont einfügen.

Die Sammlung FOTOGRAFIS ist somit Bestandteil einer wichtigen Periode der österreichischen visuellen Kultur, eine der Achsen, um die sich das Land – erneut als Zentrum der europäischen Kunstszene – bewegte, in einem virtuosen Kreislauf zwischen individuellem Willen und kollektiven Zielen, zwischen Markt und Forschung. Diese Position ist es auch heute noch wert, erforscht und ergründet zu werden, auch um die Zukunft einer der wichtigsten fotografischen Sammlungen zu sichern, die in den vergangenen fünfzig Jahren innerhalb eines Unternehmens entstand.

graphy at the beginning of the 1980s come alive again. It was the time when successful groups of artists such as the Forum Stadtpark in Graz and the Fotohof in Salzburg emerged, and when the magazine *Camera Austria* was established, which would later make history. These were all milestones for a small though extraordinarily active community of artists set on restoring Austrian photography to the zenith it had occupied half a century earlier. At the head of this community were the originators of an approach towards photography that was strongly linked to personal experience and that was explicitly systematic in its method, which they then imposed as a strict concept. The early decision to include an artist like Duane Michals in the collection becomes apparent since his series of tense photographs of autobiographical points of reference blend into the same cultural horizon.

Consequently, the FOTOGRAFIS collection is part of an important period in Austrian visual culture. It is one of the axles around which the country, now reinvigorated as the centre of the European art scene, moves in a perfect cycle between the will of the individual and collective aims – between the market and research. Today, it is still worth researching and investigating this role in order to protect the future existence of one of the most important photographic collections to have developed within a company over the last fifty years.

Manfred Willmann, aus der Serie / from the series *Das Land*, 1981–1983
Farbfotografie / colour photograph, 51 × 51,5 cm
Sammlung FOTOGRAFIS Bank Austria /
FOTOGRAFIS Bank Austria Collection

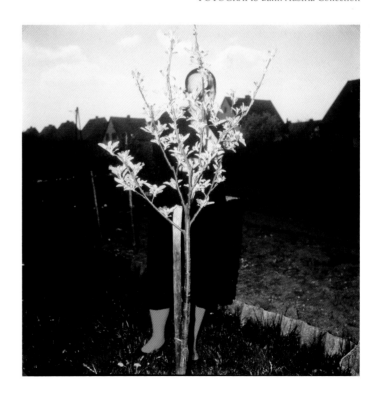

Horst P. Horst

Geboren 1906 in Weißenfels/Deutschland, mit bürgerlichem Namen Horst Bohrmann, verstorben 1999 in Palm Beach Gardens, Florida/USA. Sein in Hamburg begonnenes Architekturstudium setzte er 1930 bei Le Corbusier in Paris fort, wo er George Hoyningen-Huene kennenlernte, durch den er sich der Fotografie zuwandte. Bis 1935 fotografierte er hauptsächlich für die britische *Vogue*, übersiedelte dann in die USA, wo er im Zweiten Weltkrieg im amerikanischen Heer diente. Er nahm seinen Künstlernamen an, wurde amerikanischer Staatsbürger und fertigte Mode- und Porträtfotos für die amerikanische *Vogue* an, bis die *Vogue*-Studios 1951 geschlossen wurden. Daran schließt sich eine Zeit mit ausgedehnten Reisen an, auf denen er sich vermehrt der Porträt-, Stillleben-, Landschafts- und Pflanzenfotografie widmete. 1977 war er auf der documenta 6 vertreten.

Es waren die großen Roben und die spektakulären Posen, der theatralisch ausgeleuchtete Raum ebenso wie das effektvolle Arrangement, für die Horst P. Horst ein Gespür hatte. Die Künstlichkeit seiner Motive und Inszenierungen korreliert mit den Inhalten: Die Kunst und ihre Protagonisten sind Geschöpfe einer »Kunst«-Welt. Dies trifft auch auf die umstrittene englische Dichterin Edith Sitwell (1887–1964) zu, die sowohl mit ihren ausgefallenen Auftritten als auch mit ihren Gedichtbänden und der Textsammlung über englische Exzentriker Aufsehen erregt hatte. Sie wurde als *Dame Commander* in den britischen Adelsstand erhoben. Ihr Porträt zeigt sie als skulpturhaft aufragende Persönlichkeit mit einer monumentalen Ausgabe ihrer *Gedichte* auf dem Schoß und einem Lesepult als silhouettenhafte Aura hinter ihrem stark konturierten Profil.

Born in 1906 as Horst Bohrmann in Weissenfels/Germany, died in 1999 in Palm Beach Gardens, Florida/USA. After starting his architecture studies in Hamburg, he continued in 1930 with Le Corbusier in Paris, where he met George Hoyningen-Huene, who helped him turn to photography. He took photographs mainly for British *Vogue* until 1935 and then moved to the USA, where he served in the American army in the Second World War. He adopted his pseudonym, became an American citizen and made fashion and portrait photographs for American *Vogue* until the *Vogue* studios were closed in 1951. This was followed by a time of extensive travel during which he increasingly devoted himself to portraiture, still life, landscape and plant photography. He participated in documenta 6 in 1977.

Horst P. Horst had a flair for big robes and spectacular poses, theatrically lit rooms and highly effective arrangements. The artificiality of his motifs and staging correlated with the content: art and its protagonists are creatures of an "artificial" world. This also applies to the controversial English poet Edith Sitwell (1887–1964), who created excitement with her unusual performances, her volumes of poetry and her collection of texts about English eccentrics. She was elevated to Dame Commander in the British nobility. Her portrait shows her as a sculpture-like towering personality with a monumental edition of her poems on her lap and a lectern as a silhouette-like aura behind her highly contoured profile.

Literatur/Further reading: Reinhold Misselbeck, Rainer Wick und/and
Richard J. Tardiff (Hrsg./eds.), *Horst P. Horst*, New York 1992

Horst P. Horst
Dame Edith Sitwell, 1948
Silbergelatineprint/silver gelatin print

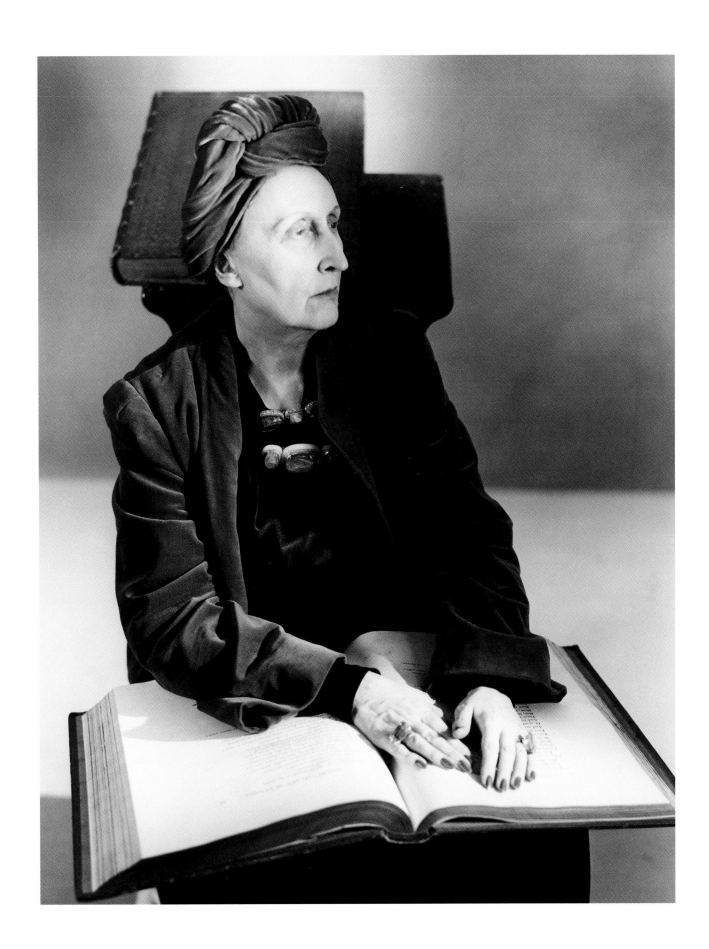

Henri Cartier-Bresson

Geboren 1908 in Chanteloup, Département Seine-et-Marne/Frankreich, verstorben 2004 in Montjustin, Provence/Frankreich. Sein erstes Studium widmete Cartier-Bresson 1922 und 1923 sowie 1927 und 1928 in Paris der Malerei. In den Jahren 1928 und 1929 studierte er Philosophie und Malerei in Cambridge. Nach einer Reise an die Elfenbeinküste begann er 1931 seine Karriere als Fotograf. Es folgten ethnografische Exkursionen nach Mexiko. 1937 drehte Cartier-Bresson Dokumentarfilme über den Spanischen Bürgerkrieg. Die Jahre 1940 bis 1943 verbrachte er in deutscher Kriegsgefangenschaft. 1947 war er Gründungsmitglied der Fotoagentur Magnum. Von 1948 bis 1965 fotografierte er in Birma, Pakistan, China, Indonesien, Kanada, Kuba, Japan, Indien und der Sowjetunion. 1952 postulierte er in seinem Buch *Images à la Sauvette*, es gelte in einem Foto immer, den *moment décisif* einzufangen. Er etablierte damit in der Life-Fotografie einen entscheidenden Begriff. Ab 1973 wandte er sich vermehrt seinen alten Passionen, der Malerei und dem Zeichnen, zu.

Born in 1908 in Chanteloup, département Seine-et-Marne/France, died in 2004 in Montjustin, Provence/France. Cartier-Bresson devoted his first studies to painting in 1922 and 1923 as well as in 1927 and 1928 in Paris. In 1928 and 1929 he studied philosophy and painting at Cambridge. After a trip to the Ivory Coast, he began his career as a photographer in 1931. This was followed by ethnographic excursions to Mexico. In 1937 Cartier-Bresson made a documentary film about the Spanish Civil War. He spent the years from 1940 to 1943 in a German POW camp. In 1947 he was a founding member of the Magnum photo agency. From 1948 to 1965 he took photographs in Burma, Pakistan, China, Indonesia, Canada, Cuba, Japan, India and the Soviet Union. In 1952 he postulated in his book *Images à la Sauvette* that a photograph always needs to capture the *moment décisif*. He thus established a crucial term in life photography. From 1973 he increasingly turned his attention to his old passions of painting and drawing.

Nach den großen Reisen der 1930er-Jahre interessierte sich der Fotograf ab den 1940er-Jahren verstärkt für seine Umgebung und den Alltag mit seinen Besonderheiten und Zufällen. Von der dokumentarischen Bilderstrecke gelangte er damit zum packenden und spannenden Einzelbild, das sich durch den Moment des Wahrnehmens und Festhaltens einer bestimmten Situation zu einem modernen, aktuellen Bildmedium wandelt. Im Pariser Museum für angewandte Kunst, dem Musée des Arts décoratifs, erhaschte Cartier-Bresson das zufällige Aufeinandertreffen eines Soldaten der Nationalgarde und eines im Bild dargestellten, ähnlich adjustierten orientalischen Kämpfers.

After the big trips of the 1930s, the photographer, from the 1940s onward, was increasingly interested in his environment and everyday life with its peculiarities and coincidences. From the documentary photo series he thus gets to the thrilling and exciting single frame that transforms it into a modern, current image medium with the moment of perception and the capturing of a specific situation. In the Paris decorative-arts museum, the Musée des Arts décoratifs, Cartier-Bresson caught a glimpse of a chance meeting of a National Guard soldier and an oriental combatant who is similarly depicted in a painting.

Literatur/Further reading: *Henri Cartier-Bresson. Die Photographien*, mit einem Text von/with a text by Yves Bonnefoy, München/Munich, Paris und/and London 1992

Henri Cartier-Bresson
Musée des Arts décoratifs, Paris, 1969
Silbergelatineprint/silver gelatin print

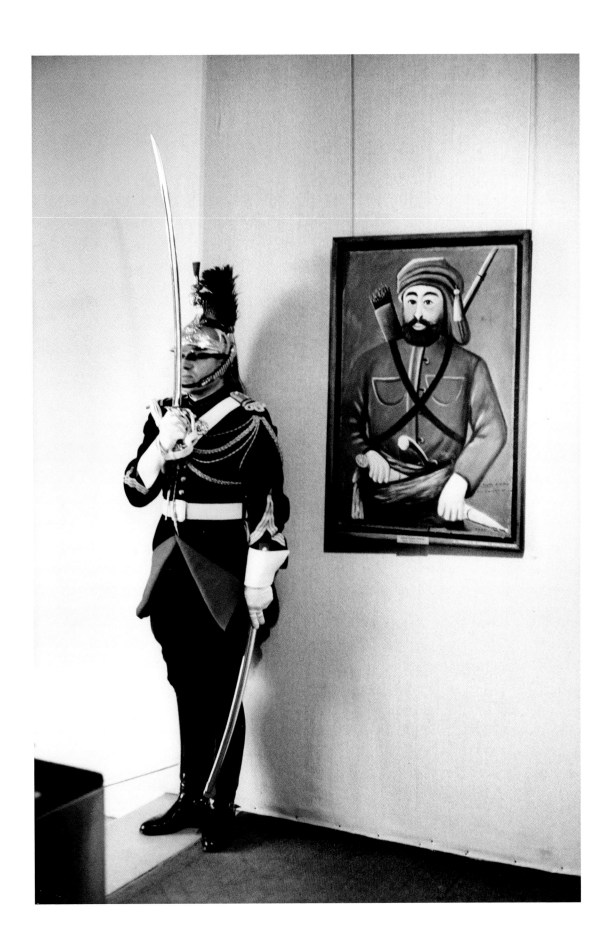

Mario Giacomelli

Geboren 1925 in Senigallia/Italien, verstorben 2000 in Senigallia. Als 13-Jähriger begann Giacomelli seine Ausbildung zum Schriftsetzer und Drucker, später wurde er Teilhaber und Besitzer einer Druckerei in seiner Heimatstadt. Seine erste Kamera kaufte er 1953. Die Themen Zeit, Vergänglichkeit und Alter beschäftigten ihn schon in jungen Jahren. So entstanden Serien aus dem Hospiz, die erste von 1955 bis 1957, die zweite in den Jahren 1966 bis 1968. Von 1964 bis 1966 fotografierte Giacomelli die Serie *La buona terra* (Die gute Erde).

Seine bekannten Landschaftsfotografien entstanden in den Jahren 1955 bis 1980. Die Vogelperspektive auf die Landschaftsformationen rund um seinen Geburts- und Heimatort definiert den fotografischen Stil von Giacomelli ebenso wie das Augenmerk des Künstlers auf grafische Strukturen in der Natur, die er vom Flugzeug aus in seinen Luftaufnahmen ortete. Die auf hartem Papier, oft mit Eingriffen im Negativ und in kontrastreichem Hell-Dunkel vergrößerten Fotos zeichnen sich durch Einfachheit und monumentale Strenge aus.

Literatur/Further reading: Karl Steinorth (Hrsg./ed.), *Mario Giacomelli. Fotografien 1952–1995/Photographs 1952–1995* (Ausst.-Kat./exh. cat. Museum Ludwig, Köln/Cologne), Ostfildern 1995

Born in 1925 in Senigallia/Italy, died in 2000 in Senigallia. As a 13-year-old, Giacomelli began his apprenticeship as a typesetter and printer and later became a partner and owner of a printing company in his hometown. He bought his first camera in 1953. In his youth he was already interested in the issues of time, transiency and age. Thus he created series at a hospice, the first from 1955 to 1957 and the second from 1966 until 1968. From 1964 to 1966 Giacomelli photographed the series *La buona terra* (The Good Earth).

His well-known landscape photographs were taken between 1955 and 1980. A bird's-eye view of the landscape formations around his birthplace and hometown defines the photographic style of Giacomelli, as does the attention paid by the artist to graphical structures in nature, which he pinpointed from a plane in his aerial photography. Simplicity and monumental strength characterize the enlarged photographs that were put on hard paper, often with interventions in the negatives and high-contrast chiaroscuro.

Mario Giacomelli
Paesaggio, 1968
Silbergelatineprint/silver gelatin print

Verena von Gagern

Geboren 1946 in Bonn/Deutschland, lebt und arbeitet in Niederbayern/Deutschland. Verena von Gagern studierte von 1966 bis 1972 Architektur und Städtebau in Aachen, München und in den USA. Ab 1972 konzentrierte sie sich auf Fotografie im Themenfeld des familiären und ländlichen Lebens. Von 1975 bis 1986 leitete sie das International Photography Program am Salzburg College und unterrichtete von 1982 bis 1989 die Fotografie-Klasse an der Salzburger Sommerakademie. Ein Lehrauftrag führte von Gagern von 1986 bis 1991 an die Schule für Gestaltung nach Zürich. 1975 wurde sie mit einem Preis des Internationalen Foto-Festivals in Arles ausgezeichnet. Mit ihrem Mann, dem Architekten Otto Steidle (1943–2004), beschäftigte sie sich mit den Wechselwirkungen zwischen Fotografie und Architektur. Seit 1989 lebt sie auf einem Einödhof in Niederbayern und widmet sich fotografischen Projekten.

Born in 1946 in Bonn/Germany, lives and works in Lower Bavaria/Germany. From 1966 to 1972 Verena von Gagern studied architecture and urban development in Aachen, Munich and the USA. From 1972 she focused on photography in the areas of family and rural life. From 1975 to 1986 she headed the International Photography programme at Salzburg College and from 1982 to 1989 taught a photography class at the Salzburg Sommerakademie. A lectureship took von Gagern to the Schule für Gestaltung in Zurich from 1986 to 1991. In 1975 she was awarded a prize at the International Photo Festival in Arles. With her husband, the architect Otto Steidle (1943-2004), she explored the interactions between photography and architecture. Since 1989, she has lived on a farmstead in Lower Bavaria and has devoted herself to photography projects.

Ihre fotografischen Arbeiten konzentrieren sich auf die Beziehung zur urbanen Umwelt, auf ihr familiäres und berufliches Umfeld. Wie mit Tagebuchnotizen füllt sie ihren Bilderkosmos mit Einblicken und Eindrücken. Die Gegend rund um Salzburg, in der sie über viele Jahre immer wieder Wochen und Monate verbrachte, inspirierte sie zu einem ausschnitthaften Blick vom Untersberg: Die schwarzen Dohlen umkreisen die Terrasse, die altmodische Ausflugsgaststätte präsentiert ihren verwitterten Charme, die undefinierbare Figur des gesichtslosen Kellners vermittelt zwischen Luft und Berg, zwischen Himmel und Erde – so wie die sagenumwobenen Rabenvögel zwischen Einst und Heute vermitteln als Träger der Legende von Kaiser Karl dem Großen, der im Untersberg schlummern soll, bis keine Dohlen mehr um den Gipfel kreisen.

Her photographic work focuses on her relationship with the urban environment, her family and her professional environment. Similar to diary notes, she fills her world of images with insights and impressions. The region around Salzburg, where she has spent many weeks and months over the years, inspired her to create a fragmentary view of Untersberg: the black crows circle the terrace, the old-fashioned tourist restaurant presents its weather-beaten charm, and the indefinable character of the faceless waiter intercedes between air and mountain, between heaven and earth, like the fabled ravens that intercede between past and present, as carriers of the legend of Emperor Charles the Great, who will remain dormant in Untersberg mountain until the crows no longer circle the summit.

Literatur/Further reading: Verena von Gagern, *Der anatomische Engel*/
The Anatomical Angel, München/Munich 1994

Verena von Gagern
Untersberg, 1975
Silbergelatineprint/silver gelatin print

Werner H. Mraz

Geboren 1941 in Wien/Österreich, verstorben 2009 in Sankt Bartholomä, Steiermark/Österreich. Neben dem Studium der Informatik an der Technischen Universität Wien beschäftigte Mraz sich als Autodidakt intensiv mit Fotografie. 1969 war er Bildredakteur bei einem Fotoverlag in Düsseldorf und gründete 1970 gemeinsam mit Anna Auer in Wien die Fotogalerie Die Brücke, die die konzeptive Grundlage für die Sammlung FOTOGRAFIS der damaligen Länderbank, heute Bank Austria, darstellte. Um 1970 fotografierte er Dokumentationen für verschiedene Künstler, unter anderem für Peter Weibel und VALIE EXPORT. Ab 2000 war er in den Bereichen Software-Entwicklung und Computertechnologie tätig.

Auf seinen Streifzügen durch die Straßen von Wien entdeckte Werner H. Mraz seine Leidenschaft für skurril ausgestattete Schaufenster und markante Fassadengestaltungen auf den Flaniermeilen der Großstadt. Das Parlando der Geschäfte mit Schriftzügen, Dekorelementen und ausgeprägter Architektur wird in seiner Fotografie mit sachlicher Distanz vorgeführt. Mraz war Kenner der amerikanischen Fotografie der 1940er- und 1950er-Jahre und Freund von amerikanischen Fotografen, die seinen Stil geprägt und seine Sichtweise mit beeinflusst hatten.

Literatur/Further reading: »Werner Mraz. Die ersten 80 Jahre«, in: *Galeriespiegel. Zeitschrift für österreichische Kunst der Gegenwart*, Nr./no. 29, 1977

Born in 1941 in Vienna/Austria, died in 2009 in Sankt Batholomä, Styria/Austria. In addition to studying computer science at the Technical University of Vienna, Mraz was intensively involved with photography as an autodidact. In 1969 he was photo editor at a photo publishing house in Düsseldorf, and in 1970 in Vienna he founded, together with Anna Auer, the photo gallery Die Brücke, which constituted the conceptual basis for the FOTOGRAFIS collection of what was then the Länderbank and is now Bank Austria. Around 1970 he made photographic documentations for various artists, including Peter Weibel and VALIE EXPORT. From 2000 he worked in the areas of software development and computer technology.

In his wanderings through the streets of Vienna, Werner H. Mraz discovered his passion for bizarrely decorated shop windows and striking façade designs on the promenades of the city. The parlando of businesses with letterings, decorative elements and distinct architecture is demonstrated in his photography in a matter-of-fact style. Mraz was a connoisseur of the American photography of the 1940s and 1950s, and a friend of American photographers who shaped his style and influenced his perspective.

Werner H. Mraz
Tuchlauben, Wien, 1979
Silbergelatineprint/silver gelatin print

Christian Wachter

Geboren 1949 in Oberwart/Österreich, lebt in Wien/Österreich. Christian Wachter studierte von 1970 bis 1977 Medizin in Graz. Seit 1980 ist er fotografisch tätig. Nach der Übersiedlung nach Wien studierte er 1982 an der dortigen Graphischen Lehr- und Versuchsanstalt. Seit 1983 zeigt Wachter seine Arbeiten in Ausstellungen und Publikationen und ist als Dozent tätig, zuletzt 2010 und 2011 am Zentrum für Bildwissenschaften an der Donau-Universität in Krems.

Born in 1949 in Oberwart/Austria, lives in Vienna/Austria. Christian Wachter studied medicine in Graz from 1970 to 1977. He has been active as a photographer since 1980. After moving to Vienna in 1982, he studied at the Graphische Lehr- und Versuchsanstalt. Since 1983 Wachter has shown his work in exhibitions and publications and has been a lecturer, most recently in 2010 and 2011 at the Zentrum für Bildwissenschaften at Donau University in Krems.

Für Christian Wachter war das Medium Fotografie immer mehr als bloße Dokumentation: Er beschäftigt sich mit analytischen und konzeptuellen Methoden und Themen der Fotografie. Ausgehend von historischen Fakten wie auch von fiktiven, narrativen oder persönlichen Elementen hinterfragt und reflektiert Wachter semantisch und visuell die Wahrnehmung und Interpretation von Geschichte und Identität. Seine Bildfolgen stellen Bezugssysteme und ikonische Parallelitäten her, in denen formale Entsprechungen aufgespürt, fotoimmanente Charakteristika thematisch integriert und gedankliche Konzeptionen anschaulich werden. Derselbe Ort im urbanen Gefüge wird einmal bei Tag, einmal bei Nacht, einmal bei Sonnenlicht, einmal mit Blitzlicht fotografiert – die Entsprechungen von Flächen und Linien, von lesbaren Inhalten und formalen Abstraktionen verändern Präsenz und Charakter desselben Motivs jeweils fundamental.

For Christian Wachter, the medium of photography has always been more than mere documentation: he works with analytical and conceptual methods and themes of photography. Starting from historical facts and from fictional, narrative or personal elements, Wachter semantically and visually questions and reflects on the perceptions and interpretations of history and identity. His image sequences produce reference systems and iconic parallelisms in which formal associations are detected, inherent photographic characteristics are thematically integrated, and which demonstrate his intellectual concepts. The same place in the urban landscape is photographed once during the day, once at night, once in the sunlight and once with a flash. The associations of surfaces and lines, of readable content and formal abstractions fundamentally change the presence and character of the same subject in each case.

Literatur/Further reading: Christian Wachter, »Passage du Désir oder Ist die Moderne eine Baustelle?«, in: Christian Wachter, *Impressions d'Afrique*, Salzburg 2007

Christian Wachter
aus der Serie/from the series
disappearance of landscape (tag/nacht), 1983
Silbergelatineprints, montiert/silver gelatin prints, mounted

Sepp Dreissinger

Geboren 1946 in Feldkirch/Österreich, lebt und arbeitet in Wien/Österreich. Nach einem Musikstudium am Salzburger Mozarteum begann Dreissinger 1976 zu fotografieren. Er spezialisierte sich auf die klassische Schwarz-Weiß-Fotografie und wurde bekannt für seine Schauspielerporträts sowie Fotoserien über Thomas Bernhard, Friedrich Gulda, Maria Lassnig und Elfriede Jelinek. 1981 war er Mitbegründer der Galerie Fotohof in Salzburg, die sich zu einer wichtigen Plattform für österreichische Fotografie entwickelte. Seit dem Jahr 2000 beschäftigt Dreissinger sich verstärkt mit dem Medium Film. Für seine Kurzdokumentation *artgenossen. 35 minutenporträts* wurde er 2005 bei der Viennale ausgezeichnet und erhielt 2006 den ersten Preis der Diagonale. Seit 1983 ist er zudem als Musikerzieher und freier Mitarbeiter an Theatern und beim Hörfunk tätig.

Der österreichische Schriftsteller Franz Innerhofer wurde 1944 in Krimml im Salzburger Pinzgau geboren und erlebte eine harte und entbehrungsreiche Jugend, über die er in seinem Roman *Schöne Tage* schonungslos berichtet. Das Buch erschien 1974 und machte den zurückgezogen lebenden Literaten schlagartig im gesamten deutschen Sprachraum bekannt. Dreissingers Fotografie zeigt Innerhofer an seinem Wohnort Graz – isoliert und im tristen Ambiente einer Wohnsiedlung. Der nüchterne, realitätsnahe Stil der Aufnahme gleicht dabei Innerhofers literarischem Idiom. 2002 starb Innerhofer durch Selbstmord.

Born in 1946 in Feldkirch/Austria, lives and works in Vienna/Austria. After studying music at the Salzburg Mozarteum, Dreissinger began taking photographs in 1976. He specialized in classic black-and-white photography and was known for his portraits of actors and his photographic series about Thomas Bernhard, Friedrich Gulda, Maria Lassnig and Elfriede Jelinek. In 1981 he became the co-founder of the Galerie Fotohof in Salzburg, which developed into an important platform for Austrian photography. Since 2000, Dreissinger has been increasingly interested in the medium of film. He received an award at the Viennale in 2005 for his short documentary *artgenossen. 35 minutenporträts* and in 2006 he received the first prize at the Diagonale. Since 1983 he has also been active as a music educator and freelance collaborator at theatres and on the radio.

The Austrian writer Franz Innerhofer was born in 1944 in Krimml in Salzburg's Pinzgau region and experienced a difficult youth full of hardship, which he bluntly describes in his novel *Schöne Tage*. The book was published in 1974 and the reclusive literary figure was suddenly well known in the entire German-speaking world. Dreissinger's photographs show Innerhofer in Graz, where he lived – isolated and in the dreary atmosphere of a housing development. The austere, realistic style of the photography parallels Innerhofer's literary idiom. Innerhofer committed suicide in 2002.

Literatur/Further reading: Ingrit Seibert und/and Sepp Dreissinger,
Die Schwierigen. Portraits zur österreichischen Gegenwartskunst, Wien/Vienna 1986

Sepp Dreissinger
Franz Innerhofer, 1986
Silbergelatineprint/silver gelatin print

Manfred Willmann

Geboren 1952 in Graz/Österreich, lebt in Graz. Von 1966 bis 1970 studierte Manfred Willmann Dekorative Gestaltung an der HTBL in Graz und besuchte dort in den Jahren 1970 und 1971 die Meisterklasse für Gebrauchsgrafik. 1974 und 1975 war Willmann Leiter der Fotogalerie im Schillerhof in Graz. 1975 gründete er die Fotogalerie im Forum Stadtpark in Graz. 1979 rief er die *Symposien über Fotografie* ins Leben, die im Rahmen des Festivals *steirischer herbst* abgehalten wurden. Beide Veranstaltungen leitete Willmann bis 1996. Ab 1980 war er Gründer und Herausgeber der Zeitschrift *Camera Austria International* und leitete sie bis 2009. Vortrags- und Ausstellungstätigkeiten führten Willmann durch Österreich, Deutschland, Frankreich, Norwegen, Mexiko, Japan und die Niederlande. 1991 erhielt er den Rupertinum-Fotopreis, 1994 den Kulturpreis der Deutschen Gesellschaft für Photographie und 2009 den Österreichischen Staatspreis für Fotografie.

Die künstlerische Arbeit Manfred Willmanns entsteht immer aus einem sehr persönlichen Bezug zu seinem Umfeld: Sein Elternhaus und seine Familiengeschichte sind ebenso Thema und Ausgangspunkt umfangreicher Bildserien wie sein Freundeskreis und die Künstlerszene im innovativen Klima der 1970er-Jahre in Graz. Das Forum Stadtpark war das Zentrum einer avantgardistischen und unangepassten Generation von Literaten, Theatermachern und Theoretikern, zu der neben den aufkommenden Stars auch deren Entourage, bestehend aus ihren Freundinnen, Begleitern und anonymen »Adabeis«, gehörte. Die Künstlerin Silvia Bauer ist die geschiedene Ehefrau des Schriftstellers Wolfgang Bauer (1941–2005), der 1968 mit seinem psychedelischen Theaterstück *Magic Afternoon* einen Skandalerfolg landete. Willmann porträtierte die Personen in dieser Kunstwelt gewohnt unprätentiös, oft spätabends im Freundeskreis, ohne Verstellung oder Pose. Die Atmosphäre und der direkt wiedergegebene Moment unterstreichen dabei deutlich und in Sekundenschnelle die Charakterisierung des Porträtierten. Das einzelne Porträt ist dabei Teil einer umfassenden Serie. Das hier gezeigte Foto gehört zum Portfolio *Portraits für …* aus den Jahren 1979 bis 1981, welches in Willmanns Publikation *Schwarz und Gold* veröffentlicht wurde.

Born in 1952 in Graz/Austria, lives in Graz. From 1966 to 1970 Manfred Willmann studied decorative design at the Vocational College HTBL in Graz and then attended master classes in commercial art there in 1970 and 1971. In 1974 and 1975 Willmann was director of the Fotogalerie im Schillerhof in Graz. In 1975 he founded the Fotogalerie im Forum Stadtpark in Graz. In 1979 he initiated the *Symposien über Fotografie* (Symposia on Photography) held during the *steirischer herbst* festival. Willmann directed both until 1996. From 1980 he was founder and editor of the magazine *Camera Austria International* and directed it until 2009. Willmann has carried out lecture and exhibition activities in Austria, Germany, France, Norway, Mexico, Japan and The Netherlands. He received the Rupertinum Photography Award in 1991, the Cultural Prize of the German Society for Photography in 1994 and the Austrian State Prize for Photography in 2009.

The artistic work of Manfred Willmann always comes from a very personal relationship to his environment: his parents' home and his family history are subjects and starting points of his extensive series of images, as are his friends and the arts scene in the innovative climate of the 1970s in Graz. Forum Stadtpark was the centre of an avant-garde and non-conformist generation of writers, theatre artists and theorists that also included emerging stars and their entourages consisting of their friends, companions and anonymous "wannabes". The artist Silvia Bauer is the divorced wife of the writer Wolfgang Bauer (1941–2005), whose psychedelic play *Magic Afternoon* became a scandalous success in 1968. Willmann portrayed the people in this art world unpretentiously, often late at night with friends, without affectation or posturing. The atmosphere and directly reproduced moment express this clearly and the characterization of those he portrays can be seen within seconds. The individual portrait is part of a comprehensive series. The photograph shown here is part of the portfolio of *Portraits für …* from the years 1979 to 1981, which was reproduced in Willmann's publication *Schwarz und Gold*.

Literatur/Further reading: Peter Pakesch (Hrsg./ed.), *Manfred Willmann. Werkblick* (Ausst.-Kat./exh. cat. Neue Galerie Graz am Landesmuseum Joanneum, Graz), Köln/Cologne 2005

Manfred Willmann
Portrait Silvia Bauer, 1979–1981
Silbergelatineprint/silver gelatin print

Arnulf Rainer

Geboren 1929 in Baden bei Wien/Österreich, lebt in Wien, in Oberösterreich und auf Teneriffa/Spanien. An ein technisches Studium wollte Arnulf Rainer ein Kunststudium anschließen. Er verließ jedoch Kunstakademie und Kunsthochschule nach kürzester Zeit, um sich gemeinsam mit Künstlerkollegen einer nichtakademischen Kunstpraxis zu widmen, die teils in aktionistische, teils in informelle Ausübung in den 1950er- und 1960er-Jahren mündete. Er gehörte zum Kreis um Monsignore Otto Mauer und der Galerie nächst St. Stephan und hatte 1968 seine erste Retrospektive im Museum des 20. Jahrhunderts in Wien. Mit seinen Bild-Über- und Zumalungen wurde er international berühmt; sein Arbeiten mit Fotografien war vom Gestus der Aneignung und Überarbeitung sowie der Akzentuierung und Rhythmisierung geprägt. 1999 ehrte ihn das Stedelijk Museum in Amsterdam und 2002 die Pinakothek der Moderne in München mit je einer Retrospektive.

Das Konzept der Bildüberarbeitung hatte Arnulf Rainer in der Grafik und Malerei entwickelt. Es waren alte Stiche, Buchdrucke, Postkarten, Kunstreproduktionen und ab Ende der 1970er-Jahre zunehmend auch Fotografien, die ihn zu seinen Zustreichungen anregten. Die Aura und die Magie von Totenmasken sind einem umfangreichen Zyklus von Fotoübermalungen eigen, dem auch die bearbeiteten Fotografien von Mumienköpfen zugeordnet werden können. Rainer fotografiert nie selbst, sondern sucht für ihn relevante Fotografien in Antiquariaten, Buchläden und auf Flohmärkten. Durch zeichnerisches Umkreisen des Kopfes, durch das Akzentuieren des Gesichtes mittels Kreidestrichen und Liniensetzungen nähert er sich dem Tabu der Anwesenheit des Todes in einem menschlichen Antlitz.

Literatur/Further reading: Christina Natlacen, *Arnulf Rainer und die Fotografie. Inszenierte Gesichter, ausdrucksstarke Posen*, Petersberg 2010

Born in 1929 in Baden near Vienna/Austria, lives in Vienna, Upper Austria and Tenerife/Spain. While pursuing his technical studies, Arnulf Rainer also wanted to study art. However, he left the Kunstakademie and Kunsthochschule art schools after a very short time to devote himself to non-academic art practice together with fellow artists, which resulted in both Actionism and the informal practice of the 1950s and 1960s. He was involved in the group around Monsignore Otto Mauer and the Galerie nächst St. Stephan, and in 1968 had his first retrospective at the Museum of the 20th Century in Vienna. He became internationally famous for his overpaintings and layered paintings; his work with photographs was characterized by gestures of appropriation and revision as well as accentuation and rhythmicization. In 1999 the Stedelijk Museum in Amsterdam and in 2002 the Pinakothek der Moderne in Munich each honoured him with a retrospective.

Arnulf Rainer developed the concept of image revision in graphics and painting. Old engravings, book prints, postcards, art reproductions and, from the end of the 1970s, increasingly also photographs inspired him in his multimedia work. The aura and magic of death masks are characteristic of an extensive cycle of overpainted photographs to which the photographs of mummy heads can be assigned. Rainer never takes photographs himself, but instead looks for relevant photographs in antique shops, bookshops and flea markets. By using concentric graphisms, by accentuating the face by means of chalk lines and line placements, he approaches the taboo of the presence of death in a human face.

Arnulf Rainer
Ohne Titel/Untitled, 1980
Silbergelatineprint und Kreide/
silver gelatin print and chalk

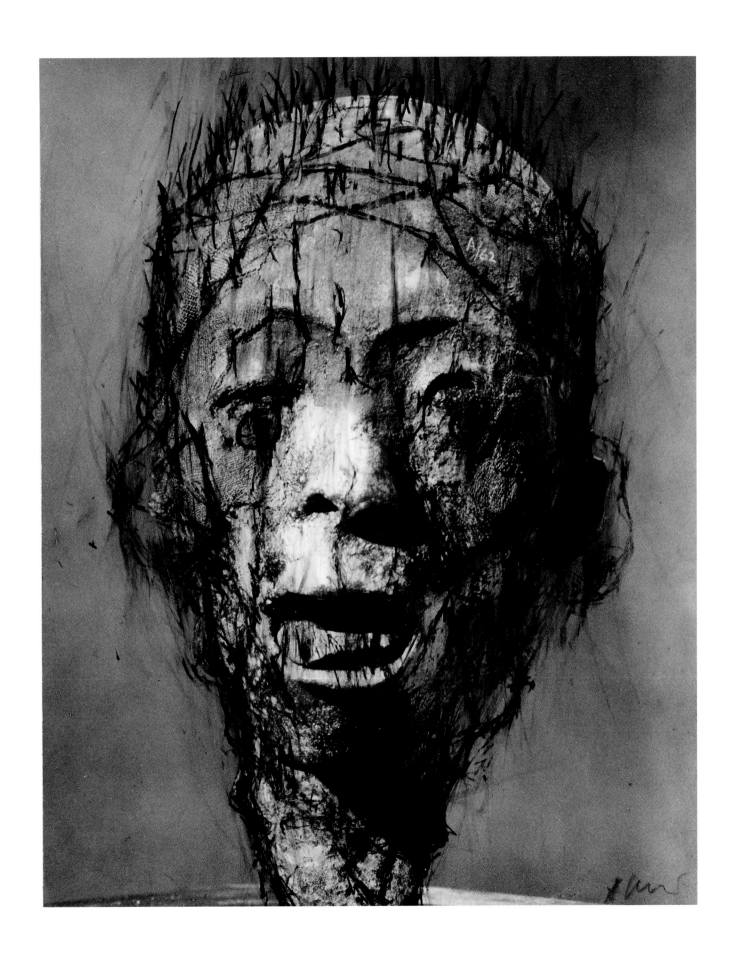

VALIE EXPORT

Geboren 1940 als Waltraud Lehner in Linz/Österreich, mit bürgerlichem Namen Waltraud Höllinger, lebt in Wien/Österreich. Von 1955 bis 1958 besuchte sie die Kunstgewerbeschule in Linz und von 1960 bis 1964 die Höhere Bundes-Lehr- und Versuchsanstalt für Textilindustrie in Wien. Seit 1967 führt sie den Künstlernamen VALIE EXPORT. 1977 nahm sie an der documenta 6 in Kassel teil. 1980 folgte die Repräsentanz für Österreich auf der Biennale in Venedig gemeinsam mit Maria Lassnig. Von 1989 bis 1992 war sie Professorin an der University of Wisconsin-Milwaukee, School of Fine Arts, USA. Von 1991 bis 1995 lehrte sie als Professorin für den Fachbereich Visuelle Kommunikation an der Hochschule der Künste Berlin sowie von 1995 bis 2005 als Professorin für Multimedia-Performance an der Kunsthochschule für Medien in Köln. 2007 war sie sowohl auf der Biennale in Venedig als auch auf der documenta 12 vertreten. 2010 und 2011 wurden ihre Arbeiten in *Zeit und Gegenzeit* gezeigt, einer gemeinsamen Ausstellung des Belvedere in Wien und des Lentos Kunstmuseums in Linz.

Born in 1940 as Waltraud Lehner in Linz/Austria, lives in Vienna/Austria under the legal name of Waltraud Höllinger. From 1955 to 1958, she attended the Kunstgewerbeschule in Linz and from 1960 to 1964 the Höhere Bundes-Lehr- und Versuchsanstalt für Textilindustrie in Vienna. Since 1967 she has used the pseudonym VALIE EXPORT. She participated in documenta 6 in Kassel in 1977. In 1980 she and Maria Lassnig represented Austria at the Biennale in Venice. From 1989 to 1992 she was a professor at the University of Wisconsin-Milwaukee, School of Fine Arts, USA. From 1991 to 1995, she was a professor in the Department of Visual Communication at the Hochschule der Künste Berlin, and from 1995 to 2005 she was a professor of multimedia performance at the Kunsthochschule für Medien in Cologne. In 2007 she participated in both the Venice Biennale and documenta 12. The Belvedere in Vienna and Lentos Kunstmuseum in Linz showed her works in 2010 and 2011 in the joint exhibition *Zeit und Gegenzeit*.

Die Genderthematik ist seit den 1960er-Jahren inhaltlicher Schwerpunkt der Recherche in den Video-, Installations- und Fotoarbeiten von VALIE EXPORT. Mit den *Körperfigurationen* der 1970er-Jahre lotet sie ihr eigenes Ich-Bewusstsein als Frau und als menschliches Individuum gegenüber den vorgegebenen Maßstäben im urbanen Raum aus. Territorialer und machtpolitischer Anspruch werden in Dialog mit der Verletzlichkeit der eigenen Physis gestellt.

Since the 1960s, gender issues have been a major focus of research in the video, installation and photographic works of VALIE EXPORT. In *Körperfigurationen* from the 1970s, she explores her own sense of self as a woman and as a human individual in juxtaposition with the measures specified in urban areas. Territorial demands and power politics are placed in dialogue with the vulnerability of the body.

Literatur/Further reading: Agnes Husslein, Angelika Nollert und/and Stella Rollig (Hrsg./eds.), *Valie Export. Zeit und Gegenzeit* (Ausst.-Kat./exh. cat. Belvedere Wien und/and Lentos Kunstmuseum Linz), Köln/Cologne 2010

VALIE EXPORT
Einkreisung, 1976
Silbergelatineprint, übermalt/
silver gelatin print, overpainted

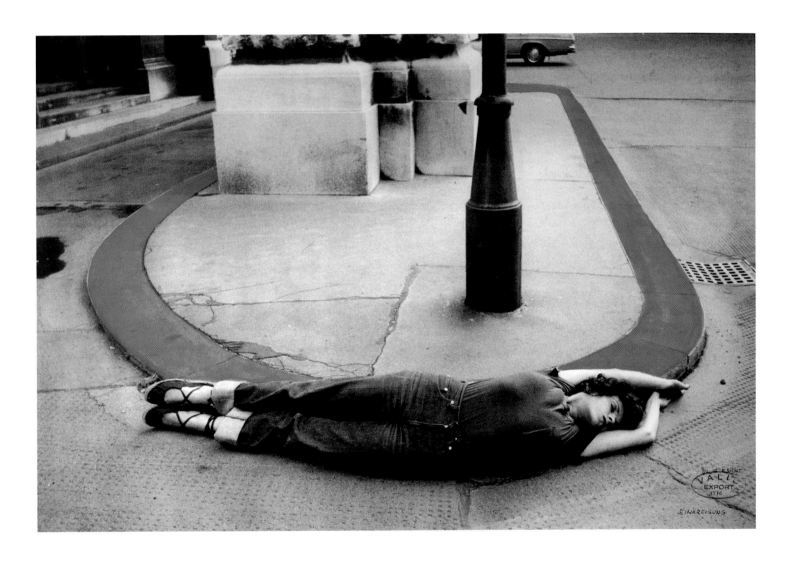

Appendix

VERZEICHNIS DER ABGEBILDETEN WERKE
INDEX OF REPRODUCED WORKS

Jaromír Funke
Komposition/Composition, 1927
Silbergelatineprint, getont/silver gelatin print,
toned, 29,7 x 23,2 cm
S./p. 97

Verena von Gagern
Untersberg, 1975
Silbergelatineprint/silver gelatin print,
28,8 x 28,6 cm
S./p. 217

Mario Giacomelli
Paesaggio, 1968
Silbergelatineprint/silver gelatin print,
22,6 x 36,6 cm
S./p. 215

Raoul Hausmann
Ohne Titel/Untitled, 1946
Silbergelatineprint mit aufgeklebten Fotoaus-
schnitten/silver gelatin print with glued-on pho-
tograph cuttings, 23,5 x 17,2 cm
S./p. 121

Lewis Hine
Gastonia, North Carolina, 1911–1915
Silbergelatineprint/silver gelatin print,
11,5 x 16,5 cm
S./p. 171

Kitty Hoffmann
Ohne Titel/Untitled, 1929
Bromsilberprint/bromine silver print, 16 x 23 cm
S./p. 151

Horst P. Horst
Dame Edith Sitwell, 1948
Silbergelatineprint/silver gelatin print,
34,5 x 27 cm
S./p. 211

André Kertész
Distortion no. 40, 1933
Silbergelatineprint/silver gelatin print,
20 x 25 cm
S./p. 113

Les Krims
Human Being as a Piece of Sculpture, 1970
Bromsilberprint, getont/bromine silver print,
toned, 11,5 x 17 cm
S./p. 201

Heinrich Kühn
Walther, Edeltrude und Hans, um/ca. 1906
Gummidruck/gum print, 24 x 30 cm
S./p. 71

Alfred Stieglitz, 1904
Platinotypie/platinotype, 25,6 x 20,5 cm
S./p. 72

Heinz Loew
Plastische Werkstatt, 1927/28
Silbergelatineprint/silver gelatin print, 8 x 8 cm
S./p. 131

Jan Lukas
Die Terrasse des Opern Cafés, um/ca. 1935
Silbergelatineprint/silver gelatin print,
12,7 x 15 cm
S./p. 149

Werner Mantz
Siedlung Köln – Kalker Feld, 1928
Silbergelatineprint/silver gelatin print, 17 x 23 cm
S./p. 137

Duane Michals
Things are Queer, 1973
9 Silbergelatineprints/9 silver gelatin prints,
13 x 18 cm
S./p. 199

László Moholy-Nagy
Zwischen Himmel und Erde I, 1926
Abzug vermutlich von/print thought
to be from 1971/72
Silbergelatineprint/silver gelatin print,
24 x 18,4 cm
S./p. 109

Werner H. Mraz
Tuchlauben, Wien, 1979
Silbergelatineprint/silver gelatin print,
19,6 x 24,6 cm
S./p. 219

Nadar
George Sand, 1864
Karbonprint/Woodburytype, 24 x 19,6 cm
S./p. 43

Beaumont Newhall
The Chase National Bank, 1928
Silbergelatineprint/silver gelatin print,
35,2 x 28 cm
S./p. 183

Karel Novák
Ohne Titel/Untitled, 1926
Gummidruck/gum print, 32 x 30,2 cm
S./p. 95

Paul Outerbridge
Inkwell and Stamp Holder, 1924
Platinprint/platinum print, 8,2 x 8,4 cm
S./p. 181

Arnulf Rainer
Ohne Titel/Untitled, 1980
Silbergelatineprint und Kreide/silver gelatin print
and chalk, 30 x 24 cm
S./p. 227

Man Ray
Ohne Titel/Untitled, zwischen/between
1924 und/and 1929
Silbergelatineprint/silver gelatin print,
28,1 x 19,4 cm
S./p. 111

Portrait of Meret Oppenheim, 1933
Teilsolarisation/partial solarization, 29 x 21,5 cm
S./p. 2 (Frontispiz/frontispiece)

Albert Renger-Patzsch
Ohne Titel/Untitled (Zeche/coal mine
Scholven bei/near Buer), um/ca. 1926
Silbergelatineprint/silver gelatin print,
17,8 x 12,7 cm
S./p. 147

Alexander Rodtschenko/Rodchenko
Die Jazz-Band/The Jazz Band, 1923
Silbergelatineprint/silver gelatin print,
17 x 11 cm
S./p. 107

Jaroslav Rössler
Gesichtsstudie I/Face Study I, um/ca. 1927
Pigmentdruck/carbon print, 24 x 23,2 cm
S./p. 91

Lothar Rübelt
»Perlen der Großstadt«, Wien,
Michaelerplatz, 1932
Silbergelatineprint/silver gelatin print,
45,2 x 60,6 cm
S./p. 153

Drahomír Josef Růžička
Pennsylvania Station, 1921
Print um/ca. 1936, Pigmentdruck/carbon print,
34,7 x 27 cm
S./p. 87

August Sander
Der Töpfermeister, 1926
Silbergelatineprint/silver gelatin print, 28 x 20 cm
S./p. 145

Xanti Schawinsky
Bauhaus-Bühne, Szene aus dem
Stück »Circus«, 1924
Silbergelatineprint/silver gelatin print, 9 x 14 cm
Druck der Postkarte/postcard printing:
Atelier Eckner, Weimar
S./p. 133

Friedrich Seidenstücker
Ohne Titel (See-Elefant Roland)/Untitled
(Roland the Elephant Seal), um/ca. 1935
Silbergelatineprint/silver gelatin print,
16,5 x 13,1 cm
S./p. 143

Ron Stark
Egg Mirrored, 1971
Kontaktprint/Silbergelatineprint auf
Azo-Papier/contact print/silver gelatin print
on Azo paper, 13 x 17,8 cm
S./p. 203

Edward Steichen
Auguste Rodin, 1903
Fotogravüre auf Japanpapier/photogravure on
Japanese tissue paper, 21 x 16 cm
S./p. 68

Cyclamen - Mrs. Philip Lydig. New York, 1905
Gummi-Bichromat-Abzug/gum bichromate print,
43 x 35 cm
S./p. 67

Otto Steinert
Strenges Ballett (Hommage à
Oskar Schlemmer), 1949
Silbergelatineprint/silver gelatin print,
40 x 30,2 cm
S./p. 135

Alfred Stieglitz
The Steerage, 1907
Fotogravüre auf Japanpapier/photogravure on
Japanese tissue paper, 20 x 16 cm
S./p. 173

Paul Strand
White Fence, 1916
Fotogravüre/photogravure, 17 x 22,5 cm
S./p. 175

Carl Strüwe
Schuppen auf einem Schmetterlingsflügel
(Admiral, Ala papilionis), 1928
Silbergelatineprint nach Mikrofotografie auf Glas-
negativ/silver gelatin print of a microphotograph
on glass negative, 39 x 29,5 cm
S./p. 141

Josef Sudek
aus dem Zyklus/from the work cycle *Gläserne*
Labyrinthe/Glass Labyrinths, 1968–1972
Silbergelatineprint/silver gelatin print,
38,2 x 30 cm
S./p. 99

Frank Meadow Sutcliffe
Expectation, 1888/89
Albuminprint/albumen print, 15 x 20 cm
S./p. 39

Maurice Tabard
Ohne Titel/Untitled, 1929
Silbergelatineprint/silver gelatin print,
23,5 x 17,6 cm
S./p. 117

Hugo Táborský
Ohne Titel/Untitled, 1934
Silbergelatineprint/silver gelatin print,
30 x 24 cm
S./p. 93

William Henry Fox Talbot
Blatt einer Pflanze/Leaf of a Plant, 1844
Talbotypie/Talbotype, 22,2 x 18 cm
S./p. 29

Christian Wachter
aus der Serie/from the series *disappearance*
of landscape (tag/nacht), 1983
Silbergelatineprints, montiert/silver gelatin
prints, mounted, 23,5 x 16 cm
S./p. 221

Weegee
The Flower Peddler, um/ca. 1940
Silbergelatineprint/silver gelatin print,
35,5 x 28 cm
S./p. 185

Edward Weston
Shadow on a Barn and Margrethe, 1920
Silbergelatineprint/silver gelatin print,
24,6 x 19,4 cm
S./p. 177

Cabbage Leaf, 1931
Silbergelatineprint/silver gelatin print,
19 x 24 cm
S./p. 178

Manfred Willmann
Portrait Silvia Bauer, 1979–1981
Silbergelatineprint/silver gelatin print,
27,5 x 27,5 cm
S./p. 225

AUTOREN
AUTHORS

ANNA AUER

Geboren 1937 in Klagenfurt/Österreich, lebt in Wien/Österreich. Buchhandelslehre, von 1954 bis 1957 Studium am Mozarteum Salzburg (Schauspiel und Regie). 1970 Gründung der Galerie Die Brücke in Wien gemeinsam mit Werner H. Mraz (1941–2009), Leitung der Galerie bis 1978. 1975 zusammen mit Werner H. Mraz Konzepterstellung für die Sammlung FOTOGRAFIS der damaligen Österreichischen Länderbank. Konsulentin der Österreichischen Länderbank und Kuratorin der Sammlung FOTOGRAFIS von 1976 bis 1986. Organisation der ersten Symposien über Fototheorie im deutschen Sprachraum, durchgeführt von der Sammlung FOTOGRAFIS von 1976 bis 1981. 1992 vom J. Paul Getty Museum in Los Angeles eingeladen zum Forschungsprojekt *Übersee*. Kuratorin der Ausstellung *Übersee. Flucht und Emigration österreichischer Fotografen / Exodus from Austria. Emigration of Austrian photographers 1920–1940* in der Kunsthalle Wien, 1997. Von 2001 bis 2010 Präsidentin der Europäischen Gesellschaft für die Geschichte der Photographie (ESHPh) mit Sitz in Wien. 2008 Verleihung des Professorentitels.

Born in 1937 in Klagenfurt/Austria, lives in Vienna/Austria. Apprenticeship in the book trade; studied from 1954 to 1957 at Mozarteum Salzburg (acting and directing). In 1970, she and Werner H. Mraz (1941-2009) founded Die Brücke gallery in Vienna; director of the gallery until 1978. In 1975 she and Werner H. Mraz conceptualized the FOTOGRAFIS collection of the former Österreichische Länderbank. Consultant at Länderbank and curator of the FOTOGRAFIS collection from 1976 to 1986. Organization of the first symposia on photography theory in the German-speaking world, carried out with the FOTOGRAFIS collection from 1976 to 1981. Invited by the J. Paul Getty Museum in Los Angeles for the research project *Overseas* in 1992. Curator of the exhibition *Übersee. Flucht und Emigration österreichischer Fotografen / Exodus from Austria. Emigration of Austrian photographers 1920-1940* at Kunsthalle Vienna, 1997. From 2001 to 2010, President of the European Society for the History of Photography (ESHPh), with headquarters in Vienna. Awarded the title of professor in 2008.

VLADIMÍR BIRGUS

Geboren 1954 in Frýdek-Místek/damalige Tschechoslowakei, lebt in Prag/Tschechische Republik. Studium der Literatur, Theaterwissenschaft und Kinematografie in Olmütz und Prag. Professor und seit 1990 Vorstand des Instituts für Künstlerische Fotografie an der Schlesischen Universität in Opava. Autor und Mitautor von 35 Büchern, darunter *Tschechoslowakische Fotografie der Gegenwart,* Köln und Heidelberg 1990; *Czech Photographic Avant-Garde 1918–1948,* Prag und Stuttgart 1999; *Czech Photography of the 20th Century*, Prag 2010. Kurator und Ko-Kurator zahlreicher großer Ausstellungen zur tschechischen Fotografie in Europa, den USA und Japan. Eigene fotografische Tätigkeit und über sechzig Einzelausstellungen.

Born in 1954 in Frýdek-Místek/former Czechoslovakia, lives in Prague/Czech Republic. Studied literature, theatre and cinematography in Olomouc and Prague. Professor and head of the Institute of Creative Photography at Silesian University in Opava, Czech Republic since 1990. Author and co-author of 35 books, including *Tschechoslowakische Fotografie der Gegenwart*, Cologne and Heidelberg 1990, *Czech Photographic Avant-Garde 1918-1948*, Prague and Stuttgart 1999; *Czech Photography of the 20th Century*, Prague 2010. Curator and co-curator of many large exhibitions on Czech photography in Europe, the USA and Japan. A photographer himself, he has shown his own photographs in more than sixty solo exhibitions.

SIMONE FÖRSTER

Geboren 1969 in Nürnberg/Deutschland, lebt in München/Deutschland. Studium der Kunstgeschichte, Italianistik und Klassischen Archäologie in Freiburg im Breisgau, Padua und Berlin. 2000 und 2001 Stipendiatin des Programms *Museumskuratoren für Fotografie* der Alfried Krupp von Bohlen und Halbach-Stiftung. 2006 Promotion an der Technischen Universität Berlin über Architekturfotografie der 1920er-Jahre. Bis 2008 freiberufliche Kunsthistorikerin und Kuratorin mit Schwerpunkt Fotografie, u.a. für das Münchner Stadtmuseum, das Museum Folkwang in Essen und das Museum Küppersmühle in Duisburg. Seit 2009 Kuratorin der Stiftung Ann und Jürgen Wilde an der Pinakothek der Moderne in München. Publikationen und Ausstellungen, u.a. zu Architekturfotografie, zu Fotobüchern, zur Fotografie im 20. Jahrhundert und zu zeitgenössischer Fotografie, zuletzt: *Architektur im Buch*, hrsg. mit Burcu Dogramaci, Dresden 2010; *Hans-Christian Schink,* hrsg. mit Ulrike Bestgen u.a., Ostfildern 2011; *Die neue Wirklichkeit*, Ausstellung in der Pinakothek der Moderne in München, 2011; »Love Affair. *America* von Andy Warhol«, in: Nina Schleif (Hrsg.), *Reading Andy Warhol,* Ostfildern 2013.

Born in 1969 in Nuremberg/Germany, lives in Munich/Germany. Studied art history, Italian language and literature and classical archaeology in Freiburg im Breisgau, Padua and Berlin. In 2000 and 2001 scholarship holder of the Alfried Krupp von Bohlen und Halbach Foundation's programme *Museum curators for photography*. 2006 doctoral degree in architectural photography of the 1920s at Technische Universität Berlin. Until 2008, freelance art historian and curator specializing in photography for the Munich Stadtmuseum, Museum Folkwang in Essen and Küppersmühle Museum in Duisburg. Since 2009, curator of the Ann and Jürgen Wilde Foundation at Pinakothek der Moderne in Munich. Publications and exhibitions range from architectural photography to photo books on photography to 20th-century and contemporary photography, most recently: *Architektur im Buch*, ed. with Burcu Dogramaci, Dresden 2010; *Hans-Christian Schink*, ed. with Ulrike Bestgen and others, Ostfildern 2011; *Die neue Wirklichkeit*, exhibition at Pinakothek der Moderne in Munich, 2011; "Love Affair. *America* by Andy Warhol", in: Nina Schleif (ed.), *Reading Andy Warhol*, Ostfildern 2013.

WALTER GUADAGNINI

Geboren 1961 in Cavalese/Italien, lebt in Bologna/Italien. Seit 1992 Inhaber des Lehrstuhls für Geschichte der Fotografie an der Kunstakademie Bologna. Von 1995 bis 2005 Direktor der Galleria Civica in Modena. Von 1995 bis 2003 Kunstkritiker der Tageszeitung *La Repubblica*. Seit 2004 Präsident der wissenschaftlichen Kommission des Projekts *UniCredit e l'Arte*. Seit 2006 Verantwortlicher für die Fotografie-Beiträge im *Giornale dell'Arte*. 2007 Kurator für den italienischen Beitrag bei *Paris Photo*. Kuratorische Tätigkeit, u.a. 2007 für

Pop Art! 1956–1968, Scuderie del Quirinale in Rom; 2009/10 für *Past Present Future. Highlights aus der UniCredit Group Sammlung,* Kunstforum Wien, Palazzo della Ragione in Verona und Yapi Kredi Cultural Center in Istanbul; 2011 für *Things are Queer,* MARTa Herford. Vielfältige Publikationstätigkeit, v.a. zur Fotografiegeschichte, u.a. *Una storia della fotografia del XX e del XXI secolo,* Bologna 2010.

Born in 1961 in Cavalese/Italy, lives in Bologna/Italy. Professor of history of photography at the Art Academy of Bologna since 1992. Director of Galleria Civica in Modena from 1995 to 2005. Art critic for the newspaper *La Repubblica* from 1995 to 2003. President of the academic committee for the project *UniCredit e l'Arte* since 2004. Responsible for photography articles in *Giornale dell'Arte* since 2006. Curator of the Italian contribution to *Paris Photo* in 2007. Curatorial work in 2007 for *Pop Art! 1956-1968*, Scuderie del Quirinal in Rome; *Past Present Future. Highlights from the UniCredit Group Collection* 2009/10, Kunstforum Wien, Palazzo della Ragione in Verona and Yapi Kredi Cultural Center in Istanbul; in 2011 for *Things are Queer*, MARTa Herford. Various publications, mainly on the history of photography, including *Una storia della fotografia del XX e del XXI secolo*, Bologna 2010.

WALTER MOSER

Geboren 1979 in Wels/Österreich, lebt in Wien/Österreich. Studium der Kunstgeschichte in Wien und Rom. Bis 2007 freier Mitarbeiter des Wien Museums. Von 2008 bis 2011 wissenschaftlicher Mitarbeiter der Fotosammlung des Österreichischen Filmmuseums. Seit 2011 Leiter der Fotosammlung der Albertina in Wien. Ausstellungen und Publikationen zur Fotogeschichte, zuletzt: *Lewis Baltz,* hrsg. mit Susanne Figner, Köln 2012.

Born in 1979 in Wels/Austria, lives in Vienna/Austria. Studied art history in Vienna and Rome. Freelance work for the Wien Museum until 2007. Academic assistant for the photographic collection of the Austrian Film Museum from 2008 to 2011. Director of the photographic collection of the Albertina in Vienna since 2011. Exhibitions and publications on the history of photography, most recently: *Lewis Baltz,* ed. with Susanne Figner, Cologne 2012.

ULRICH POHLMANN

Geboren 1956 in Schönberg, Holstein/Deutschland, lebt in München/Deutschland. Studium der Kunstgeschichte, Ethnologie und Didaktik der Kunsterziehung in Kiel, Bamberg und München. 1989 Promotion. Seit 1991 Leiter der Sammlung Fotografie im Münchner Stadtmuseum. Kurator zahlreicher monografischer und thematischer Ausstellungen zur Fotografie sowie Herausgeber und Autor internationaler Veröffentlichungen zur Kulturgeschichte der Fotografie und zur zeitgenössischen Fotografie. Gastdozent des Studiengangs »Aisthesis. Historische Kunst- und Literaturdiskurse« im Rahmen der Exzellenzinitiative Bayerns. Vorträge, Vorlesungen und Seminare zur Geschichte der Fotografie und zur zeitgenössischen Medienkunst; Verfasser zahlreicher Monografien. Seit 2006 Mitglied des wissenschaftlichen Beirats im European Research Council in Brüssel und wissenschaftlicher Beirat in diversen Museen.

Born in 1956 in Schönberg, Holstein/Germany, lives in Munich/Germany. Studied art history, ethnology and art education instruction in Kiel, Bamberg and Munich. Doctoral degree in 1989. Head of the photographic collection at the Munich Stadtmuseum since 1991. Curator of numerous monographic and thematic exhibitions on photography and editor and author of international publications on the cultural history of photography and on contemporary photography. Guest lecturer for the course "Aisthesis. Historic art and literary discourse" as part of the Excellence Initiative of Bavaria. Lectures, presentations and seminars on the history of photography and contemporary media art; author of numerous monographs. Member of the Academic Advisory Board at the European Research Council in Brussels since 2006 and academic advisor to various museums.

UWE M. SCHNEEDE

Geboren 1939 in Neumünster/Deutschland, lebt in Hamburg/Deutschland. Studium der Kunstgeschichte, Literaturwissenschaft und Archäologie an den Universitäten Kiel und München. 1965 Promotion. 1967 und 1968 wissenschaftlicher Assistent an der Kunsthalle Düsseldorf, von 1968 bis 1973 Leiter des Württembergischen Kunstvereins Stuttgart. Von 1973 bis 1984 Leiter des Kunstvereins in Hamburg. Gründungs- und Vorstandsmitglied von Kommunale Kinos e.V. in Stuttgart (1971–1973) und Hamburg (1977–1984). Von 1985 bis 1990 Professor für Kunstgeschichte mit Schwerpunkt 20. Jahrhundert am Kunsthistorischen Seminar der Universität München. Ab 1991 Direktor der Hamburger Kunsthalle. In seine Amtszeit fielen der Neubau und die Etablierung der Galerie der Gegenwart (Eröffnung 1997). Herausgeber einer Reihe von Büchern zu Kunst und Kunstgeschichte. Ab 1994 Teilzeitprofessor für Kunstgeschichte an der Hochschule für bildende Künste Hamburg. Mitglied des Kuratoriums der Hanne Darboven Stiftung. 2009 ausgezeichnet mit dem Bundesverdienstkreuz am Bande.

Born in 1939 in Neumünster/Germany, lives in Hamburg/Germany. Studied art history, literature and archaeology at the universities of Kiel and Munich. Doctoral degree in 1965. Research assistant at Kunsthalle Düsseldorf from 1967 to 1968, Director of the Württemberg Kunstverein Stuttgart from1968 to 1973. Head of Kunstverein in Hamburg from 1973 to 1984. Founder and board member of Kommunale Kinos e.V. in Stuttgart (1971 to 1973) and Hamburg (1977 to 1984). Professor of art history with a focus on the 20th century in the Art History Department of the University of Munich from 1985 to 1990. Director of Hamburg Kunsthalle from 1991. The new building and the establishment of Galerie der Gegenwart (opening in 1997) fell into his term of office. Editor of a series of books on art and art history. Part-time professor of art history at Hochschule für bildende Künste Hamburg from 1994. Member of the board of the Hanne Darboven Foundation. Awarded the Federal Cross of Merit on Ribbon in 2009.

TONI STOOSS

Geboren 1946 in Bern/Schweiz, lebt in Salzburg/Österreich. Studium der Kunstgeschichte, Klassischen Archäologie und Publizistik in Bern und Berlin.

Seit 1972 rege Ausstellungstätigkeit, u.a. als Kurator für die Neue Gesellschaft für Bildende Kunst in Berlin. Ausstellungsprojekte in der Akademie der Künste in Berlin, der Neuen Nationalgalerie in Berlin, dem Neuen Berliner Kunstverein, der neuen DAAD-Galerie in Berlin u.v.m. Ab 1982 Ausstellungsleiter und Konservator am Kunsthaus Zürich, nebenbei Tätigkeit als Berater der Kunstkommission der Schweizerischen Kreditanstalt sowie Mitglied der Städtischen Kunst-Ankaufskommission Zürich. 1992 zum Gründungsdirektor gewählt und bis 1995 Leiter der Kunsthalle Wien. Von 1996 bis 2001 Direktor des Kunstmuseums Bern. Ab 2003 künstlerische Leitung und 2004 und 2005 Konservator und Kurator der Stiftung Liner Appenzell in der Schweiz. Seit 2006 Direktor des Museum der Moderne Salzburg. Zahlreiche Ausstellungen und Publikationen zur modernen und zeitgenössischen Kunst.

Born in 1946 in Bern/Switzerland, lives in Salzburg/Austria. Studied art history, classical archaeology and journalism in Bern and Berlin. Active exhibition activity since 1972, including work as curator for Neue Gesellschaft für Bildende Kunst in Berlin. Exhibition projects at Akademie der Künste in Berlin, Neue Nationalgalerie in Berlin, Neuer Berliner Kunstverein, the new DAAD Gallery in Berlin and many more. Starting in 1982, exhibition director and conservator at Kunsthaus Zürich, in addition to working as a consultant to the Art Committee of Credit Suisse and as a member of the Municipal Art Acquisitions Committee Zürich. Elected founding director of Kunsthalle Wien in 1992 and head until 1995. Director of Kunstmuseum Bern from 1996 to 2001. Artistic director in 2003 and conservator and curator in 2004 and 2005 of the Liner Foundation Appenzell, Switzerland. Since 2006 director of the Museum der Moderne Salzburg. Numerous exhibitions and publications on modern and contemporary art.

MARGIT ZUCKRIEGL

Geboren 1955 in Salzburg/Österreich, lebt in Salzburg. Studium der Kunstgeschichte, Archäologie und Philosophie in Salzburg und Rom. 1983 Promotion. Studienaufenthalte in den USA und in Barcelona. Kuratorin für zeitgenössische Kunst an den Salzburger Landessammlungen Rupertinum, Museum der Moderne Salzburg, und seit 1985 Leiterin der Österreichischen Fotogalerie. 2004 und 2005 Lehrauftrag am Kunsthistorischen Institut der Universität Salzburg. 2006 Preisträgerin des International Award of Photography, verliehen vom CRAF/Spilimbergo, Italien. Seit 2011 Lektorin für Kunstgeschichte an der Kunstuniversität Mozarteum Salzburg. Zahlreiche Publikationen zur modernen und zeitgenössischen Kunst.

Born in 1955 in Salzburg/Austria, lives in Salzburg. Studied art history, archaeology and philosophy in Salzburg and Rome. Doctoral degree in 1983. Study abroad in the USA and Barcelona. Curator of contemporary art at Salzburg Landessammlung Rupertinum, Museum der Moderne Salzburg, and director of Österreichische Fotogalerie since 1985. Lecturer at the Institute of Art History at Universität Salzburg. International Award of Photography by CRAF/Spilimbergo, Italy, in 2006. Art history lecturer at Kunstuniversität Mozarteum, Salzburg since 2011. Numerous publications on modern and contemporary art.

DANK
ACKNOWLEDGEMENTS

Zahlreiche Kolleginnen und Kollegen haben im Rahmen der Aktualisierung der Angaben zu den Werken in der Sammlung FOTOGRAFIS Bank Austria mit hilfreichen Hinweisen und fachlichen Ratschlägen zu einem neuen Wissensstand beigetragen. Dafür bedanken wir uns namentlich bei

Numerous colleagues have contributed to the field of knowledge within the framework of the updating of the cataloguing of the works in the FOTOGRAFIS Bank Austria Collection with helpful suggestions and expert advice. In particular, we would like to thank

Dr. Péter Baki, Direktor des Ungarischen Museums für Fotografie/ director of the Hungarian Museum of Photography, **Kecskemét**

Gabriele Conrath-Scholl und/and Rajka Knipper, Die Photographische Sammlung/SK Stiftung Kultur der Sparkasse KölnBonn

Duncan Forbes, National Galleries of Scotland und/and Fotomuseum Winterthur

Christine Frisinghelli, Graz

Floris Neusüss und/and Renate Heyne, Kassel

Gerald Piffl, IMAGNO brandstätter images, Wien/Vienna

und/and Lutz Schöbe, Stiftung Bauhaus Dessau.

Des Weiteren möchten wir uns bei allen Fotografinnen und Fotografen, deren Werke in dieser Publikation gezeigt werden, bei ihren Rechtsnachfolgern und allen Rechteinhabern für ihr Entgegenkommen bedanken. Unser verbindlicher Dank geht an

We would also like to express our thanks to all photographers whose work is shown in this catalogue, and to their legal successors and all holders of rights for their amenability. We are sincerely grateful to

Hilla Becher, Judy Dater, Hannelore Ditz, Elliott Erwitt, Les Krims, Daniel Schawinsky, Dr. Diether Schönitzer, Raymond Stark, Petra Steinhardt für den/for Nachlass Otto Steinert im Museum Folkwang, Essen, Sylvia Vitova-Rösslerova und/and Ann und/and Jürgen Wilde.

BILDNACHWEIS
PHOTO CREDITS

IMPRESSUM
COLOPHON

Diese Publikation erscheint anlässlich der Ausstellung/
This catalogue is published on the occasion of the exhibition

Fotografie im Fokus
Die Sammlung FOTOGRAFIS Bank Austria

Focus on Photography
The FOTOGRAFIS Bank Austria Collection

05.10.2013 – 12.01.2014
Museum der Moderne Salzburg Rupertinum

Herausgeber/Edited by: Toni Stooss und/and Margit Zuckriegl,
MdM SALZBURG
Konzeption/Concept: Margit Zuckriegl
Redaktion/Editorial: Toni Stooss, Margit Zuckriegl
Redaktionelle Assistenz/Editorial assistence: Astrid de Knecht,
Christina Penetsdorfer, Anna Rechberger
Bildredaktion/Picture editor: Katja Mittendorfer-Oppolzer
Kurzbiografien der Fotografinnen und Fotografen/
Short biographies of the photographers: Astrid de Knecht
Kurztexte zu den Fotografien/Short texts about the photographs:
Margit Zuckriegl

Projektleitung/Editorial direction (Hirmer): Karen Angne
Projektmanagement/Project management:
Sabine Gottswinter-Pätzold, Vilsheim
Gestaltung, Satz und Cover/Design, typesetting and cover:
Petra Ahke und/and Erill Fritz, Berlin
Übersetzungen/Translations: Ad Verbum, St. Johann im Pongau
Lektorat/Copy-editing: Sabine Gottswinter-Pätzold, Vilsheim
(deutsch/German), Susanna Rachel Michael, München/Munich
(englisch/English)
Lithografie/Lithography: Reproline Mediateam, München/Munich
Papier/Paper: Profisilk, 150 g/qm
Schrift/Set in: Berkeley, Corporate
Druck und Bindung/Printed and bound by:
Passavia Druckservice GmbH & Co. KG, Passau

Printed in Germany

ISBN 978-3-7774-2152-0 (deutsches Cover/German cover)
ISBN 978-3-7774-2153-7 (englisches Cover/English cover)

www.hirmerverlag.de
www.hirmerpublishers.com

Bibliografische Information der Deutschen Nationalbibliothek
Die Deutsche Nationalbibliothek verzeichnet diese Publikation in der
Deutschen Nationalbibliografie; detaillierte bibliografische Daten sind
im Internet über http://www.dnb.dnb.de abrufbar.

Bibliographic information published by the Deutsche Nationalbibliothek
The Deutsche Nationalbibliothek lists this publication in the Deutsche
Nationalbibliografie; detailed bibliographic data are available on the
Internet at http://www.dnb.dnb.de.

Umschlagvorderseite/Front cover: Horst P. Horst, *Dame Edith Sitwell*
(Ausschnitt/detail), 1948, siehe S./see p. 211

Umschlagrückseite/Back cover: Karl Blossfeldt, *Dipsacus laciniatus*,
vor 1926/pre-1926, Print 1975, siehe S./see p. 139

Frontispiz/frontispiece: Man Ray, *Portrait of Meret Oppenheim*, 1933,
siehe S./see p. 233

S./pp. 16/17: Antonio Beato, *Les trois pyramides avec le village à Gizeh*
(Ausschnitt/detail), 1873, siehe S./see p. 33

S./pp. 230/231: Verena von Gagern, Ohne Titel/Untitled (Ausschnitt/
detail), 1979, Silbergelatine/Baryt/silver gelatin/barite, 18 x 26,6 cm,
Sammlung FOTOGRAFIS Bank Austria/FOTOGRAFIS Bank Austria Collection